# FOR THE LOVE OF SHOES

EDITED BY

PATRICE FARAMEH

teNeues

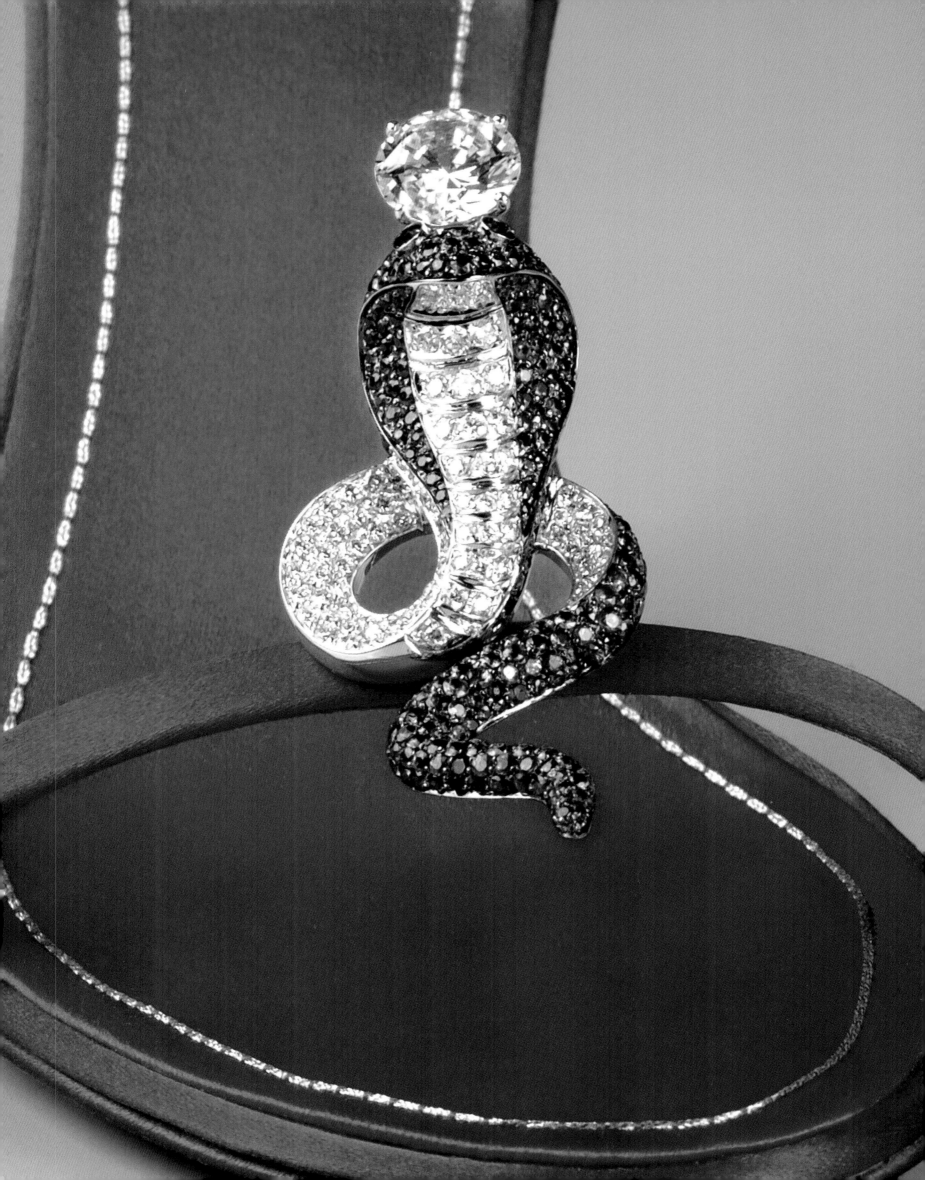

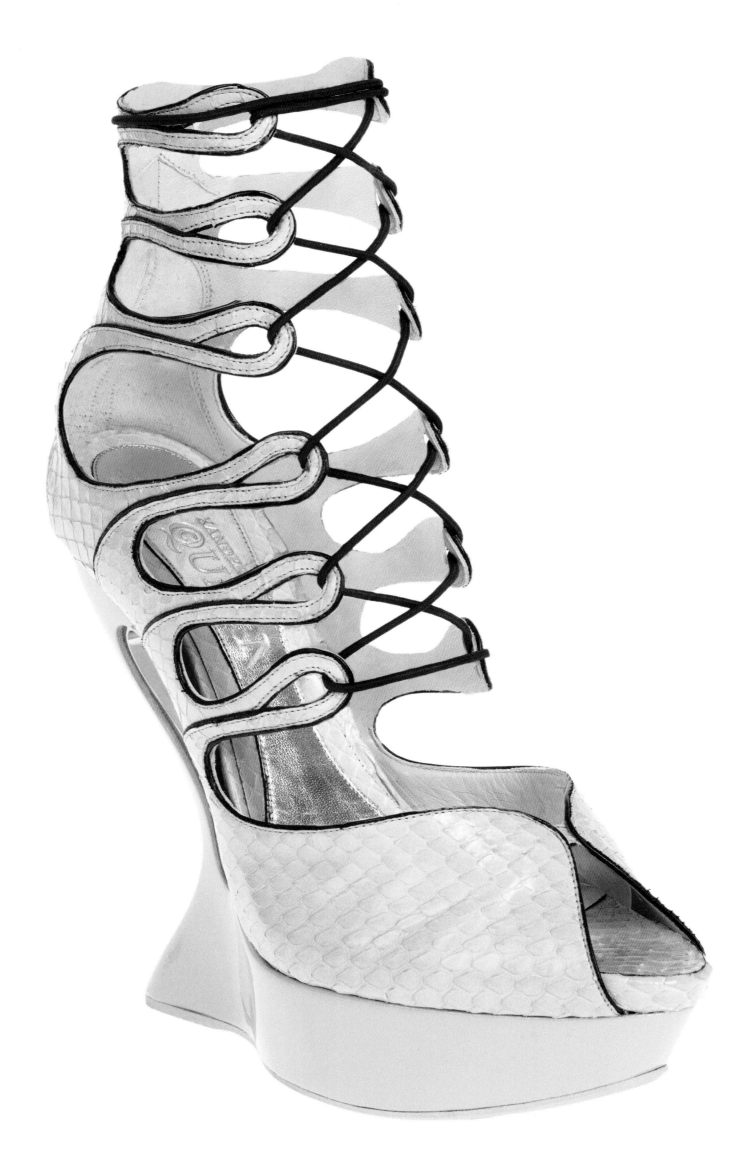

4

# LITTLE PLEASURES
## PATRICE FARAMEH

The transformation was instant. Marilyn Monroe had it right when she said, "Give a girl the right shoes, and she can conquer the world."

If there was ever a night to debut the fantastically high heels I'd fantasized about for ages, it was tonight. I carefully pulled the box from my closet and placed it on the bed, unwrapping delicate silk paper to reveal what I'd spent half my rent to own. Slowly, ritualistically, I slipped them on. My body was uplifted and my nerves were immediately injected with the most exhilarating rush of confidence.

Fast forward a few whirlwind hours later. My date was handsome, charming, and kind. I was glowing as we left the restaurant, hardly noticing that a drizzle had descended on the streets of an early spring night. He stepped out of the doorway and began walking, but turned back to find me still standing, frozen in place, shaking my head frantically as though he'd asked me to leap into a burning building. It wasn't my hair and dress that concerned me. It was the love for my impossible-to-get pair of shoes.

At that crucial moment in the evening, I let slip what some might consider a "deal breaker." Herein, the love of shoes: the catalyst behind this book. It is a very real paradox and, sometimes, borderline-psychotic. *Ipso facto*, a single girl in the notoriously rigorous dating scene of Manhattan would rather pay half her month's rent and risk losing the man of her dreams for a pair of high heels.

The hit television series *Sex and the City* was not far off in its portrayal of Carrie Bradshaw, whose neurotic and irrational hunger for stilettos steered the storyline of many an episode. Bradshaw represents the multitudes of women who create regal storage spaces in matchbox-sized studio apartments to properly house their collections. If it's a question between her life or her shoes, for these women, the answer is a resounding, emphatic, "Blahnik's." Furthermore, some tales of footwear fiends have historical significance. We only need look to the notorious former first lady of the Philippines, Imelda Marcos, whose three thousand pair-strong collection regulary made front-page news.

With such varied cultural touchstones and countless friends and acquaintances who can share at least one memorable "shoe story," it is clear that many women have a special connection to this object that cradles, kisses, and contorts their lowest body part. Moreover, it has become increasingly impossible to ignore the fact that footwear is metamorphosing into giant iridescent lobster claws and other surreal shapes. Shoes have gotten wilder

and more imaginative over the years, like the whimsical designs of Kobi Levi, for example, or the architecturally inspired pieces by Tea Petrovic and United Nude. As coverings of an appendage necessary for mobility, shoes manifest what we stand for and where we want to go—both literally and figuratively.

The shoe wields a strange and erotic power, and its popularity has become more widespread and confrontational with each passing year. In researching and conducting countless interviews with some of the world's foremost shoe designers and fashion experts for this book, profound theories on this phenomenon came to light. Shoes take us places, transform us, elevate us. They change our physical appearance, yet can be easily removed, not unlike a push-up bra. Whether they be stilettos or platforms, they accentuate the feminine characteristics of the body: they automatically lengthen the legs, lift the butt, and thrust the breasts forward. In essence, shoes make women feel statuesque and goddess-like.

Without a doubt, this brand of beauty is linked to sex appeal. The fetishistic quality of shoes lead Sigmund Freud to hypothesize that they symbolize female genitals, with slipping in the foot representative of intercourse. Others view the heel as a phallic substitute. Its eroticism is proudly displayed in iconic images by fashion photographers like Miles Aldridge and Helmut Newton, not to mention in pornographic films. Aside from the fact that high heels help the body achieve a feminine archetype, they also blend strength with vulnerability, rendering the wearer incapable of running a marathon, but able to stand at eye-level with just about everyone in the room. Aoi Kotsuhiroi's wearable pieces of art are great examples of this: bondage-inspired and created from hand-carved wood wrapped with soft leather, they look like they could both entrap and destroy. Whatever reaction shoes elicit from the vast spectrum of human emotion, across the board, high heels are considered sexy.

The desire to be physically appealing is nothing new; it seems that as soon as people had time left over from hunting and gathering, they were dedicating at least some of it to the contemplation and attainment of beauty and fashion, both as a means to attract potential mates and as a form of self-expression. Though seemingly "superficial," the subject carries incredible cultural weight. In America alone, the cosmetics and apparel industries rake in a combined revenue of over $200 billion. Indigenous tribes from the African bush to the Amazon jungle undergo painful scarification practices in the endeavor to appeal to others. In every era across the globe, human beings aspired to the aesthetic ideals dictated by their environments. Maybe it's the biological drive to find a mate, procreate, and propel the human species forward. Maybe it's mass hysteria. Perhaps there's a cosmic aspect to it, something akin to seeking the mathematical Golden Ratio in nature. Whatever it is, the shoe

is one method of getting that much closer to perfection, or at least society's standards of it. It is one of the most transforming embellishments we can attain without surgery.

Heels appeal to both the sexual and social drives. The human tendency to want more and to want the best took fashions of the foot to great heights. In the Middle Ages, as the wealth of some increased to epic proportions while others were born into fieldwork, the patten shoe came to represent status. A simple construction worn outdoors over a pair of normal shoes, it comprised a wooden slab similar to a small table, but lifted the wearer up off the unpaved, dusty, and dirty ground. This way, they could keep their poulaines (pointed shoes) clean, distinguishing them from laboring serfs. Another form of shoe, chopines, the footwear of choice for aristocratic Renaissance women and courtesans, reflected the wearer's lavish lifestyle with exotic materials and increasing heights.

Many centuries later, shoes are continuing their upward ascent, as seen in the famous styles of Noritaka Tatehana, whose work for Lady Gaga created a trend for hovering above the masses in ten-inch platform heels. Heels like those and their antecedents (like those worn by 1970s and '80s glam-rockers like Elton John, David Bowie, and Prince) are daring, potent, and luxurious statements of self-expression. Today the abundance of new, varying styles appeals to the postmodern palette. When everything has been done, it's necessary to do it differently—and better. Diamond-encrusted Stuart Weitzman shoes and human hair-covered Lauren Tennenbaum creations are natural heirs to the extravagant chopine. Meanwhile, avant-garde heels, such as the sharp blades of Chau Har Lee or the heel-less varieties of Kermit Tesoro, suggest not only a more philosophical approach to fashion, but also impressive technological advancements. Marloes ten Bhömer and Naim Josefi take this a step further with their three-dimensional printed heels.

Luxury, craftsmanship, and creativity never fail to appeal. As the director of The Museum at the Fashion Institute of Technology and self-professed shoe lover Dr. Valerie Steele points out, these little objects, though expensive, are often priced in a range more approachable than designer clothing, or other accessories, like jewelry or watches. Hence, their popularity only increases during times of economic decline. Not to mention that the shoe is an object we can savor as a piece of ourselves and as a vehicle for obtaining our deepest desires. Luckily, my date that rainy night understood my predicament. He patiently stood by as the restaurant's hostess found a plastic bag where I could safely place my very own pair of "glass slippers." After walking barefoot to the cab and a little under a year later, we were married. In the end, every shoe story has a silver lining.

—Patrice Farameh

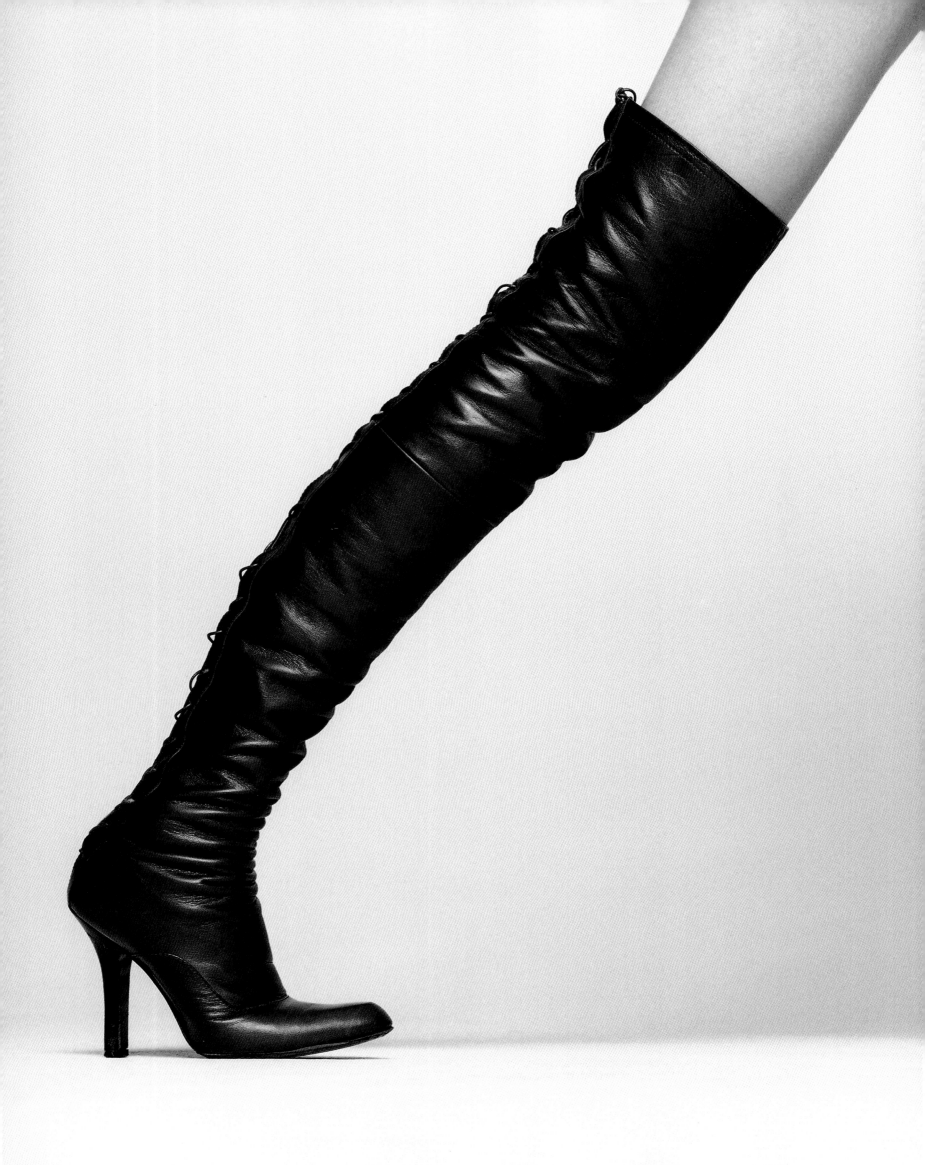

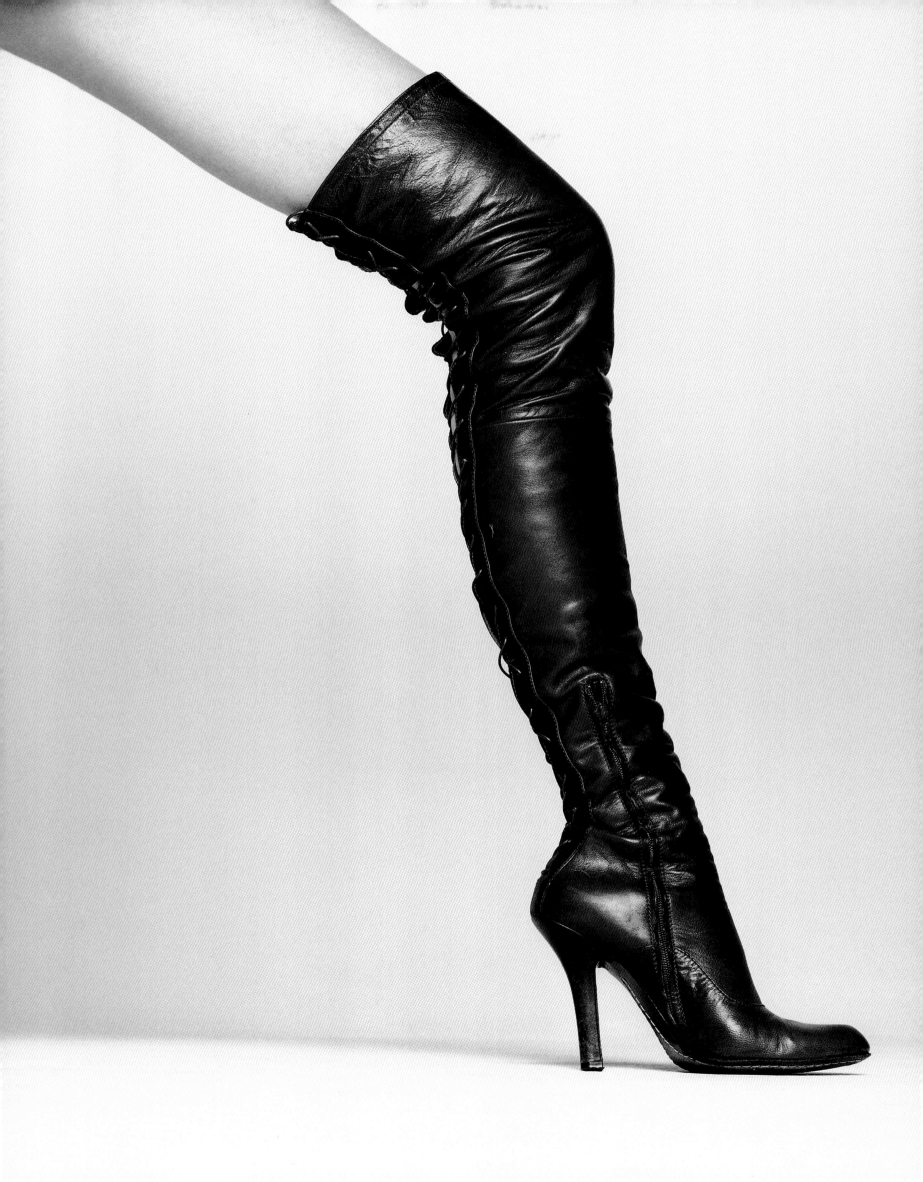

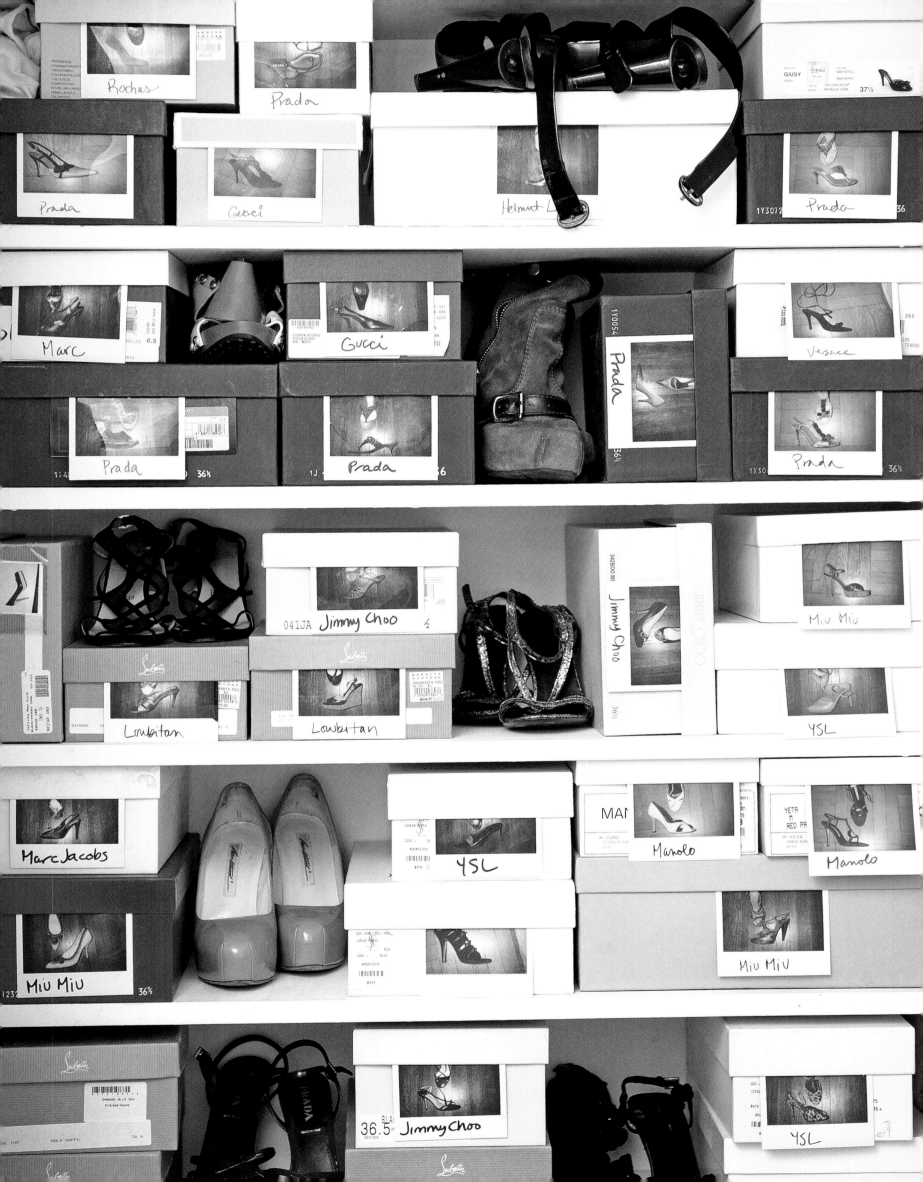

As a young girl growing up in the Midwest, Mary Alice Stephenson fell in love with fashion. In her hometown of Birmingham, Michigan, shopping every Saturday was the norm for a teenage girl, and Stephenson couldn't help but soak up its sartorial influences. Her small town—with its charming streets laden with shoe stores and retail shops that beckon at every turn—was a breeding ground for young fashionistas. In high school she was one of the first to wear acid-washed jeans, cut-off sweatshirts, and the sharp-toed, spike-heeled shoes of the day—a bold move when just getting dressed for most teenagers is nerve-wracking, at best. For Stephenson, being bold was innate. With striking, all-American good looks and a six-foot frame, Stephenson knew from the start that a career in fashion was her calling. After studying at Boston College, Stephenson's career path cut right to New York, where she quickly landed positions at *Vogue*, Isaac Mizrahi, *House Beautiful*, and *Harper's Bazaar*. It was at the latter publication where she made her mark, eventually attaining the esteemed position of fashion director. Stephenson has scaled the heights of fashion with a job that has taken her all over the world, allowing her to forge friendships with the business's top names. She used her impeccable taste to create campaigns with some of the best photographers in the fashion world, such as Bruce Weber, Mario Testino, and Patrick Demarchelier. Television shows, Web sites, and publications, from the *Today* show and *Good Morning America* to *Marie Claire*, *Esquire*, *Allure*, and *Harper's Bazaar* now call upon Stephenson as an expert editor and stylist. With New York as her home, Stephenson delights in all the city has to offer and finds it prime territory for the art of walking. Her closet is a treasure trove of creations from footwear greats, a fantasyland for shoe aficionados everywhere.

# THE STYLIST: MARY ALICE STEPHENSON

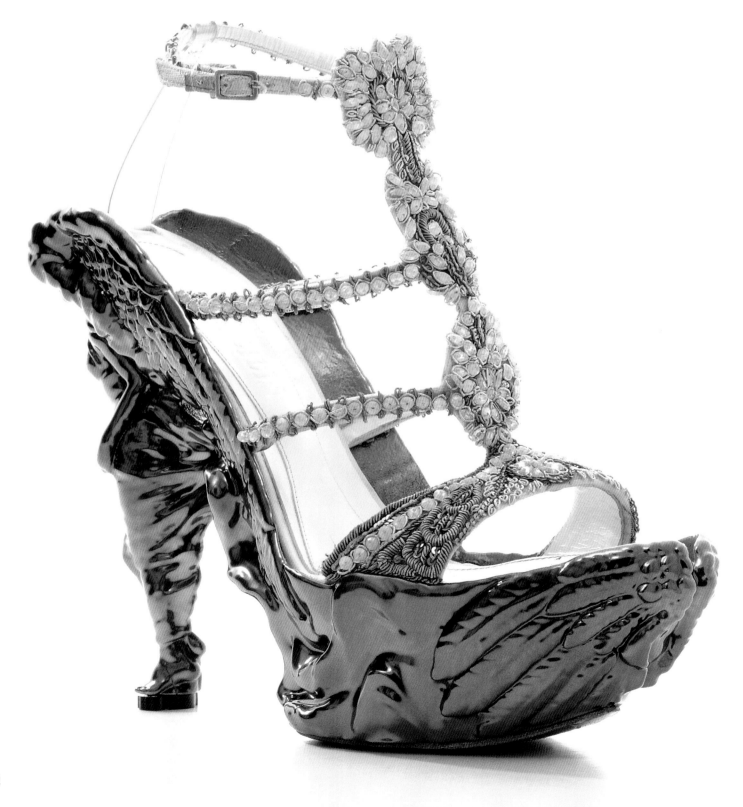

12

**Q:** *IN WHAT DIRECTION ARE DESIGNERS GOING WHEN IT COMES TO SHOES?*

**MAS:** Right now, there is a return to a lower heel but this time it's about making them as sexy as possible. Riccardo Tisci of Givenchy and Balenciaga's Alexander Wang are leading the way; both are creating innovative shoes that look sexy and modern but with lower heels. What is refreshing about their designs is the fact that they don't look dainty. Instead, they have a sexy edge, making them look hot and feel good on your feet, not to mention that they're fun to wear.

*WHEN IT COMES TO SHOES, WHAT DO YOU LIKE TO WEAR?*

Whether it's flats, kitten heels, boots, or stilettos, I like my shoes to be beautiful, sexy, and sleek. My feet are the chariots to my dreams and I don't want to be driven anywhere in a jalopy.

*WHAT WOULD A PEEK INTO YOUR SHOE CLOSET LOOK LIKE?*

My shoe closet is a library of shoes that goes from A to Z! A is for Alexander Wang; B is for Balenciaga; C is for Chrissie Morris; D is for Derek Lam; E is for Edmundo Castillo; F is for Fendi; G is for Givenchy; H is for Hermès; I is for Isa Tapia; J is for Jimmy Choo; K is for K. Jacques; L is for Lanvin; M is for Manolo Blahnik; N is for Nicholas Kirkwood; O is for Charlotte Olympia; P is for Proenza Schouler; Q is for Alexander McQueen; R is for Sergio Rossi; S is for Sigerson Morrison; T is for Tabitha Simmons; U is for Emanuel Ungaro; V is for Roger Vivier; W is for Walter Steiger; X is for Badgley Mischka's "Xavier" heel; Y is for Yves Saint Laurent; and Z is for Giuseppe Zanotti.

*WHAT IS THE MOST INNOVATIVE SHOE YOU HAVE EVER SEEN?*

Alexander McQueen's designs pushed the envelope in an extreme way. What he created dramatically affected our culture by blowing away the boundaries of what women would consider wearing on their feet. Then along came Lady Gaga, the perfect global footwear muse. Her outlandish shoe fetish drove the idea home. Suddenly, what a woman wore on her feet became more important than any other piece of fashion. Shoes have stolen the spotlight and women are ready to give them the close-up they deserve.

*WHO ARE YOUR FASHION ICONS?*

My fashion icons are people who have taken their talent and love for fashion, created something magnificent with it, and then used their gift to make a positive impact on people's lives. Evelyn Lauder, Ralph Lauren, and Donna Karan are examples of my fashion heroes because of all the good they have done with their skills and knowledge to help others. For me, fashion does not look or feel good if it's not doing good.

*WHAT DO YOU PREDICT WILL BE THE NEXT BIG THING IN SHOES?*

Technology will take over as the driving force in how shoes are designed and what results. Shoes of the future will look outrageous but feel like slippers.

*WHO ARE THE ONES TO WATCH?*

There are so many, but I love the talent, creativity, and wearability that Isa Tapia, Tabitha Simmons, Charlotte Olympia, and Alejandro Ingelmo are bringing to the scene.

*WHAT SUMS UP YOUR PERSONAL FASHION PHILOSOPHY WHEN IT COMES TO SHOES?*

As they say, "The higher the heel, the closer to God." This quote pretty much says it all.

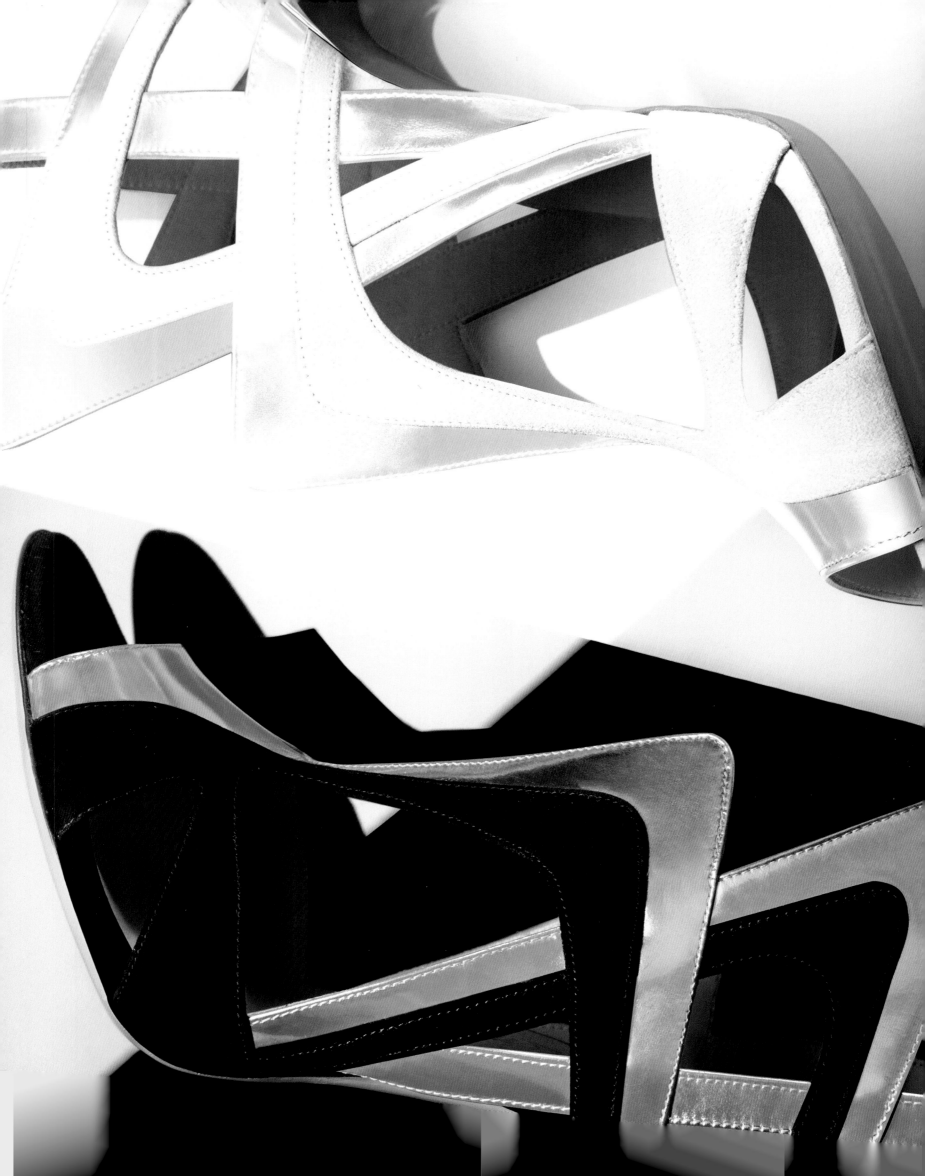

Accessories designer Alejandro Ingelmo—whose family once owned the prestigious Ingelmo Shoes firm in Cuba—introduced his first collection of women's shoes during the fall/winter 2006 season. The Miami native marries influences from his Cuban heritage with an edgy New York sensibility in all of his shoes, working exclusively out of his SoHo-based studio in Manhattan. Following the immense success of his women's line, Ingelmo decided to focus on a men's shoe collection that launched in spring/summer 2007. Dubbed "AIs," the designer's creations quickly developed a cult following, which included esteemed editors and celebrities. All of his fans were captivated by his shoes' classic silhouettes fashioned from exotic materials. Ingelmo was among the CFDA/*Vogue* Fashion Fund Top Ten candidates in 2008, and was also nominated for the Swarovski Award for Accessory Design in both 2009 and 2011.

# ALEJANDRO INGELMO

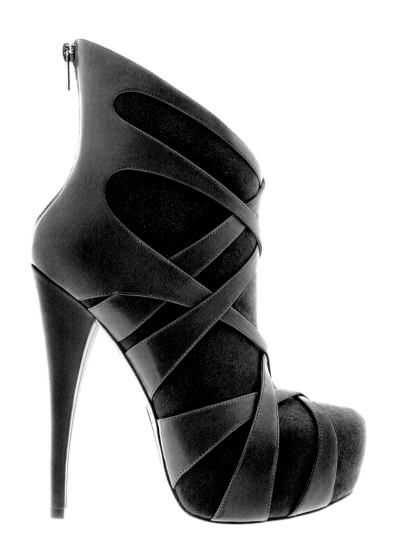

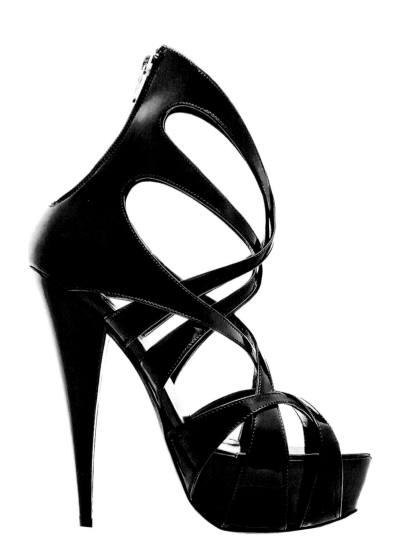

*WHEN YOU HAIL FROM FOUR GENERATIONS OF SHOEMAKERS, DEVELOPING TALENT IS ALMOST A GIVEN.* "Shoes are definitely my passion, but I didn't fully realize it until I came to New York," says Alejandro Ingelmo, whose family has been practicing the craft for close to a century. "Going to New York and attending Parsons The New School for Design confirmed that this was what I wanted to do. In my family, it is in our blood."

Anyone would agree that good design is an amalgam of skill, study, and the many influences that come into play during the course of one's life. "Architecture is a huge influence, especially the modern, very geometric kind. There is always a rhythm to what I do, with high and low points, like a building," says Ingelmo. "You have to understand not only what the function of a shoe is, but also the foundation and materials. There has to be a flow," he states of his methodology and perspective. The designer's inspirations are found in the simplicity of daily life and his surroundings. "I can't pinpoint it; what inspires me is always different. It can be traffic or the sunset in a city." Regarding the influences of art, music, literature, technology, or politics on his work, Ingelmo states

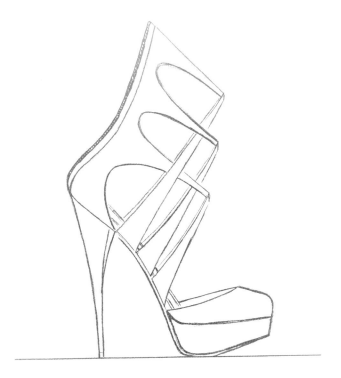

that, "It's more of an organic process. I just see something and think about what has attracted me to it."

Even before he graduated from Parsons, Ingelmo had turned out his own collection, followed by an internship at Donna Karan. "Everything else I learned by making mistakes," he admits. His other design influences were found on the home front. "My grandmother and mother were very chic women with a simple, sophisticated style—jet-black hair and super-red lipstick. Being from a Cuban background, women are very strong role models within the family; while being extremely devoted mothers and wives, they are still put together. They are able to take good care of a family and look good while doing it." This combination of personal polish and familial craftsmanship has resulted in a footwear aesthetic that is sexy but also refined. For this designer, applying that type of craftsmanship comes in the form of expert stitching and utilizing new processes and finishes. "You have to think about how to make something beautiful, chic, and sexy, but that also has a certain comfort to it," Ingelmo explains. He constantly finds himself discovering ways to change the materials he uses and is always thinking about how he can push the limits. "If you love what you do, you experiment and see what happens."

Ingelmo has shown his collections with the likes of Helmut Lang, Michael Bastian, and Chris Benz, to name a few of his design collaborations. His current collection is comprised of shoes as well as bags, which are a recent addition to his repertory. Ingelmo's signature bag, dubbed *Tron City*, started out as a duffle because he wanted something he could carry to the gym and then to dinner. Overall, the designer's work is "very structured." "There's never anything hanging out or off." He counts musicians, painters, and even lawyers as clients—proving that people from all walks of life can enjoy his wearable works of art.

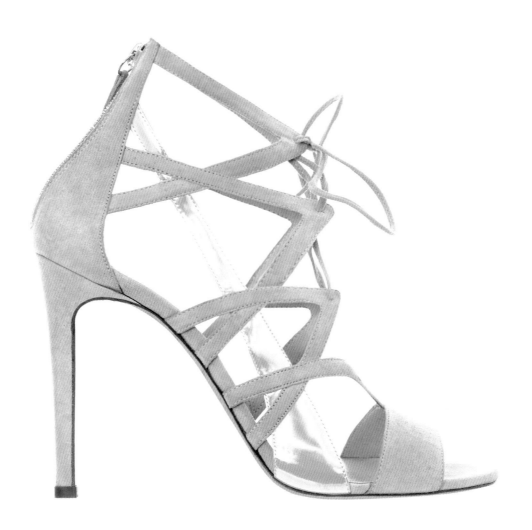

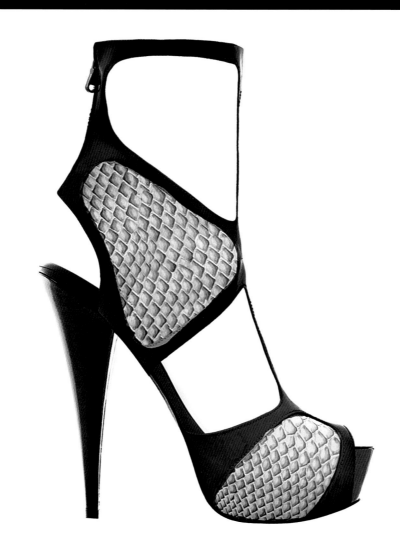

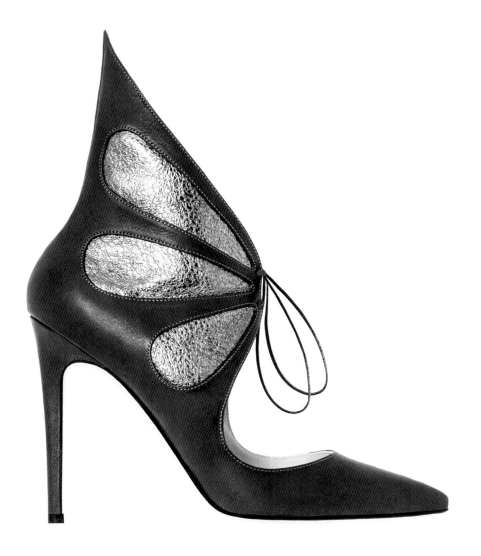

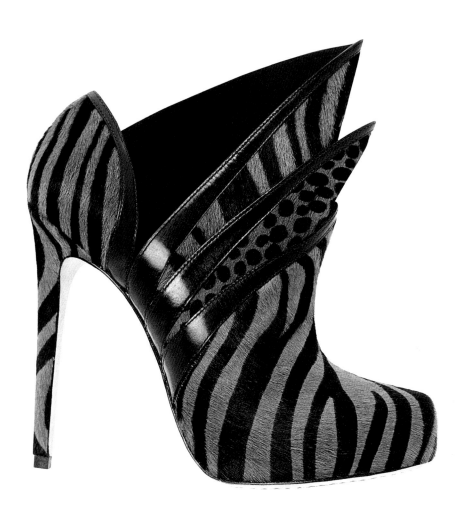

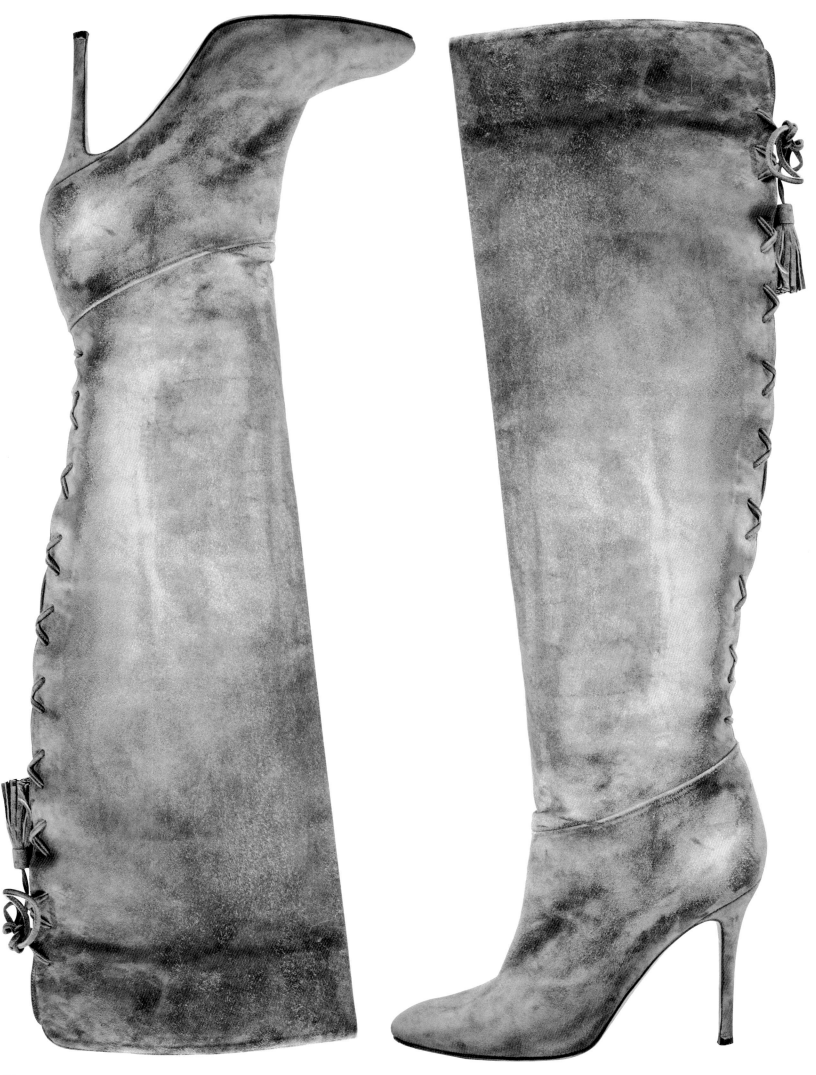

With great enthusiasm, Alexa Wagner has taken one of her most vivid childhood dreams and turned it into reality: developing her eponymous women's shoe line. In February 2004, she launched Alexa Wagner shoes in Paris and Milan. The feedback was so positive that Wagner continued to create her line with a feminine spirit, quality, and drive translated into exquisite shoes and, later on, bags. Wagner's fascination with shoes and bags began at a very early age thanks to her grandmother, an elegant woman with a larger-than-life wardrobe of shoes and matching handbags. A young Wagner spent all the time she could with her grandmother's collection, fueling her imagination and the future style of the Alexa Wagner brand through this wealth of inspiration. While Wagner's passion has always been designing, she was also drawn to finance and management. After completing a degree in international business for fashion industries in Germany, she lived and worked in Stuttgart, Paris, Buenos Aires, New York, and Milan.

*WITH HER USE OF SUMPTUOUS LEATHERS AND EXOTIC SKINS, ALEXA WAGNER IS SYNONYMOUS WITH LUXURY.* Raised in Europe and based in Italy, the footwear designer has traveled the world enough to know what the well-heeled woman wants to sport on her feet.

Wagner's immense curiosity regularly comes in handy throughout the creative process and is employed in all she does. "Inspiration comes through observing, being open-minded, traveling, and in the design process itself," states Wagner. "The more drawings I create, the more ideas I have. Then it's hard to stop!"

As much as practicality reigns in Wagner's mind ("Every woman should own a nice open-toe heel for all occasions, and a nice pair of ballerinas"), she knows that—at the end of the day—shoes are a pleasure in which women love to indulge. Wagner is thrilled every time she sees a woman wearing her creations. "I try to emphasize women's beauty instead of distracting from it," she says. "I aim to give her this 'I feel perfect' sense." How would Wagner describe her ultimate client? "A modern woman handling different situations every day. She is self-confident and natural, with inner beauty that equates sex appeal."

Wagner describes her design style as simple and glamorous; she isn't "out there" and vulgarity isn't her thing. It's "simply Alexa Wagner," she states. "What we do have is a lot of passion in what we are doing. We have combined German organization and Italian craftsmanship." Wagner's love for luxury is communicated throughout all of her creations and she is a great admirer of glamorous stars who dazzle on the red carpet, such as Charlize Theron.

Although today she is an established designer, Wagner did not exactly see immediate success. Designing shoes began as an inner childhood dream but—like any other creative endeavor—she had to start from zero. "There was a moment when I was a child and I couldn't find any shoes I liked. I realized that was the moment to start."

Her surroundings additionally served as a source of inspiration. "My grandmother had this big wardrobe only for shoes and handbags; it was my treasure trove," remembers Wagner. Because she had a lot of passion, Wagner feels that she was geared toward success. Her parents also helped set the stage by nurturing her artistic sensibility along with her sense for business. Wagner does hold that art and commerce form a natural bond. "It is a continuous process; there is never a start or an end. It is like a book with endless chapters, a nonstop evolution."

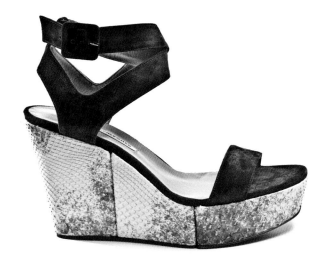

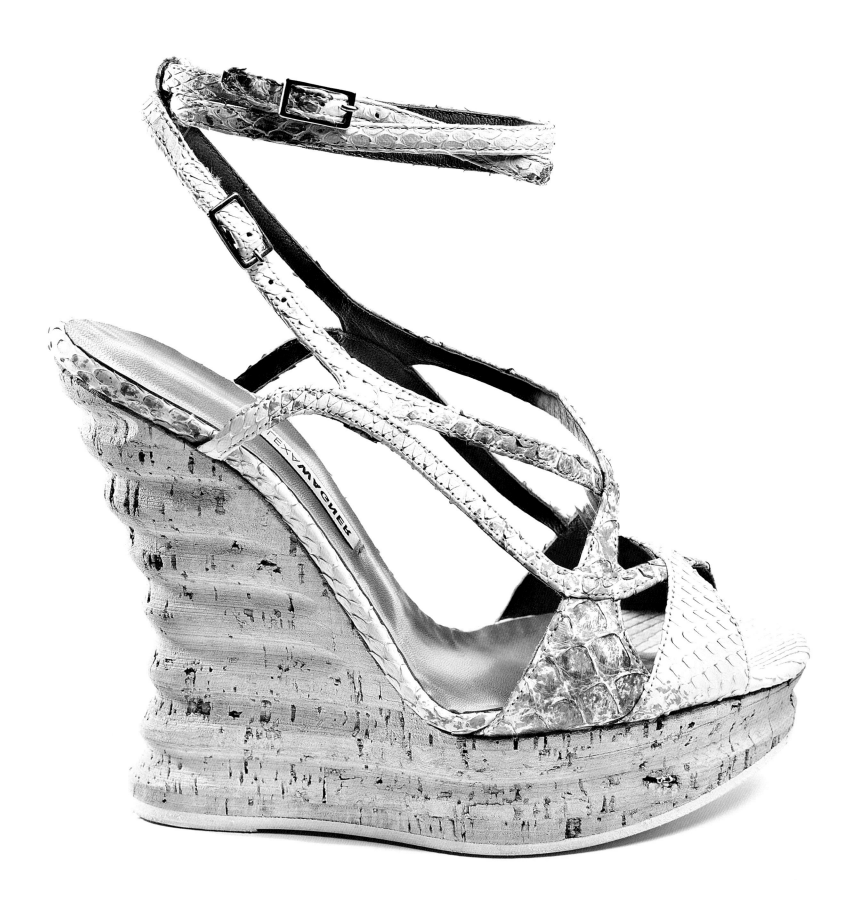

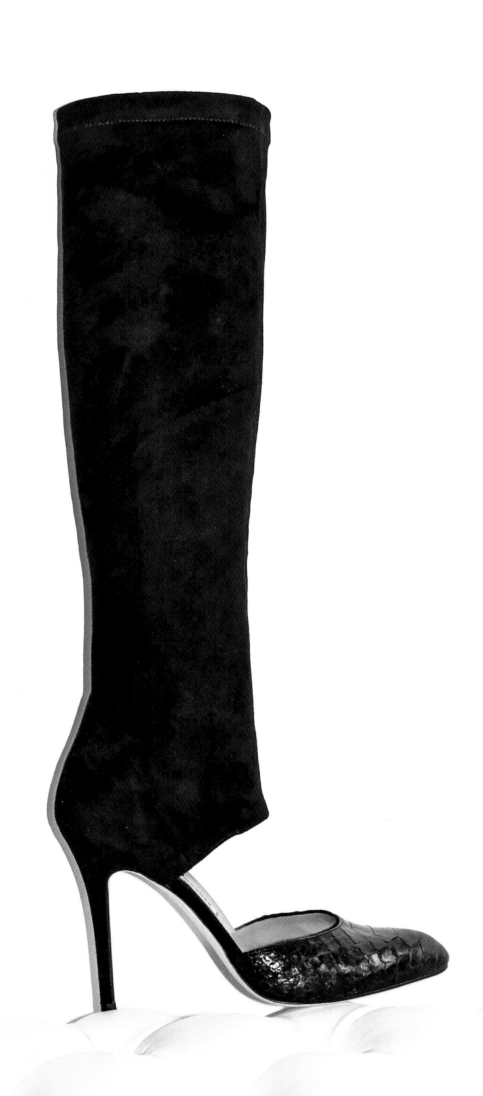

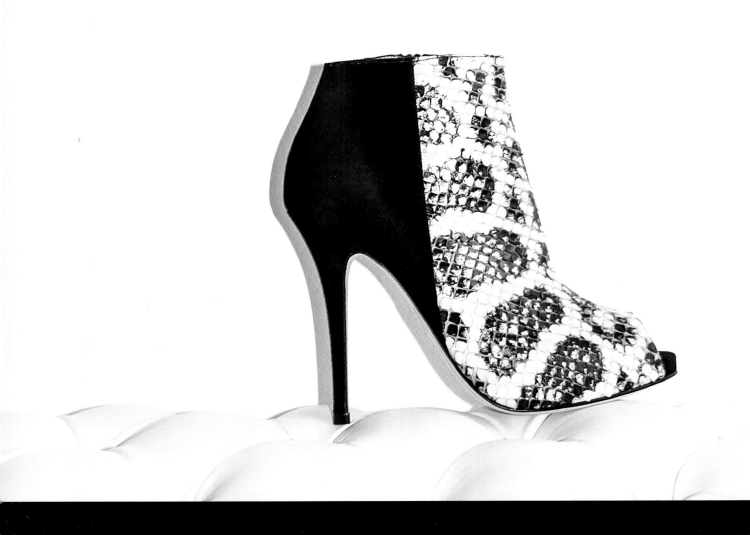

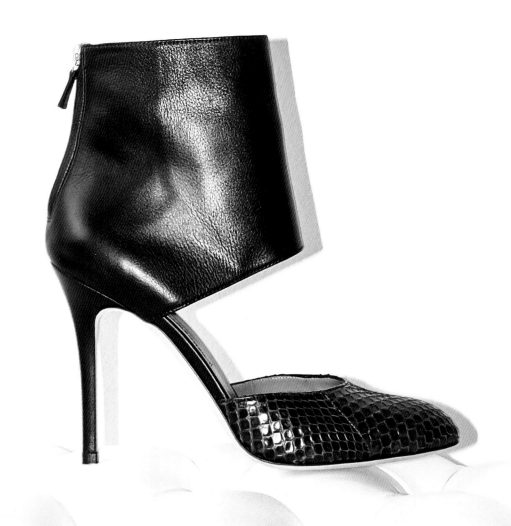

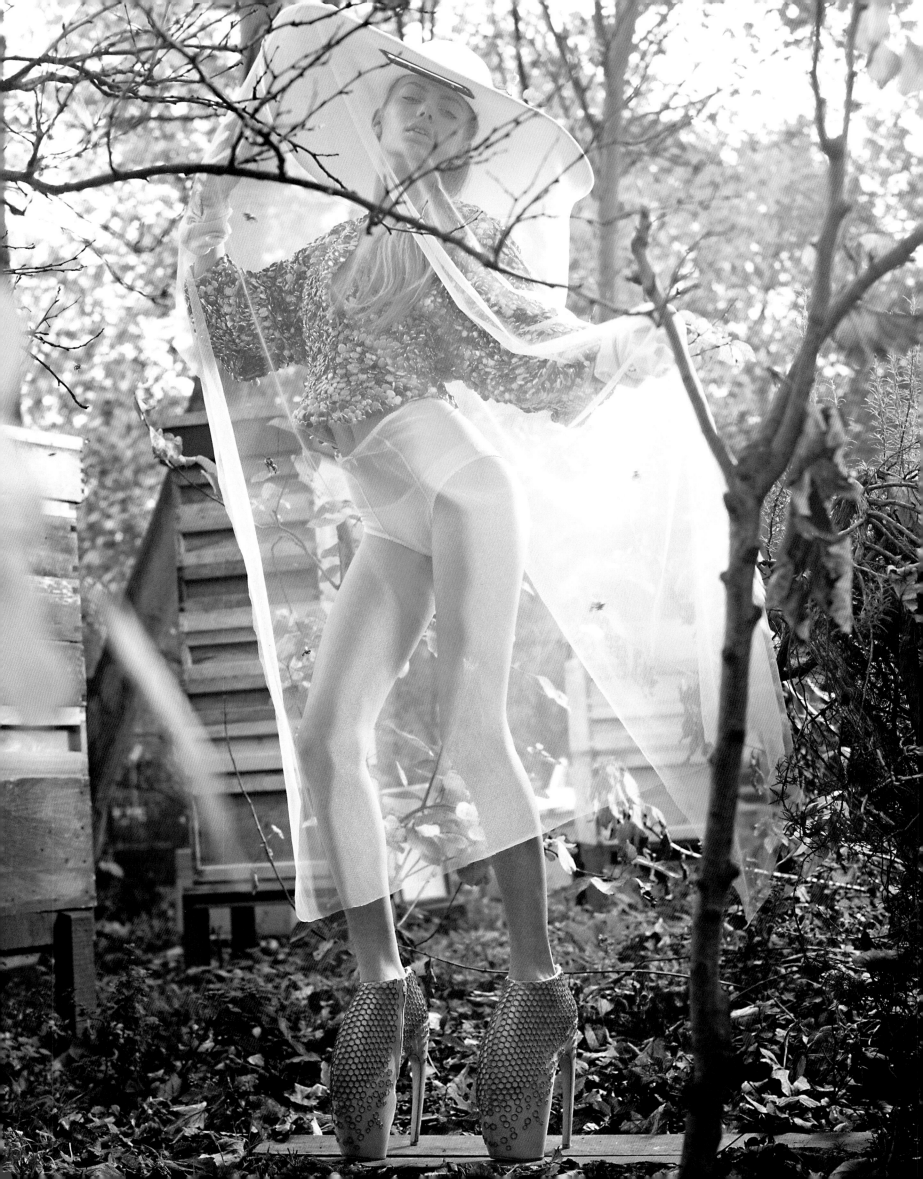

The youngest of six children, Lee Alexander McQueen was born in London to a Scottish taxi driver and a schoolteacher. As a child, he was constantly creating clothes for his sisters to wear, which eventually led him to apply for a teaching position at Central Saint Martins College of Arts and Design. The admissions director was so impressed with McQueen's portfolio that he offered him a spot in their master's degree program. His graduate collection was bought in its entirety by the style icon Isabella Blow and it was at that point that McQueen dropped his first name and became the genius couturier he came to be known as. From then on, McQueen pervaded fashion with some of the most sought-after mainstream trends of recent times. The infamous *Armadillo* shoe made its debut in one of the designer's final collections in 2010, and became an immediate piece of fashion history. He won his first British Designer of the Year award in 1996 and was made a Commander of the Order of the British Empire by Queen Elizabeth in 2003. In 2010, Sarah Burton was appointed creative director of the Alexander McQueen brand after working alongside Lee Alexander McQueen for more than fourteen years. Burton received global recognition as the designer of the wedding dress for HRH the Duchess of Cambridge, Catherine Middleton, to HRH Prince William. She has continued to produce acclaimed collections every season, invigorating them with delicacy and femininity. Burton's achievements were recognized in 2011 when she received the Designer of the Year Award at the British Fashion Awards and named an Officer of the Order of the British Empire in 2012.

# *ALEXANDER* MCQUEEN

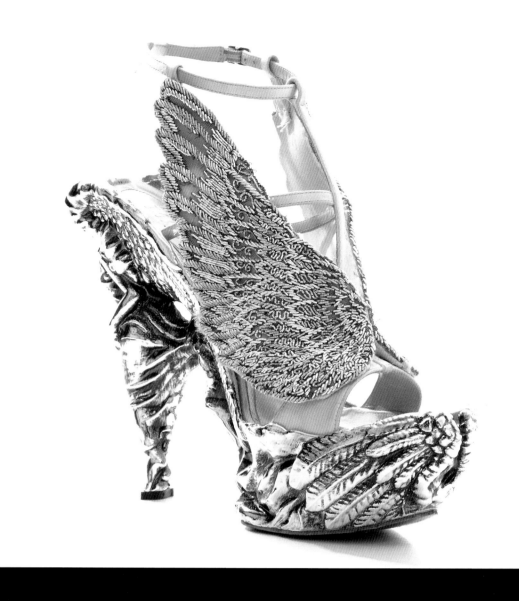

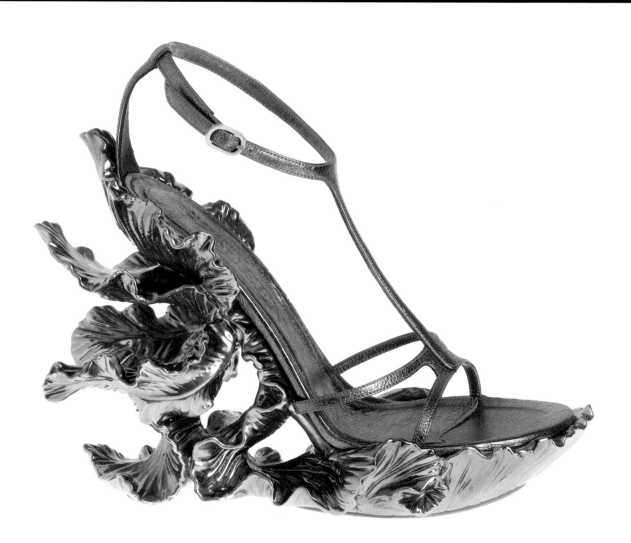

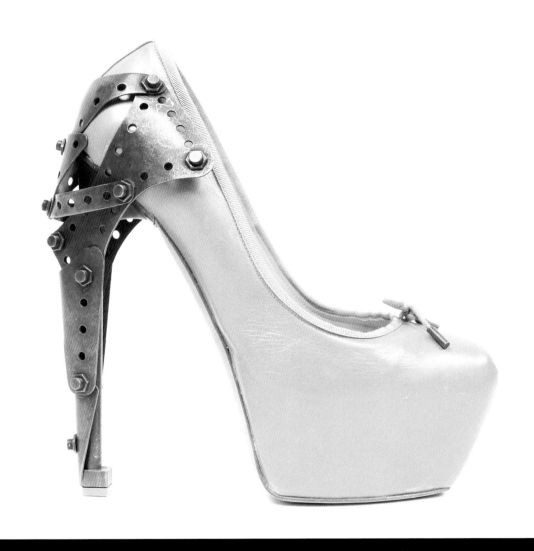

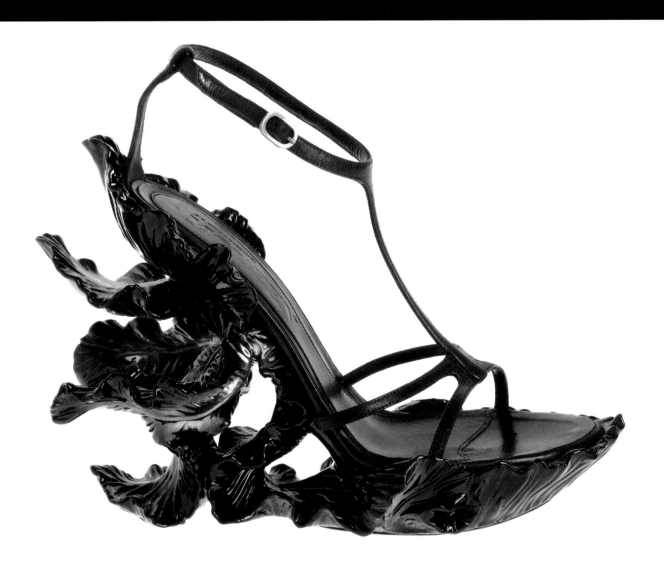

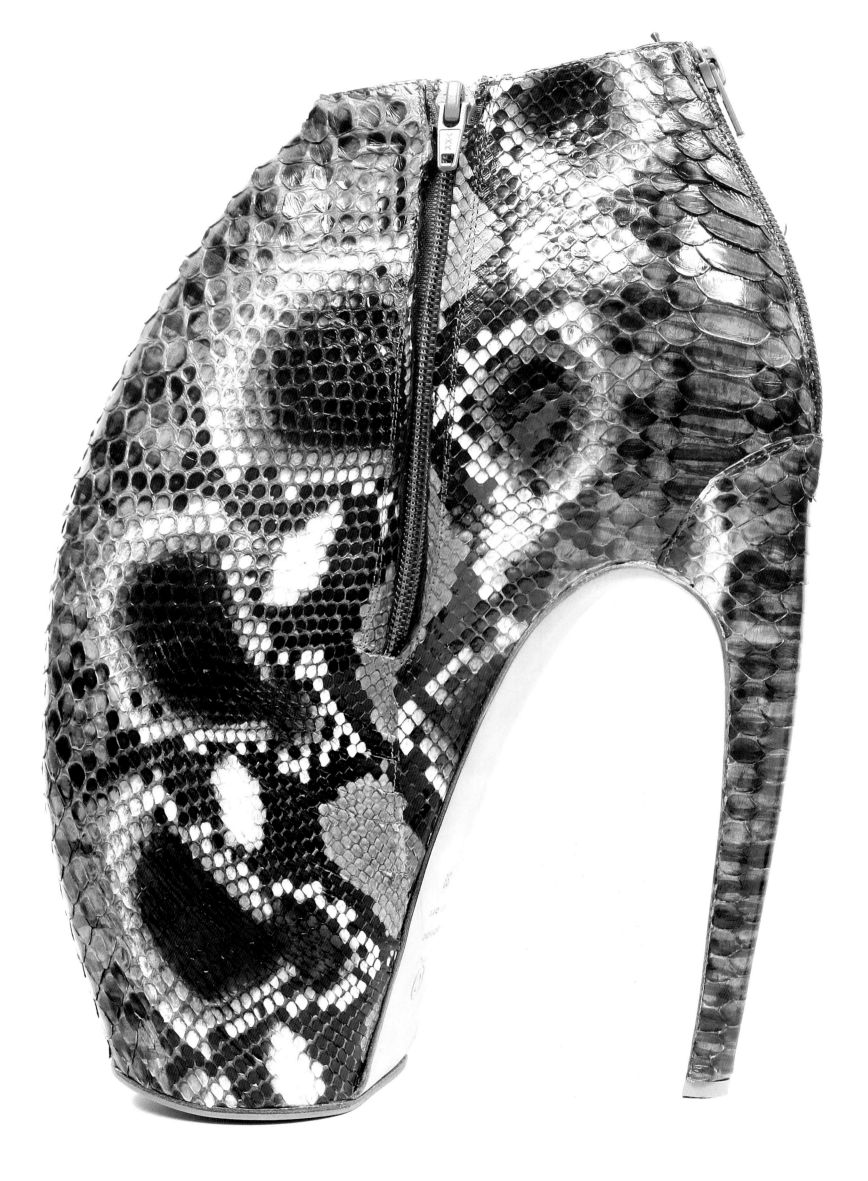

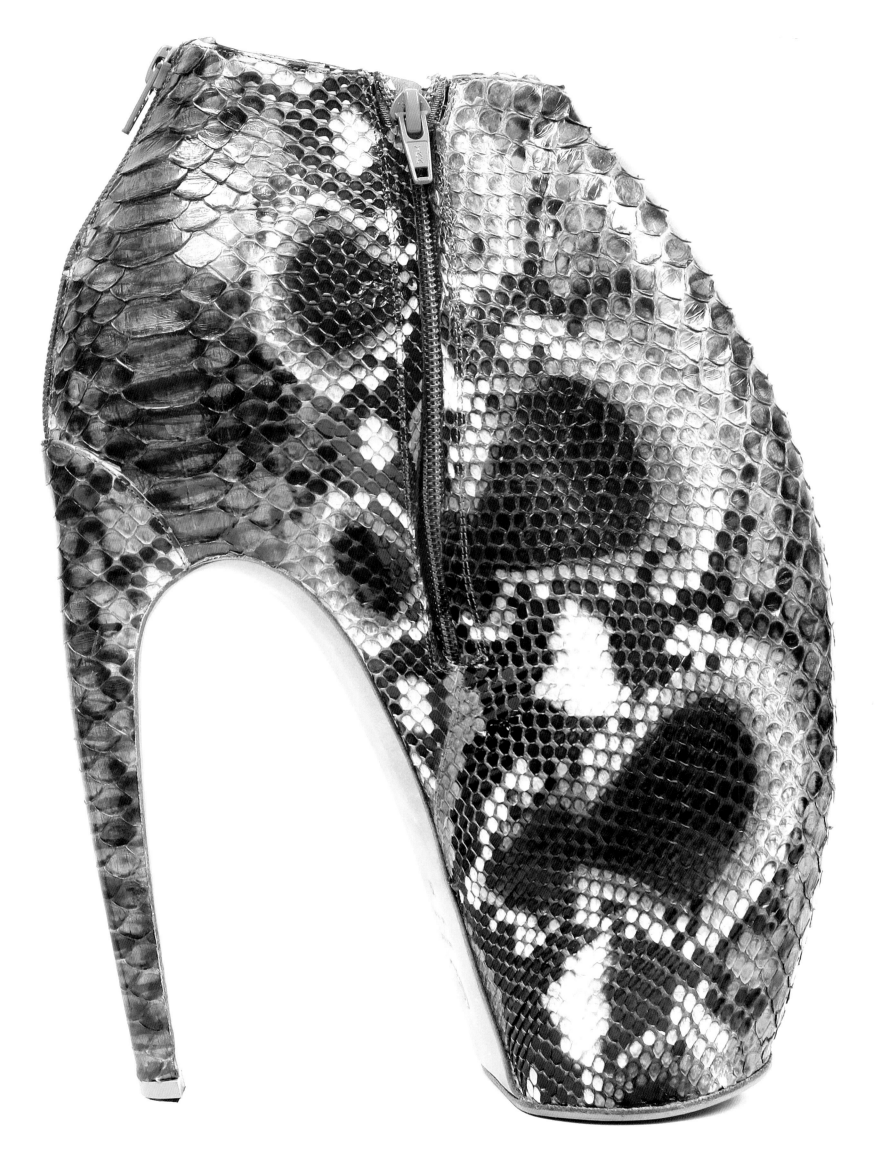

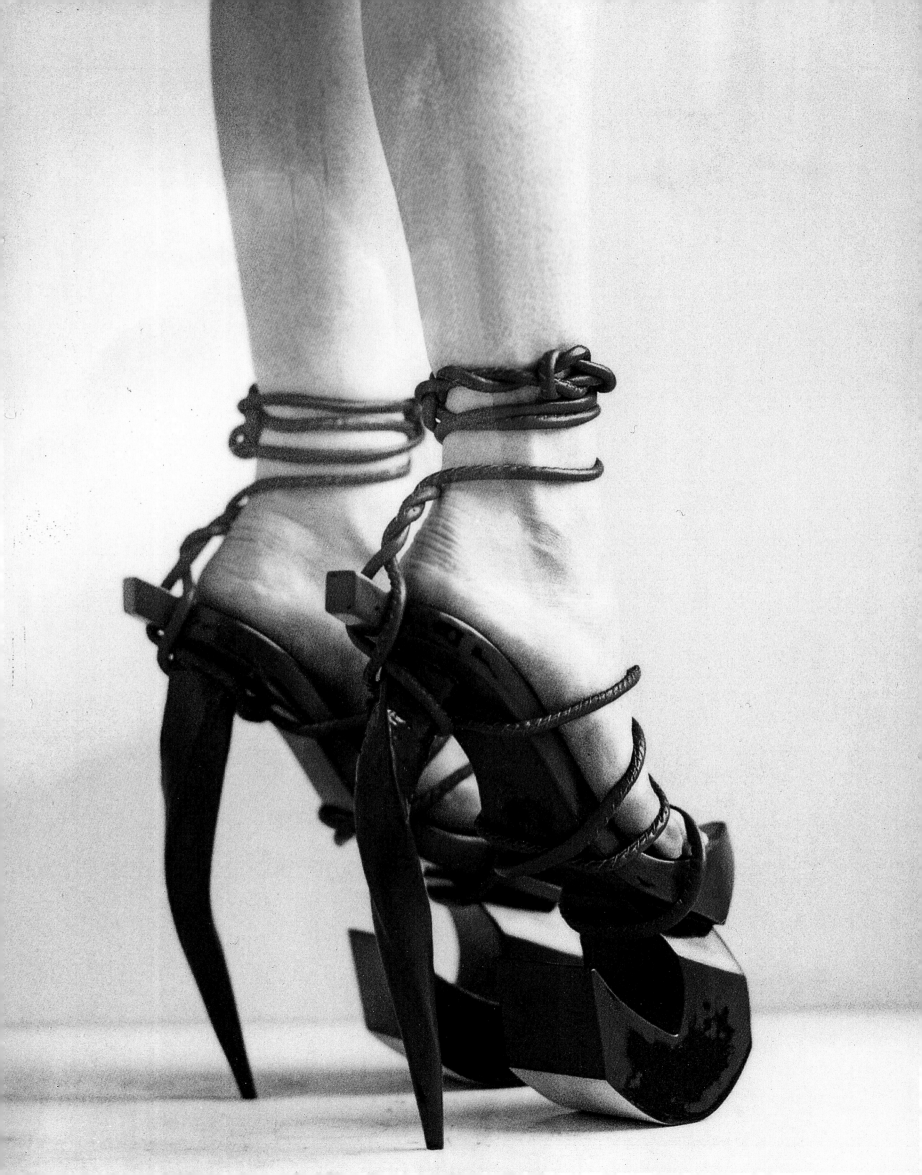

Born in Japan and based in France, Aoi Kotsuhiroi has developed a post-apocalyptic yet poetic design sense. Inspired by what is non-conformist, her collections are often composed with unique materials, including human hair, leather, and bone, blurring the line between fashion and fine art. As wearable sculptures, Kotsuhiroi's shoes, or "feet objects," as she calls them, combine animal materials, like horsehair and lacquered horns, with precious materials such as wood, charcoal, and cherry tree wood. She believes that beauty has no role or status, as it is a timeless and invisible entity. For the designer, there's a story within each object and she views her objects as a connected part of her, almost like a self-portrait.

# AOI KOTSUHIROI

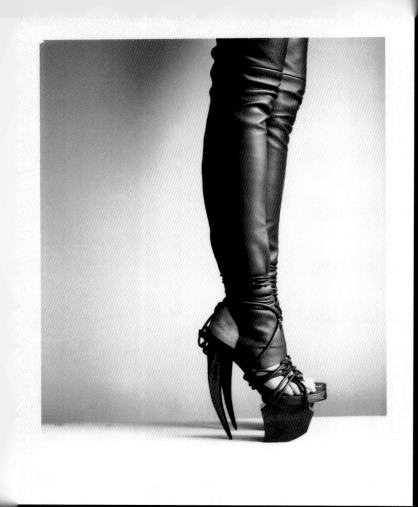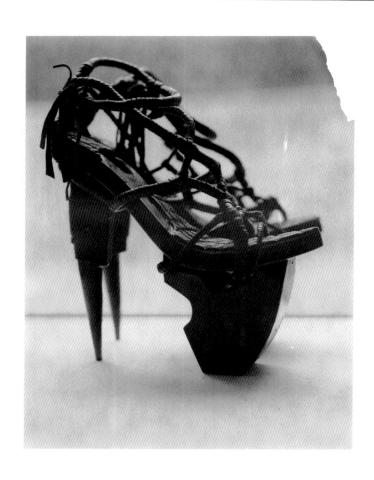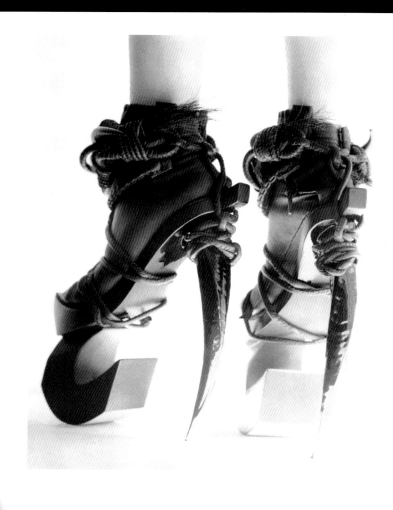

FOR AOI KOTSUHIROI, POETRY IS THE BEGINNING, DESIGN IS THE END, AND SHOES ARE THE CONDUIT TO EXPRESSING WHAT SHE SEES AS BEAUTIFUL IN THE WORLD. Making shoes is more than a mere exercise in moving a pencil across a pad or a cursor across a screen, with the result as a new collection that shows up in stores. It's more about depicting a whole range of emotions that involve the wearer and the moment.

The design of "feet objects"—as Kotsuhiroi calls them—is high artistry at its best. A designer must take immense chances when, one easily assumes, she could care less whether her work is reproduced for the masses or not. When asked about her thoughts on fantasy versus reality in shoe design, especially whether high concept designers like herself are out of touch with reality, Kotsuhiroi answers with quiet deflection, "If reality means mediocrity, consumption, and the lie of the 'beautiful,' I think those people must be very boring and tiresome. I prefer to see the reality far away from all this, and build a writing of the body that allows it to exist in this absolute."

The ensuing imagery on the designer's Web site features softly pornographic photos, such as an image of a woman wearing shoes with horns for heels (at a staggering 7.7 inches high) and tethered rope-like material for straps that lace high up the calf. Some of the images are entitled *Moments*, some called *Reliquaries*, and others that are *Fragments*. The shoes are constructed from a diverse array of avant-garde materials: silk thread, human hair, horsehair, Urushi lacquer, lacquered horns, antique Buddhist carnelian prayer beads, antique Roman twenty-four-karat gold beads (circa 100–400 AD), antique elephant leather, buffalo leather, crocodile leather, cherry tree wood, antique indigo fabric, phantom crystals, pit-fired porcelain, and antique Roman glass beads (circa 100–400 AD). Each object she creates is unique, to say the least.

Many psychologists postulate that there is a phallic Freudian element related to the eroticism of a foot going into a shoe, an erotic symbol as it were. Desire and sexuality are two major actors in the design of Kotsuhiroi's shoes. One is never far from the other, each playing key roles and having dialogues. "Their stories sometimes take place together or apart," she remarks, but what's important is that they maintain a sort of balance of life and sensations. Kotsuhiroi is more interested in the conjoining of shoes on people as opposed to the shoes themselves. "There is a story, complete with movement and poetry in motion."

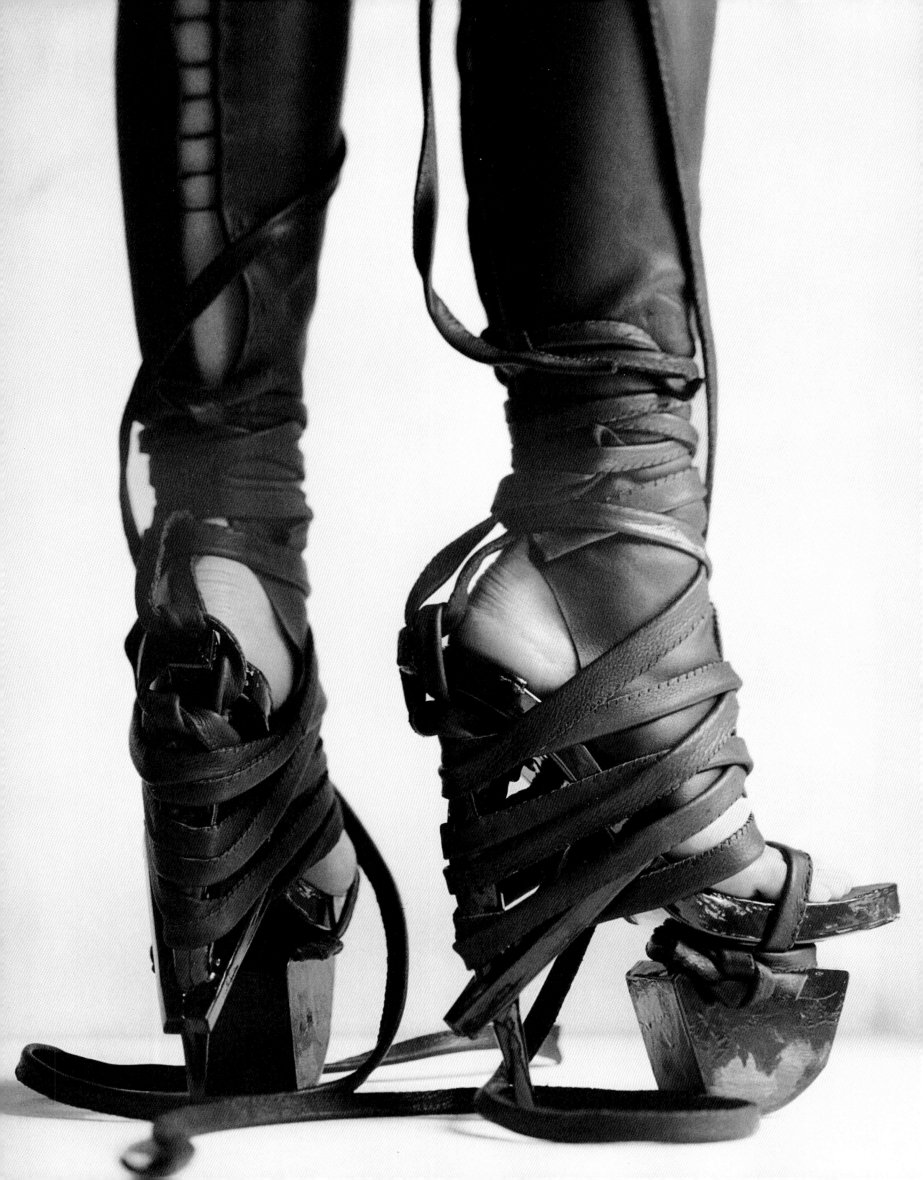

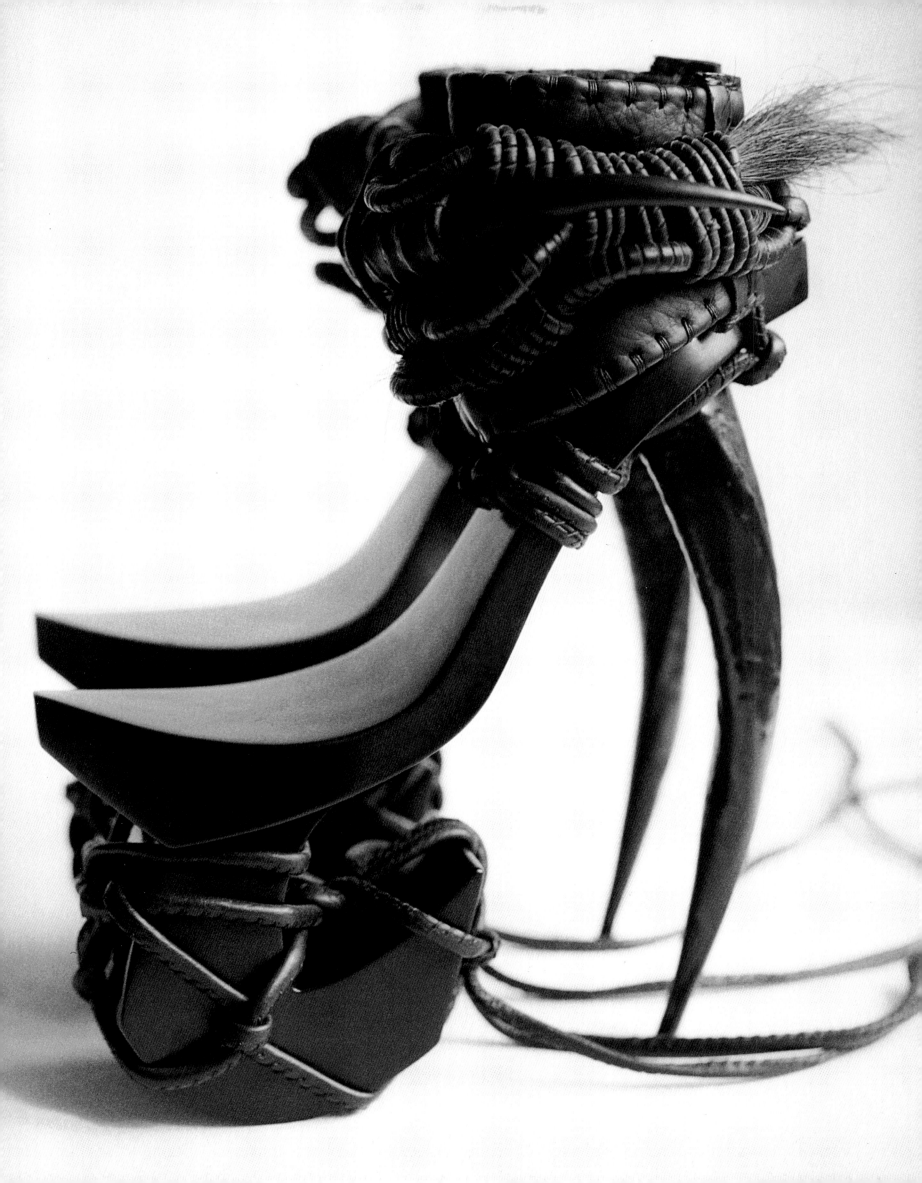

A graduate of the esteemed Cordwainers College, London College of Fashion, Atalanta Weller launched her first solo shoe collection in 2009 following several collaborations with avant-garde British designers, including Gareth Pugh, House of Holland, and Sinha-Stanic. Today the Gloucestershire native is recognized by the fashion industry as a designer to watch, and her namesake label has morphed from a mere footwear trend into an established brand. Since Weller's debut, she has steadily accumulated a global fan base, which led to her receiving the British Fashion Council's NEWGEN award for three consecutive seasons. Weller's cutting-edge vision also stems from her experience working with the renowned brands Clarks, Hugo Boss, and John Richmond, as well as through her collaborative work. The driving forces behind her beautifully luxurious shoes are technical know-how and unparalleled vision. As a woman designing for women, Weller understands that the technical aspects of shoe design are of utmost importance when constructing a shoe. Whether it be a sky-high stiletto or a simple flat, a shoe must above all be comfortable. Weller has served as a guest lecturer for the master's course at the London College of Fashion and was additionally a guest judge of the Footwear Friends Annual Awards in 2011. The bevy of creativity found in London's fashion, art, and design scenes inspire the ideas for Weller's astounding one-off sculptural pieces, merging the boundaries of each.

# ATALANTA WELLER

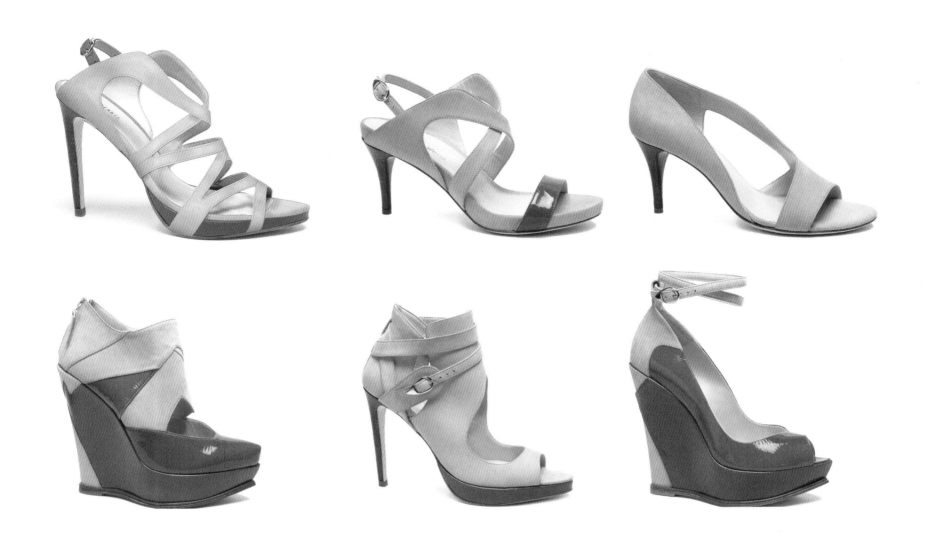

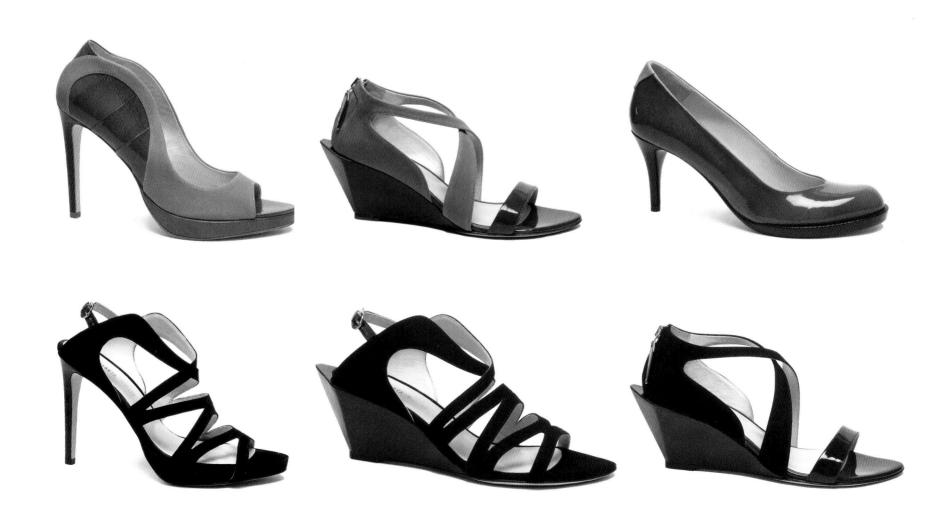

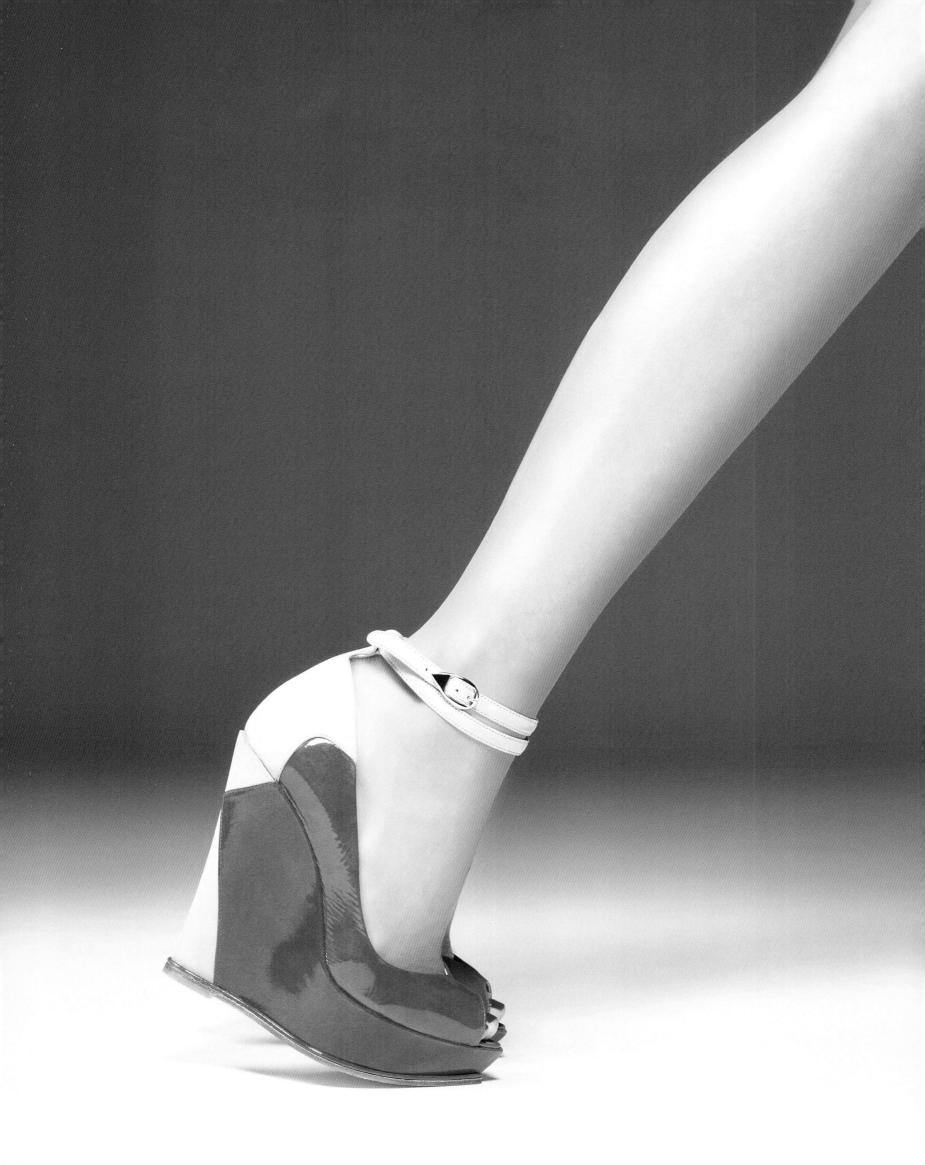

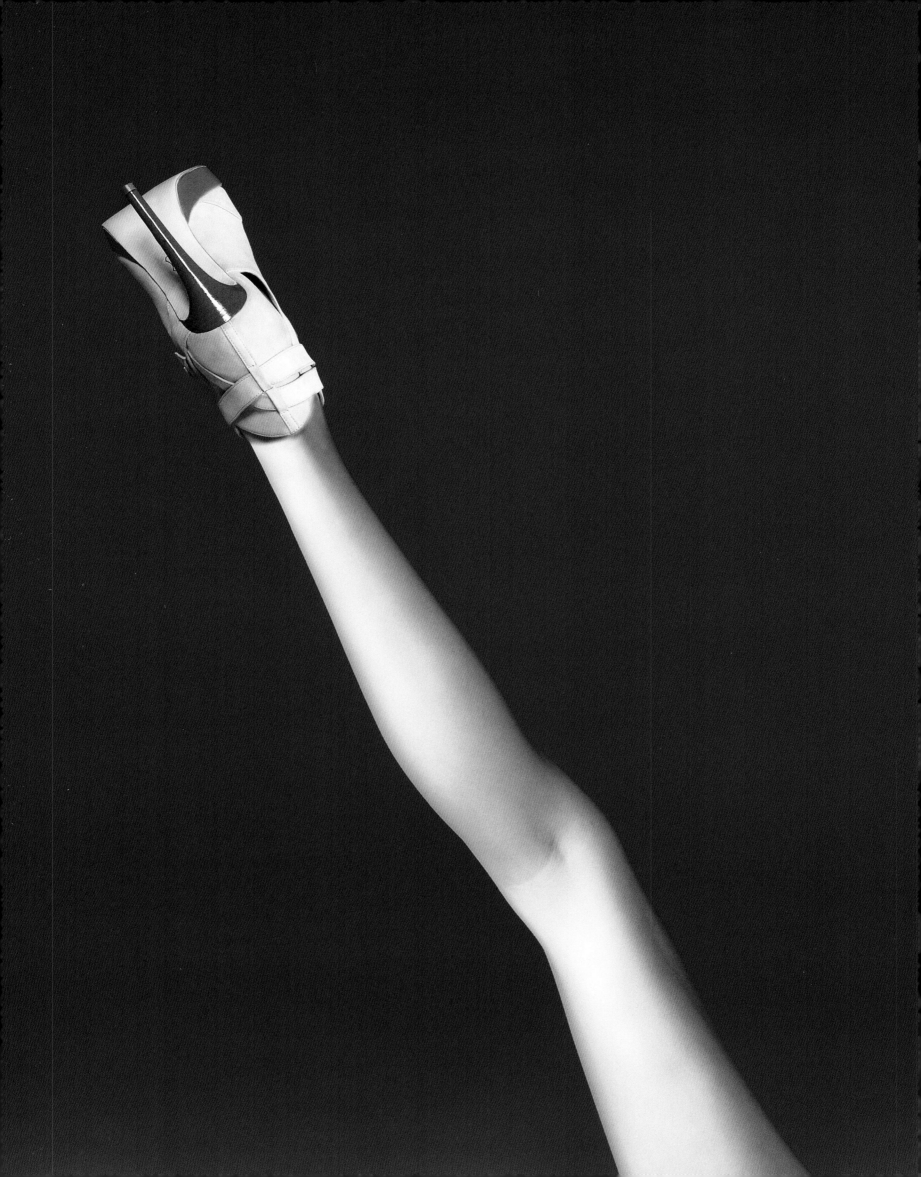

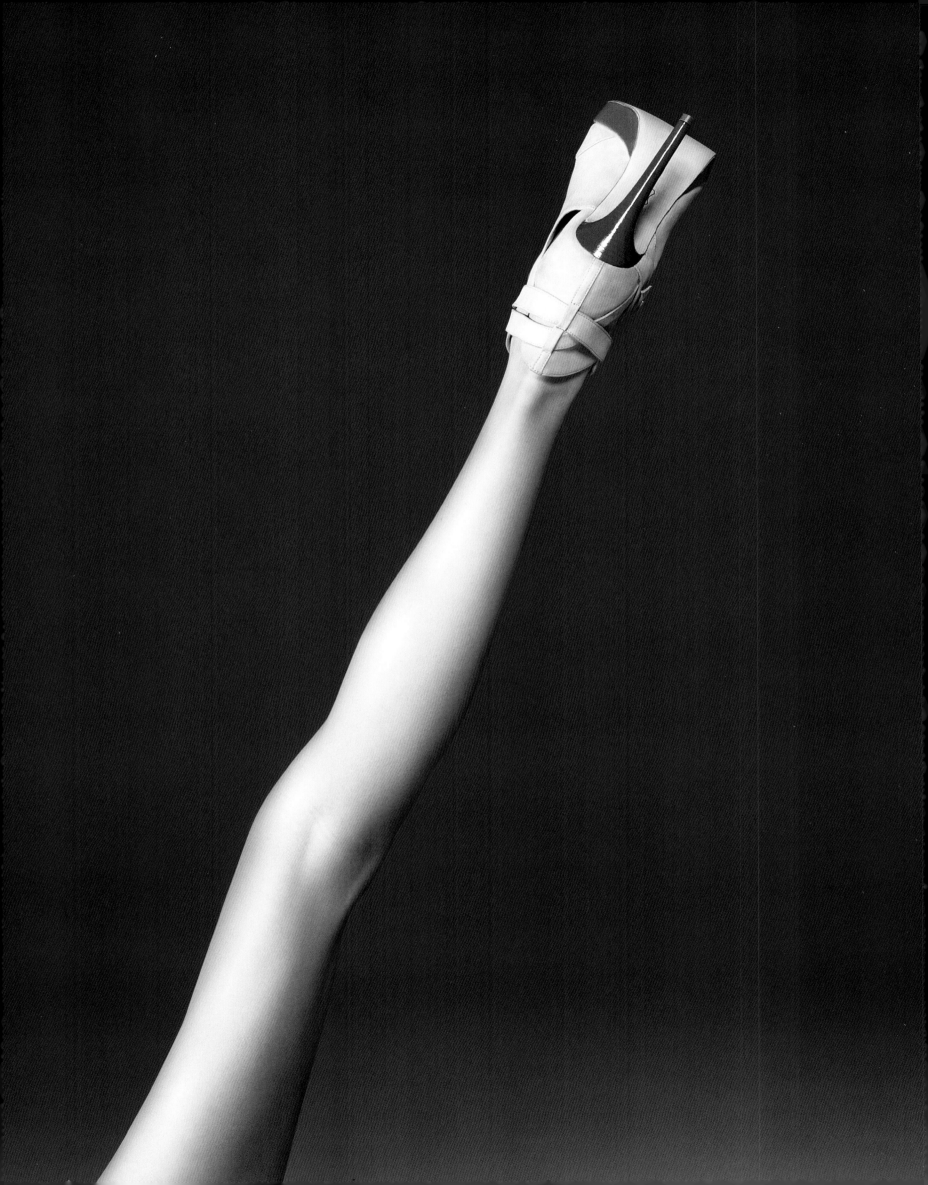

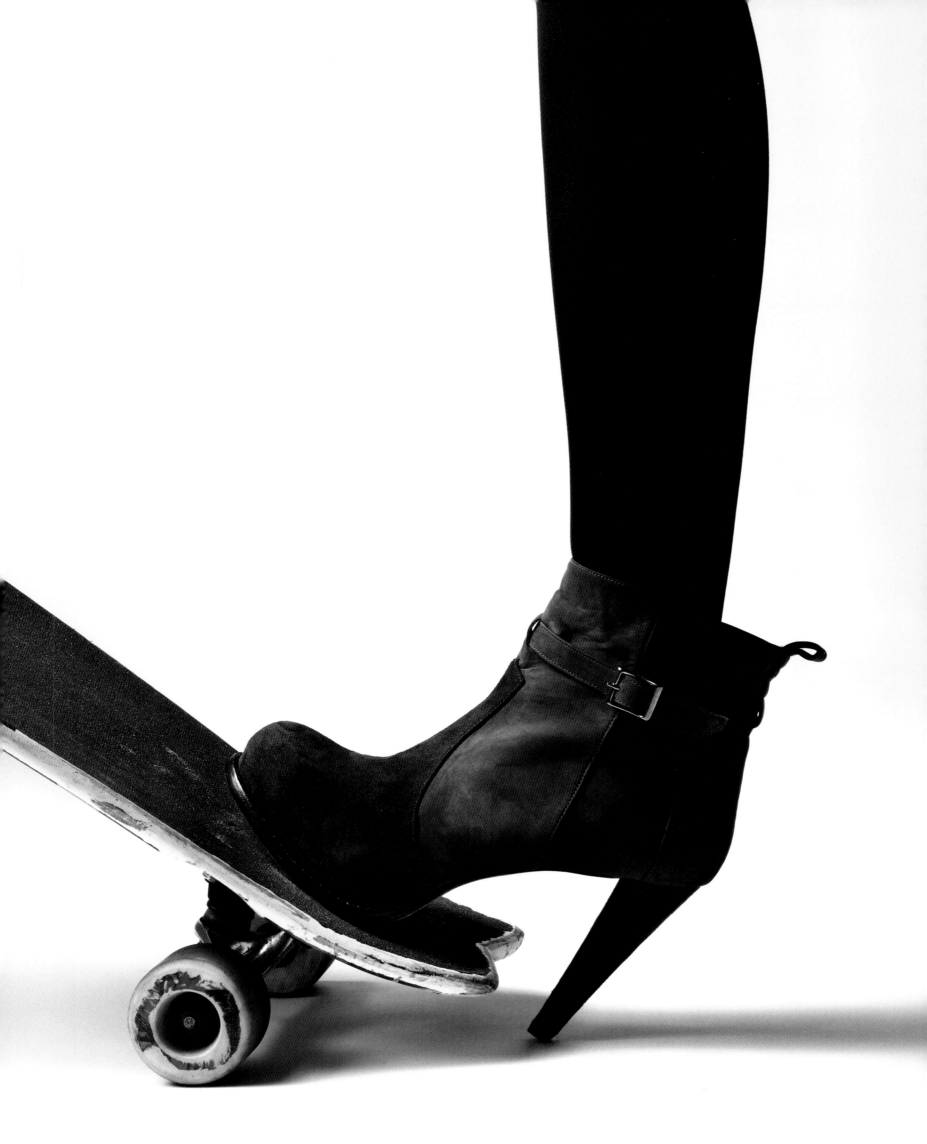

A combination of her love for both old-world artisans and contemporary design, Barbara Briones's shoes compose a creatively unique handmade collection. Briones began her design education in Chile and then moved to Argentina, where the influence of leather artists enhanced her passion and dedication to shoe design. She was subsequently inspired to continue her studies at Cordwainers College, London College of Fashion. Post graduation, Briones moved to Florence, Italy, where she worked for the house of Salvatore Ferragamo, and later to London, where she took a position at Mulberry. Briones's store and studio are both located in Santiago, Chile, and each of her shoes is made by hand. From artful detailing to the use of high-quality leather, to mixes of standout colors and textures, her shoes are wearable works of art and feature an eclectic yet classic style.

# *BARBARA* BRIONES

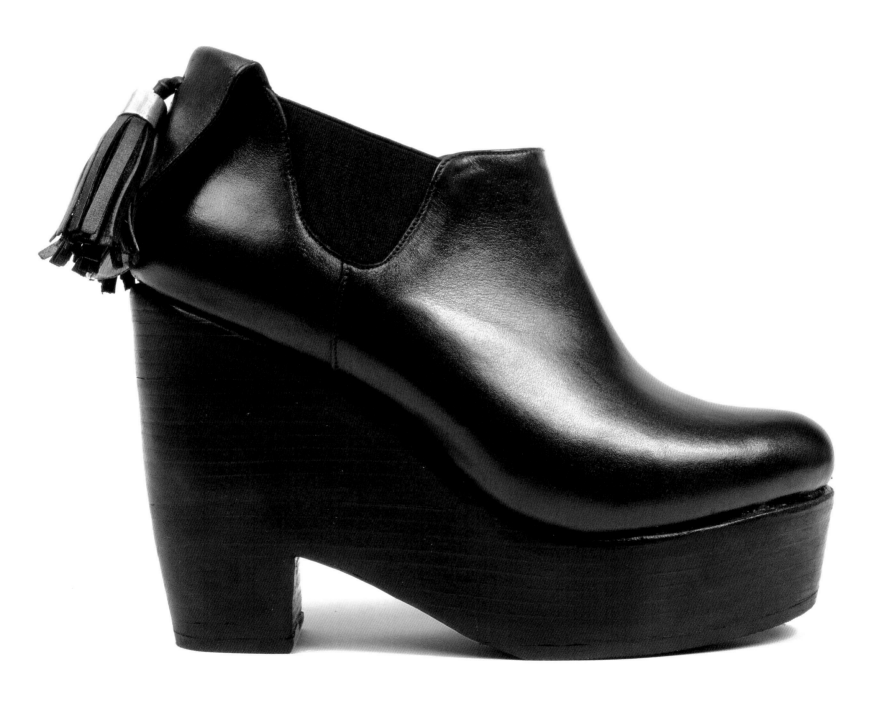

*MORE OFTEN THAN NOT, THE MOST IN-TENSE INFLUENCES COME FROM THOSE CLOSEST TO YOU.* For Barbara Briones, it was her grandmother Sylvia. "She is the most stylish woman I know," says the Chilean-born designer. "A tour inside her closet is a snapshot of design throughout the years, and such a great panorama." Briones's other sources of inspiration come from everywhere. Designing exclusively for women, she believes it's important to keep the focus on what they want. "My goal is to make them feel modern, stylish, and pretty with timeless and beautiful handmade pieces. That is what we try to do in our atelier in Chile." As a native Chilean, Briones is the beneficiary of a culture where beautiful, handcrafted, traditional objects and the work of artisans still reigns. She employs many such workers and finds their creations and attention to detail highly motivating.

The designer has always been inclined toward a more artistic way of life. At one point she even wanted to be a dancer and a musician (she still owns a cello). After studying fine arts, she ended up in Buenos Aires and learned the art of shoemaking from local shoemakers. Fine art has indeed been a highlight in every collection Briones has designed, although she believes design is also related to the everyday and what happens around her. Briones holds that you can't ignore the economy, politics, or technology; everything people use, observe, and touch will always affect who they are and what they wear. The designer has lived in many cities that have

each left a mark: "Santiago de Chile, where I was born, with its natural surroundings; Buenos Aires and its uniqueness; London, which has a quirky style; the old, beautiful heritage of Florence; and New York, with its diversity. I'm able to mix all these ingredients to create shoes featuring various distinct elements."

As for her footwear, Briones's pieces for fall and winter involve color, and a lot of it. During the warmer months, there is less color but the shoes are still beautifully sculpted and almost formal in their construction, presenting themselves as if standing at attention. Briones views them as her jewels, each one unique and possessing a personality all its own. "Each of my shoes has a name that gives it an identity," she explains. "I really cannot choose a favorite from one collection to another. I think that my favorite is always the one I'm working on at the moment."

During her studies in Argentina, Briones was more adventurous with designs, creating very dramatic shoes. "I used to go to vintage stores and buy clothes with these amazing fabrics, and then convert them into shoes," she recalls. "It was fun always exploring new shapes and ways to stitch them." For an admirer of such fine craftsmanship, is there such a thing as an ugly shoe? "That's a hard question. I think that each design, whether it's something I like or not, evolves into something else, or helps give rise to more and more."

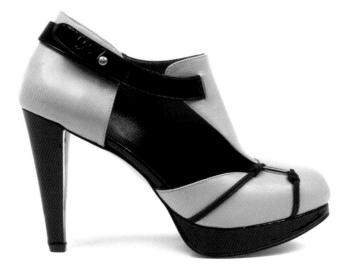

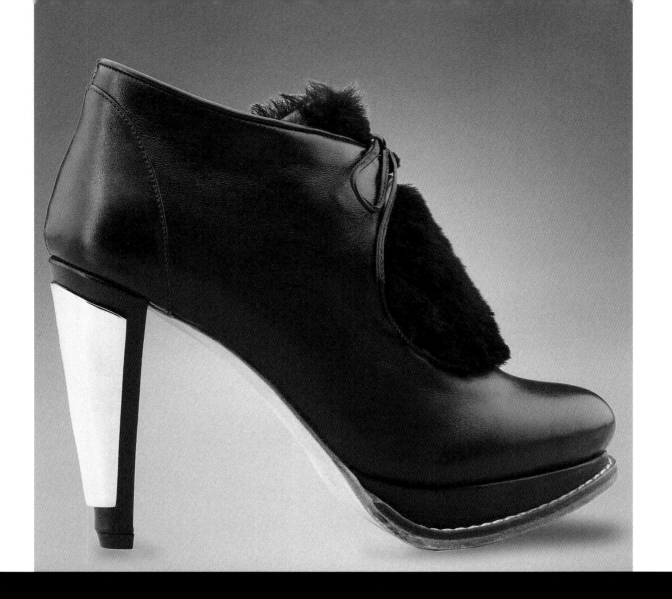

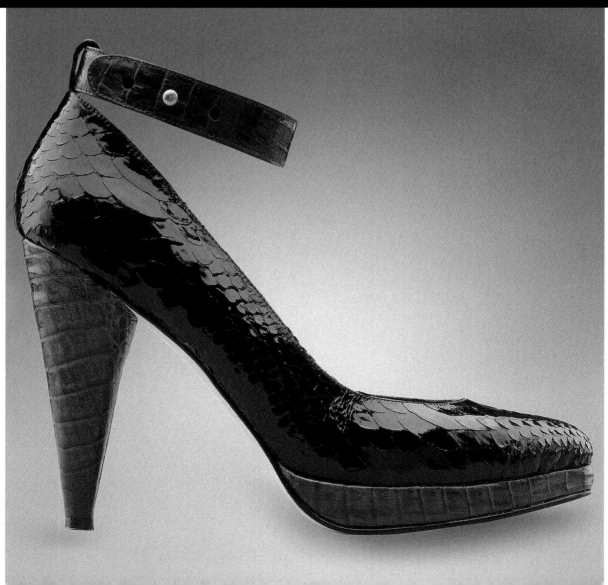

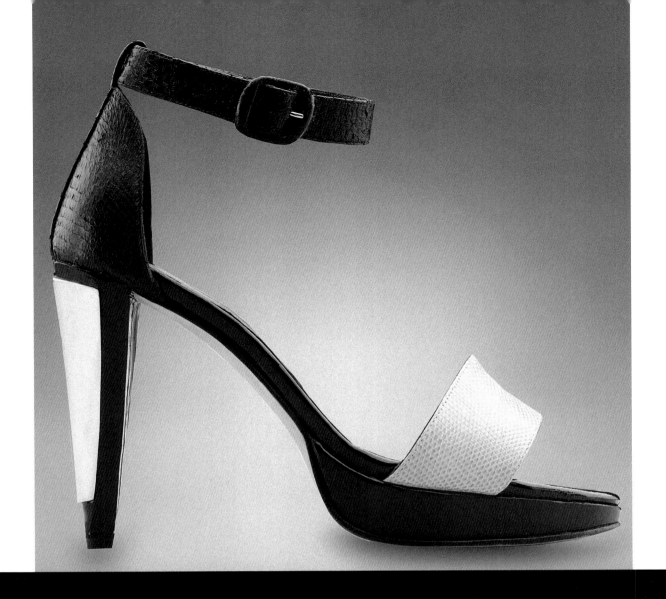

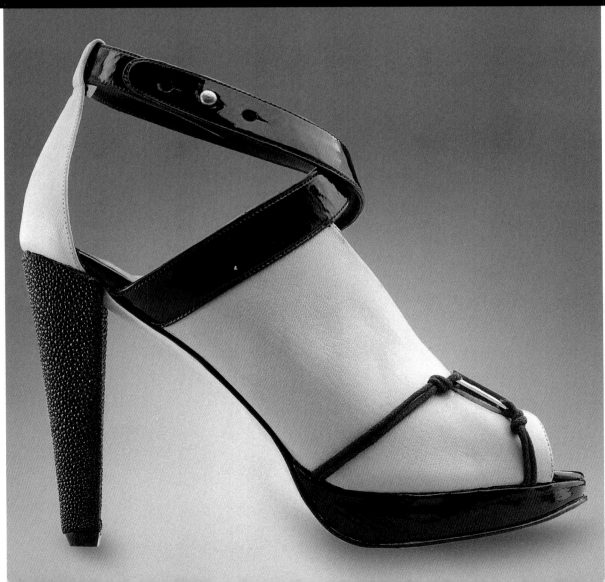

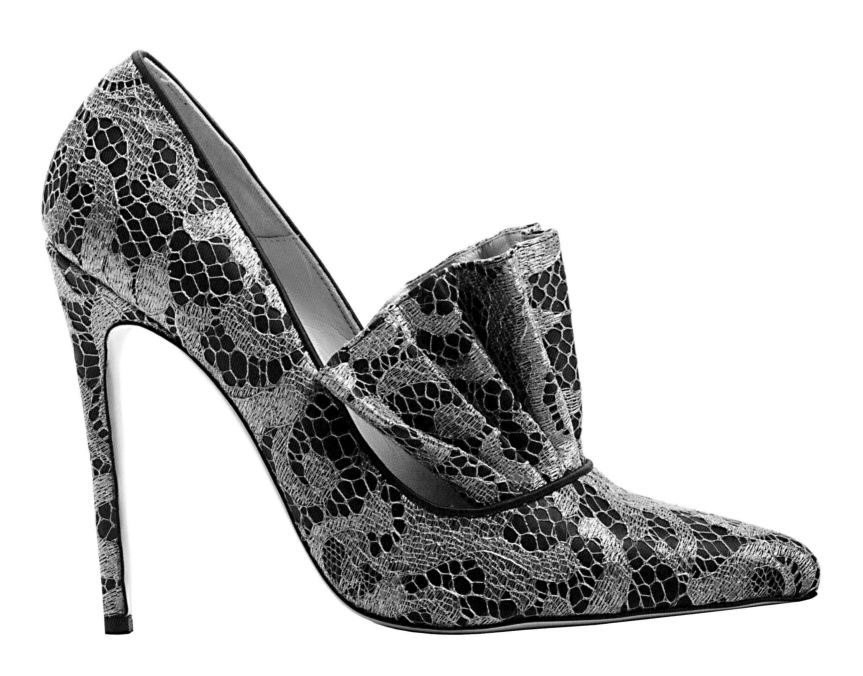

Despite their brand's Italian name, the design duo behind Bionda Castana hails from South London—although both are of Italian descent. Inspired by a nickname they acquired while in college meaning "blonde brunette," Jennifer Portman and Natalia Barbieri have built a label that proposes classically shaped shoes with a modern edge. Both Portman and Barbieri possess a unique understanding of design and quality. They often traveled to Italy as young children, which opened their eyes to the glamour and culture of Italian design and incited a passion for high heels. After launching their first collection in 2007, Bionda Castana won the Best New Accessories Designer award the following year at the AltaRoma/*Vogue* Italia Who Is On Next? competition, giving them instant international recognition and a large celebrity fan base. Bionda Castana creates feminine, edgy, and handcrafted designs with a wide variety of materials, including studding, woven silk, lace, velvet, and buckles.

*BIONDA* CASTANA

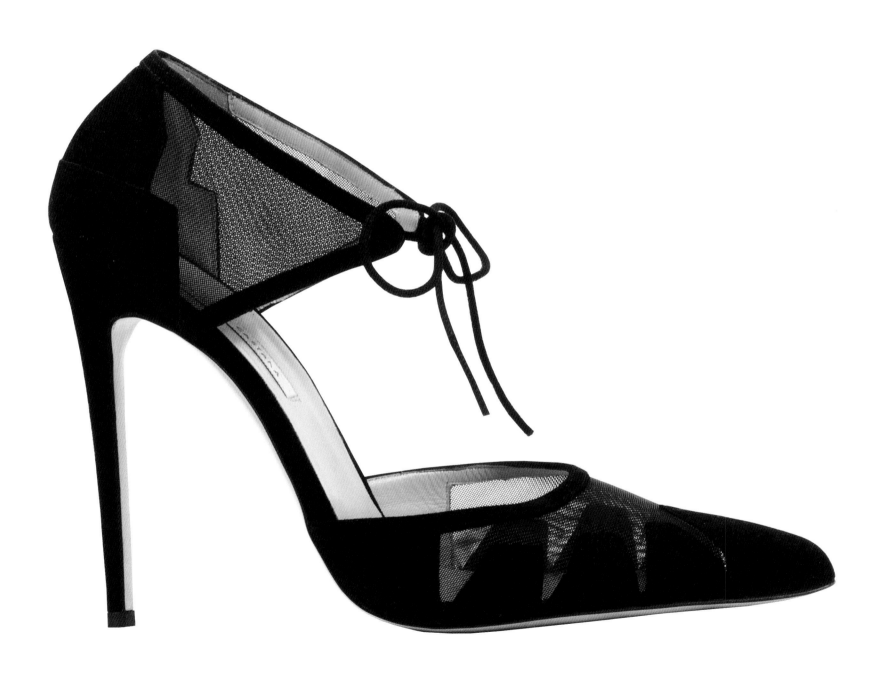

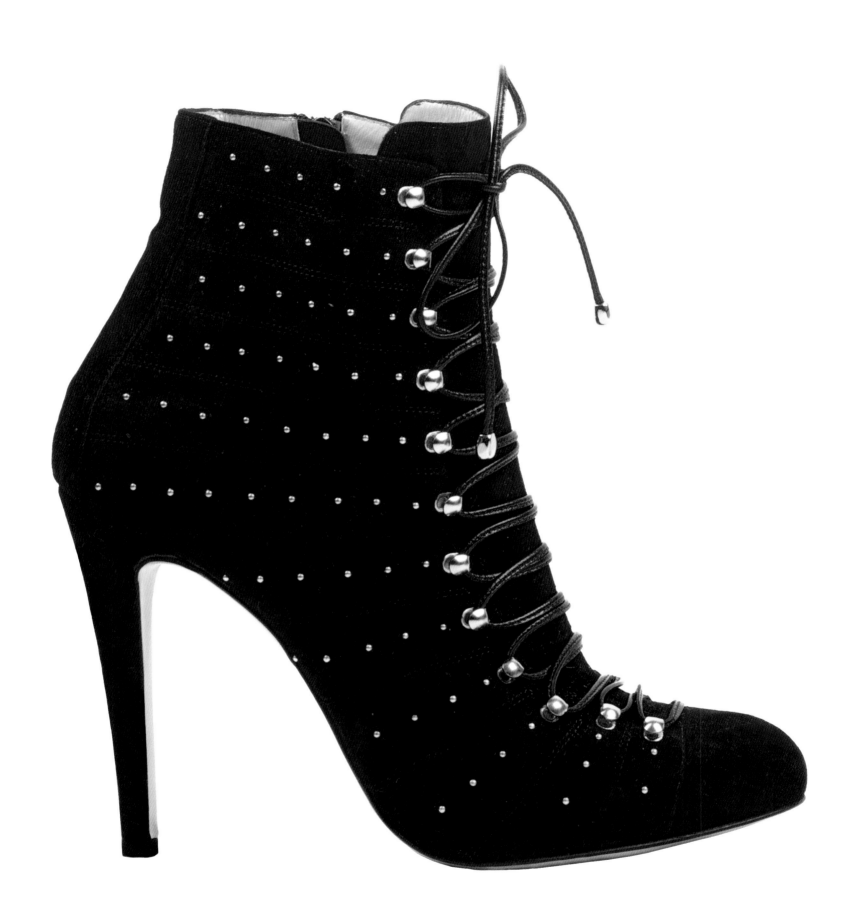

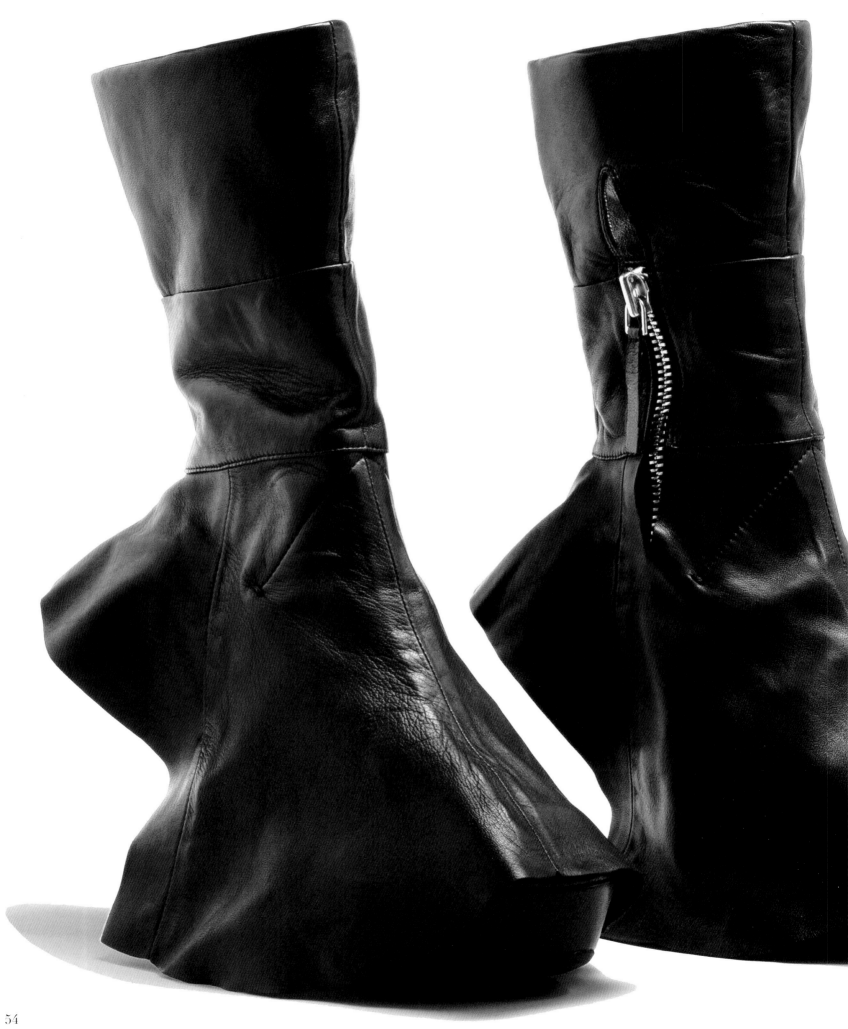

A native of Denmark, Camilla Skovgaard began her career at the age of twenty as a couture designer in Dubai, where a French-owned company invited her to design for some of the wives and daughters of the region's sheikhs. Following seven years in Dubai, Camilla relocated to London in 2000 to study shoemaking at Cordwainers College and the Royal College of Art. Skovgaard's self-named footwear line emerged while she was still earning her graduate degree, and Saks Fifth Avenue in the United States bought her first collection shortly thereafter. In 2007, she was awarded the Queen Elizabeth Scholarship Trust for Excellence in British Craftsmanship, and was named Accessories Designer of the Year by both the *Elle* Style Awards (2010) and the DANSK Fashion Awards (2011). Skovgaard's shoes attract worldwide recognition for their impeccable style paired with high-quality shoemaking, as well as for her emphasis on form, materials, and design. The combination of juxtaposing elements is what lends such strong character to her artful creations.

# *CAMILLA* SKOVGAARD

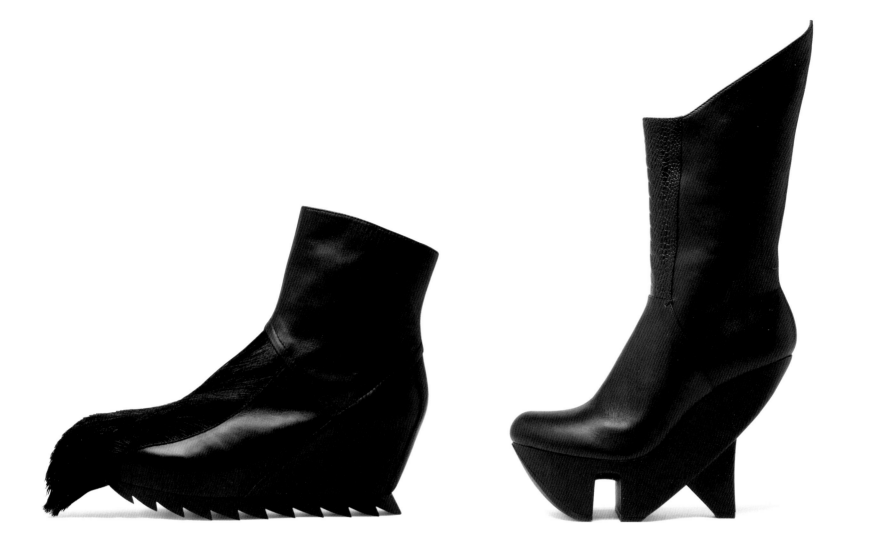

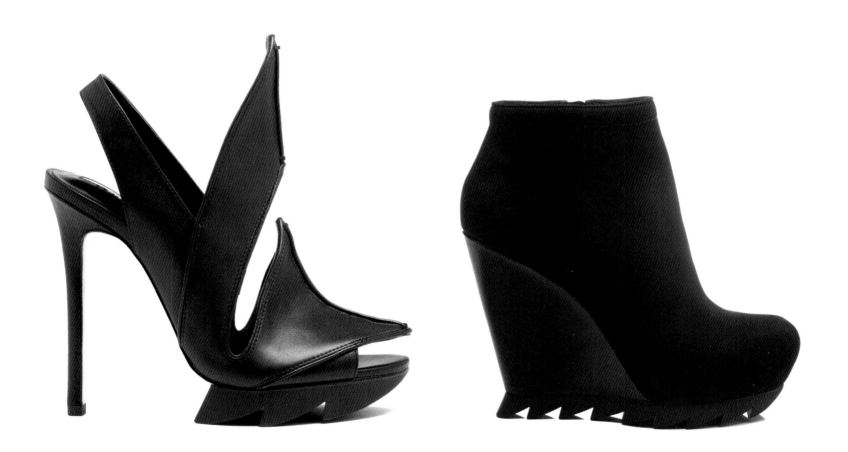

*THERE IS SOMETHING ABOUT THE DANES.* Maybe it's the isolation. Maybe it's the northern air. Or maybe it's an incalculable sense of what works. Whatever the magic ingredient, Camilla Skovgaard can be counted as one who has already made her mark. Her bold, innovative, and instantly recognizable footwear springs from a personal passion. A self-professed introvert, Skovgaard creates footwear that explores the subversive while straddling the lines between elegance and brutality.

Skovgaard affirms that what she does comes mostly from her gut. She has an affinity for eroticism, architecture, and classicism, all of which inspire her to conceive pieces that do not adhere to a season's standard influences, but rather to a state of mind and/or personal style. "It could be furniture design," she says of her métier. "I started out in clothing and after ten years moved on to footwear—and loved learning the craft of shoemaking. It is a very different process than that of constructing a garment."

For Skovgaard, it is her nearly decade-long journey that has taught her the most in life. In the 1990s she found herself in Dubai, where she was commissioned to design for the Persian Gulf sheikh families. She relocated to London, where she earned a bachelor's degree with honors in 2003, followed by a master's. Skovgaard's professional success began during the course of her studies, when Saks Fifth Avenue called one day. The retailer placed an order on some samples she had made, leaving her little time to think much about her logo or how her company should take form. Her charge was to design.

And design she did. During the relatively short period of time that has ensued, Skovgaard has earned more awards and accolades than many have seen in a lifetime, including a nomination for the Swarovski Emerging Talent–Accessories award (2009) and Accessories Designer of the Year at both the British Fashion Awards and the *Elle* Style Awards (both 2010).

In the designer's opinion, the Skovgaard woman has an eye for considerably pared-down detailing and a preference for intellectual—as opposed to girly—sophistication. Although girly may be the reigning aesthetic, Skovgaard has set her sights on unconventional shapes with architecturally inspired trends. "And I don't seem to be able to stay away from hairs and drapes that drag along the floor, either," Skovgaard says in reference to the human hair shoes she created in 2007.

Skovgaard finds inspirational interest and delight at every turn, and knows that creation is an ongoing evolution. One of the most frustrating aspects of the business for her is that the desire to design can't be switched on, like a faucet—one has to ease into it. "Sometimes I can get nearly a whole year's worth of core ideas in two hours and other times it is a directionless inquiry, which can be highly stressful. Perhaps it is all part of the greater planet's journey," Skovgaard says. "Recently, I came across a horoscope that said Neptune is coming to a fourteen-year close now in my sign, a trip that had to do with uncertainty around identity and time spent wandering and trying on different roles. Sounds surprisingly accurate."

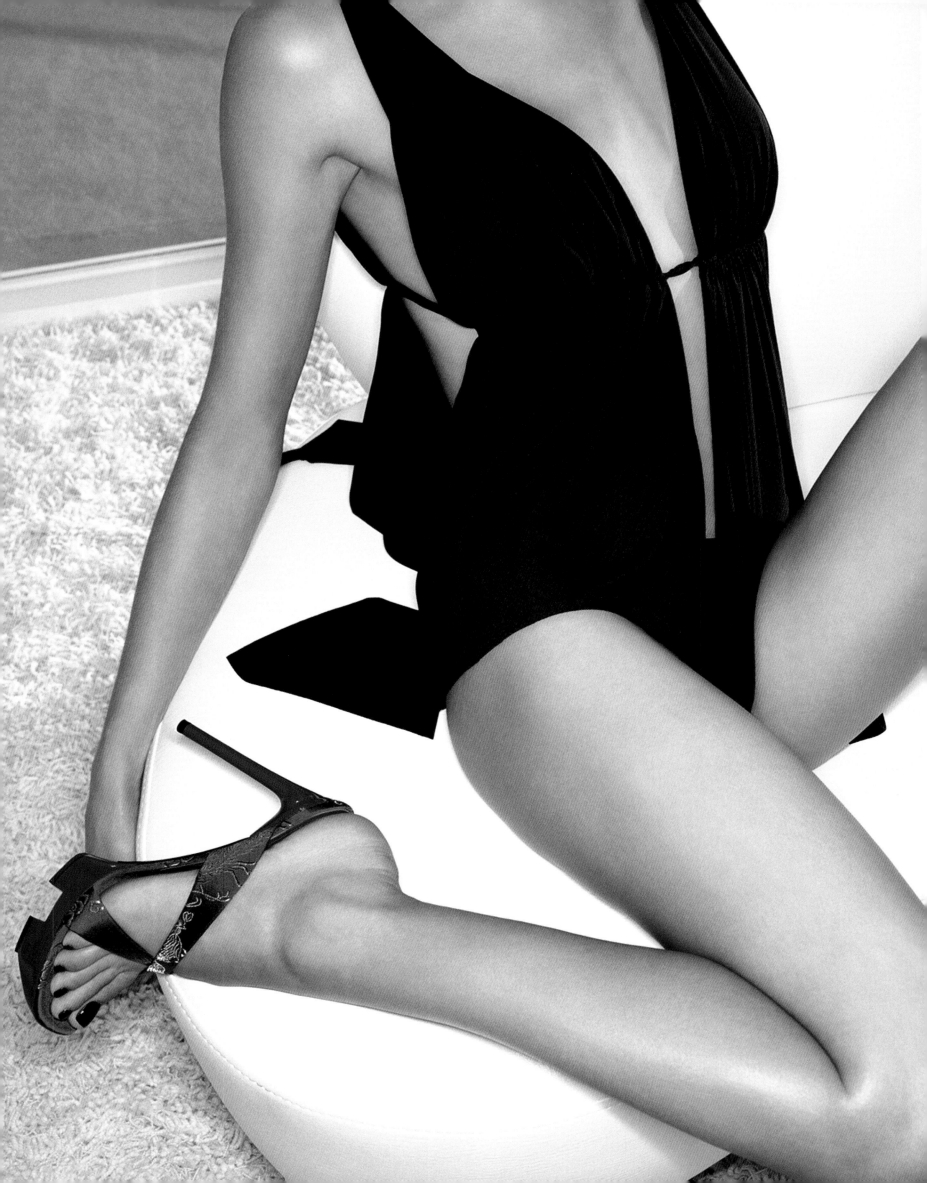

Cesare Casadei, the son of the famous footwear maker Quinto Casadei, started his career by working for his family's firm, Calzaturificio Casadei, despite his studies in economics and science at various universities. Working for his father allowed him to travel and experience new cultures and traditions, aiding him in finding his own style as a designer. Casadei first gained public recognition for his unexpected color combinations and subsequently opened his first showroom in Milan. In 1994, he was named creative director of the brand. Since then, he has collaborated with world-renowned photographers such as Mario Testino, Ilaria Orsini, Nick Knight, and Raymond Meier and his collections embody the fabulously stylish women he describes as his heroines. From hand-embroidered Swarovski crystals to unique leather processing techniques, Casadei's models showcase his creative and ingenious design acumen.

# CASADEI

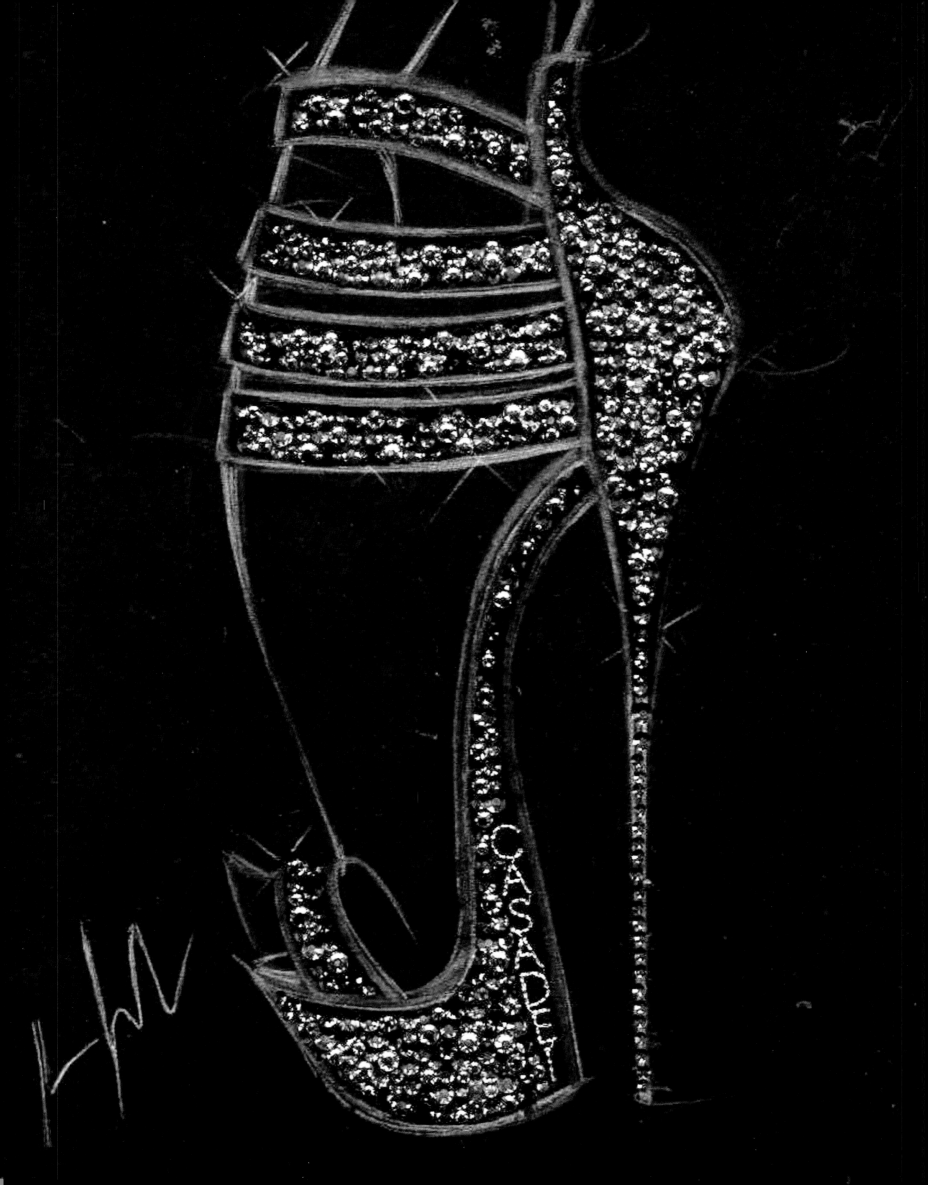

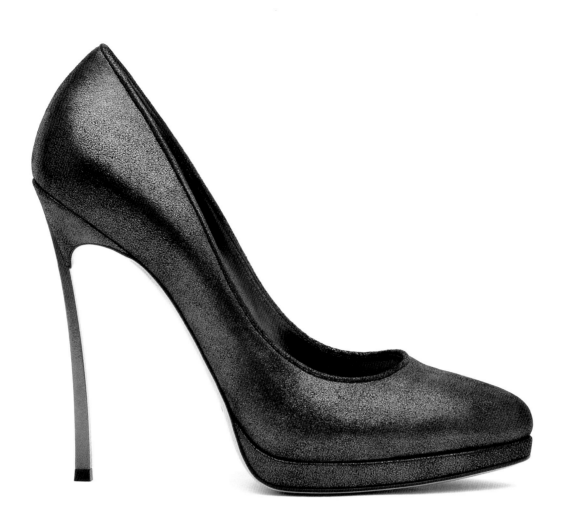

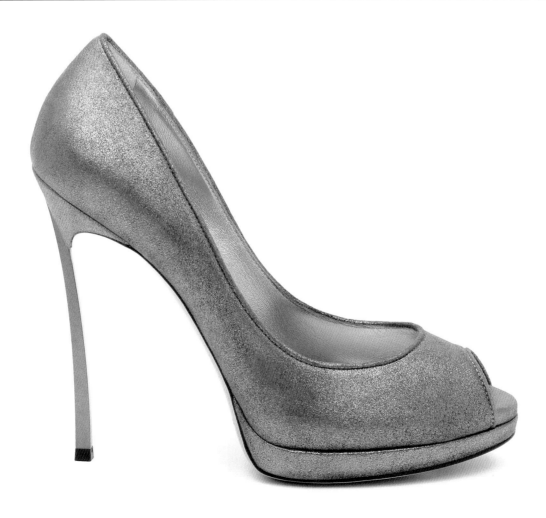

CESARE CASADEI IS KNOWN FOR HIS CLASSIC EUROPEAN CHIC SENSE OF STYLE: SKY-HIGH PUMPS THAT MAKE A WOMAN HAPPY SHE IS A WOMAN, AND SANDALS, WEDGES, AND PLATFORMS THAT SCREAM SAINT-TROPEZ. His shoes are nothing less than killer: take the *Fluo*, which features thick fluorescent cutout cork heels or fluorescent thin spikes. There is also the *Python Obsession*, which entails python wrapped pumps, delightful wedges in fruity colors, and the *Blade*, featuring a sexy slit of a wedge for a heel. The new *Blade* has a heel that is possibly the thinnest on the market.

Casadei's first collection debuted at the end of 1980 and mainly included shoes designed for daywear, sporty yet fashioned with luxurious materials and details—vastly different from what the designer produces today. During the beginning of Casadei's career, he worked in the retail department of stores to better understand the important aspects of what made something a decent piece of footwear, as well as what caused a pair of shoes to sell better than another. "For me, the most important qualities that make shoe design special and unique are brilliant ideas, a sense of aesthetics, and the right proportions, as well as sharp technical skills," states the designer.

Casadei approaches the design of a shoe's silhouette as if it were an object in motion. The silhouettes he considers strongest are the *Calder* and *Fontana* constructions of the spring/summer 2012 collection, and the *Pin-Up* of the fall/winter 2012–2013 collection. Overall, his shoes are bold with a polished sex appeal. The fall/winter 2012 collection relates back to 1940s pin-up girls—symbolized by the legendary Betty Page—with Lady Gaga as a counterpoint source of inspiration. "One collection is built around a new pump called the *Pin-Up*, which I designed in different versions to be feminine, romantic, ambiguous, and seductive, but always wearable."

Today Casadei lives in a town near the sea in his home country of Italy. While he is greatly influenced by his parents, who were esteemed footwear makers, it is also his surroundings' energy and colors that motivate his designs as well as his extensive travels. This gives him the opportunity to capture ideas from all over the world, not just those related to the place where he resides. Daily life, from movies, songs, and more, is what Casadei finds most stimulating. These then transform into stories, which he tries to evolve into a collection by allowing them to narrate constructions, materials, and shapes. At the heart of all of Casadei's creations, however, are women and their sophisticated femininity, attitudes, and diverse personalities. "It always fascinates and stimulates my creativity."

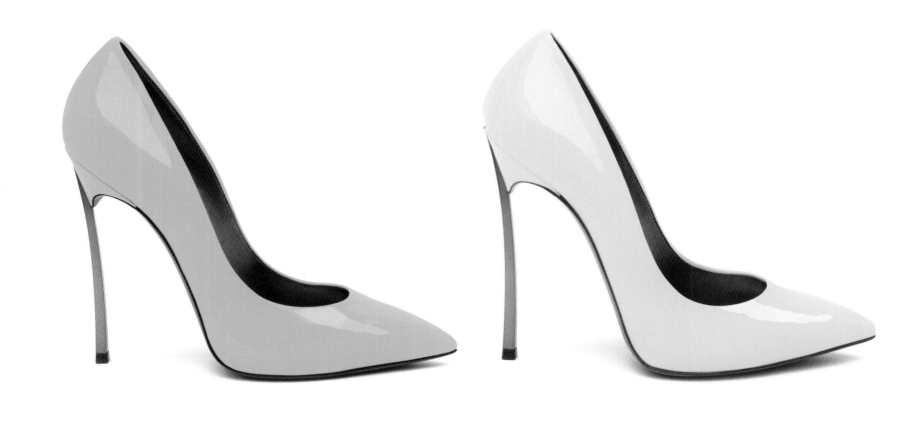

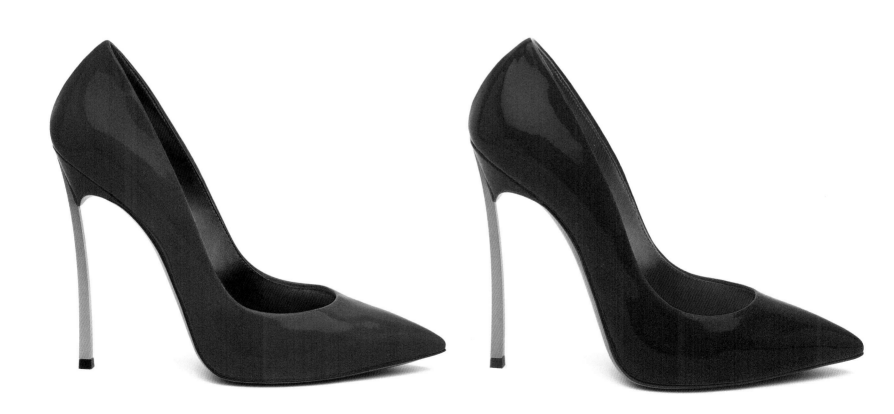

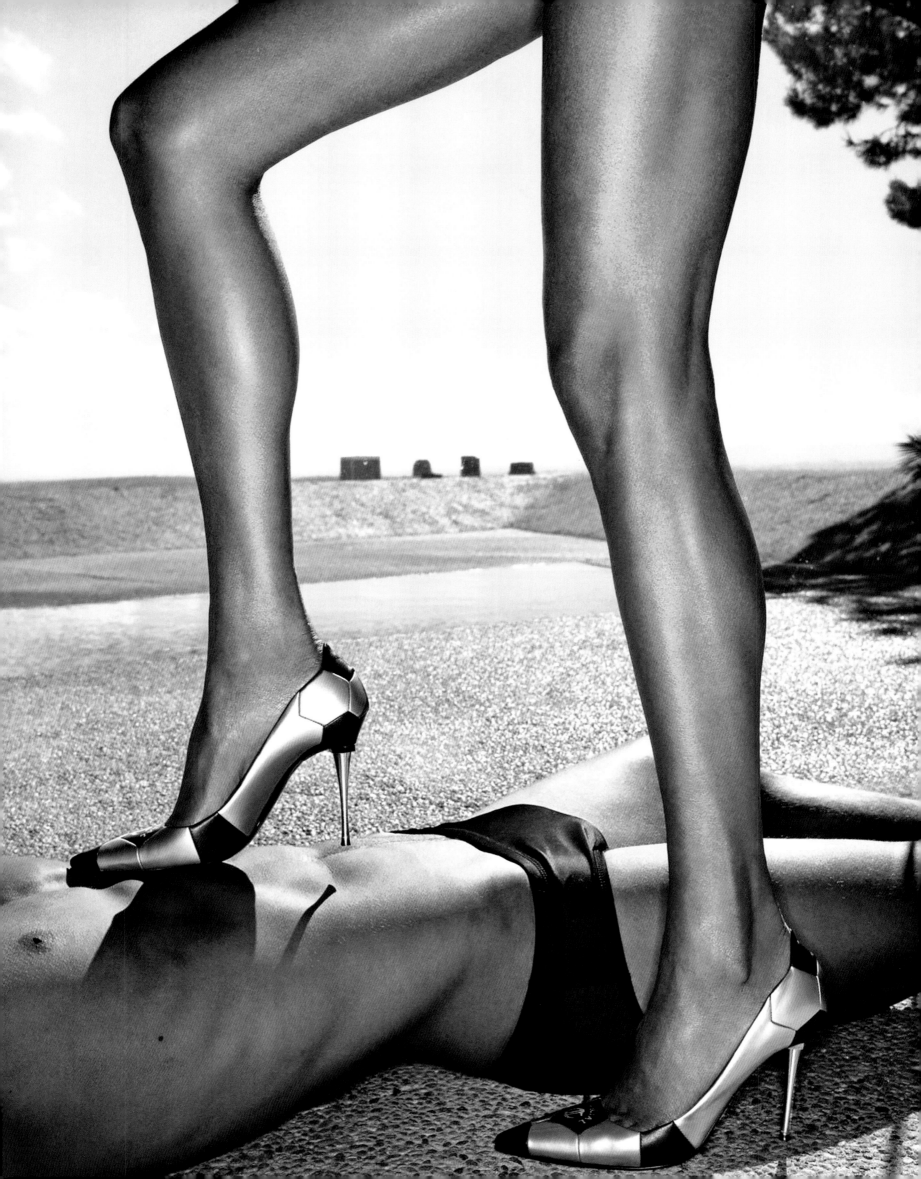

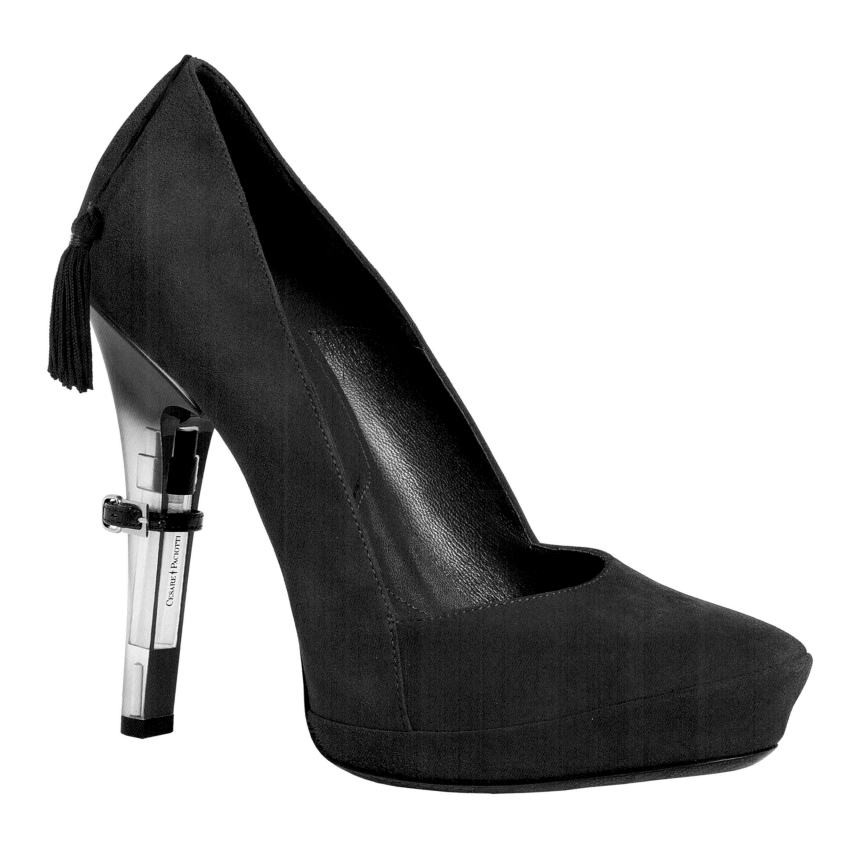

Born in Civitanova Marche, Italy, Cesare Paciotti was exposed to the world of shoes at a young age. His love for accessories came from his parents, the owners of a local shoe factory that manufactured high-end shoes. Paciotti was admitted to the Drama, Art, and Music Studies (DAMS) program at the University of Bologna, one of Italy's most renowned universities, where he was able to advance his artistic abilities and talents. Upon graduating, he traveled to major cities around the world to observe and study foreign cultures. He found different societies' uses of color inspiring, and by the time he returned to Italy, his sense of style had been enhanced; his desire to materialize his newfound knowledge was stronger than ever. After taking over the family business in 1980, Paciotti was able to debut his first men's shoe collection called Cesare Paciotti. The designer has garnered global recognition through his avant-garde ideas and provocative styles, and has partnered with several revered Italian designers including Gianni Versace, Dolce & Gabbana, and Roberto Cavalli. Paciotti's women's line caters to the strong, sophisticated, and modern woman, all of which are notable qualities present within his collection.

# *CESARE* PACIOTTI

IT WOULD SEEM A GRAND, YET VERY FAIR, CONCLUSION TO SAY THAT THE ITALIANS ARE A PEOPLE WITH GREAT STYLE AND THAT THEY HAVE SOMETHING ALMOST INNATE, ESPECIALLY WHEN IT COMES TO THEIR SHOES. As a proud Italian, Cesare Paciotti would whole-heartedly agree. "I love living in my country. Here, I feel the pride and honor of the work made," he says a bit emphatically. "I also feel satisfaction for my creations from the people who work with me. We are so glad to see our shoes appreciated on the catwalk or the red carpet—and everywhere else."

Despite his devotion to his motherland, Paciotti does consider himself a man of the world. While he received his education in his native Italy, he found he wanted, like many young people, to get out and see the world. "I came of age during the 1970s with friends who were musicians and directors. As many of my contemporaries did during that time, I wanted to express myself," he recalls, reflecting on his formative years. He enrolled in a special arts program at the University of Bologna to study cinema with the goal of becoming a director. During this time Paciotti also played harmonica in a rock band called Ice Cream as a tribute to Eric Clapton. "Cinema and music are still a huge part of my life, and consequently of my job in the way I honor great artists," says Paciotti. "For example, one collection is called *Amy*—my homage to Amy Winehouse." And then there is one of his most unforgettable shoes: a fourteen-inch heel he constructed for Sir Elton John. Art has also had a profound impact on the designer, as many artists came to be very influential in both his personal and professional growth. For example, Paciotti possesses a special kinship with Andy Warhol in the way he transmitted his work to the masses.

After the experiences of his younger years, Paciotti wanted to follow in the footsteps of his parents, who produced handcrafted Italian shoes and put all their efforts into their trade, making products realized with passion and purpose. He now credits his love for what he does as stemming from the family business as well as his parents' nurturing. Paciotti doesn't like shoes that do not possess significance. "A shoe that is just a provocation doesn't represent anything to me. If it doesn't communicate a message or have a function or an idea, it's nothing, in my opinion."

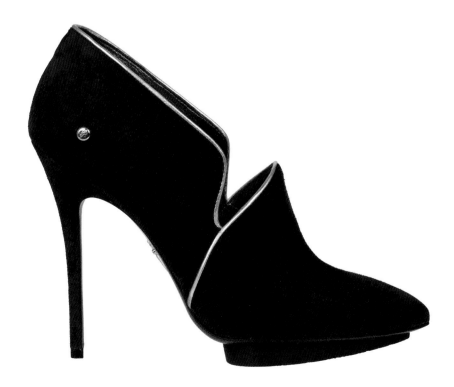

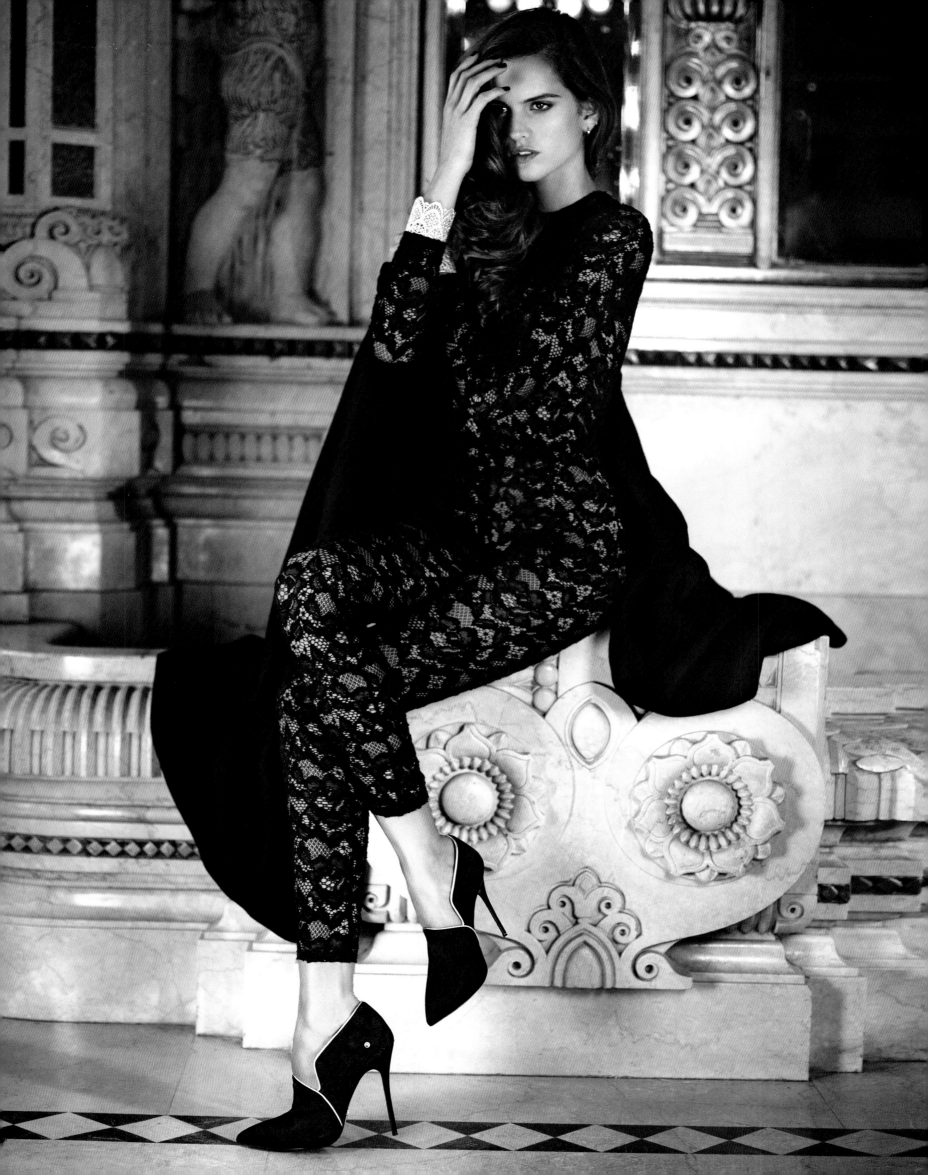

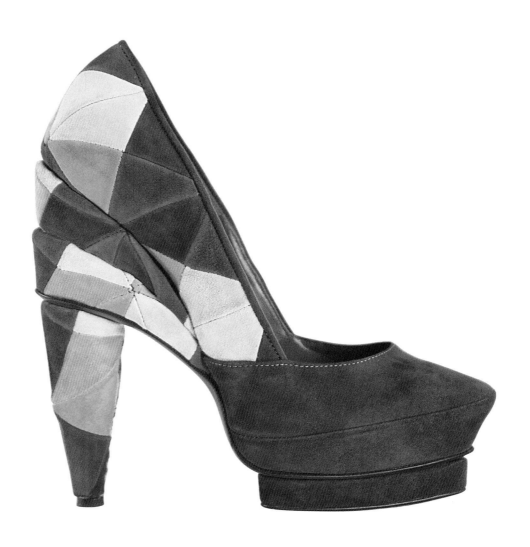

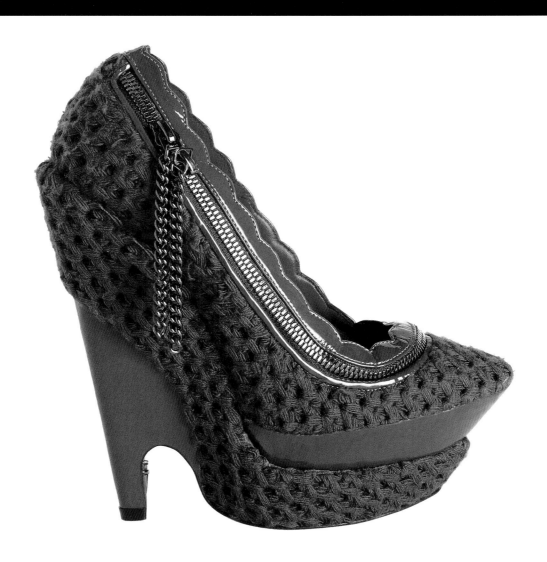

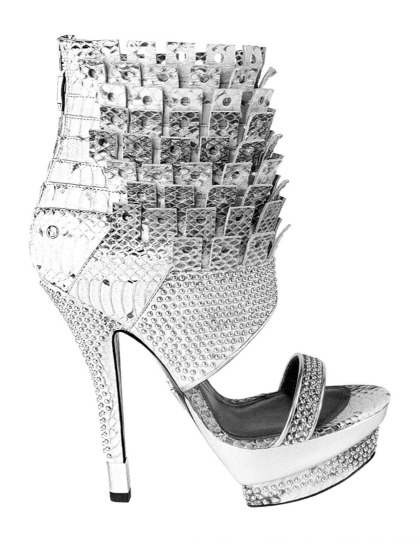

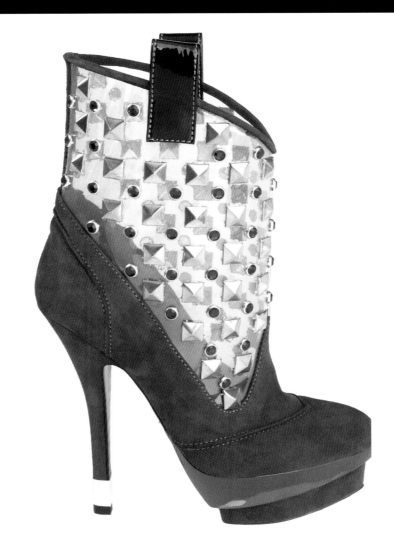

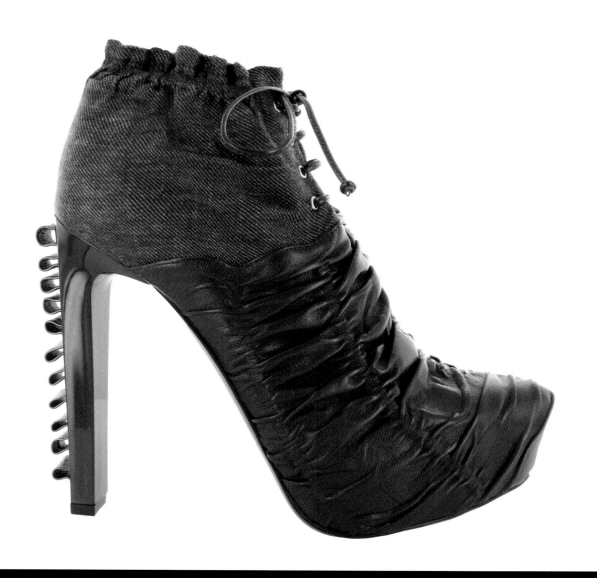

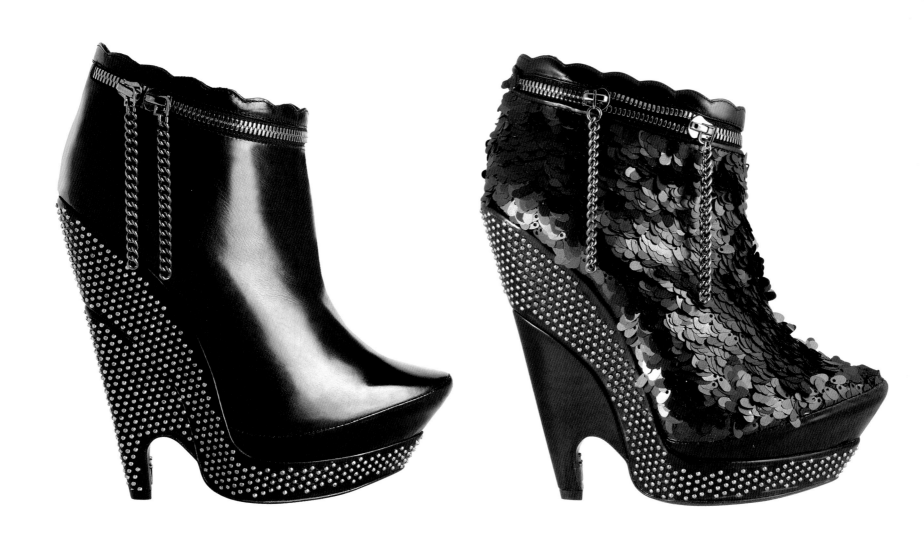

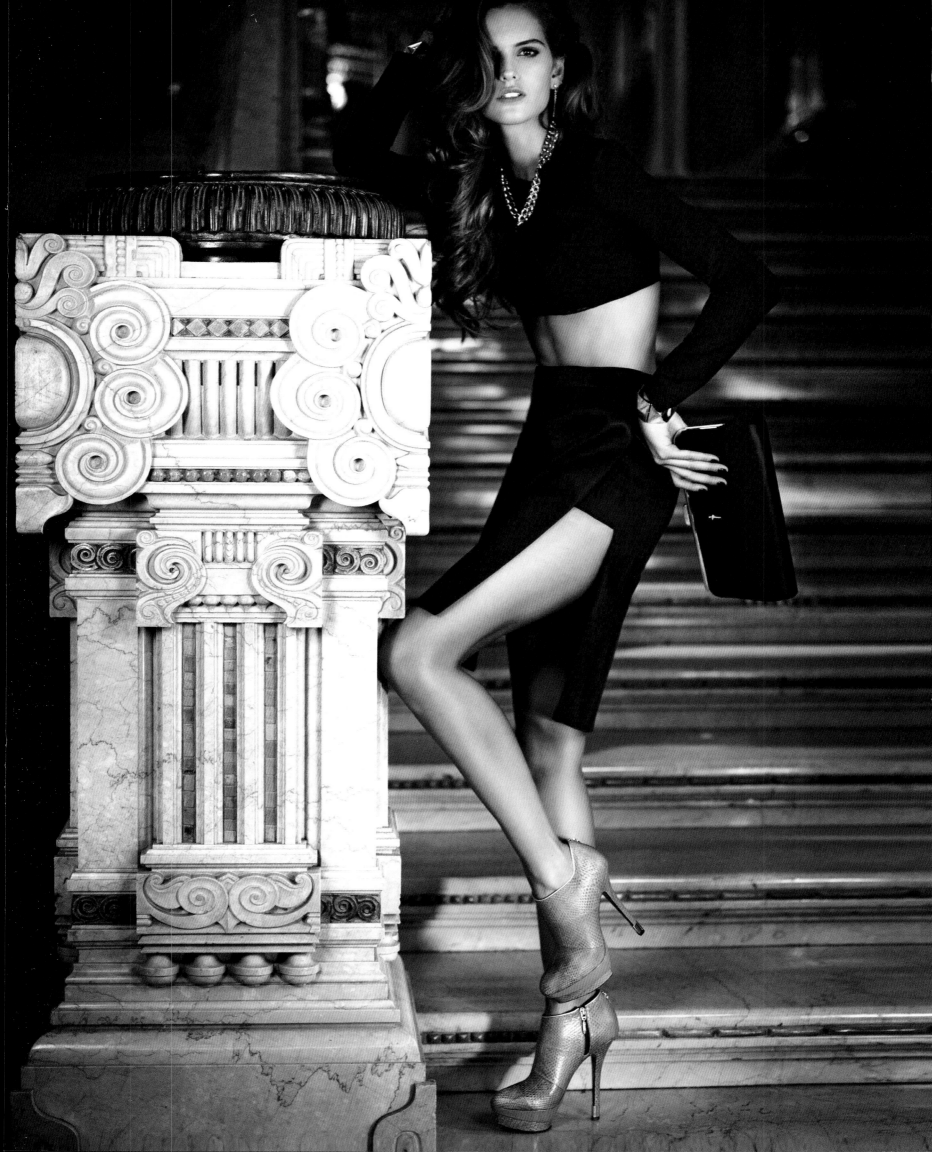

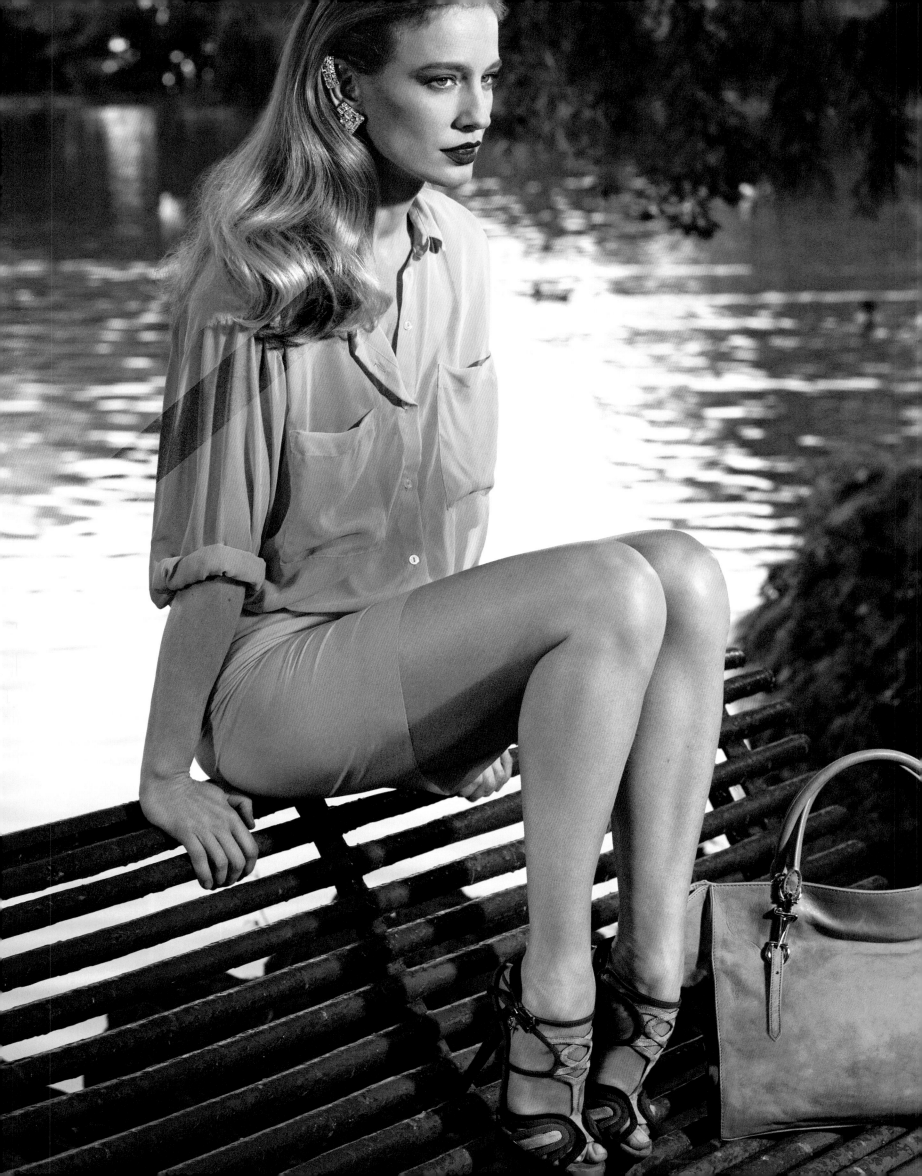

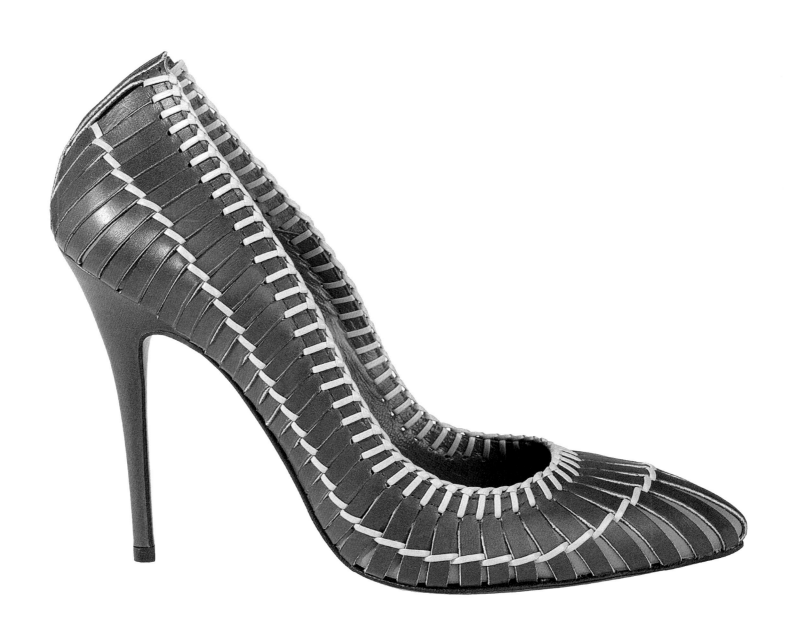

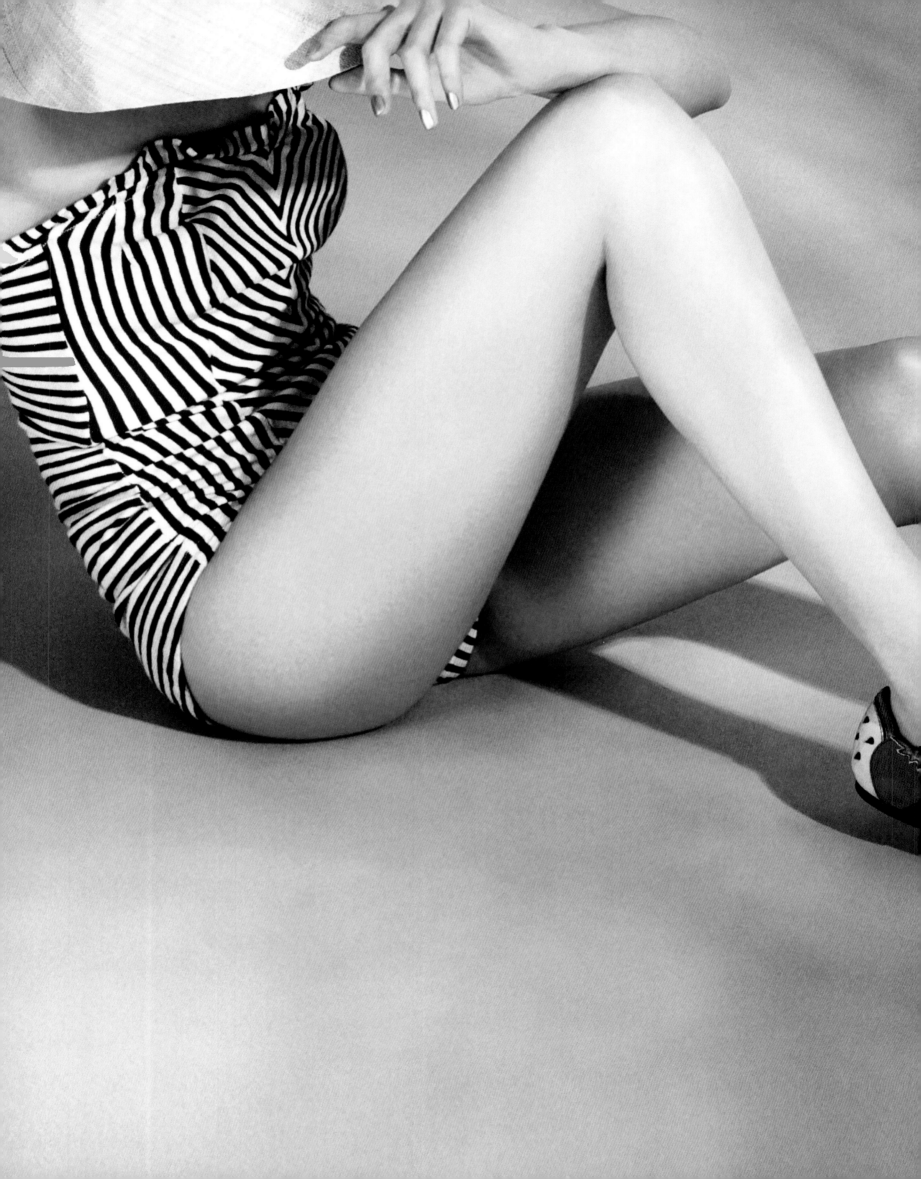

A Cordwainers College graduate, Charlotte Olympia Dellal's inspiration comes from the accessory-oriented eras of the 1940s and 1950s. Her shoes—which are all finished with her signature gold spider's web on the sole—are handcrafted in Italy and meticulously detailed. The Charlotte Olympia label has developed to include not just heels, but flats, boots, and accessories as well that come in bright, exciting colors and animal prints. (Dellal, who is of English and Brazilian decent, loves animal prints so much that she even wore leopard print shoes under her wedding dress.) She opened her first flagship store in her hometown of London in 2010 and a second store on Madison Avenue in New York just two years later. Her designs garnered her the Accessories Designer of the Year award at the British Fashion Awards in 2011 and have helped her acquire a following of celebrity fans, including Blake Lively, Penelope Cruz, and Sarah Jessica Parker.

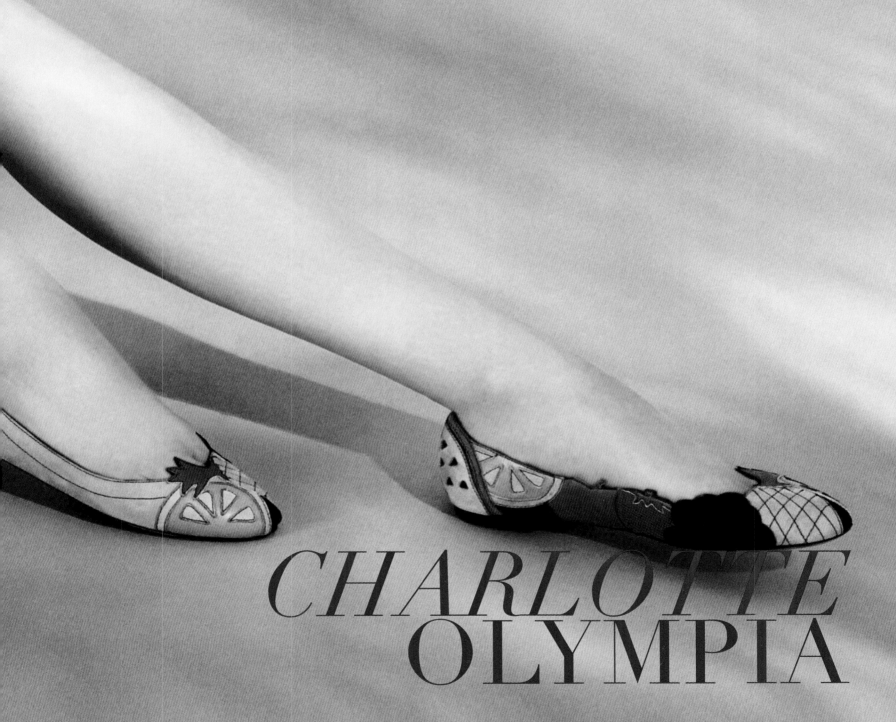

# CHARLOTTE OLYMPIA

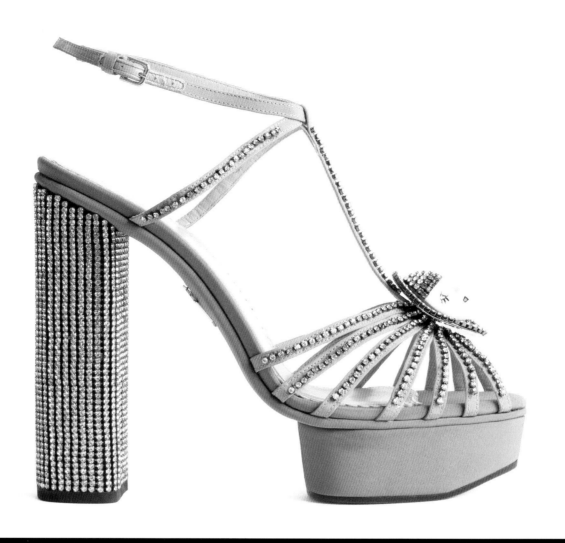

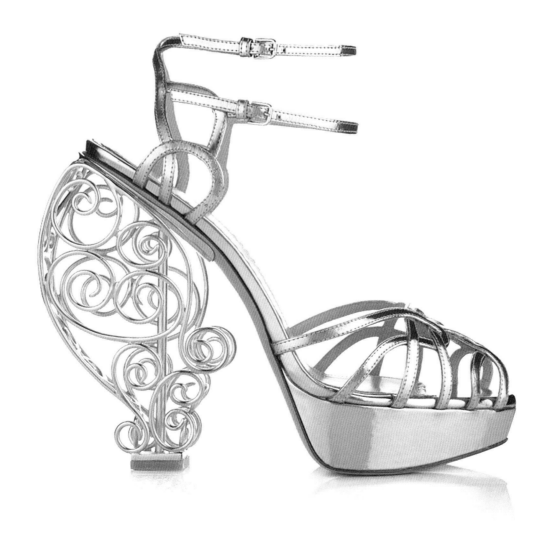

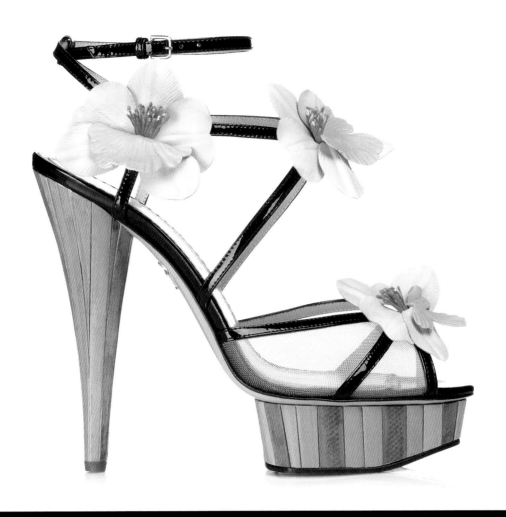

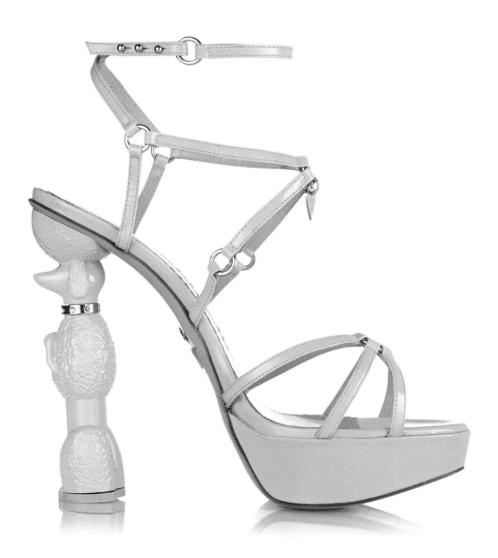

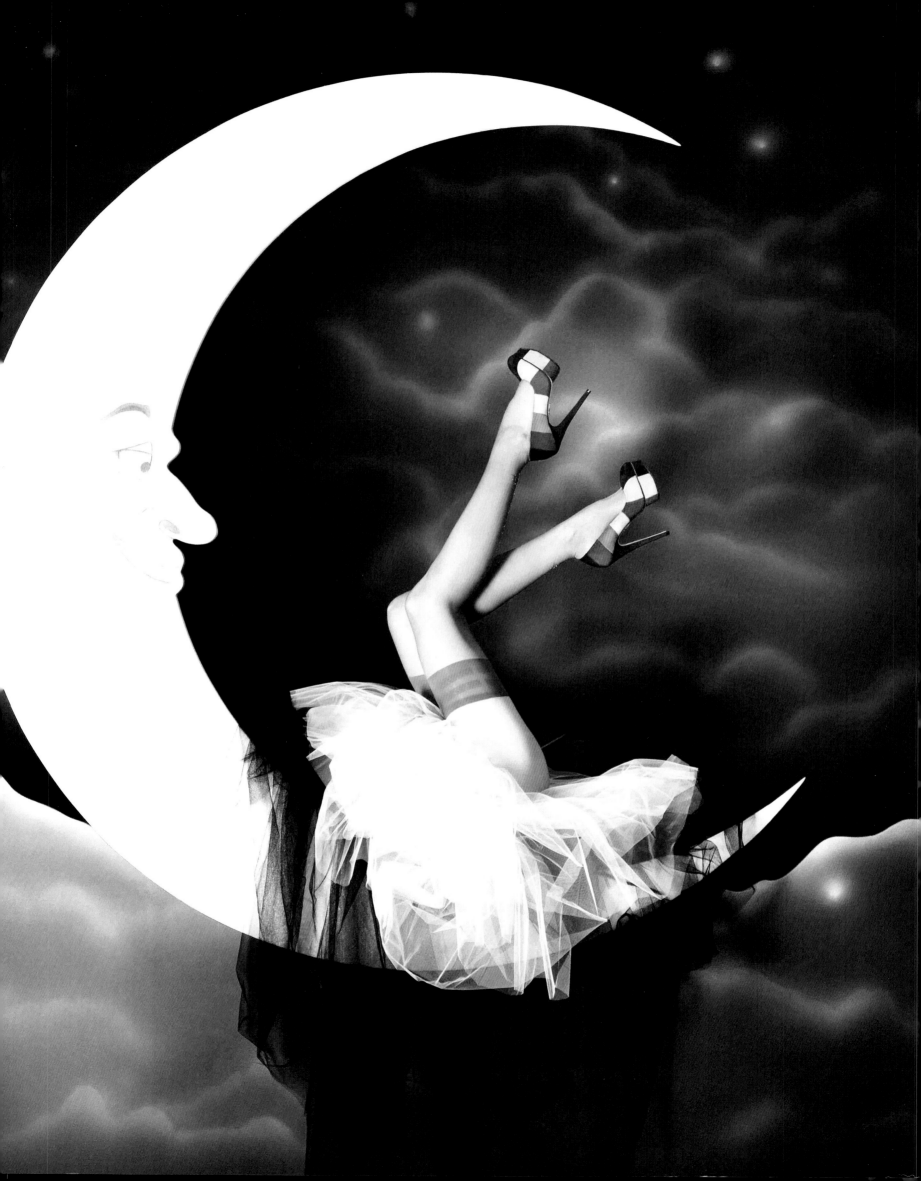

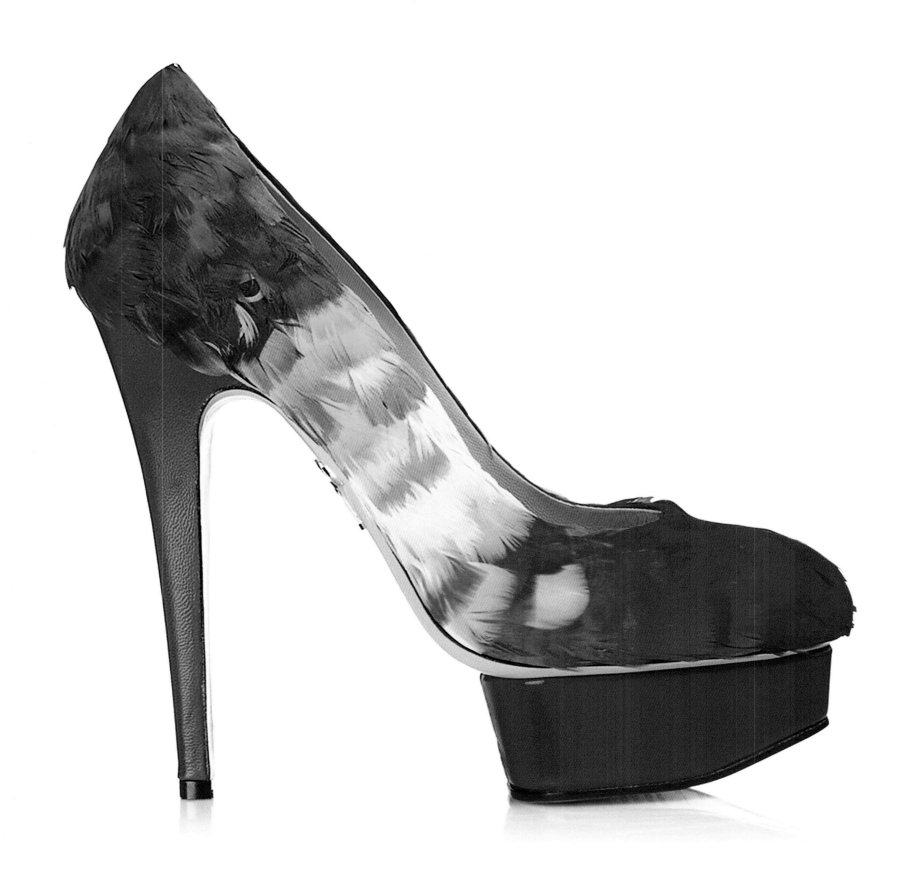

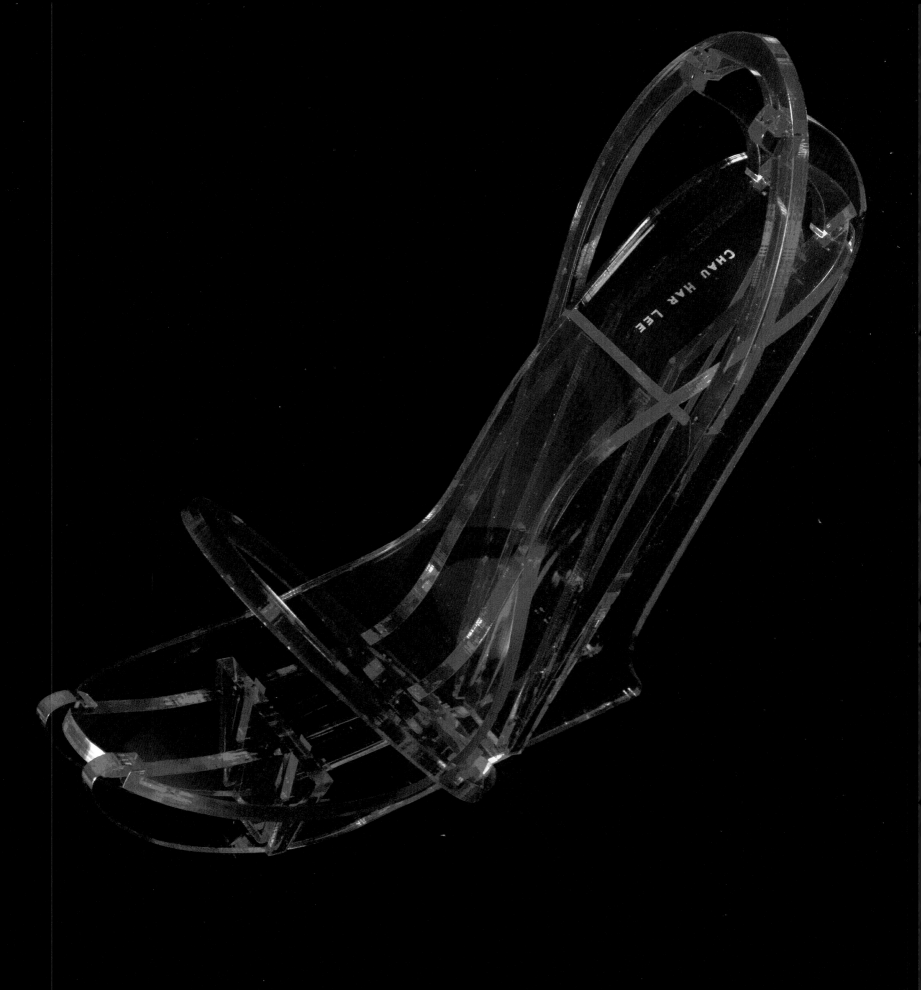

Chau Har Lee, an alumna of Cordwainers College and the Royal College of Art, has a unique design aesthetic that combines the traditional methods of shoemaking with modern technologies. Inspired by her mother's creativity, Lee felt that shoemaking was the best way to fuse her two strongest talents: sculpture and textiles. In 2009, Lee won the ITS8 Accessories Collection of the Year award and today she boasts her own namesake label of women's shoes and accessories. Not only have her creations been displayed at Paris and London Fashion Weeks, but she has also collaborated with many prestigious fashion and footwear designers, including Camper, Capulet, Bally, and Nike. In addition to her eponymous line, Lee currently holds the position of women's shoe designer at Yves Saint Laurent. While she always strives to design around the foot so that her shoes compliment the body, she uses materials in the most efficient way possible.

CHAU HAR LEE

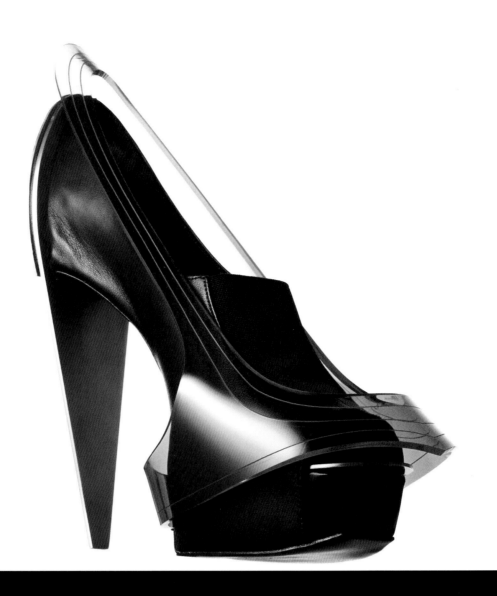
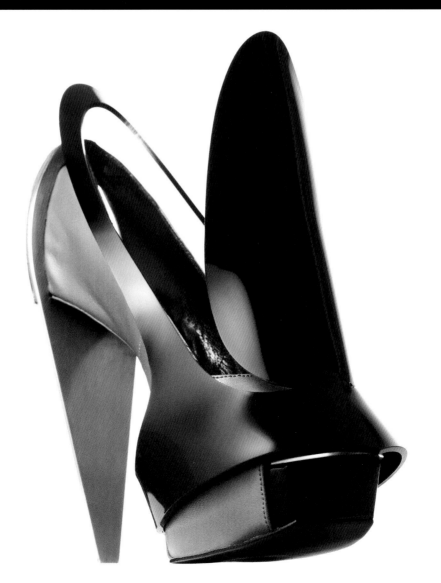

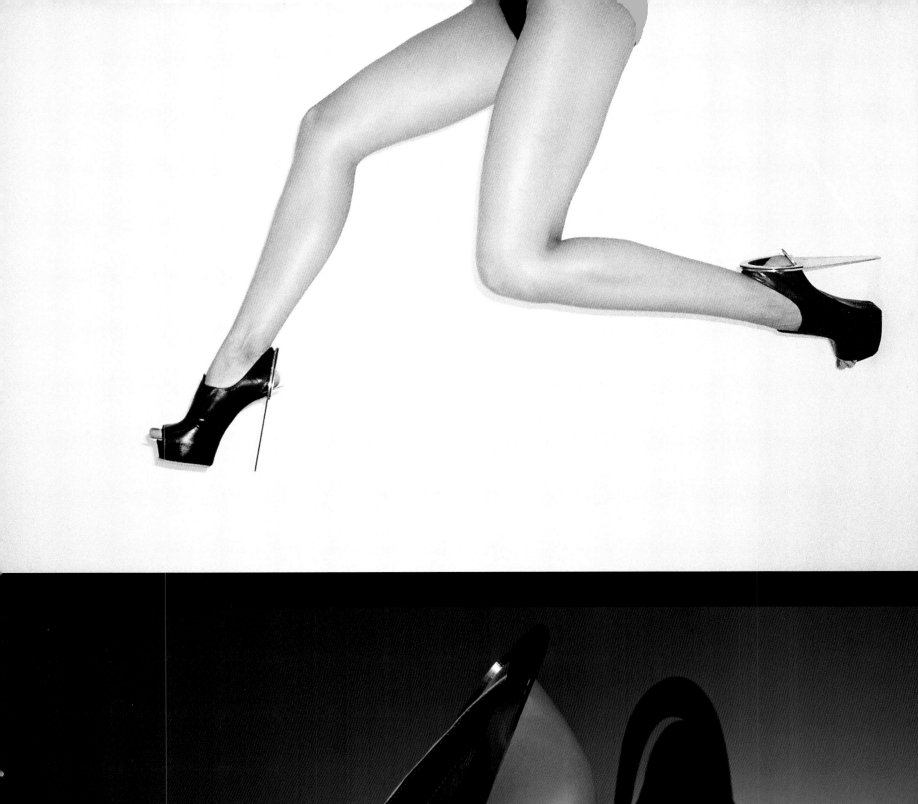
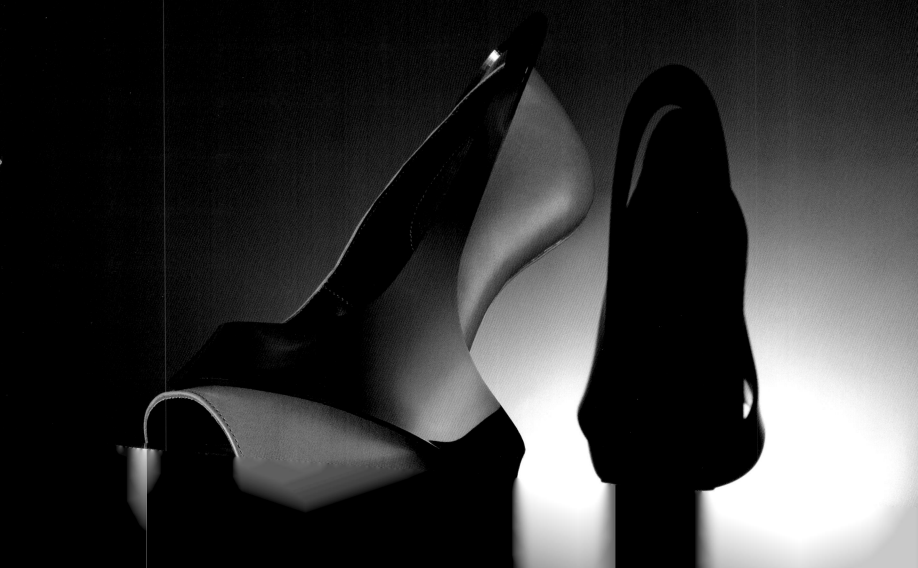

FOR A WOMAN WHO IS ALWAYS WORKING ON NEW PIECES, EXPERIMENTING WITH NEW MATERIALS, AND TRYING OUT NEW WAYS OF PUTTING HER IDEAS TOGETHER, CHAU HAR LEE'S DEFINITION OF NEW IS ALWAYS EVOLVING. "Part of the appeal of shoe design for me is seeing the vast changes in aesthetics throughout history and across the world—from wooden pattens in the eighteenth century to moon boots in the 1970s. I love seeing the diversity in footwear design." Lee, who is based in the United Kingdom, is lauded for her avant-garde creations with revolutionary function, such as her *Flat-Pack* shoe that can be made from a minimum of four pieces. Her essential goal with the *Flat-Pack* was to reduce the amount of components and manufacturing time that go into making each shoe. "I wanted to keep the pieces very simple while emphasizing the characteristics of the materials used," she says. Lee also designed a shoe that was built using three-dimensional computer software that took twenty-eight hours to "print." "This was a very different way of working for me; usually I sketch on paper and work on mock-ups until it looks right."

Her designs span from conceptual showpieces to elegant, original, yet accessible footwear. "I often employ a crossover of making and manufacturing processes from fields other than shoemaking in order to realize my concepts. This gives me a large scope for creativity by removing boundaries," Lee states. "My knowledge of traditional shoemaking helps me know how and where I can break these boundaries," she adds.

Needless to say, her shoes are available on a made-to-order basis, although they are also sold at prestigious venues, such as Selfridges. Lee's designs usually come about through an accumulation of ideas acquired over time; she always carries a sketchbook so she can record thoughts as they come—thoughts that eventually may form into a project or idea for a particular shoe or as part of an overall design. "My inspiration comes from so many things," she acknowledges. "I often look to other disciplines, such as architecture, product design, vehicle design, jewelry, or sculpture. I enjoy things that are simple but clever. I like to think of my work as a mixture of traditional and the conceptual."

A native of London who studied the trade at three of the city's universities, including a foundation diploma from Camberwell College of Arts, Lee's work is inevitably influenced by London's creativity and energy. Designing shoes soon became her focus after Lee realized how much she enjoyed the mix of aesthetic, technical, and physiological elements that need to be considered. "Shoes seemed like the natural progression that fused my two strongest areas, which were sculpture and textiles." Before becoming a footwear designer, Lee had previously worked as a production assistant in architectural leather interiors at Nicole Farhi, as an accessories designer at LMNOP, and taught at Prescott & Mackay, a fashion and accessories design school.

Lee knows that footwear draws on both form and function, the latter being more critical. There are, after all, certain things a shoe must be able to do, while at the same time being aesthetically pleasing. Lee designs out of a love for the contours of the foot—the way it moves, its strength, and its physiological beauty. "Although my most conceptual designs are showpieces, they are still built to adorn the foot."

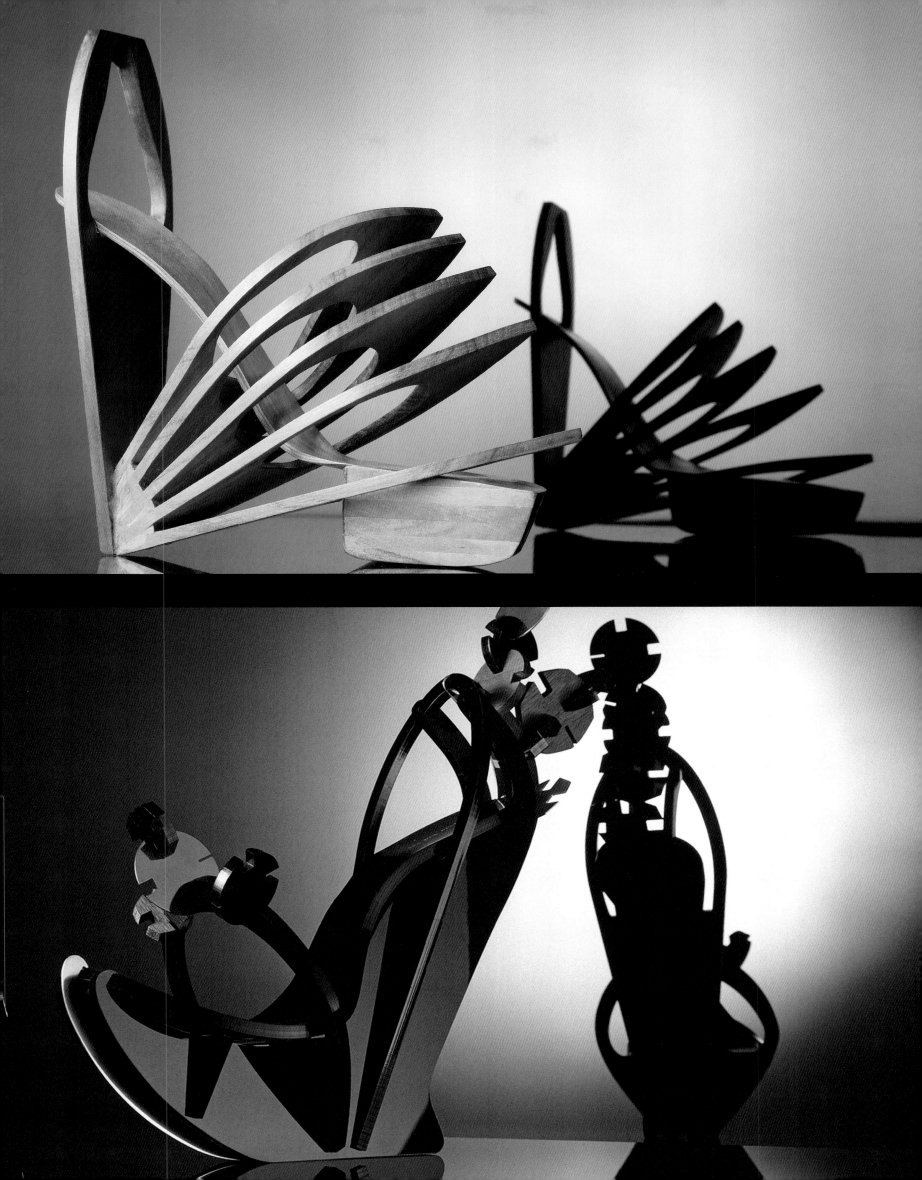

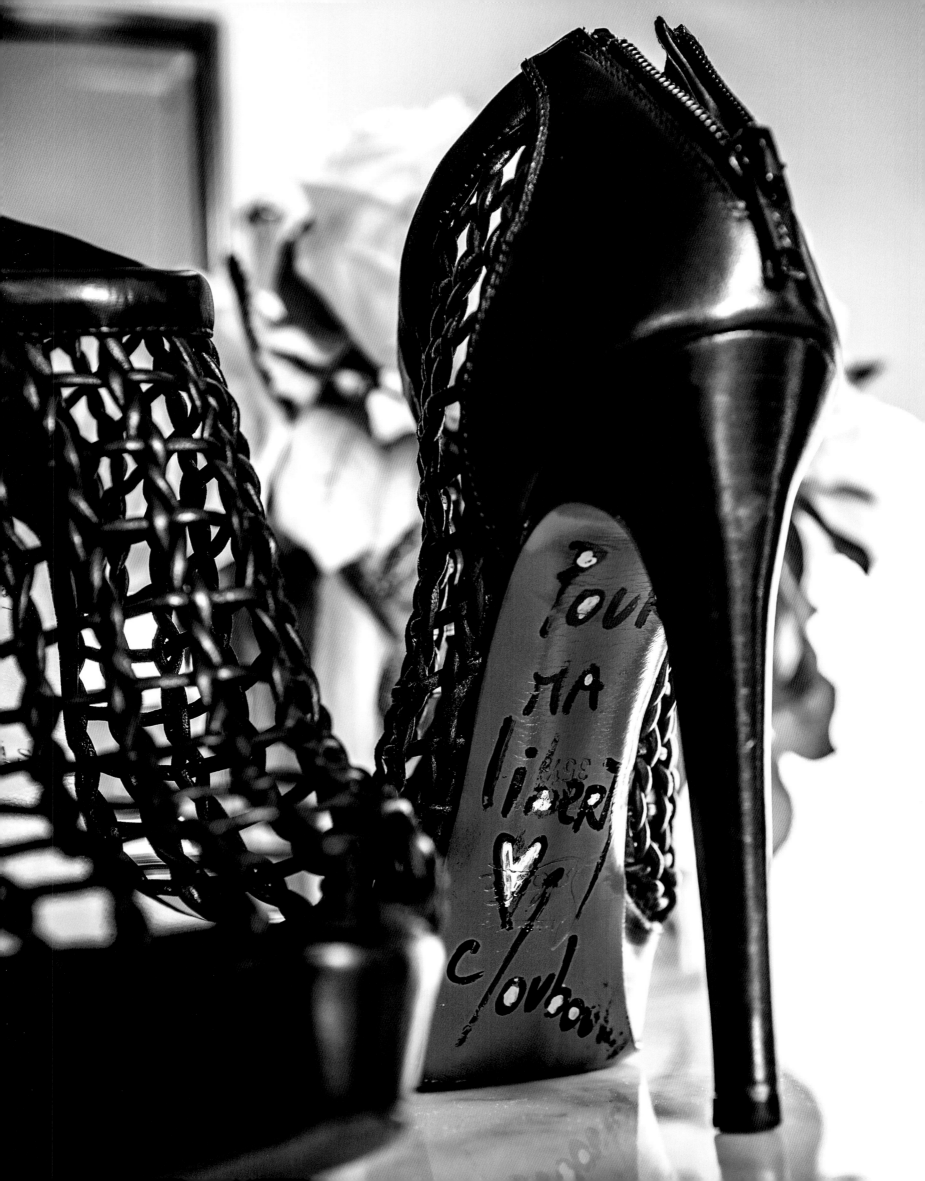

Christian Louboutin was born in Paris in 1964 to a cabinetmaker and a homemaker mother. His passion for shoes began after visiting a museum and viewing a sign warning women that heels were prohibited because they would damage the floors. He was fascinated with and inspired by the sign, because he had never seen shoes like that before. Louboutin mastered the basics of the shoe industry from Charles Jourdan after getting a job working with him in the 1980s. He eventually learned the importance of the heel from the esteemed footwear designer Roger Vivier, who is said to have invented the stiletto. The inspiration for Louboutin's trademark red outer soles came to be while he watched an assistant paint her nails red. He thought the red detail would be a statement for that particular season, but his clients begged him not to stop making shoes with red soles. From classic black stiletto heels and casual day shoes to his sky-high heels, Louboutin's shoes accentuate a woman's sexiness by elongating the legs as much as possible.

# CHRISTIAN LOUBOUTIN

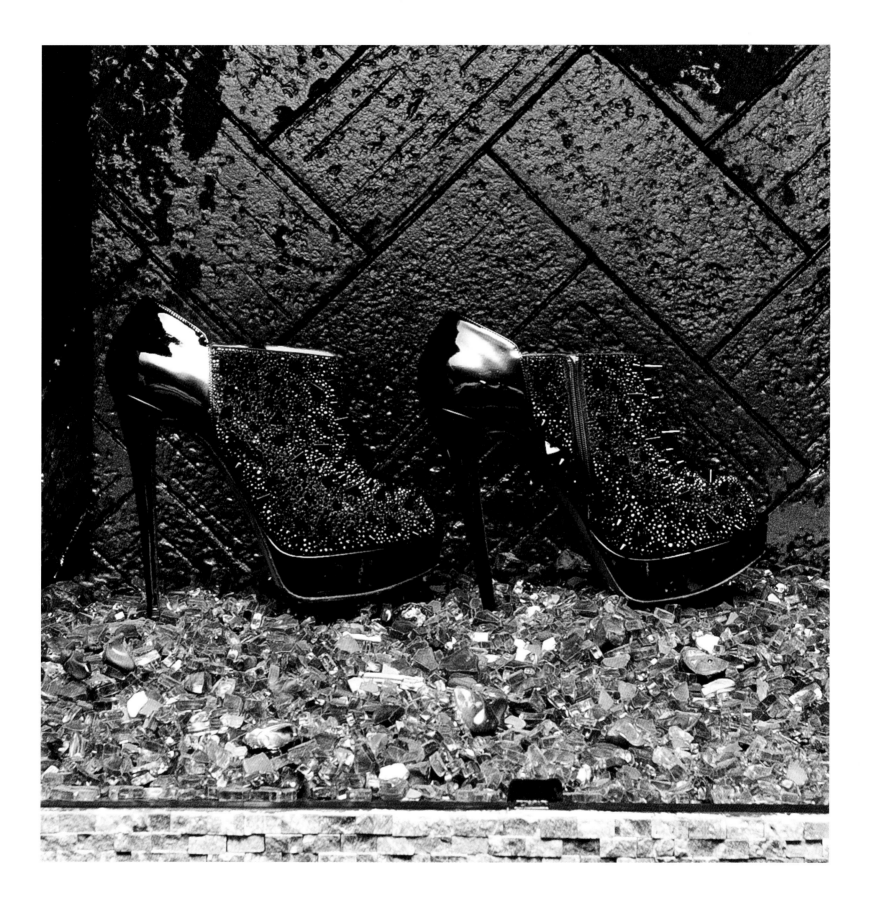

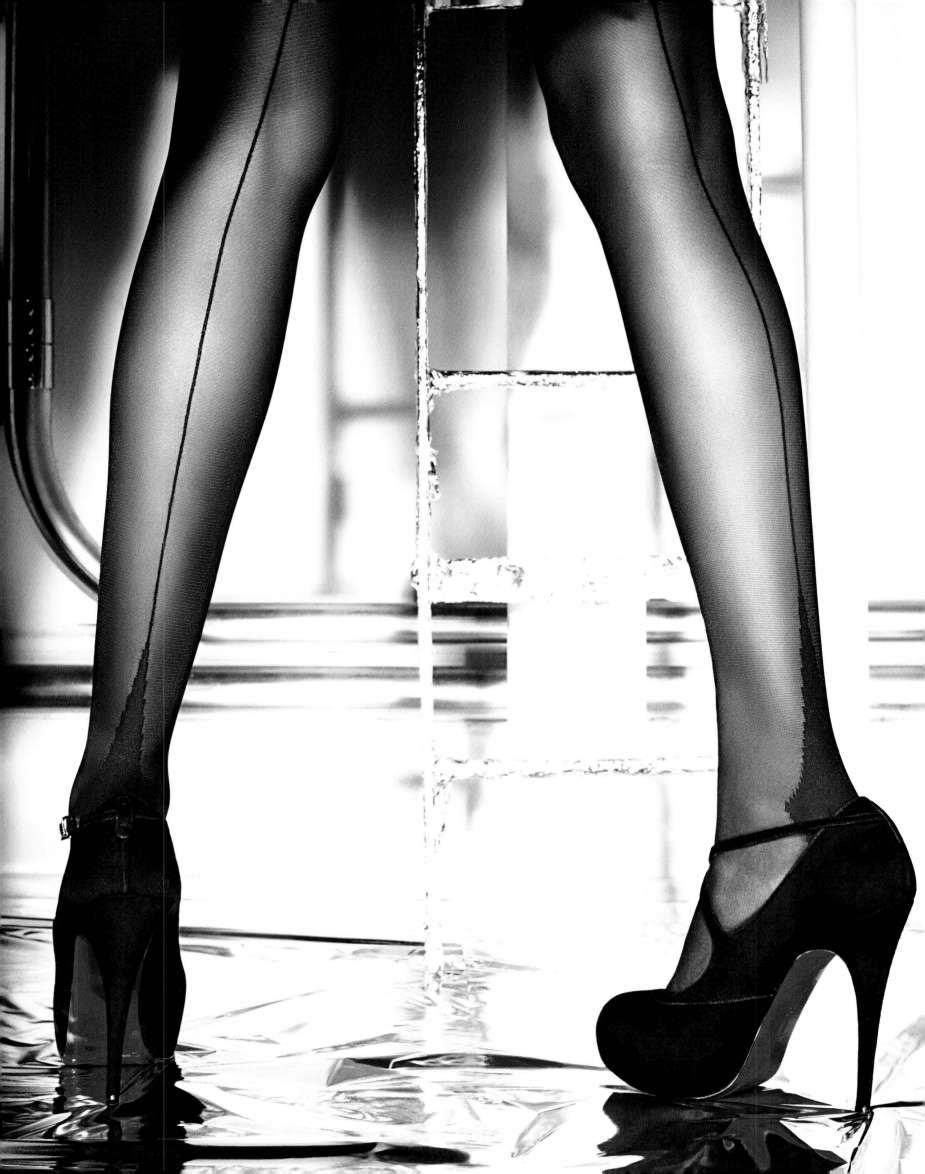

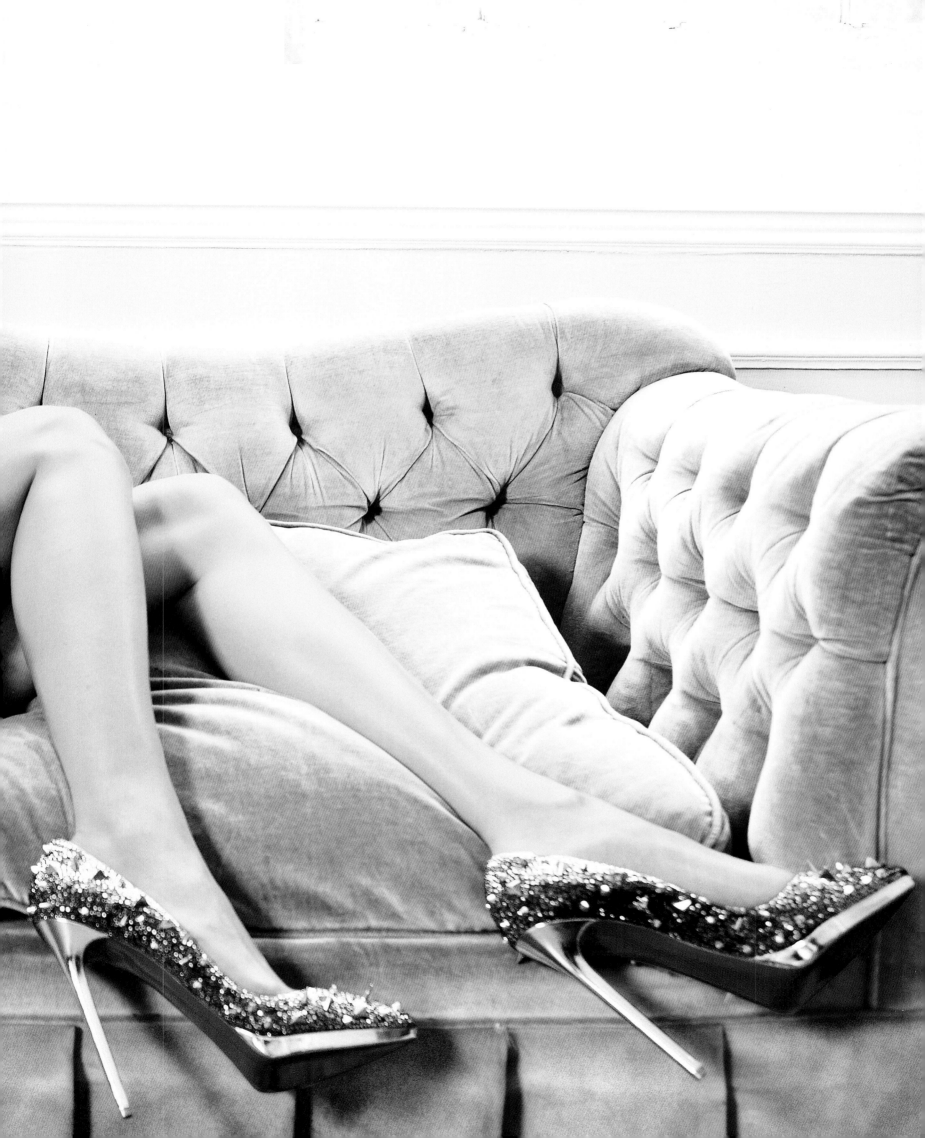

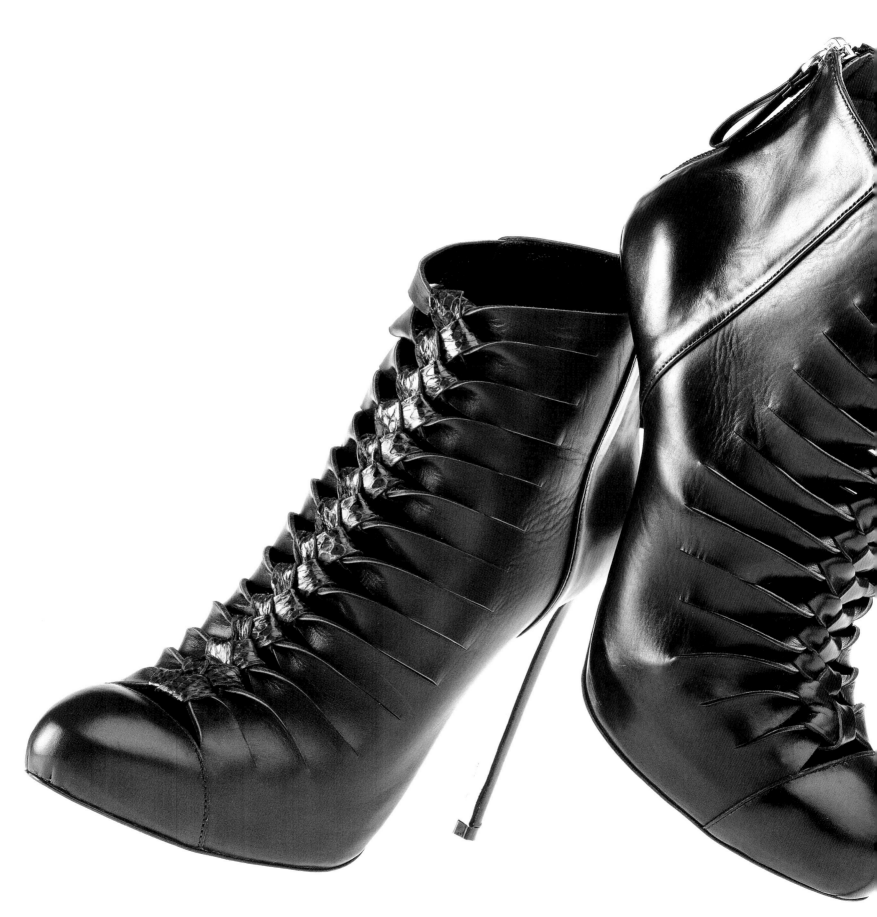

Italian-born designer Daniele Michetti started working for his family's footwear manufacturing business at a young age. While he doesn't recall the exact moment when he realized he wanted to become a designer, his decision landed him with positions working with some of the most esteemed names in the fashion world, such as Stefano Pilati, the former head designer of Yves Saint Laurent, and Sergio Rossi. Michetti believes that shoes are intimate and personal, so it is no surprise that his collections are inspired by lingerie. An aspect of desire is apparent in his design aesthetic, from the patterns and shapes of his shoes to their intricate detailing. While Michetti says that people's moods and personalities influence their choice of shoes, he does not think that shoes exercise an influence on their moods in any way.

# *DANIELE* MICHETTI

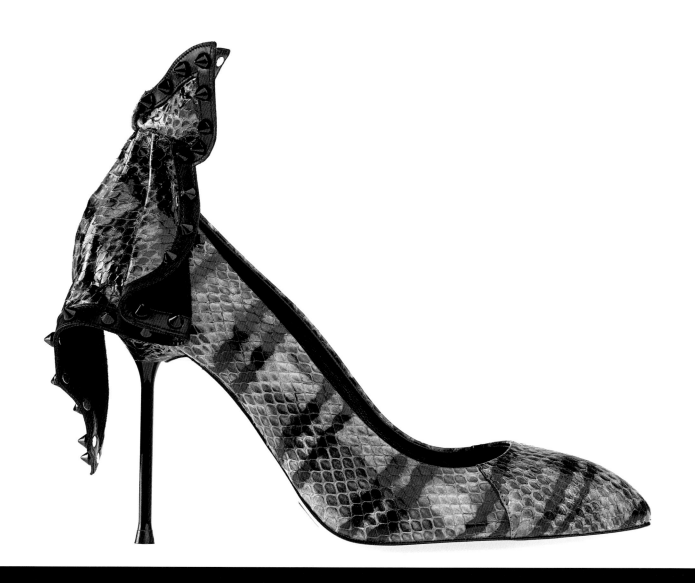

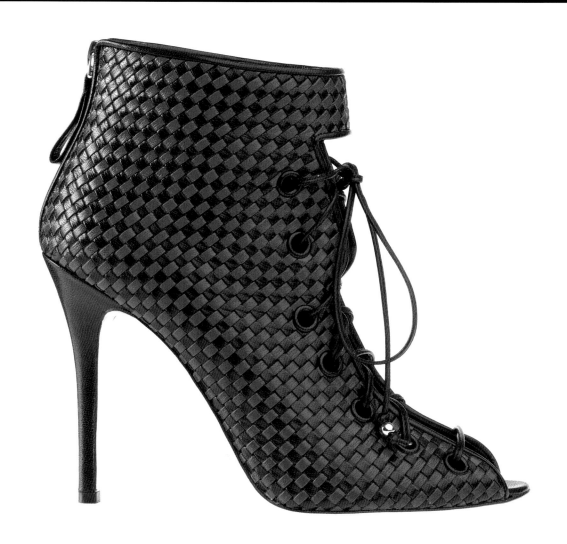

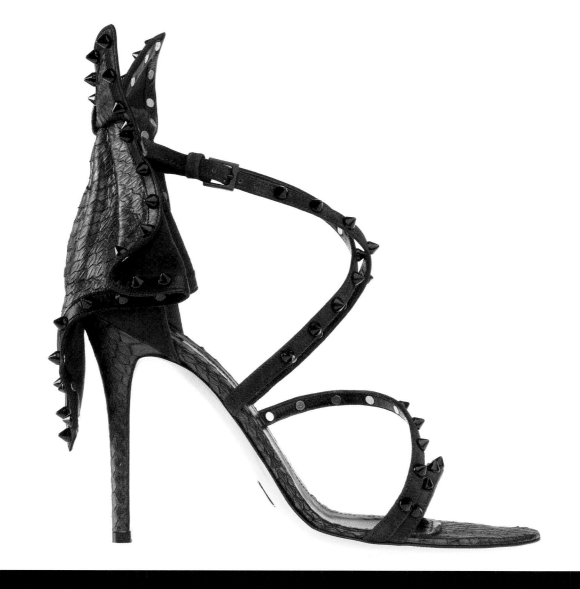

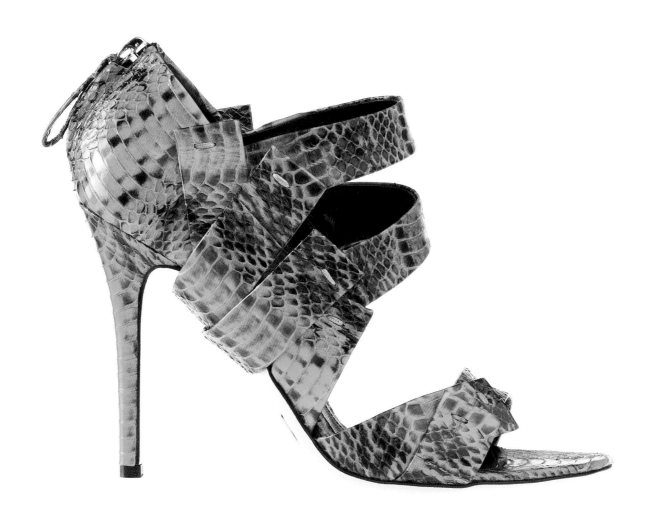

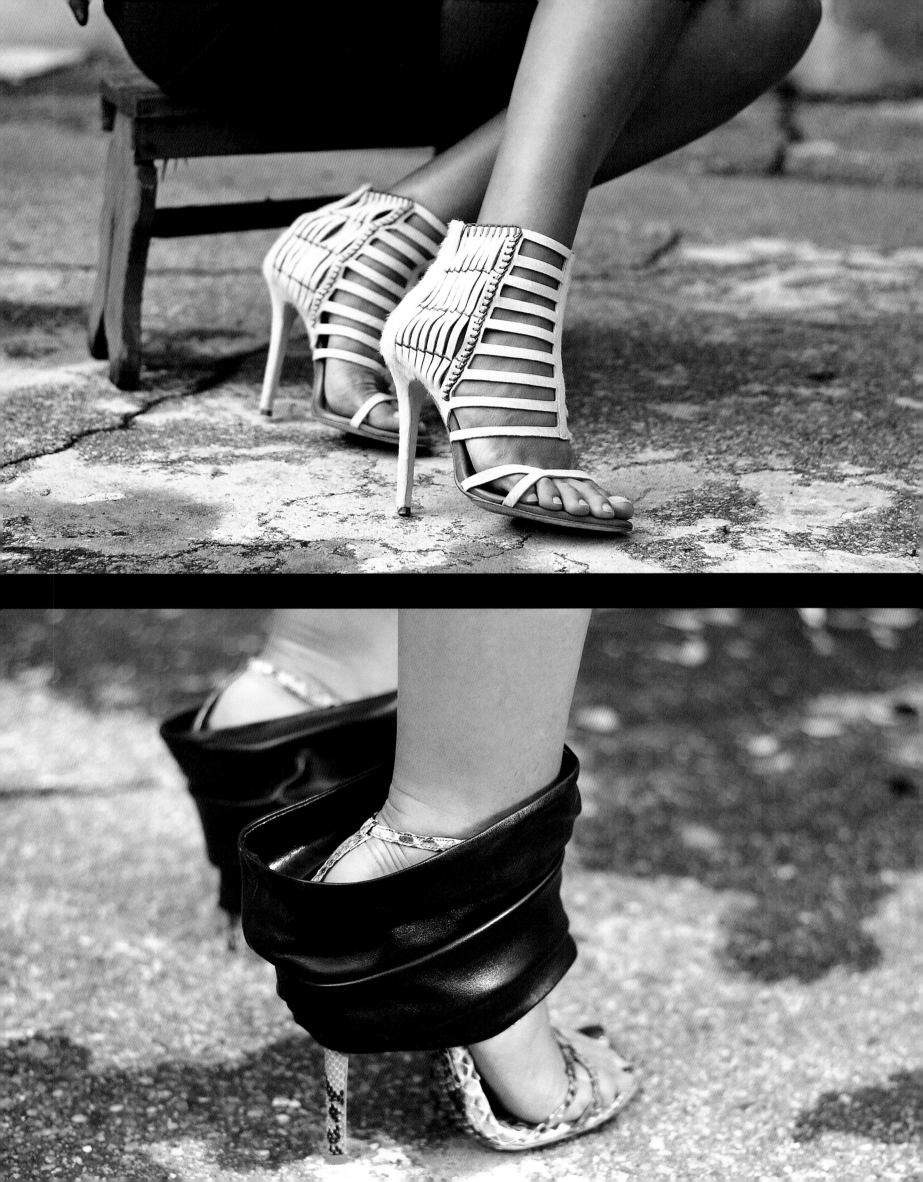

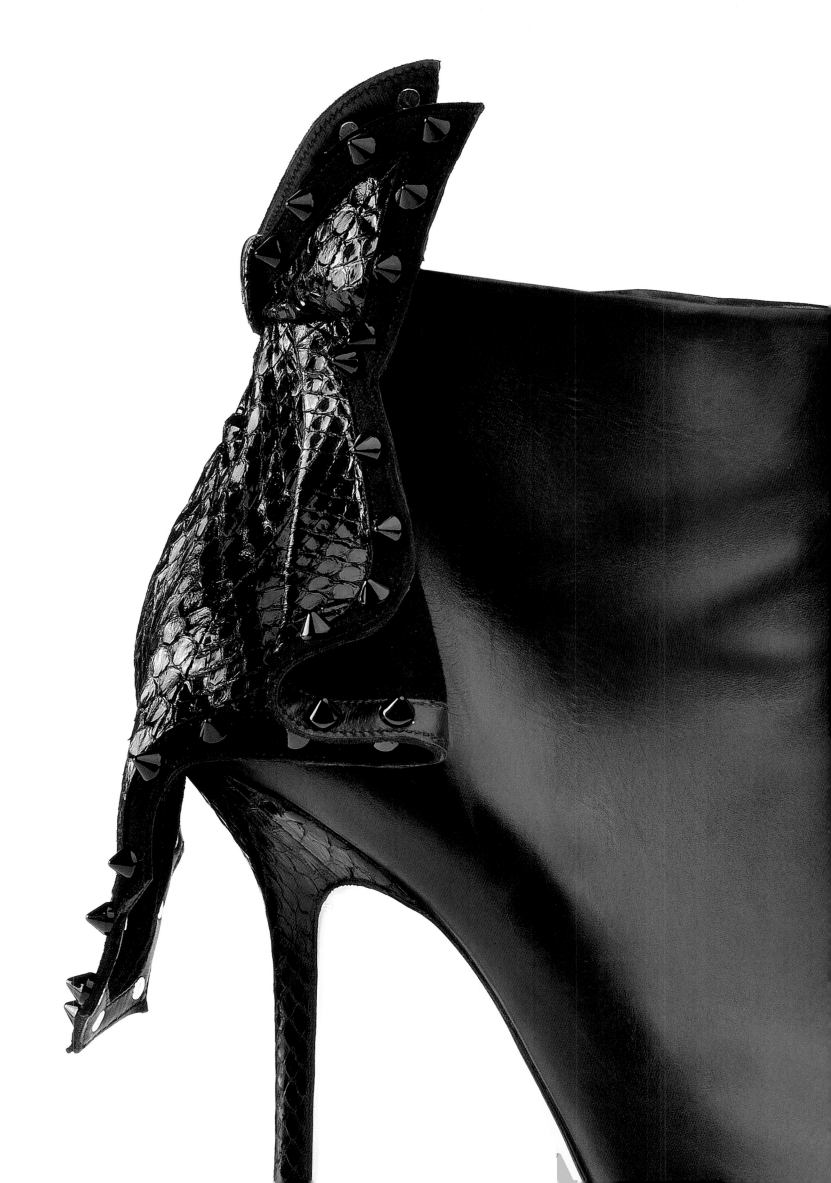

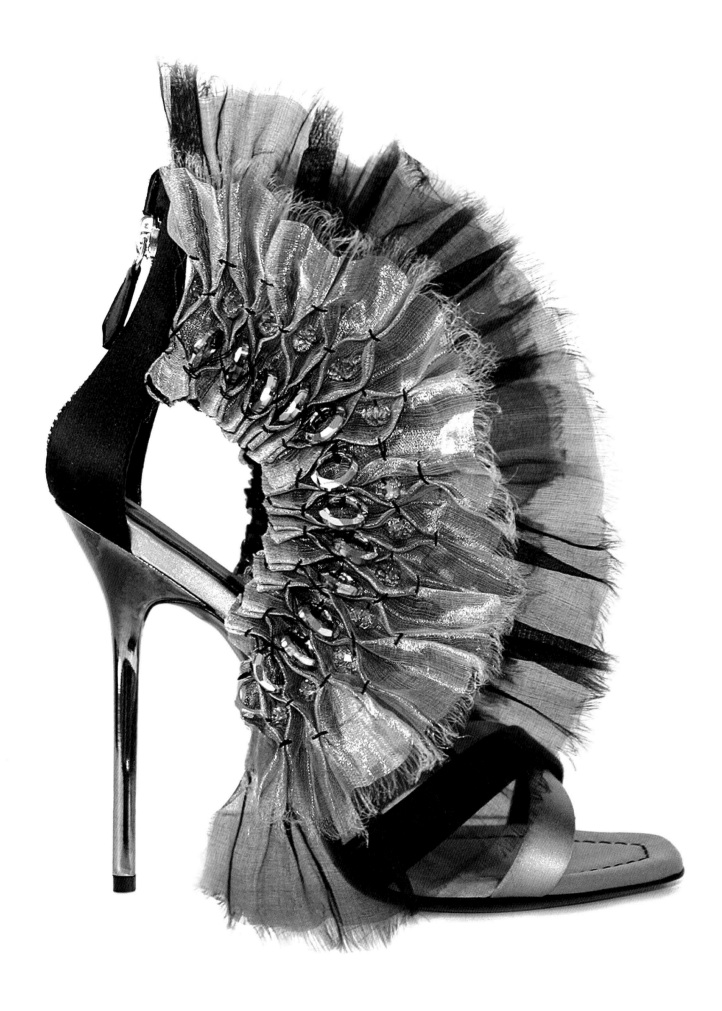

Hailing from Naples, Italy, Diego Dolcini views himself as a citizen of the world. He began his design career through a series of successful collaborations with major fashion brands after receiving a master's degree in fashion design from the Domus Academy in Milan. From designing accessories for Emilio Pucci and Bulgari fashion shows to working as a creative director for men's and women's shoes at Gucci, Dolcini's myriad accomplishments have been noted and awarded on an international level. The Diego Dolcini brand was founded in Italy in 1994 and made its debut in Paris. For Dolcini, his shoes represent dreams and emotions and are inspired by art, architecture, and cinema. He often crafts special, limited-edition shoes that are only available in the world's most exclusive boutiques. Dolcini's products are always created with a refined woman in mind, one who is able to wear them with the confidence and elegance they deserve.

# DIEGO DOLCINI

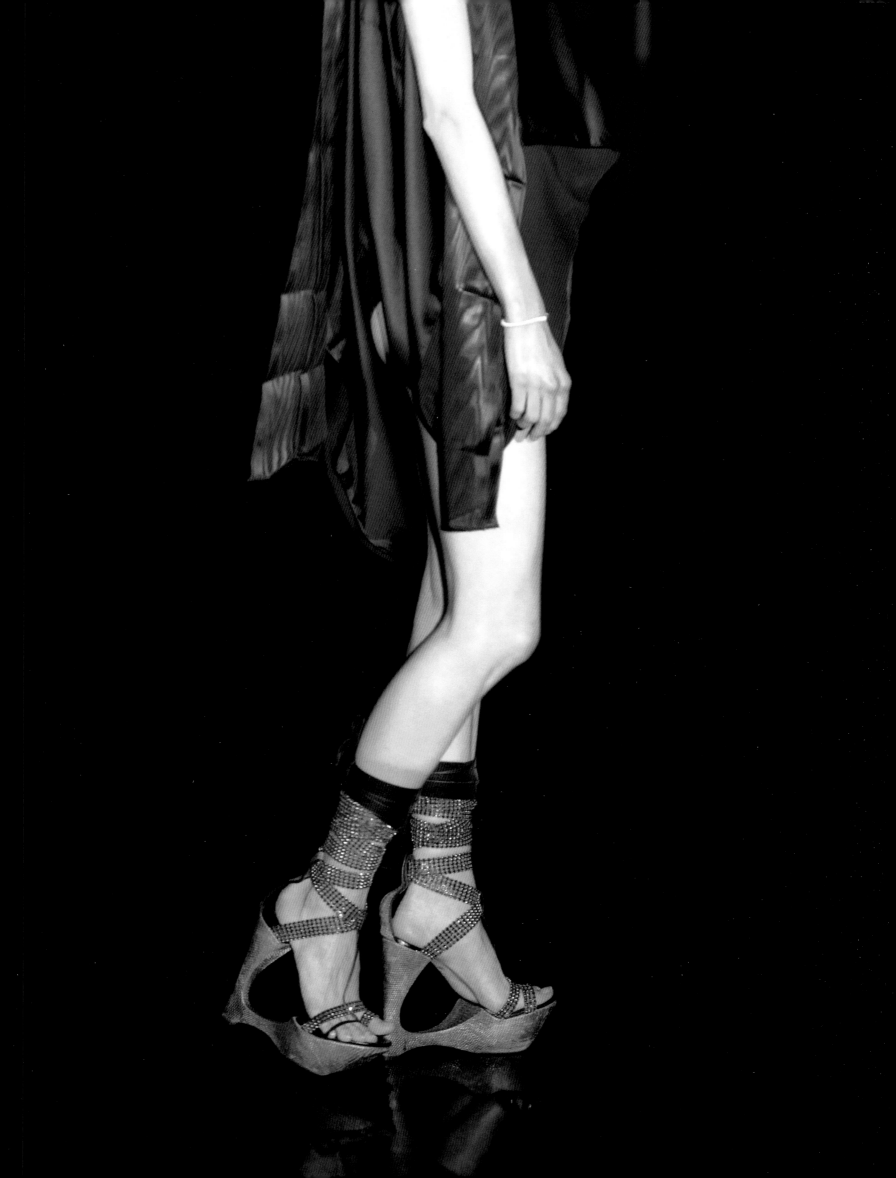

*"I HAVE ALWAYS BEEN CHARMED BY DECORATING [FEET]. IN MY OPINION, SHOES HAVE AN IDEOLOGICAL SATISFACTION MORE THAN A PROFESSIONAL ONE."* Such are the words that sum up the philosophy of Diego Dolcini, a shoe designer known as much within the fashion community as he is out, having designed for some of the most luxurious brands around the world.

"To mix and measure the beauty of the world in an ergonomic shape of a shoe." That is how Dolcini sees his job and daily challenge. With his own label, the designer gets to put forth that beauty, step by step. He is best known for his sandals, which are newly revised every season, much to his customers' delight. Like any good designer, however, Dolcini never rests on his laurels. "My inspiration does not change between the past and the future," he says. "But what I am sure to change is my personal vision of things."

His spring/summer 2012 collection truly typifies his vision: filled with asymmetric geometries defined by sharp and pointy cuts, the footwear was softened with warm and intense hues, giving each shoe a bold but feminine style. The platforms named *Gehry* and *Ando* pay homage to the legendary contemporary architects Frank Gehry and Tadao Ando and their architectural techniques that inspired the entire collection. The special processes Dolcini used for the evocative pavé effect of Swarovski crystals, plated calf, metallic napa leathers, and hand-painted python express an elegant and unusual brand of luxury. A universe of precious stones inspired the shoes' color palette with its dark and metallic nuances brightened by light vibrant shades; this is classic Dolcini, where meticulous attention in the choice of the materials, paired with impeccable leather craftsmanship, make every single piece unique.

Dolcini's work is informed by the beautiful things surrounding him: art, movies, fashion, and the people he has met. "My creativity could come from a good movie that enchanted me or a breathtaking sculpture. The influence of my creations springs from many and various fronts. Technically, I've learned so much from the different professional relationships I have had, and every new creative challenge has given me the opportunity to give, but at the same time to receive, and accumulate the know-how I needed."

Designing is all he's ever known. Dolcini says that since he was a child, he has been attracted to shoes. "I have always thought shoes were the best expression of femininity, sensuality, and elegance. The idea to forge such a strong symbol was exciting for me and I have always been trying to consider it a real and true design object."

In his creations, Dolcini attempts the perfect combination between creative madness and a technical study of the foot. "I always try to conceptualize shoes that are little dreams but perfectly wearable." It is no surprise that he studied architecture at the Politecnico di Milano as well as at the Accademia di Belle Arti di Bologna. His talent earned him a scholarship toward a master's in fashion design at the Domus Academy in Milan. Upon graduation, Dolcini started on what he calls "intense and lucky" collaborations with some of the most important fashion brands, such as Gucci (with Tom Ford), Trussardi, Emilio Pucci, and Casadei.

"This is what I would like to do: to be able, season by season, to interpret my clients' tastes, creating little dreams to wear—objects that could survive the always temporary fashion trends and remain constant." The designer believes that having style means to be able to make one's choices outside of the fashion dictate and to have the ability to choose an item that enhances one's silhouette, regardless of the season. "To quote Coco Chanel, 'Fashion fades, only style remains the same.'"

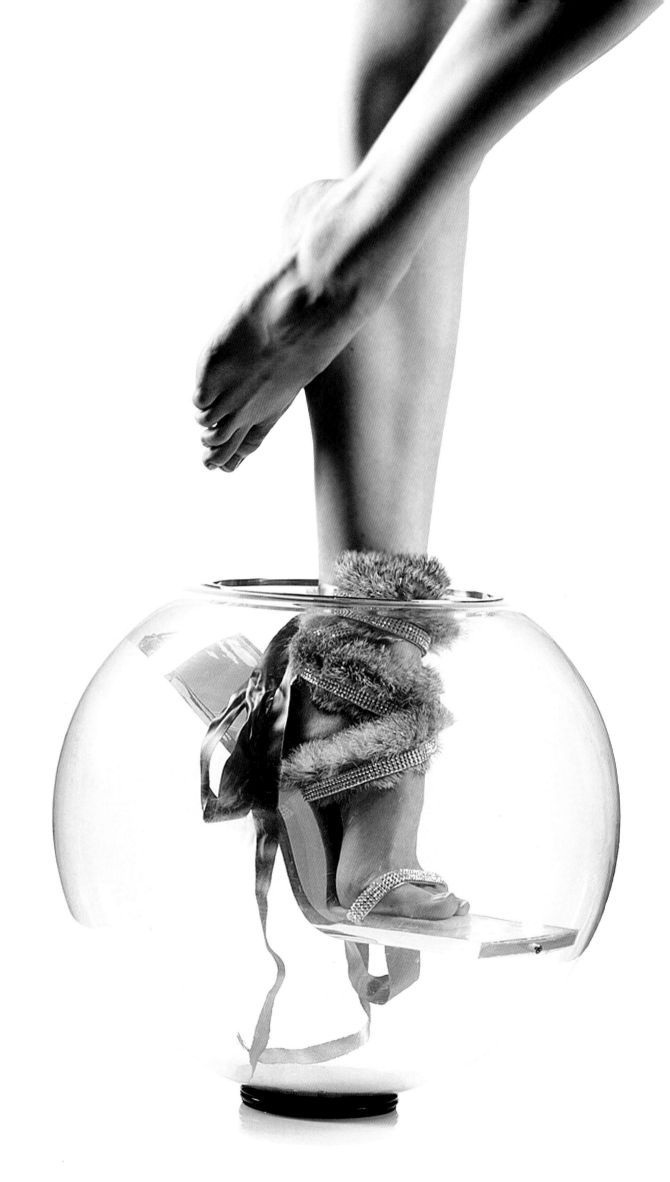

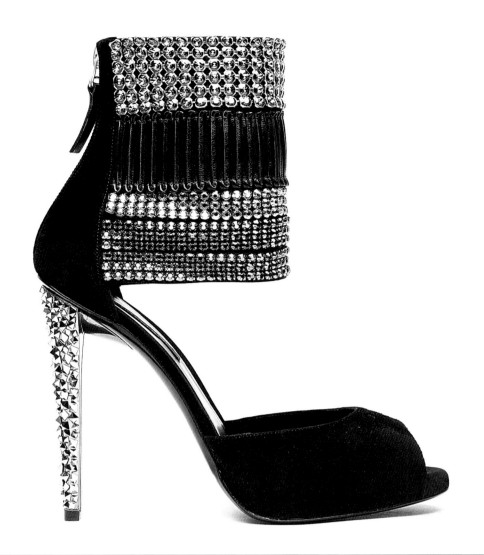

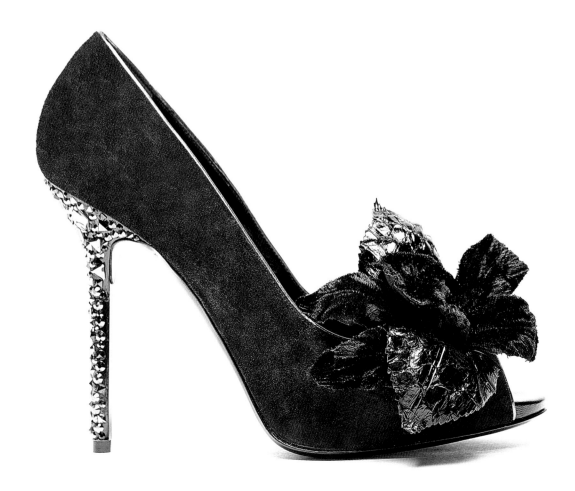

 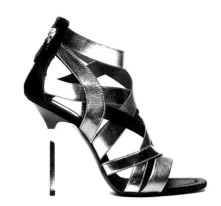 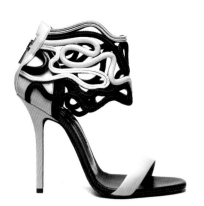

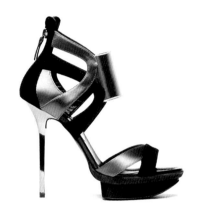 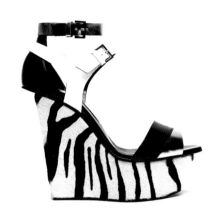 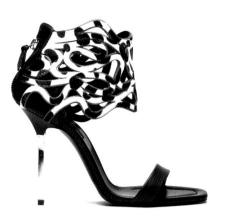

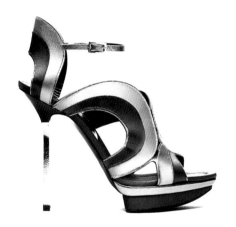 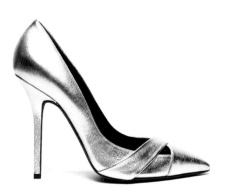 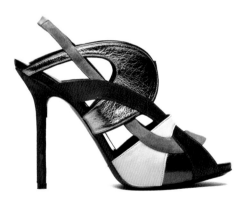

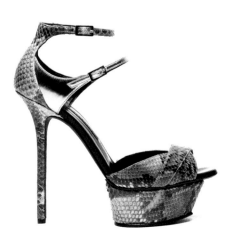 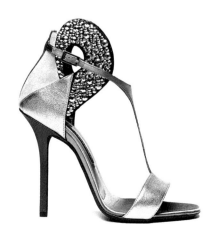 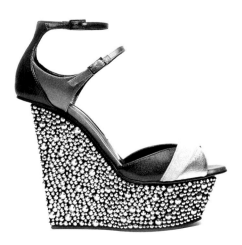

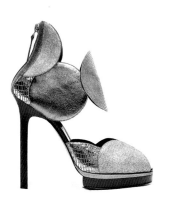 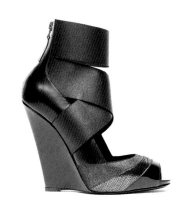 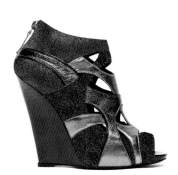

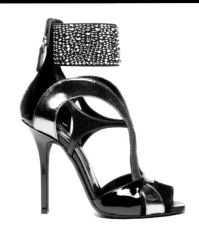 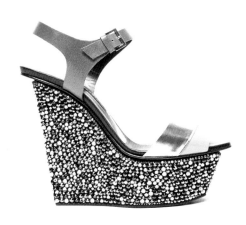 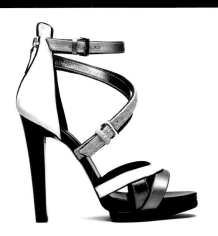

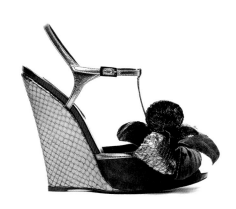 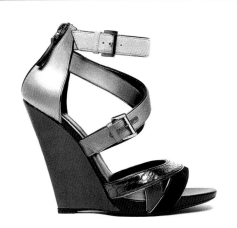 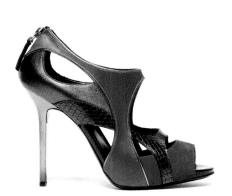

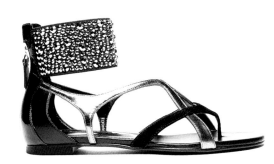 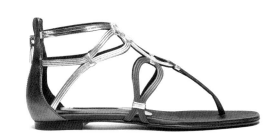 

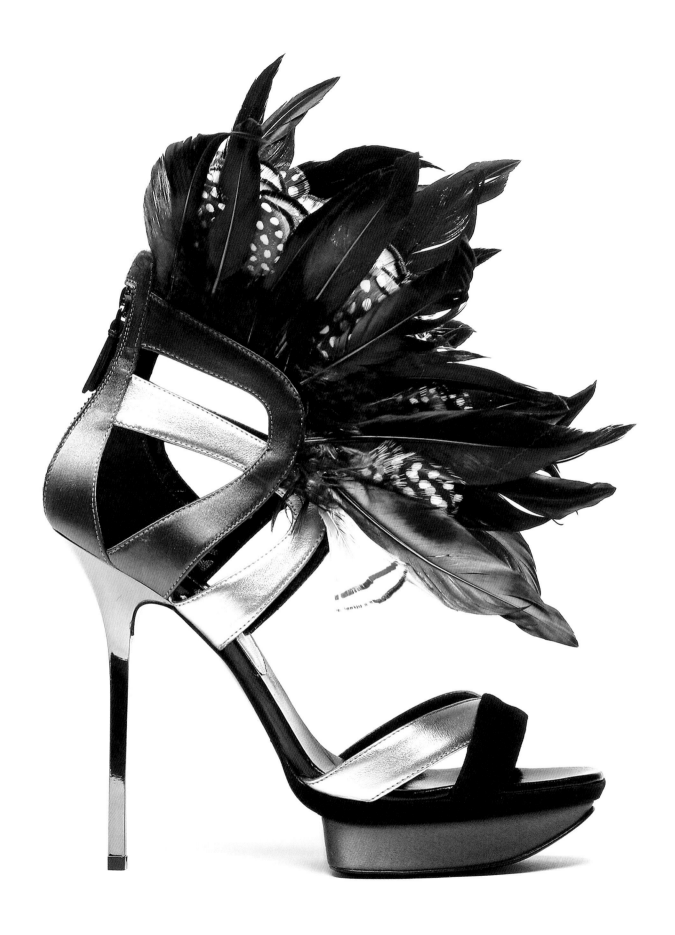

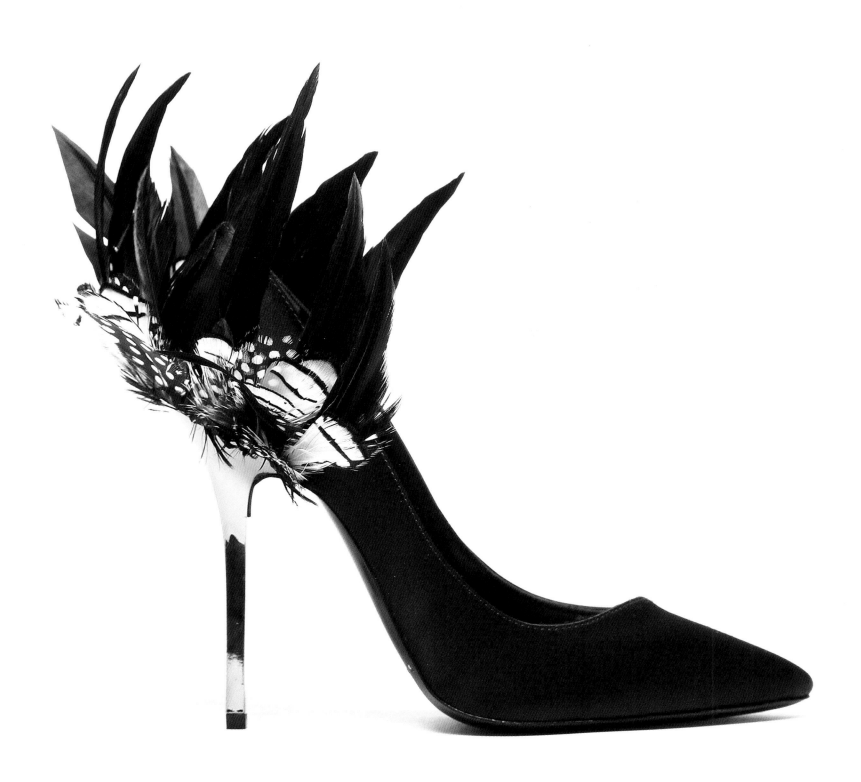

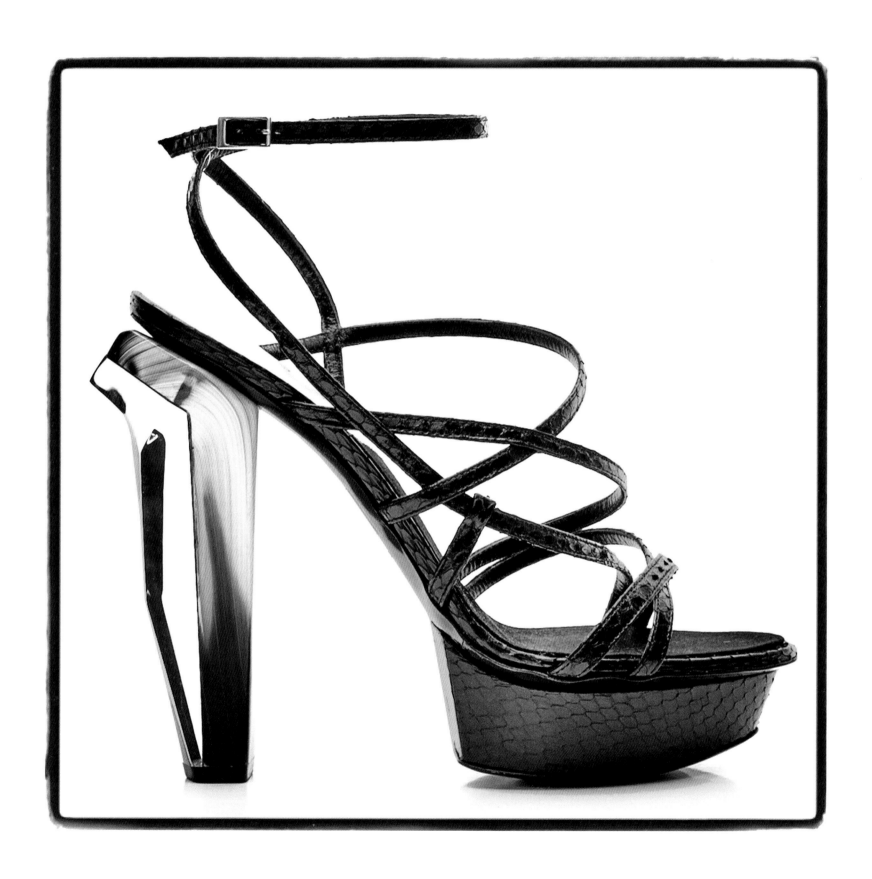

Identical twin brothers Dean and Dan Caten grew up in a suburb of Toronto, Canada. As the youngest of nine children, they were fascinated by fashion and started designing outfits for their sisters at a young age. In 1983, they moved to New York to attend Parsons The New School for Design and relocated to Italy in 1991. After several collaborations with some of the most revered fashion houses, they had their inaugural men's collection show in 1994. The duo's philosophy is a mélange of Canadian wit with Italian refinement and attention to detail, encompassing an unparalleled notion of alternative luxury. In the past few years, Dsquared²'s various collections have reached out to a wider range of people and have become more sophisticated while still maintaining their unique brand of sexiness and provocation. This evolution is partially due to the brother's never-ending sources of international inspiration, as Dean and Dan divide their lives and work between Milan and London, while creating their collections in Italy.

# DSQUARED²

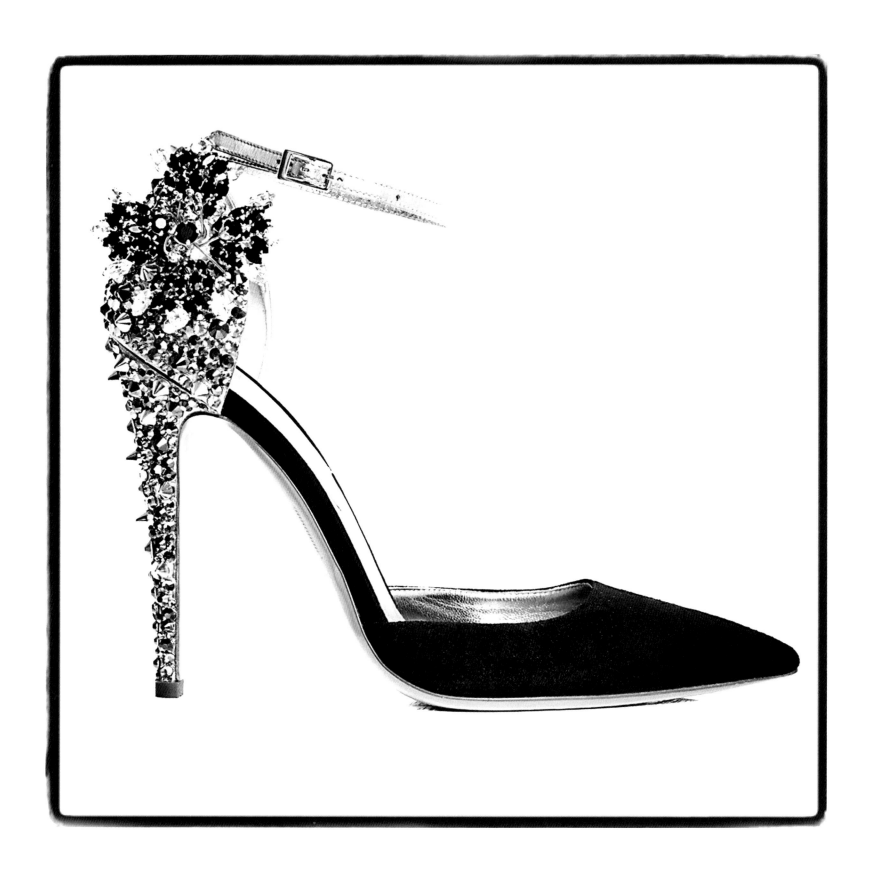

*THINK ROCK AND ROLL, PUMPED UP AMERICANA, AND YOUTH CULTURE ON FIRE, AND YOU'VE LANDED AT THE AESTHETIC THAT IS DEAN AND DAN CATEN, THE TWIN BROTHERS AT THE HEART OF DSQUARED²*. Dean and Dan embody a bravado that's fully expressed through their quirky yet spot-on style. London is currently their home and Italy their workplace, where their shoes are produced. As modern-day gypsies, the world is their primary influence and one of their mottos is "born in Canada, living in London, made in Italy."

Dean and Dan's lives mainly propel their creative spirit forward—the way they live now as well as what they have yet to. To illustrate this, their shoe and clothing collections are filled with wardrobe foundations, such as denim, gingham, plaid, oxfords, shorts, capris, T-shirts, V-necks, sweatshirts, boyfriend sweaters, and, of course, shoes. Each piece of footwear is unmistakably Dsquared² and recalls the 1950s and 1960s, when sharp dressing was in and excess was out—when women carried a proper pocketbook, sported cat-eye sunglasses, and weren't afraid to light up (their models occasionally carry a cigarette down the runway). "In the past, we've been inspired by truckers, diners, English aristocracy, decadence, early settlers, and European summer music festivals," Dean and Dan say. Clearly, these two are not conformists. The most avant-garde shoe they've designed comes from the fall/winter 2012 *Pioneer* collection: "The girls glided down the runway in eleven centimeter [4.3 inches] high-heeled ice skates."

Both Dean and Dan have wanted to be in fashion since the early days of their youth. "From as far back as we can remember, we loved and lived fashion," the brothers recall, knowing that their obvious bent for all things style rubbed some of their more macho classmates the wrong way. Random schoolyard snowball attacks would sometimes result or just plain bullying—all because the two didn't fit in with their hometown's teenage society. "All in the name of something we love called fashion." Did they ever want to be anything else? "Yes. Girls. The prom queens we never were. Or dancers on the *Cher* show," they joke.

Before their fame hit its height, though, Dean and Dan were as mortal as everyone else, even bussing tables and washing dishes to pay the rent. They credit Luke Tanabe, the founder of Ports (a Canadian fashion company), as their mentor and the one who, as they put it, "gave two nineteen-year-old twins from Willowdale, Ontario, an opportunity to prove themselves." Although the first comment made about Dsquared²'s style might be "cool!" Dean and Dan are almost anti-cool. "Cool is so overrated; it goes hand-in-hand with fitting in."

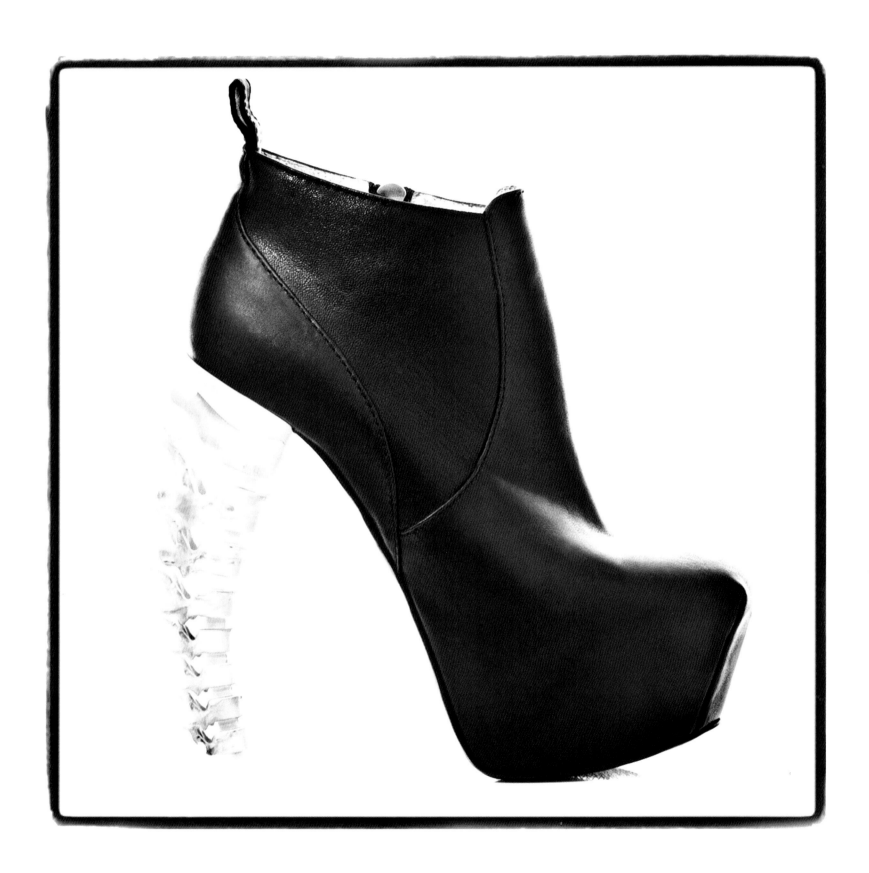

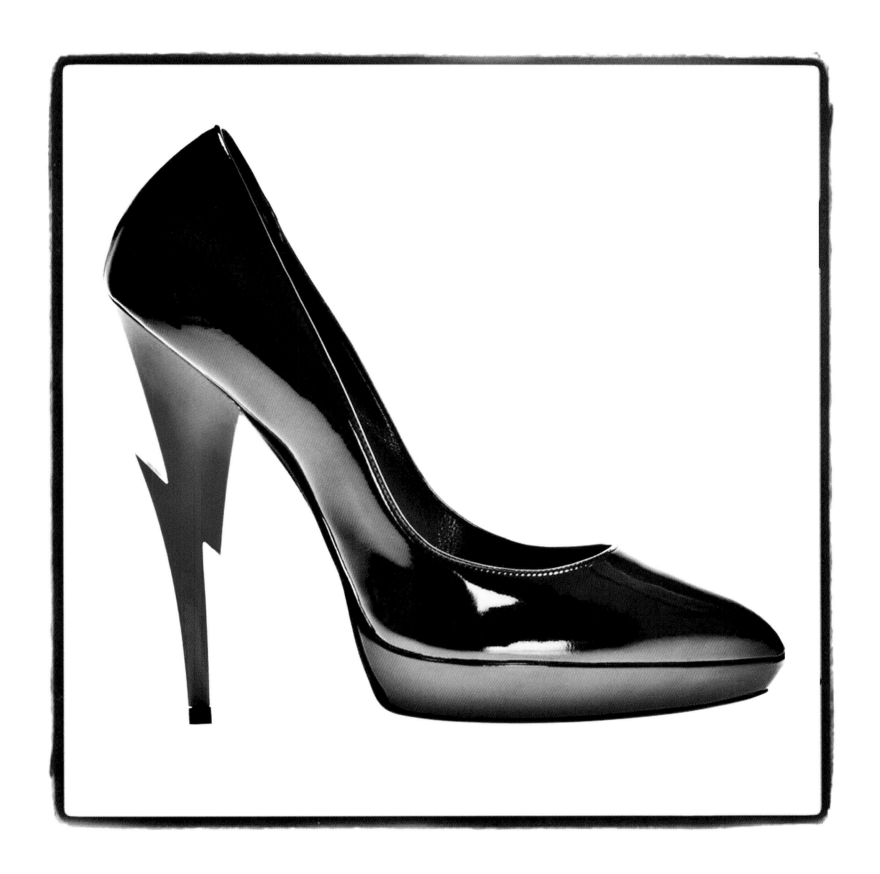

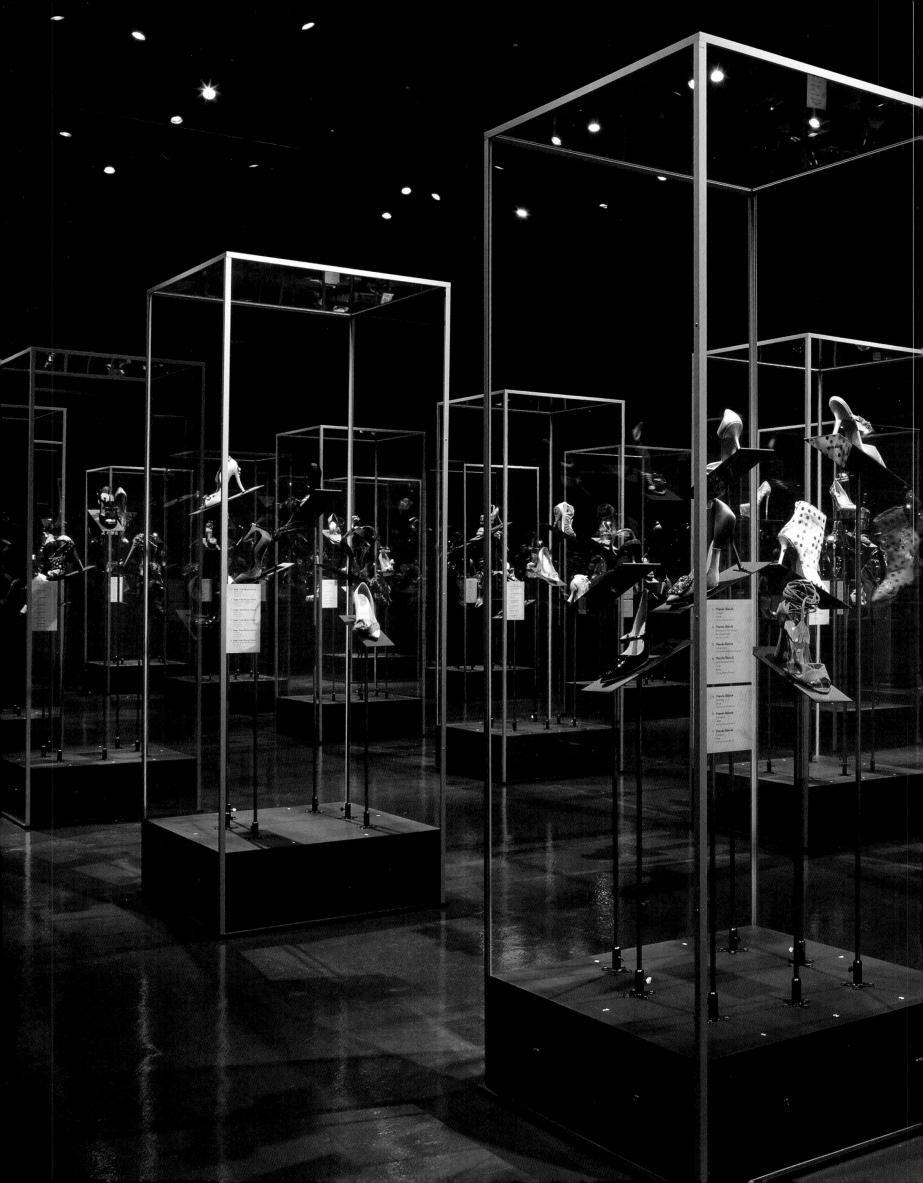

Valerie Steele, the director and chief curator of The Museum at the Fashion Institute of Technology, graduated with a Ph.D. in modern European cultural and intellectual history from Yale in 1983. Carving out her own niche in the highly academic liberal arts department of the Ivy League institution, Steele pursed the study of fashion apropos its historical and current relevance. Since receiving her doctorate, she has gone on to pen anumber of books, including *Shoes: A Lexicon of Style* (Rizzoli, 1999) and *Fetish: Fashion, Sex, and Power* (Oxford University Press, 1996). Her breadth of knowledge, profound insight, and illuminating explorations of these subjects render her an expert on fashions of the foot, and the only true choice to introduce an expansive tome on the subject, such as the one you now hold. In addition, Steele co-curated the spring 2013 exhibition at The Museum at FIT called *Shoe Obsession,* where the ever-escalating (pun intended) attraction was examined in-depth with gorgeous creations from the world's top designers, historical artifacts, and commentary by celebrities and collectors who have been bitten by this intoxicating bug. Here, she discusses just what makes this diminutive object such an important piece of culture, commerce, and the human psyche.

# *THE SHOE OBSESSION:* DR. VALERIE STEELE

**Q:** *WHAT DOES FASHION MEAN TO YOU AND THE GENERAL PUBLIC?*

**VS:** Fashion is really about the construction of your body's identity, so it is not just high fashion for women, it's men's fashion, street fashion, cosmetics, tattooing—it's any way you are constructing your exterior identity.

*DO YOU VIEW SHOES AS AN EXTENSION OF THE BODY?*

I would definitely say that shoes are the most significant accessory. The whole shoe/foot relationship is extremely important in fashion and sexual fetishism. The shoe is an unusual item of clothing inasmuch as it has its own identity, even apart from the body. When I wrote *Shoes: A Lexicon of Style,* I was amazed at how many women I spoke with who said they bought shoes without barely trying them on. They said the shoes screamed, "Buy me, buy me!" Even though they didn't even know if they could walk in them, they were just happy to look at them, as if they were little sculptures. The Museum at FIT's spring 2013 shoe exhibition, *Shoe Obsession,* explored the past ten years of the craft of shoemaking and the shoe's growing relevance in the world of fashion. With shoes, you get more bang for your buck because they can transform everything, from dressing up a look to affecting your posture or mood.

*WHAT ABOUT SHOES AS AN ART FORM?*

Artists play with shoes, and a good example of this would be Camille Norment's glass slippers, crafted out of shards of glass—I saw them and just had to buy them! Men see them and think, "Oh, Cinderella!" and women think, "Pain!" If you've ever seen the movie *Qui êtes-vous, Polly Maggoo?* [directed] by William Klein, there's a scene where this sociologist discusses the Cinderella story and concludes with, "So there you are: fetishism, mutilation, pain. Fasion in a nutshell." Shoes are a form of extreme artificiality, particularly with high heels. For fetishists, they lift feet out of banal normalcy and dress them up into a fantasy object.

*DO YOU FEEL THAT SHOE DESIGN HAS LOST TOUCH WITH REALITY?*

Without a doubt, it has become far more fantastical than before. Heels have become so much higher that even fashion models are falling down in them, let alone ordinary people. Have you seen that Ukrainian boy band that dances in high heels? They're fabulous! They even performed in one of Madonna's music videos. It's crazy that they are able to land on such small surfaces in high heels.

*IT SEEMS THAT DESIGNERS ARE USING THE STRUCTURAL CHALLENGES OF SHOES AS A FORM OF ARTISTIC EXPRESSION. WHY DO YOU FEEL THEY ARE PUSHING THE LIMITS NOWADAYS?*

Because people have been willing to follow them; people love shoes. They're really like a dessert—a way you can play with fashion. Today shoe aficionados routinely spend four figures on a pair of shoes, whereas back in the days of *Sex and the City* they cost $500. Today that would be a steal!

*PSYCHOLOGISTS SAY THERE IS A FREUDIAN ELEMENT TO IT, WITH THE FOOT AND THE SHOE FEATURING EROTICISM. DO YOU THINK THAT'S TRUE?*

For men, I think it transforms the woman into a phallic symbol: she's tall, erect, and prominent. I believe that all men have a fetishist side to them, and it's not just about slipping the foot into the shoe, which is an obvious metaphor for intercourse. The part of the brain that is associated with the foot is next to that associated with genitals, so I think there would be a lot of cross-wiring going on there. Whether or not you believe in the phallic symbolism, there are plenty of other things going on, including fantasizing. There was a wonderful psychiatrist named Robert J. Stoller who said, "A fetish is a story masquerading as an object." With the high heel there is nothing in and of itself sexy about the shoe, but it's the story we tell ourselves about it. Just by changing your pair of shoes you can

become this other, sexual person. Women may tell themselves stories, like "I'm sexy," "I'm wearing fuck me shoes," or "I'm dominant." It might be because they are taller wearing heels, or they might feel like a little ballerina wearing Lanvin flats. There's a host of stories we tell ourselves.

*THERE IS A SENSE OF CONFIDENCE INVOLVED IN WEARING SHOES.*

If you have confidence, you are automatically sexier. If you wear certain clothes or shoes, it not only affects how you hold your body, but also how you feel about yourself, and therefore how you're interacting with other people.

*WHAT ADVICE WOULD YOU GIVE TO AN ASPIRING SHOE DESIGNER?*

It's the same I would give to an aspiring fashion designer: it's not enough knowing how to sketch, you have to be able to make it. Just like a fashion designer, you have to really grasp how to make patterns. I think that the more knowledge an aspiring shoe designer can have about the artistry and high technology of making shoes, the better. I visited shoe factories in Italy and what they do is amazing, from the craftsmanship and hand stitching to laser cutting. It makes you realize the difference between cheap shoes and good shoes.

*WHAT DO YOU THINK REALLY MAKES A SHOE BEAUTIFUL?*

I think men's conceptions about what makes a shoe sexy is very traditional, [for example] a shiny patent leather stiletto. I think sexual attraction is at the core of our idea of fashionable beauty, but women are much more promiscuous—they're willing to find beauty in many different shapes. In the future I wonder if women will focus more on sneakers because that's becoming a new trend.

*IT SEEMS THAT DESIGNERS ARE GOING MORE AND MORE INTO THE WORLD OF FETISHISM.*

Oh yes, because the taboos have been broken down. In the past, Helmut Newton used to have to go to fetish stores to get shoes for his photo shoots, but today you can go into any high-end boutique. The shiny look of patent leather is very in as are high, pointed heels. One lady came up to me after a lecture and said, "What kind of shoe can I wear that won't attract some kind of horrible pervert?" I said to her that there is something for everyone, that [some men will even fetishize] a pair of ratty old sneakers.

*DO YOU THINK THERE ARE DIFFERENT ATTRACTIONS IN DIFFERENT CULTURES, SUCH AS THE JAPANESE FETISH FOR THE MANGA CARTOON STYLE?*

There's cultural variation in the shoes people like. I remember one instance when a Brazilian journalist wearing high-heeled sandals came to see an exhibition of mine about shoes at FIT. She zoomed over to this pair of Birkenstocks and screamed, "No Latin woman would wear that!"

*DO YOU THINK MAJOR DESIGNERS LIKE LOUBOUTIN AND BLAHNIK POPULARIZED THE [FETISHIZED] LOOK?*

Blahnik made the classic stiletto pump, it's just that people have ratcheted it up higher and higher and put more and more platforms on it so it can get even higher. Blahnik hates the platform thing; he thinks it's grotesque because it creates huge clumpy feet. Yet a lot of women have been attracted to these big clumpy platforms and that is the playful fashion aspect.

*IS THAT THE MAIN FASCINATION? THE PLAYFULNESS AND THE FANTASY?*

I think it's really the fantasy element, the transformation. While high heels are very sexy, women aren't collecting a closet full of phallic symbols. For women, it's really the playful fashion component. You may not be able to afford a whole look from Prada, but a Prada shoe can have so much impact.

*WHAT DO YOU THINK SHOES WILL BE LIKE IN THE FUTURE?*

If I had second sight about that, I would probably make a lot more money than I do!

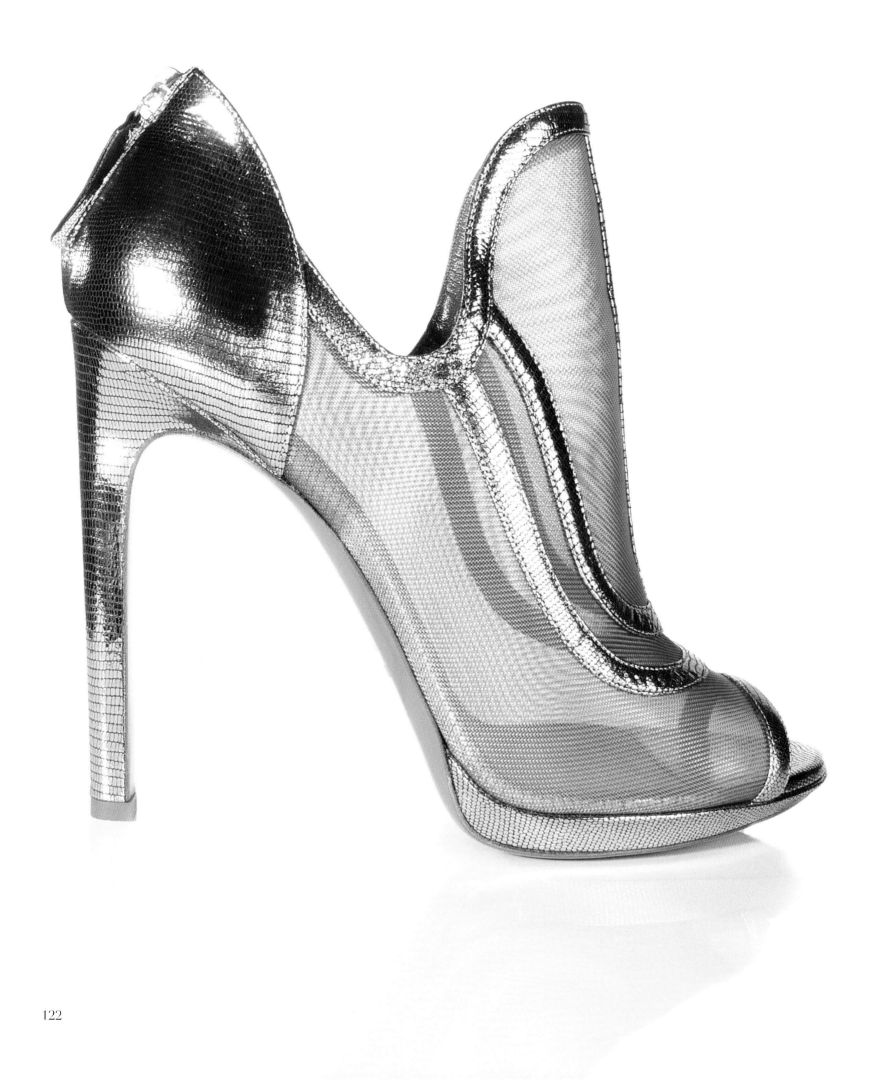

A lifelong appreciation and immense talent for shoe design led Edmundo Castillo to pursue a career in the industry. The designer launched his namesake collection in 1999, after having worked for Donna Karan and Ralph Lauren. Not long thereafter, his designs attracted boldface celebrity clients, including Kate Moss, Cameron Diaz, and Oprah Winfrey, and earned him the CFDA's Perry Ellis Award for Best Emerging Accessories Designer in 2001. In 2004, Castillo was appointed creative director of Sergio Rossi, where he worked for four years and suspended his collection in order to fully invest himself in the renowned Italian brand. Today Castillo draws inspiration for his line from chic, fashion-conscious woman, and he incorporates various hues and fine materials into his elegant designs. While he is able to evolve in the fast-paced fashion industry, he also remains true to his sensual, feminine aesthetic.

# EDMUNDO CASTILLO

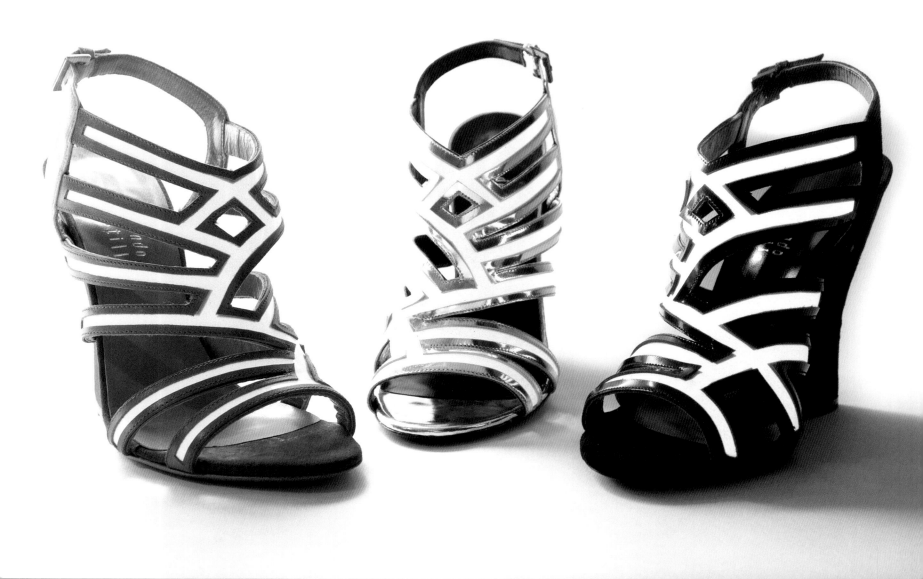

*WINNING A CFDA AWARD WOULD BE AN OBVIOUS HIGHLIGHT IN ANY FASHION DESIGNER'S CAREER.* For Castillo, winning the award for Best Emerging Accessories Designer in 2001 had to be one of his best fashion memories. And for his all-time best memory? "An argument between my sisters one early morning, with one telling the other, 'You are not getting in my car wearing those shoes!' I must have been about five years old."

Memories have a lasting imprint, and what appeared to be a spat between siblings became one of the moments Castillo remembers in his trajectory into footwear design. It started with studying the art form in his native country of the Dominican Republic, followed by a move to New York, where his design dream continued to come true. "In 1989, my dream was to design shoes for Donna Karan and I got hired to do that. It was the start of a great career," he recalls. The success carried on with a move to Ralph Lauren ten years later, and, one year after that, a return to DKNY as director of men's shoe design. A short while after that, Castillo decided to go at it alone with his self-named line.

Timeless, light, and sensual is how Castillo encapsulates his designs, with a large dose of femininity mixed in. It's a formula that has worked for a little over two decades. Castillo has been featured in nearly every magazine that could feature his work—from *Elle, Ocean Drive,* and *O, The Oprah Magazine* to *L'Officiel, Fitness, Condé Nast Traveler,* and *Footwear News.* His shoes are used by the most sought-after stylists in the business and worn by the biggest names in the entertainment industry, such as Beyoncé, Karolina Kurkova, and Kate Hudson, among others. Although some have called him "the Manolo Blahnik of the future," Castillo doesn't like comparing himself to other designers. He does what he does out of a pure love for the craft

and believes that shoes are eternal—as do many of his clients who consider them collectibles, with some of his particular designs reaching into the quadruple digits.

At heart, though, Castillo is a purist. He realizes that his shoes do fall on the luxurious side of the fashion equation but strives to create designs with simplicity of style and little adornment. He admires a simple pump for its sex appeal and ability to elongate the leg, as well as make that all-important transition from day to night. And he is not one to follow trends—in fact he hates them—and only thinks about the next season to keep his productivity sharp. For Castillo, the roadblocks have been few. "So far I've been able to solve every obstacle and move ahead. I've been successful in setting up my goals and pursuing them with confidence and determination. Success doesn't happen that fast anyway."

Castillo knows that art always has a role in commerce. "I look at designing footwear more like an exhibition of art and less like showing fashion. It ultimately takes understanding who your customer is and what she wants from you to be successful." Is he a perfectionist? "I'm not at a maniac level, but I like to see the final result exactly as I imagined it." Determination is one of his strengths, as is imagination—the key to the whole process. "I always loved shoes," he affirms, adding that going into the business was a very personal choice. "I come from a family where there are artists, musicians, and lots of creativity, so it runs in my veins," he reveals. "Shoes are like medicine."

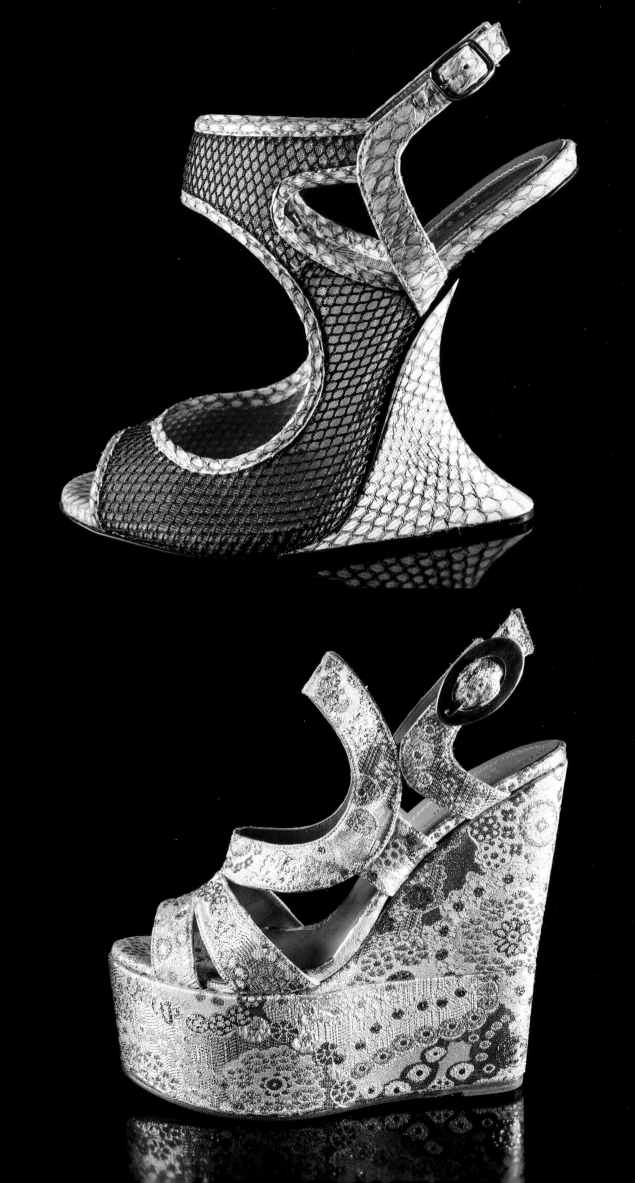

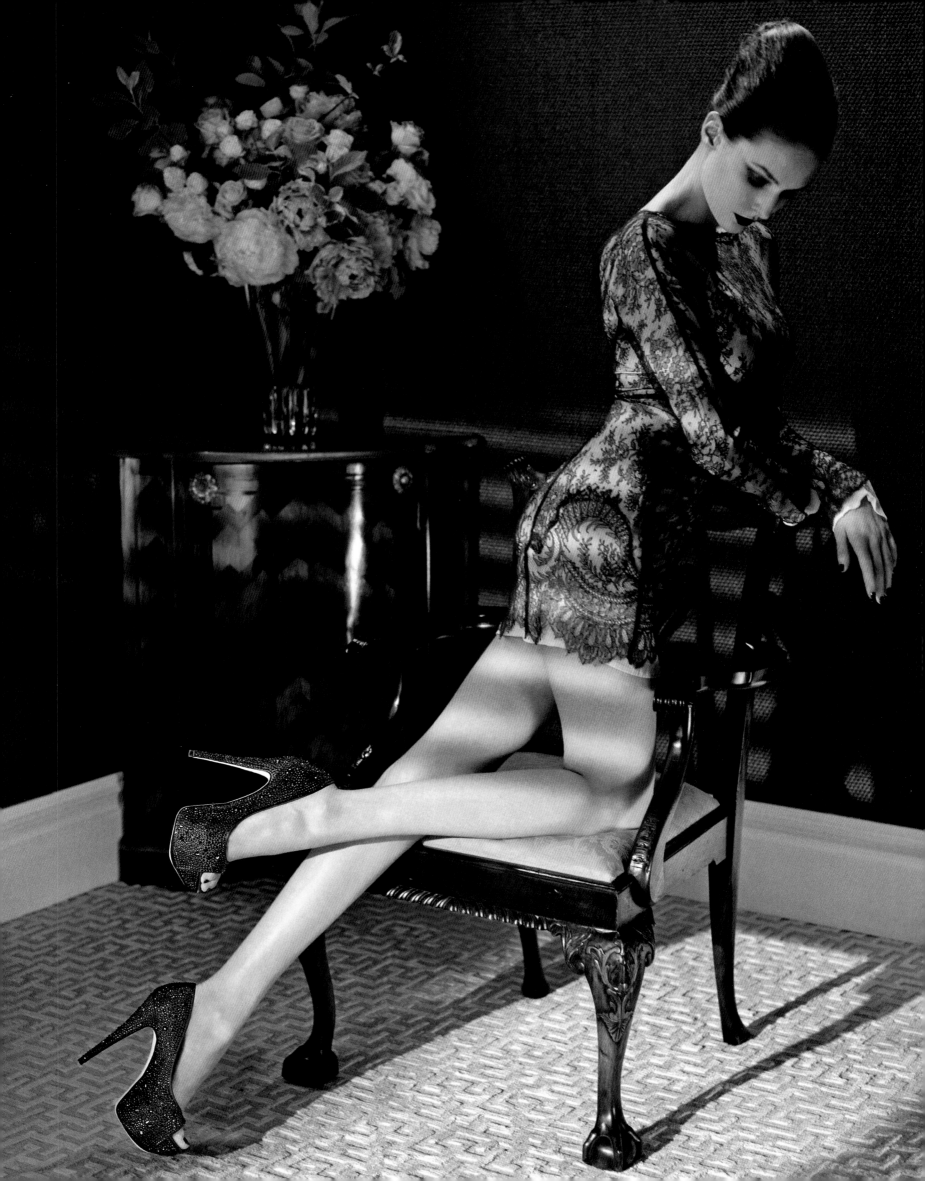

Established in London in 1954 by shoemaker Mehmet Kurdash, GINA was named after his favorite film icon, Gina Lollobrigida. Kurdash's dream was to make glamorous handmade shoes and he vowed to never compromise on quality. Today his three sons are the company's combined talent; they create exquisite heels and interweave their involvement between design, manufacturing, technology, and retail. The first-ever GINA boutique was opened in London in 1991, and a second space was acquired in London's fashionable Knightsbridge district three years later. In 1999, a pair of their luxurious slippers—alligator mules with eighteen-karat white gold buckles and thirty-six princess-cut diamonds—landed a revolutionary spot in *The Guinness Book of Records* as one of the most expensive slippers in the world, priced at £18,000 (around $27,000). GINA's creations have been seen on the feet of celebrities, supermodels, and royal family members such as Madonna, Sophie Rhys-Jones, Angelica Houston, and Jennifer Lopez.

# GINA

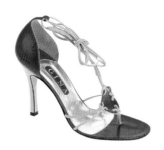
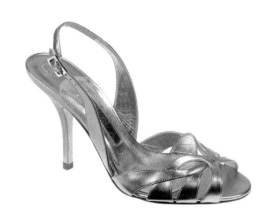
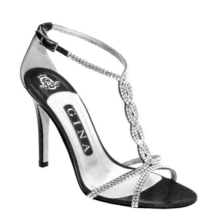
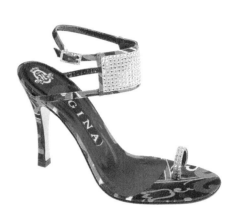
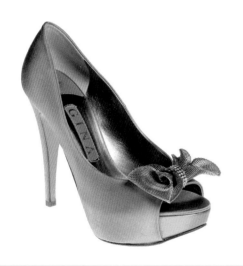
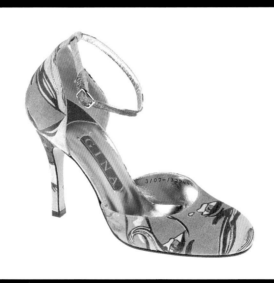
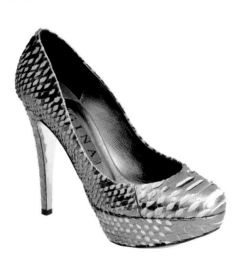
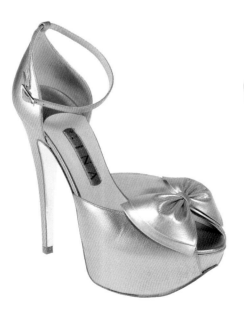
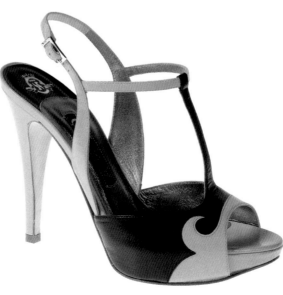
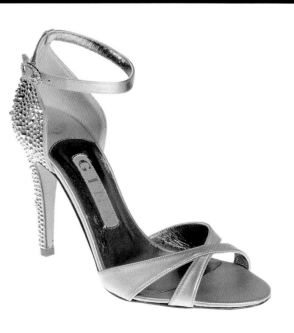

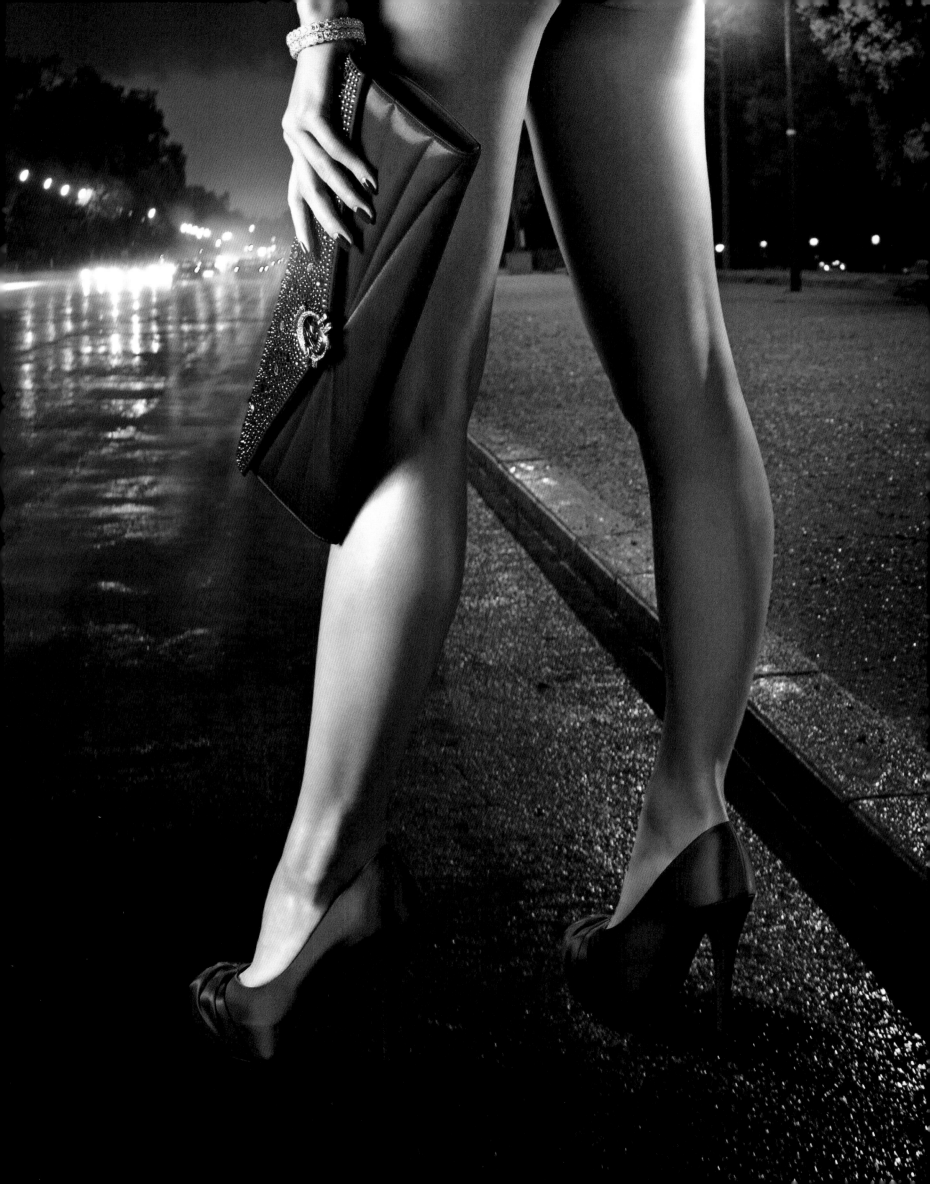

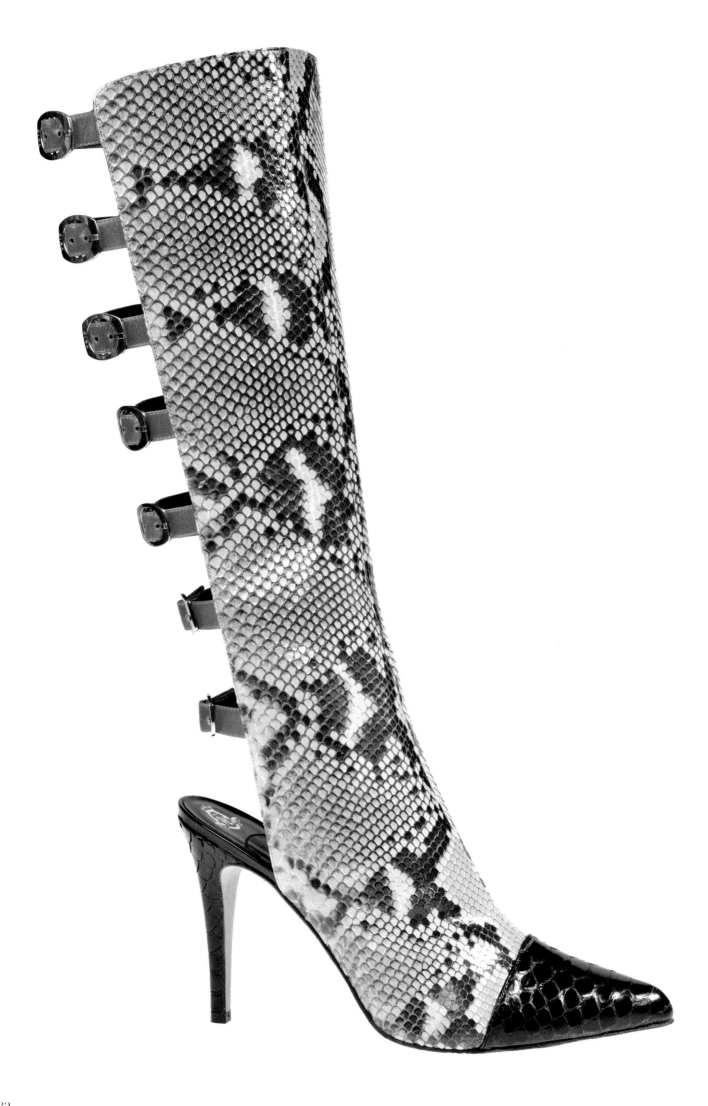

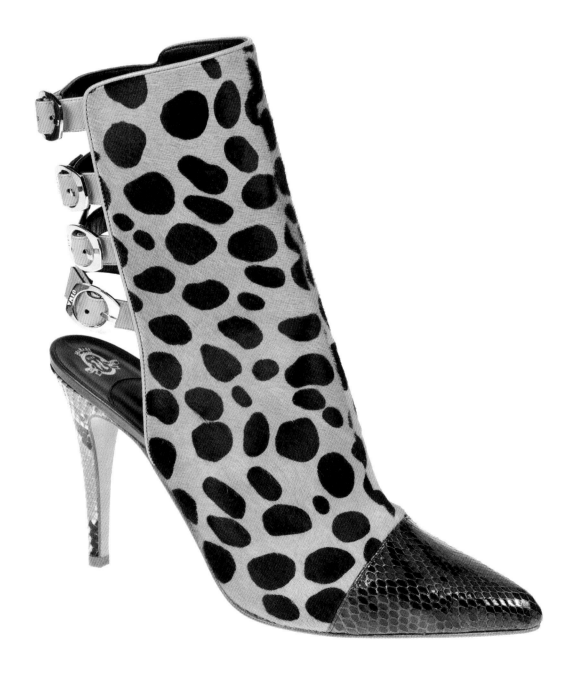

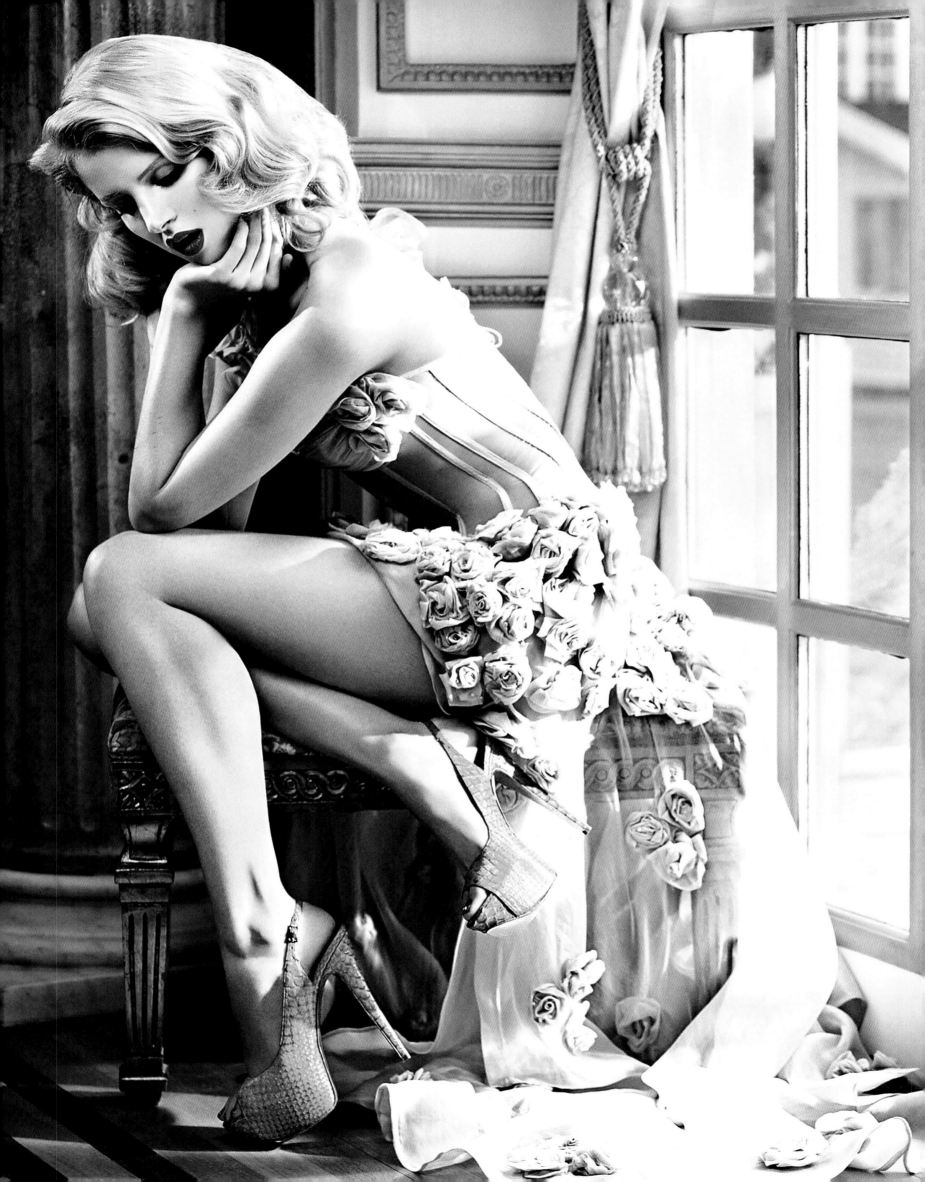

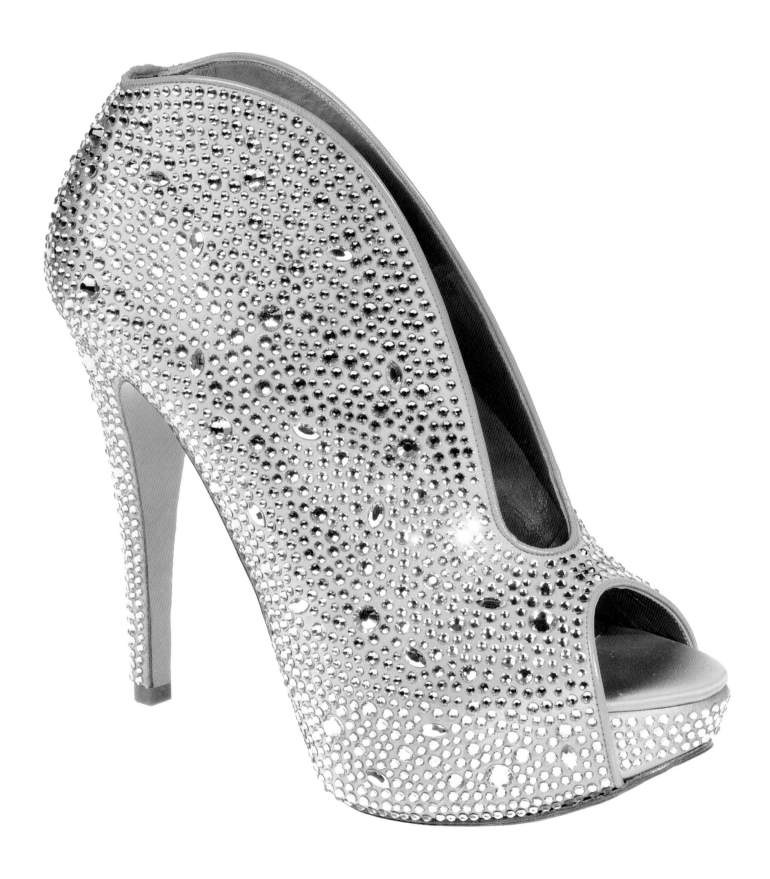

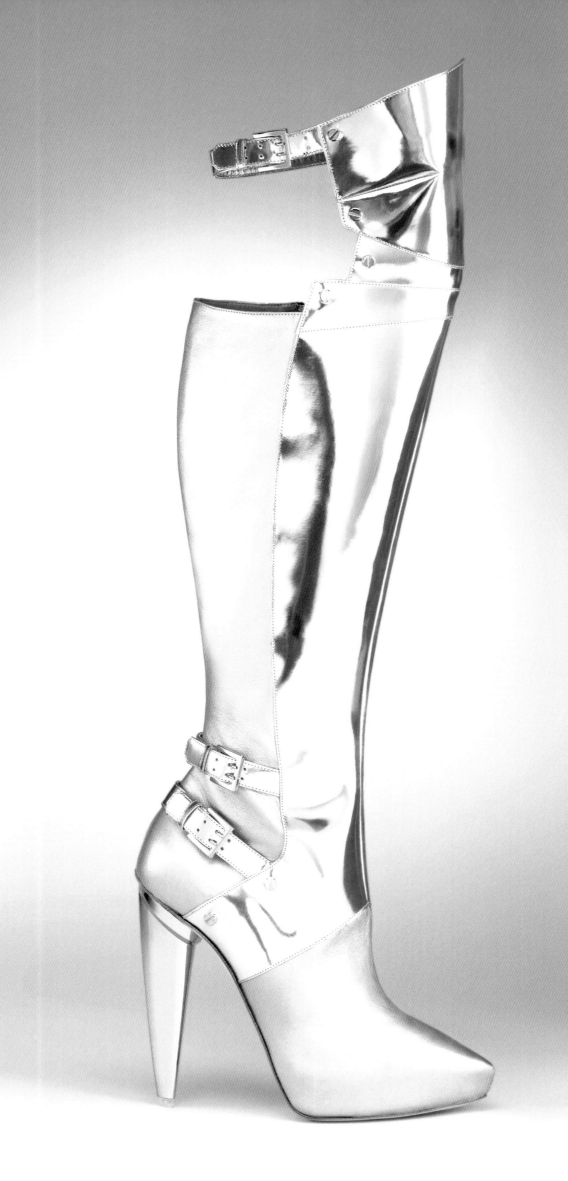

Originally from Bulgaria, Gio Metodiev has been obsessed with shoes since childhood and founded his own shoe line, Gio Diev, in 2010. He credits his aunt as his biggest influence and the first to recognize his design talent. With New York as his present home, Metodiev has not changed the way he works, but instead has been pushed forward by the special energy he has found there. Constantly inspired by curiosity and informed by everything around him, Metodiev is never afraid of looking at something that could potentially lead to an interesting concept. Metodiev's designs are about passion, stories, and the women he loves and admires most. Boots are one of his favorite types of shoes to design, as he usually centers his initial ideas around them before allowing the shoes to transcend into different styles.

# GIO DIEV

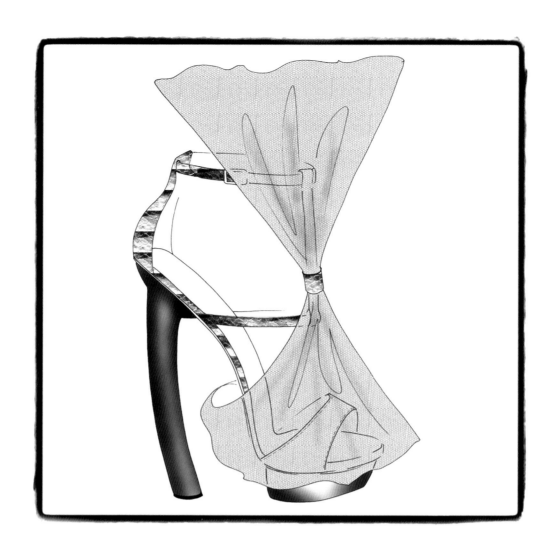

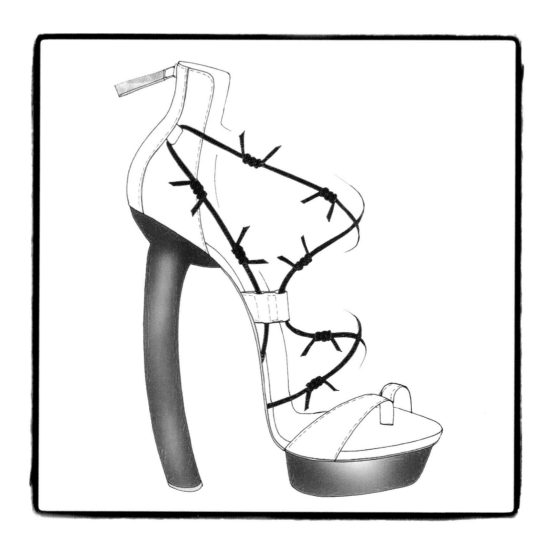

*"FOR ME, CREATIVITY IS LIKE A MUSCLE THAT NEEDS TO BE TRAINED REGULARLY. INSPIRATION IS SOMETHING DIFFERENT."* Footwear designer Gio Metodiev knows that inspiration is not always easy to locate but is rather something to be constantly awash in. "My inspiration comes from my curiosity. I can spend days at a photo library or bookstores leafing through all kinds of books, from tomes on nineteenth-century Victorian costumes to wind farming. It can be anything."

A native of Bulgaria, Metodiev has been obsessed with shoes since he was a child. His biggest influence came from an aunt to whom he was very close. The first to truly see his design talent and to encourage his career, Metodiev credits her with his heading in that direction. "We often joke that I had the fire in me all along, but she had the matchstick to light it." Fashion has been Metodiev's guiding force throughout his entire career, with roles ranging from package design to public relations. That being said, he has found shoe design as his true calling and passion.

Now living in New York, Metodiev has not changed the way he works, but instead has been pushed forward by the special energy he found there. "It has its own beat, which definitely has an impact on my creativity," he shares. "Despite this, I'm a daydreamer by nature, so I like to take mental journeys to the most remote and unexpected places while designing." Spoken like a true creative spirit, the designer's imagination literally takes shape in shoes that have sword-like heels and barbed wire straps. These are not shoes for the timid of style.

The looks for his spring/summer 2012 season were inspired by *Wuthering Heights*, Emily Brontë's 1847 novel marked by dark sexuality, obsession, and powerful imagery. Like the book itself, the collection's overall tone was very much about the macabre and the heavier aspects of existence: night visions and shapes of the moon, ravens, windswept scenes, custom-made leaves, and a multitude of crosses abound. To capture light in an interesting manner, Metodiev used ostrich-stamped velvet as well as rose gold as a dominant metallic color in a few styles.

The designer also has a soft spot for designing boots—the taller and more intricate, the better. "When I start designing a new collection, the initial ideas are usually centered around boots and then they transcend into other styles," he admits. Metodiev's favorite creation is the *Waterloo* silver boot from his fall 2011 collection. He wanted to fashion it mirrored with silver leather, but his factory dissuaded him from doing so since the material is very fragile and almost impossible to use on such large areas. After repeated tests, however, the right result was achieved and the boot was produced. All the effort was worth it.

As for the direction style is going, Metodiev feels that present fashion giants and the Internet have changed the way women dress around the world. "Fashion has become so much more globalized and, as a result, many cultures in the world have had their own fashion identities diminished. I'm always inspired and attracted to strong, witty, and confident women regardless of where they are from, and love taking in how they all dress to inform what I do."

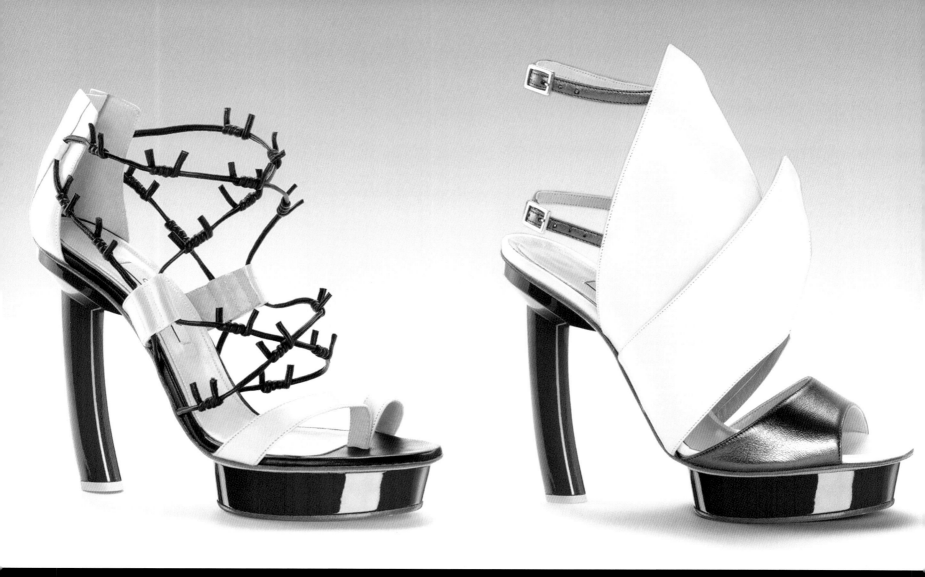

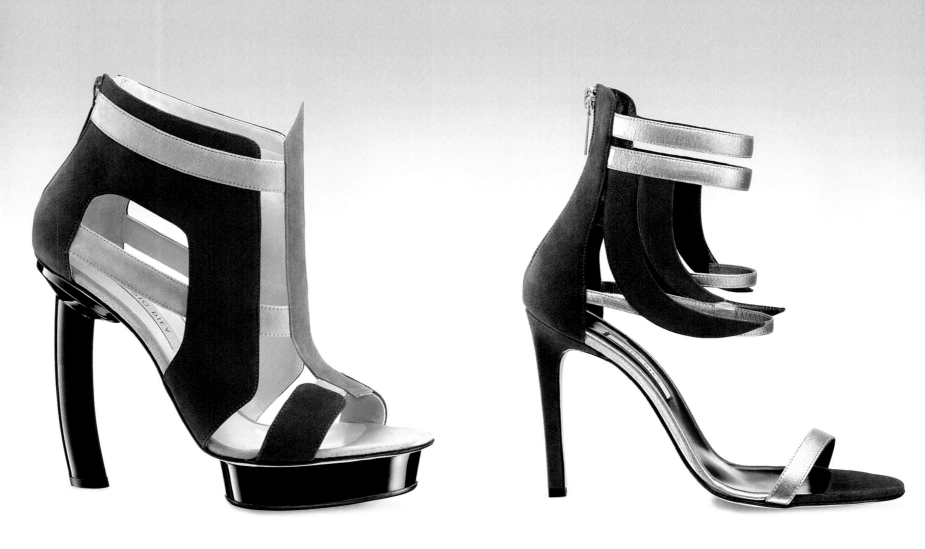

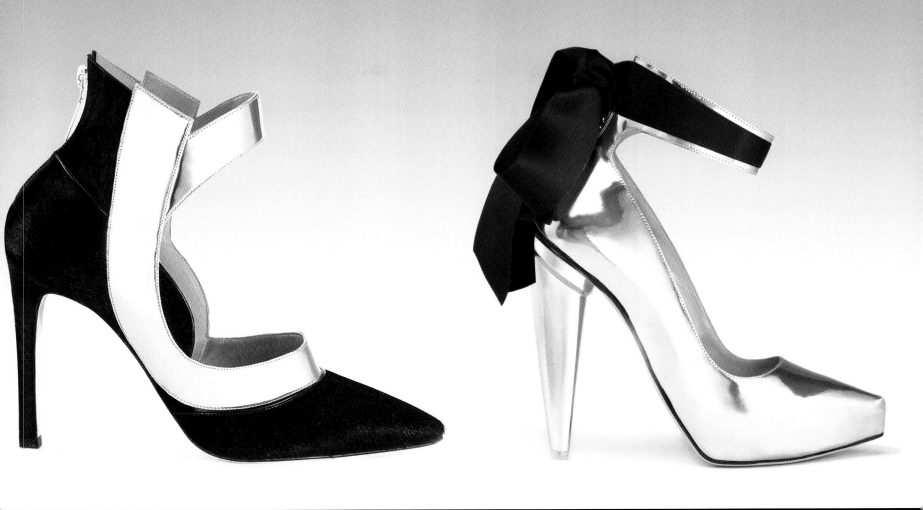

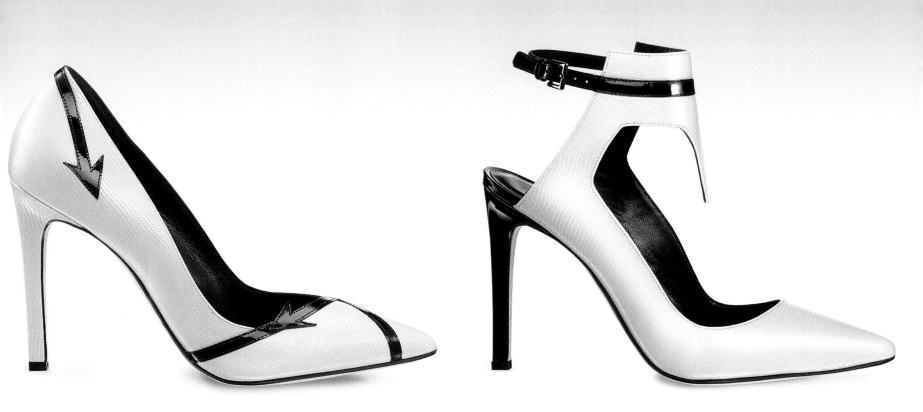

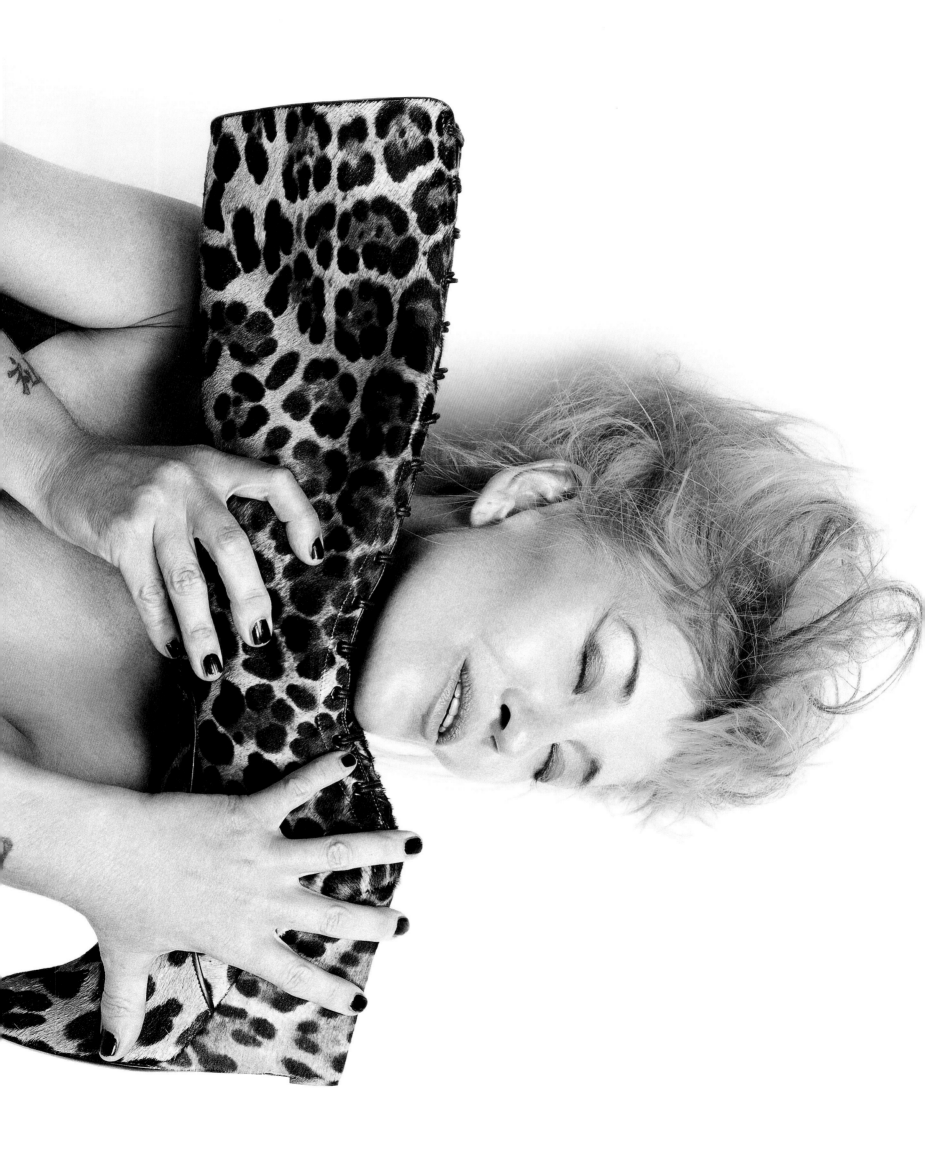

Born in Quebec, Jerome C. Rousseau's interest for design was informed by art and music. His first major influence was a Deee-Lite music video in which the overstated retro shoes caught his eye. Rousseau's design skills were accumulated over ten years in London and Los Angeles, and his inspirations range from modern art to nightlife and European design. In addition to his strong technical knowledge in footwear design from Cordwainers College, Rousseau has also worked with the fashion and accessories designers Isabella Fiore, Matthew Williamson, and John Richmond. Rousseau's collections are designed in Los Angeles and manufactured in Italy. His shoes have been featured in *Vogue, Elle, Harper's Bazaar*, and on Style.com, and celebrities such as Scarlett Johansson, Katie Holmes, and Olivia Wilde, among others, have worn his designs. Rousseau is a strong believer that every shoe has a customer somewhere, and that if a shoe makes someone happy, then it should be there.

# *JEROME C.* ROUSSEAU

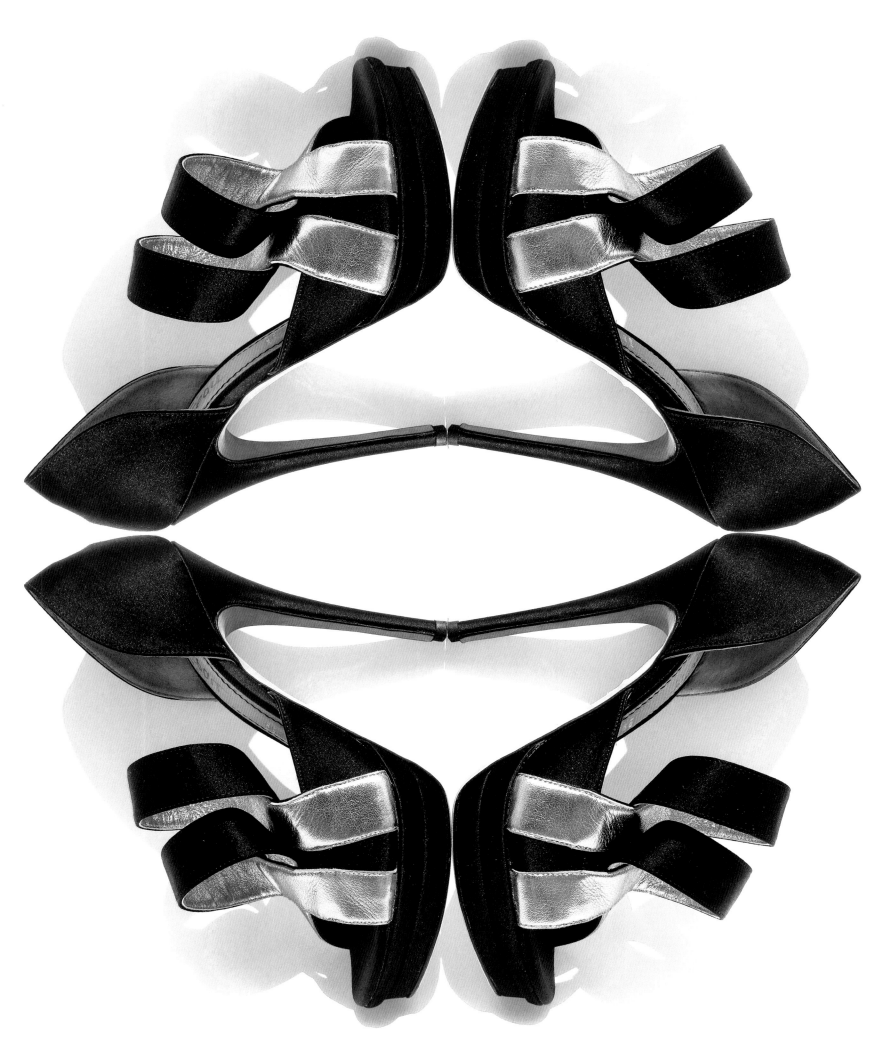

144

"EVERY SHOE HAS A CUSTOMER OUT THERE, WHETHER I LIKE IT OR NOT. If a shoe makes someone happy, then it should be there." Although at one point in his younger years he wanted to be an MTV video disc jockey, Jerome C. Rousseau quickly gravitated toward shoes. Every single job he has worked in has been in the shoe industry. "Even as a student, I worked at a shoe store."

The Quebec native finds inspiration in French culture and French women. Brigitte Bardot, France Gall, Elli Medeiros, Jarvis Cocker, and Morten Harket are just a few of his icons. Since he launched his namesake label in 2008, his muse has been the young French actress Roxane Mesquida.

Rousseau makes his home in Los Angeles and finds his West Coast surroundings to be both a calming influence as well as a creative stimulus for the incredibly gorgeous, well-crafted shoes

that exemplify his collection. "The city," he says, "has so much untapped creative potential and is exploding at the moment." The designer has tapped into the town's main line of business—film—with his footwear, collaborating on such works as *The Imaginarium of Doctor Parnassus* and the sci-fi masterpiece *Tron: Legacy*, for which he made shoes worn by Olivia Wilde's character, Quorra.

Although Rousseau's collections are designed in Los Angeles, they are manufactured in Italy, where the designer believes one can find the best of everything in the industry, both in terms of materials and labor. Concerning the stream of ideas that designers constantly need, Rousseau doesn't seem devoid of them. "Often my collections reflect my latest crushes in terms of musical or artistic influences," he explains. "I often draw my inspiration from art, music, nature, nightlife—whatever I have fallen in love with six months prior to designing the collection."

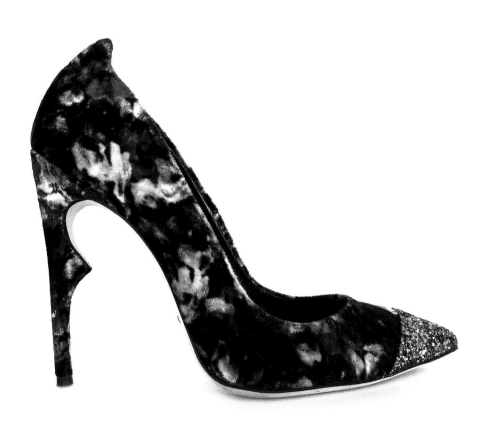

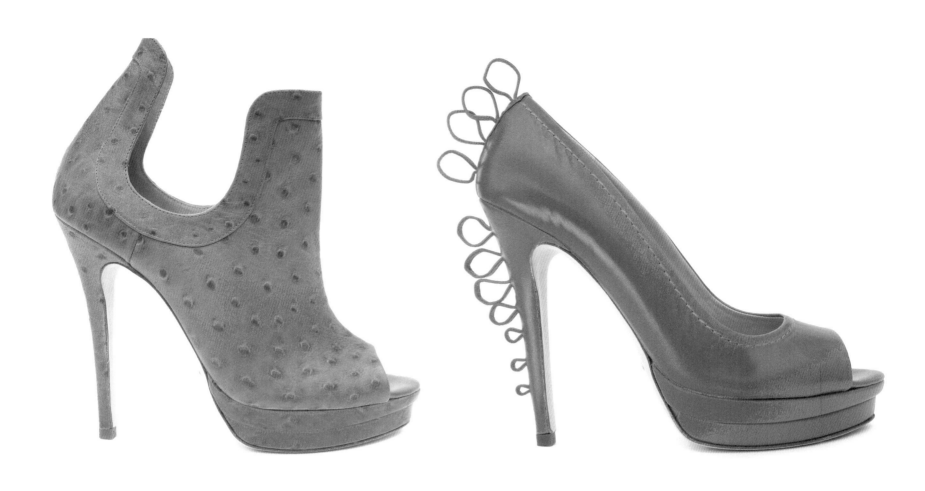
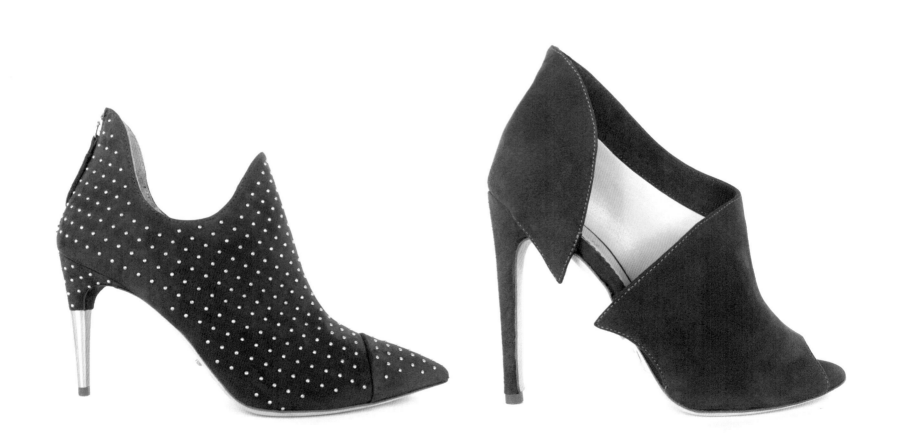

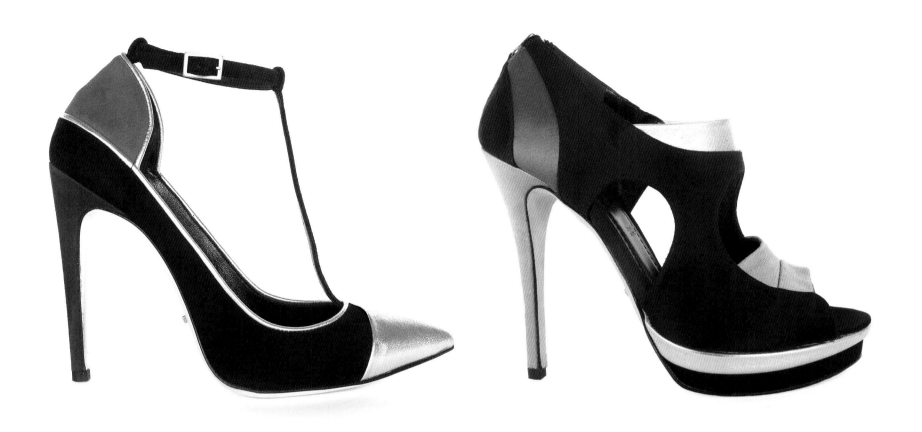

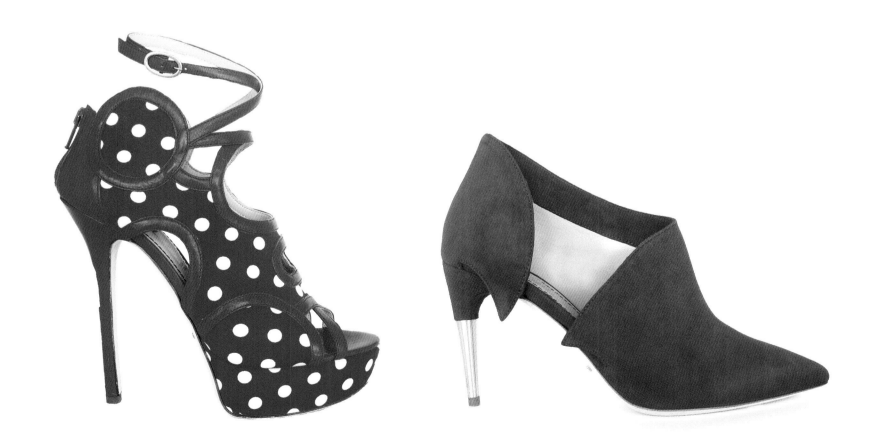

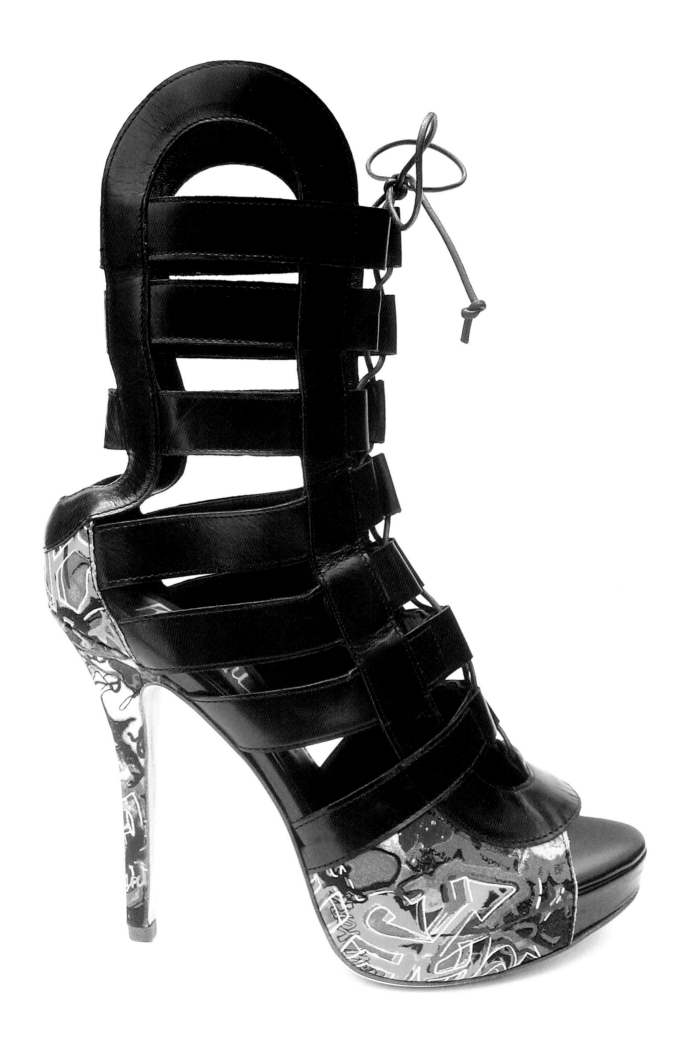

148

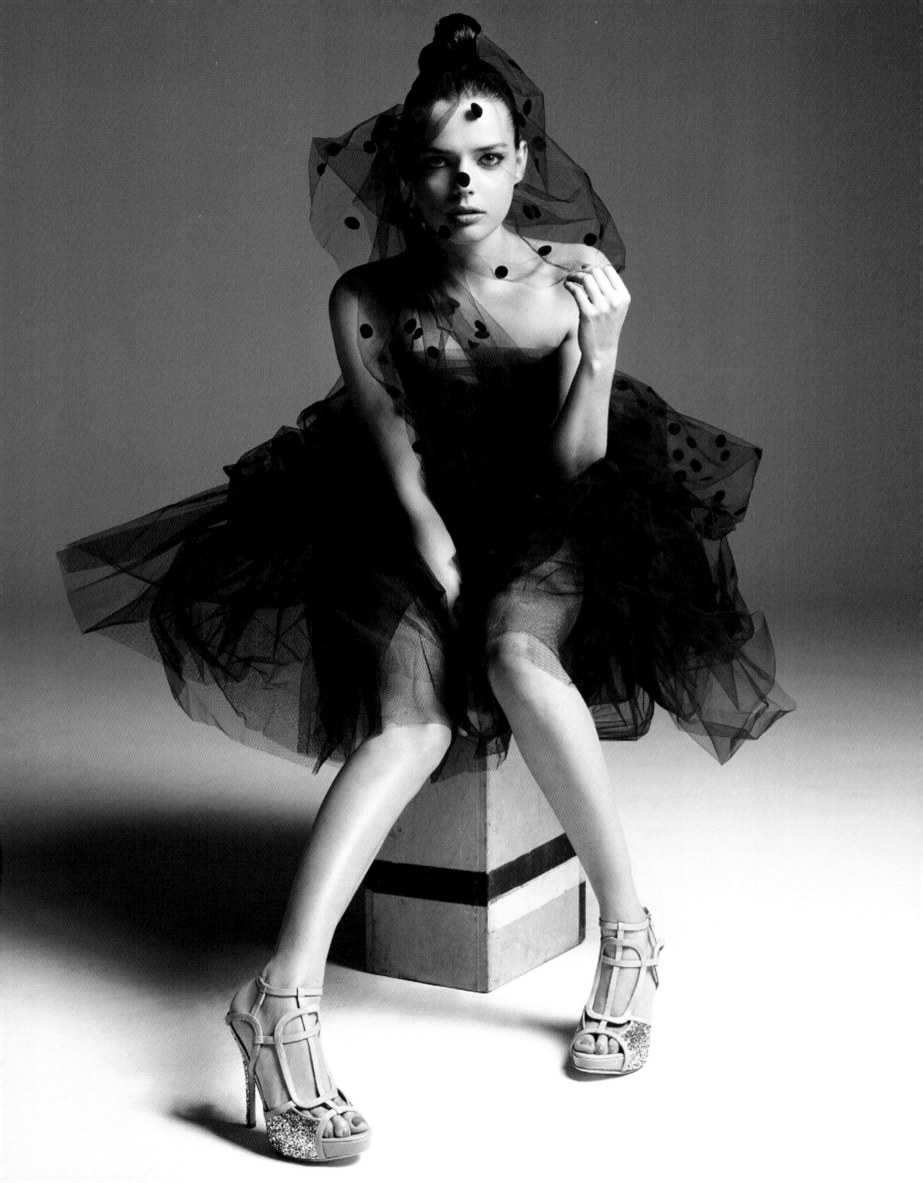

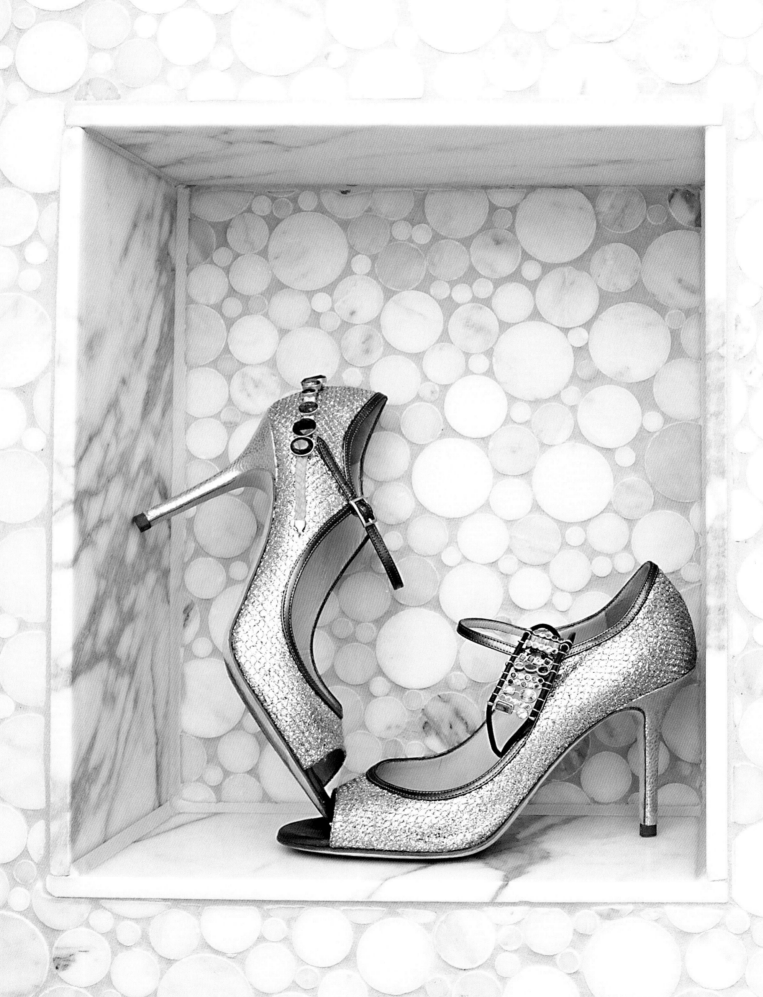

Originally born Jimmy Choo Yeang Keat, Jimmy Choo is the son of a shoemaker who was introduced to the art at a young age; he made his first pair of shoes when he was eleven years old after months of watching his father work. His love for crafting shoes led him to Cordwainers College in the early 1980s, located in the London borough of Hackney. After graduation, the young designer opened his own shop in the area, and within two years his footwear was featured in an impressive eight-page spread in *Vogue*. When Tamara Mellon, an accessories editor at *Vogue*, sensed potential in the Jimmy Choo label and growth in the high-end accessories market, she approached him about creating a partnership in a ready-to-wear shoe line. It was this partnership that gave the Jimmy Choo the opportunity to expand his company into the world-renowned brand it has become. Jimmy Choo's niece, Sandra Choi, became the creative director of the company in 1996, after spending much time perfecting her ability to create luxury shoes under the guidance of her uncle. Created with exceptional Italian craftsmanship and offering countless sexy, fashionable designs, Choo became an instant favorite with sophisticated fashion icons such as Princess Diana, Madonna, and the *Sex and the City* character Carrie Bradshaw. The brand's celebrity following was another key factor in transforming Jimmy Choo into one of the most revered names in the world of luxury footwear. Today Jimmy Choo encompasses a complete high-end lifestyle brand that consists of over 150 boutiques in thirty-two countries, as well as presence in the most prestigious department stores around the world.

# JIMMY CHOO

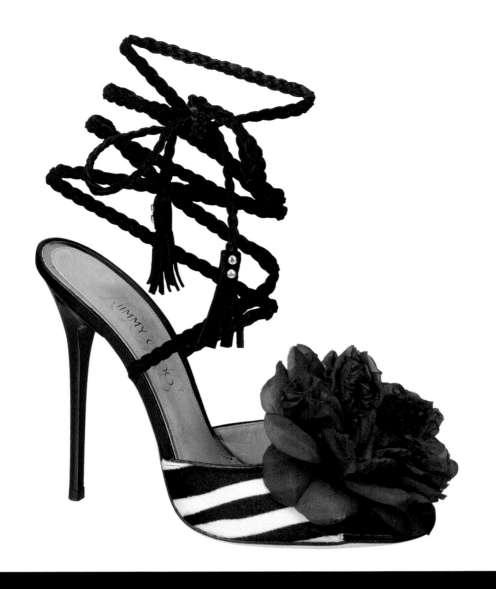

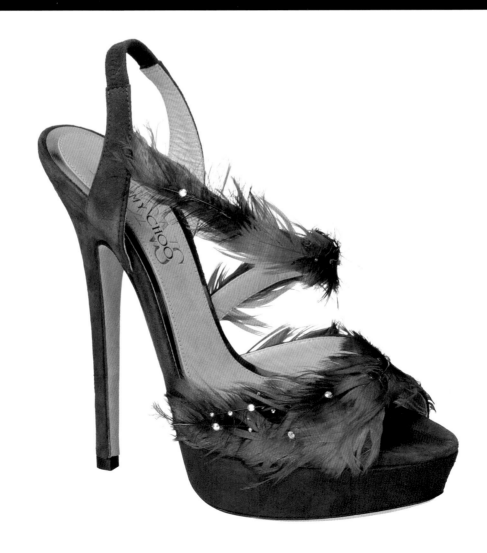

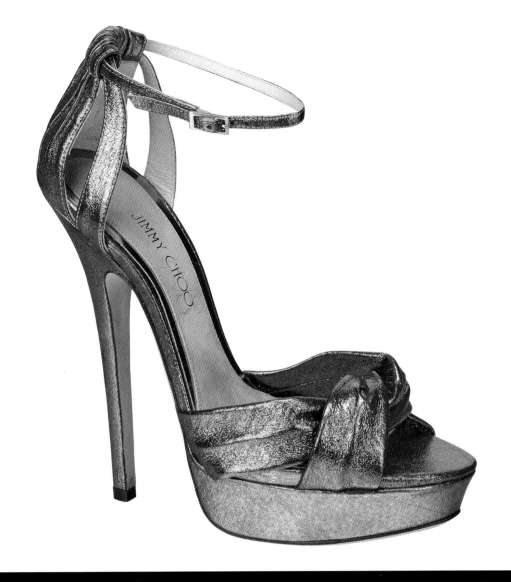

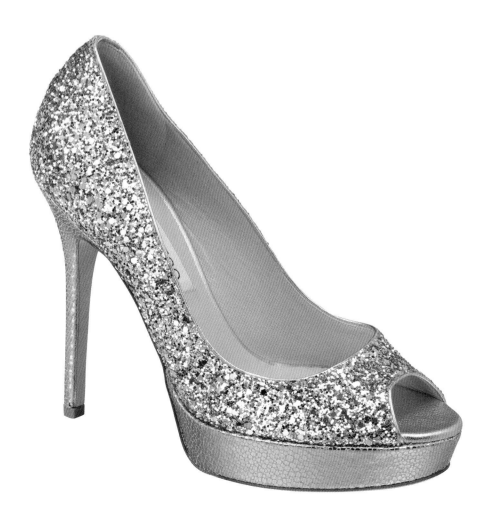

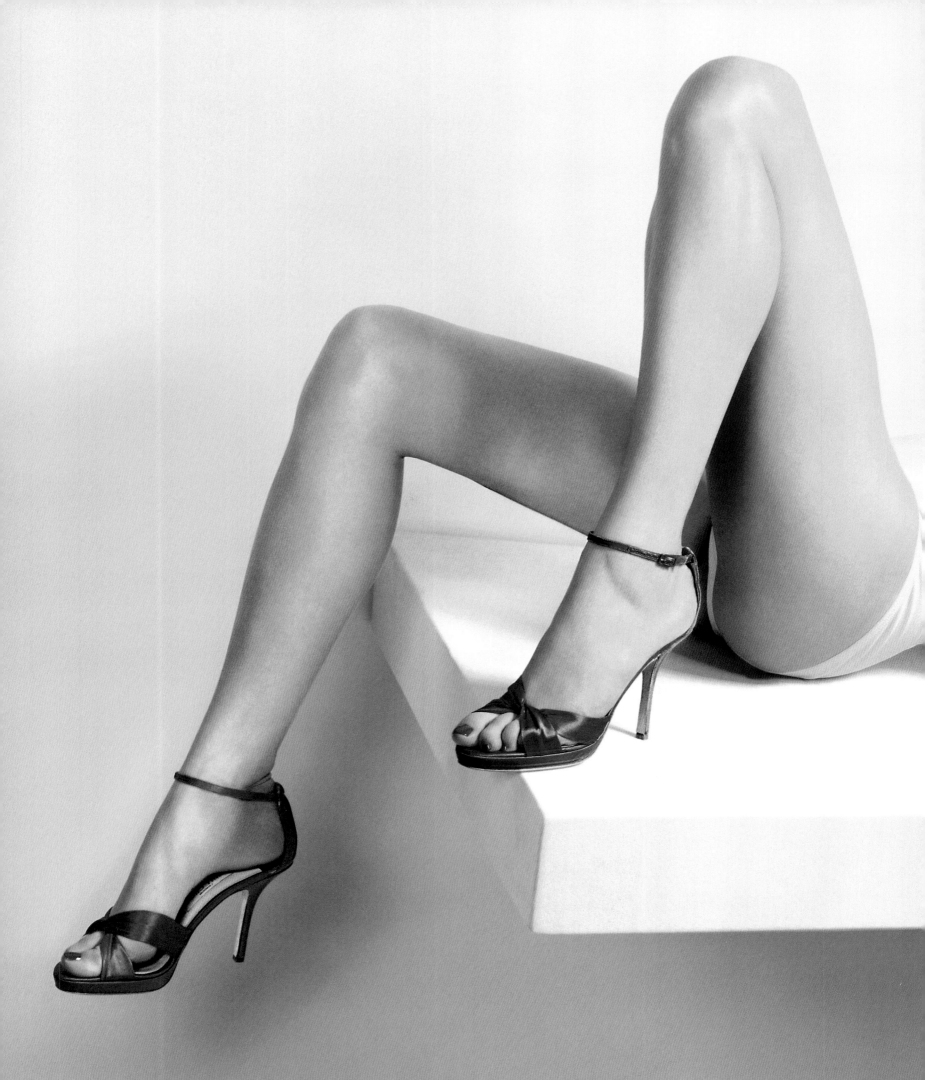

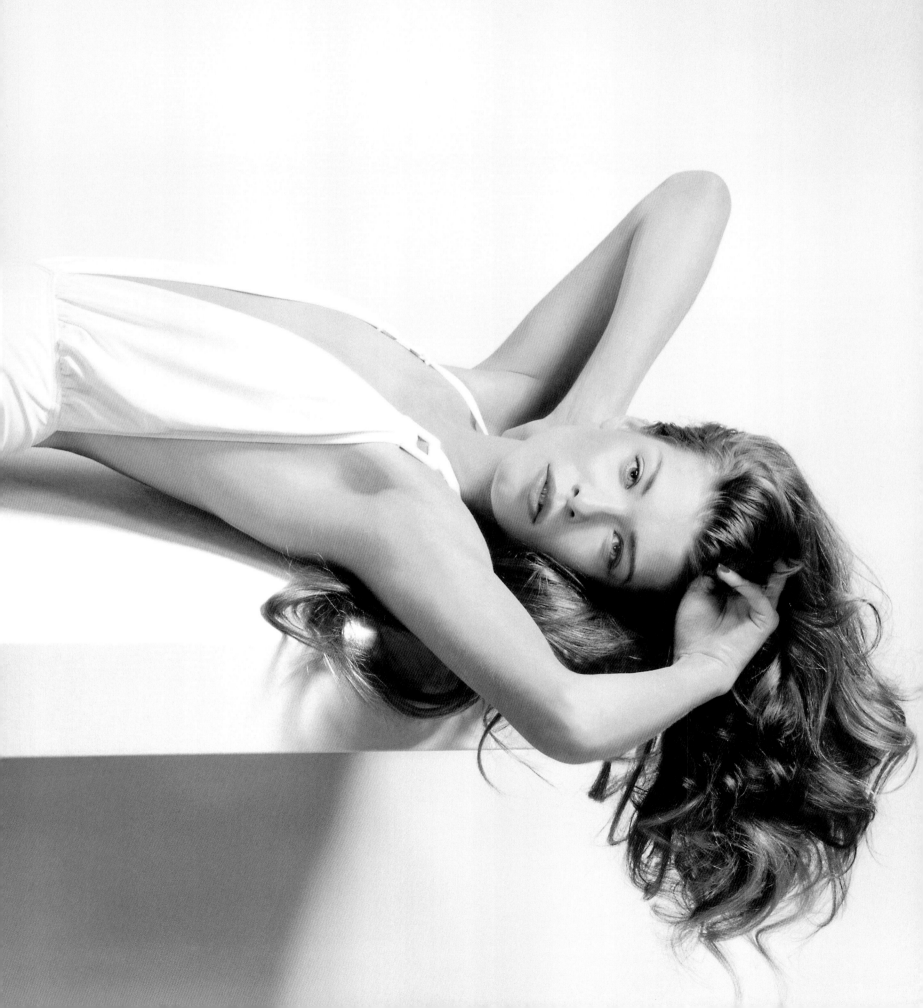

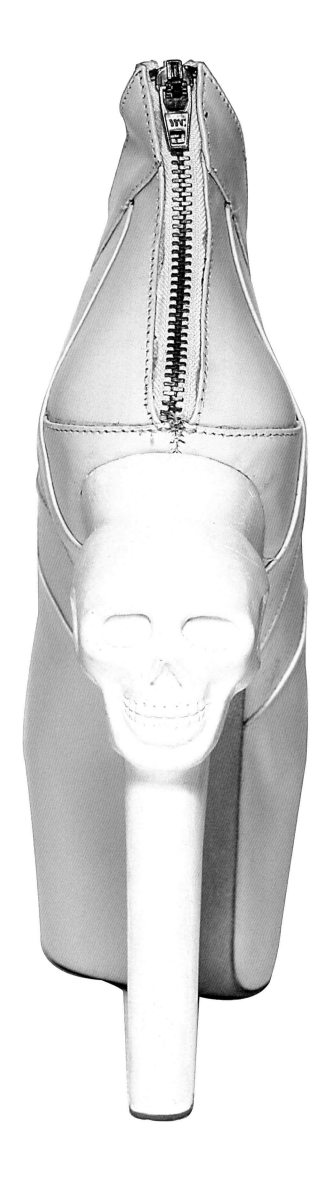

Kermit Tesoro is a Filipino artist, fashion, and shoe designer based in the Philippines. By the time he was twenty-four, Tesoro had already shown his designs during Philippine Fashion Week for three consecutive seasons. His fascination with women's shoes came from Imelda Marcos, the former first lady of the Philippines, who was renowned for her rumored three thousand–pair shoe collection. Tesoro launched his shoe designs in 2007, and debuted his famous skull heels in 2010. They are one of the most difficult pairs of shoes to acquire and were unavailable for almost a year after being officially released in 2011. Tesoro's clothes and shoes are often theatrical, so much so that some may think that his designs are too cerebral to understand. With the release of several innovative shoe designs, like his version of heel-less shoes, hypertrophy heels, cardio pumps, and the impaled chrome skull heel, Tesoro has achieved global recognition.

# KERMIT TESORO

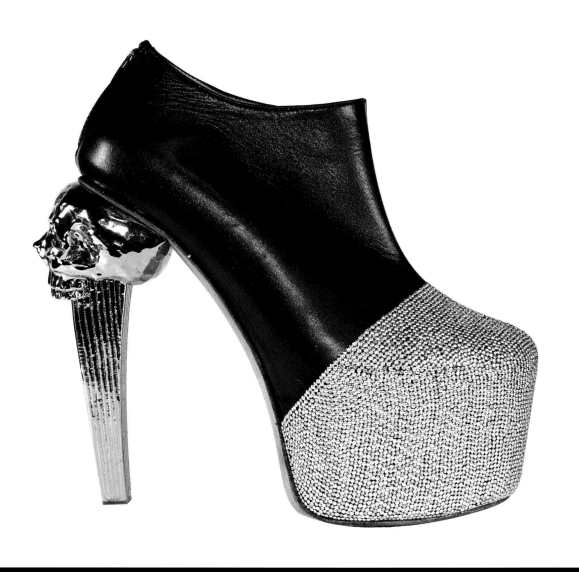

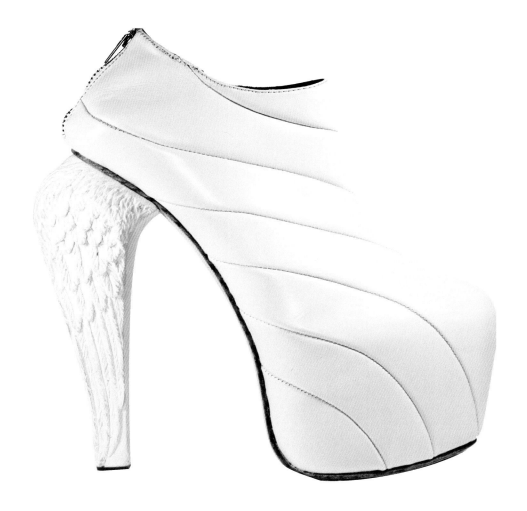

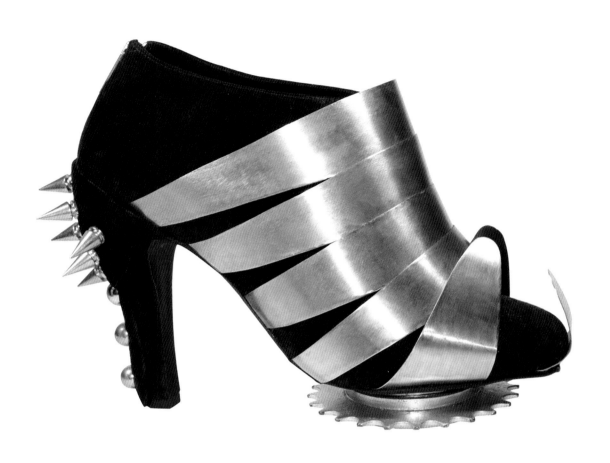

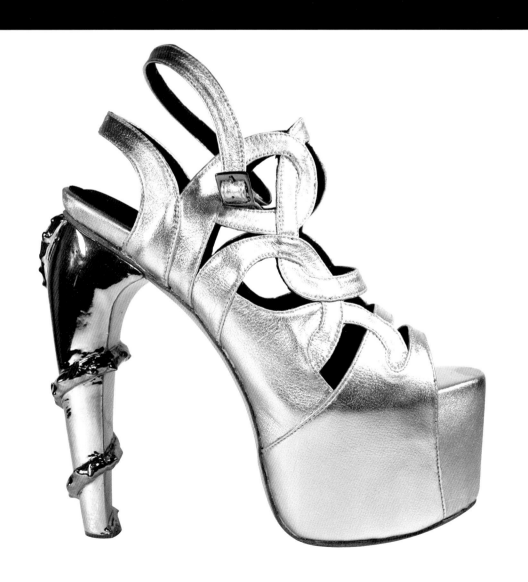

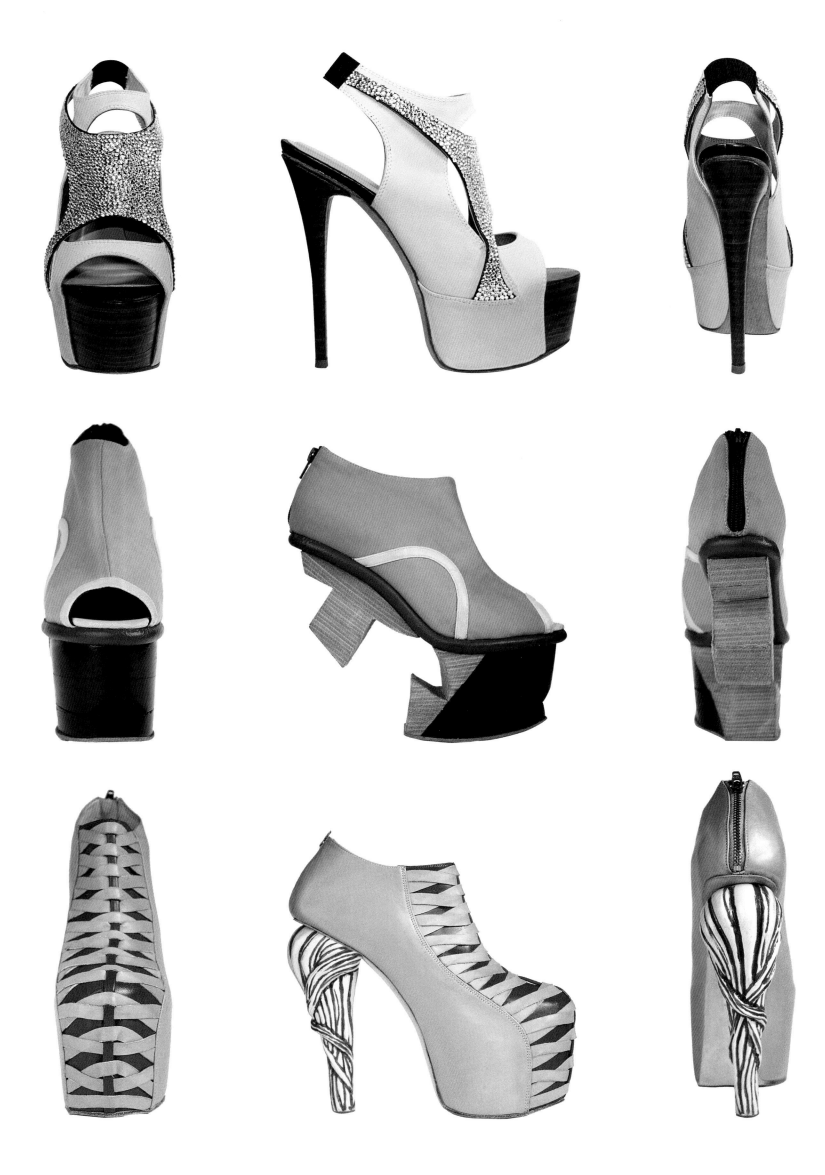

*"AS A DESIGNER, MAKING CLOTHES IS LIKE COMPOSING A SENTENCE. SHOES ARE MY PUNCTUATION MARK."* These are the bold words of Kermit Tesoro, who—even before he reached twenty-five years of age—has already shown his footwear designs at his native country's Fashion Week and garnered Lady Gaga, one of the most recognized singers in the world, as his star client. Tesoro is markedly humble about what he has achieved in a short time. "Everything I do is equally treated, and so are my career moments. I think everything should be cherished with or without the validation from your surroundings."

When asked to describe his shoe style in three words, the designer revealed a lot with his confident reply: "It explains itself." Perhaps it's his blend of confidence and a realization that one must balance art and commerce in order to get ahead: "You create, you learn, you express by creating a new form, you learn again, and the cycle goes on and on."

Tesoro tends to design daily. Every morning when he wakes up, there is a new thought, a new awareness of something he can incorporate into his design. He knows that shoes have an unchanging function, but that the intention—vis-à-vis design—has gone far. "Shoe designers are continually reworking and updating the aesthetic of shoes no matter what their purpose." Oddly enough, Tesoro started as a clothing designer but was quickly termed a shoe designer out of his designs. "All I wanted was a pair of shoes for every outfit I made," he jokes.

What does he attribute women's fascination with shoes to? Coming from the country where Imelda Marcos was in the public eye, Tesoro had a role model right in front of him. The former first lady of the Philippines, renowned for her massive shoe collection, gave shoes a whole new meaning for both Tesoro and the world at large.

Marcos, however, represented excess. Does Tesoro feel that luxury footwear is out of touch, both stylistically and monetarily? "There is actually some truth to that, although luxury footwear was never supposed to be a need but a commodity for those who could afford it. We must admit that we all get ourselves a pair of shoes with or without a name on its tag," he says. "As a designer, I have the right of free will and the right to express my mind." In his view, reality is very subjective, with a vast disparity between novelty and exclusivity, commercialization and covetable trade. "Luxury depends on a person's context, and sometimes luxury doesn't have to be practical but a medium that allows us to imagine and dream."

As much as he is a creator, Tesoro is also a traditionalist: he believes every woman should own a pair of black shoes. There is a certain safety and security in a sensible pair of shoes. A designer who carves skulls on the bases of heels, one would not describe Tesoro's shoes as demure. "We express the creative thoughts and fetishes of the unheard and deliver them to those who require creativity for their escapist and surreal world," explains Tesoro. "I don't think about the factual issues concerned with practicality." For those wanting to pursue their dreams in design, Tesoro stresses: "Just render what you have in mind. The world needs creativity."

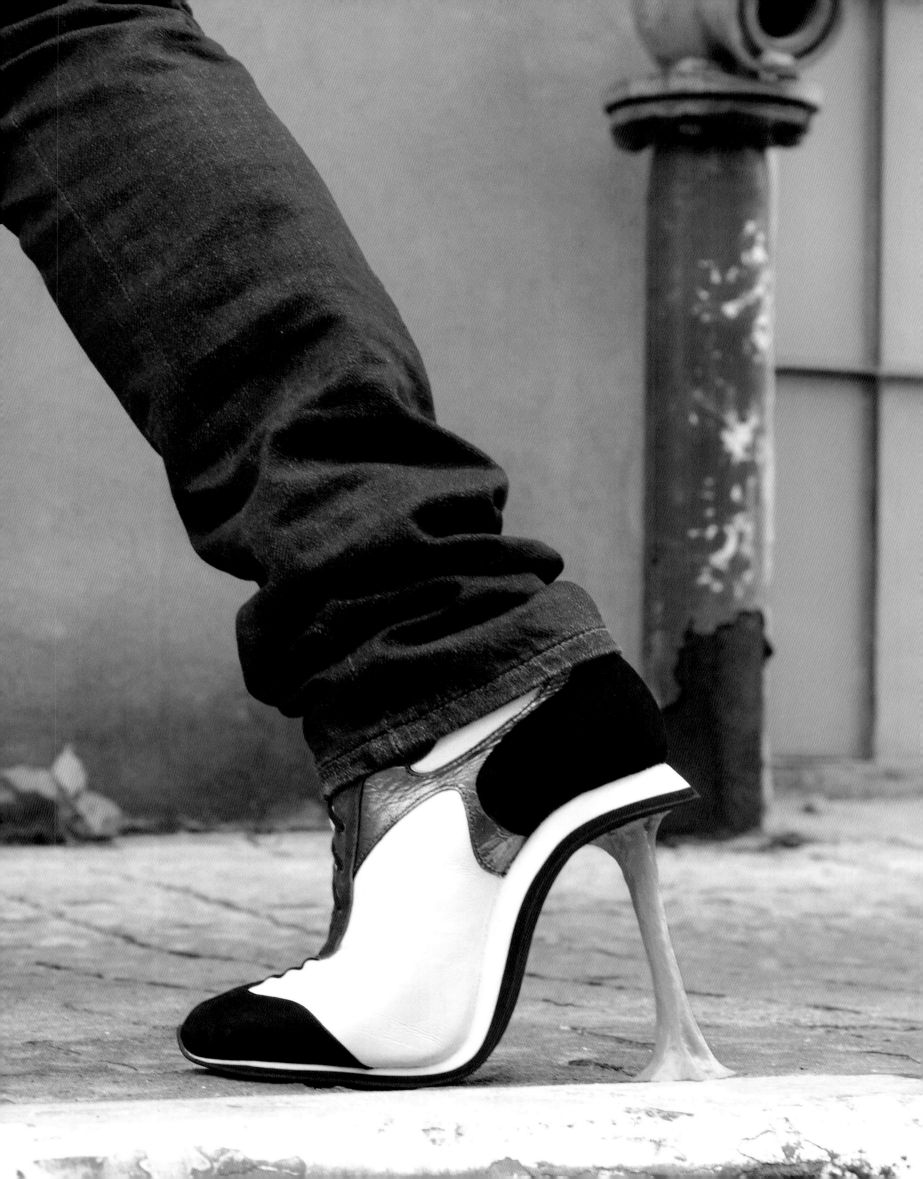

A native of Tel Aviv, Israel, Kobi Levi has possessed a strong passion for designing unique shoes since he was a high school student. He went on to attend Bezalel Academy of Arts and Design in Jerusalem, graduating in 2001. Levi became a freelance footwear designer, specializing in both design and development, and traveled to New York, Italy, Brazil, and China to work in both small workshops and large-scale factories. In 2010, Levi founded a blog to share his innovative shoe designs, which instantly went viral and gave him worldwide attention. His creations can be best defined as transforming the essence of daily objects into the shape of shoes. Levi feels that when an idea, concept, or image combines with footwear, it creates a hybrid, wearable sculpture that is alive with or without a foot. Each of Levi's pieces is handmade in his Tel Aviv studio, where he additionally designs for an Israeli women's shoe brand.

*KOBI LEVI*

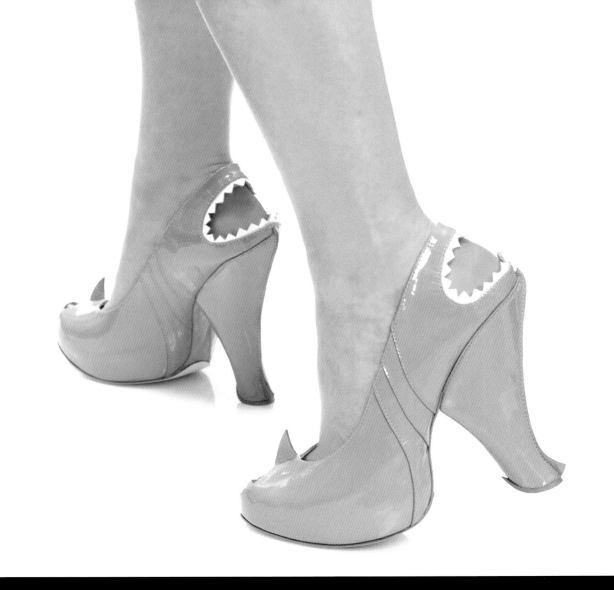

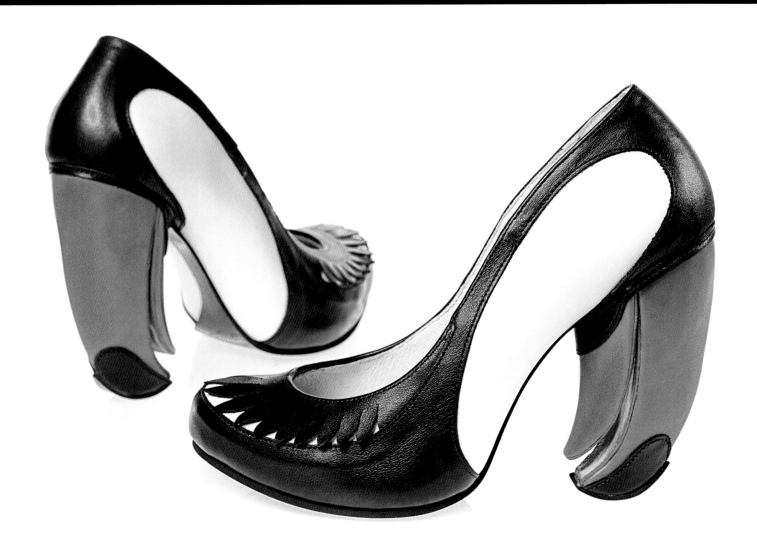

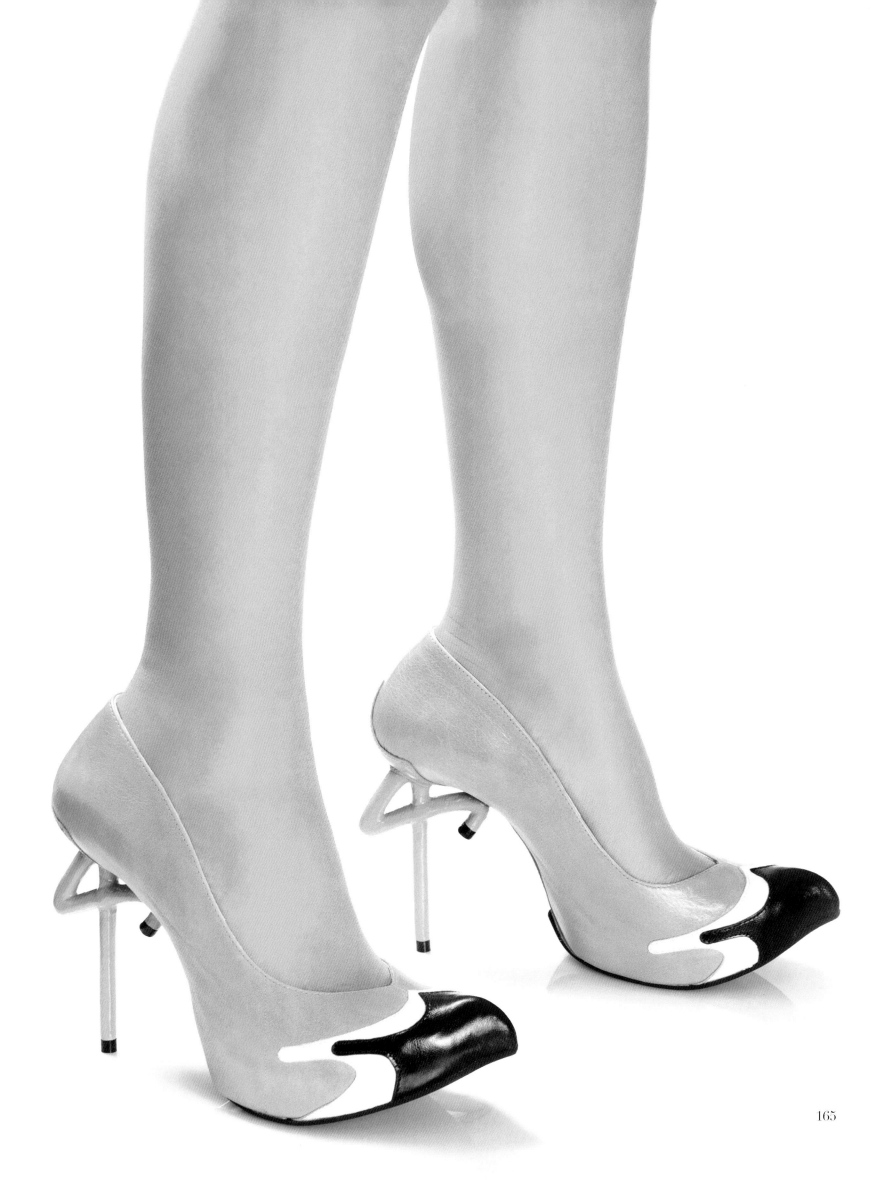

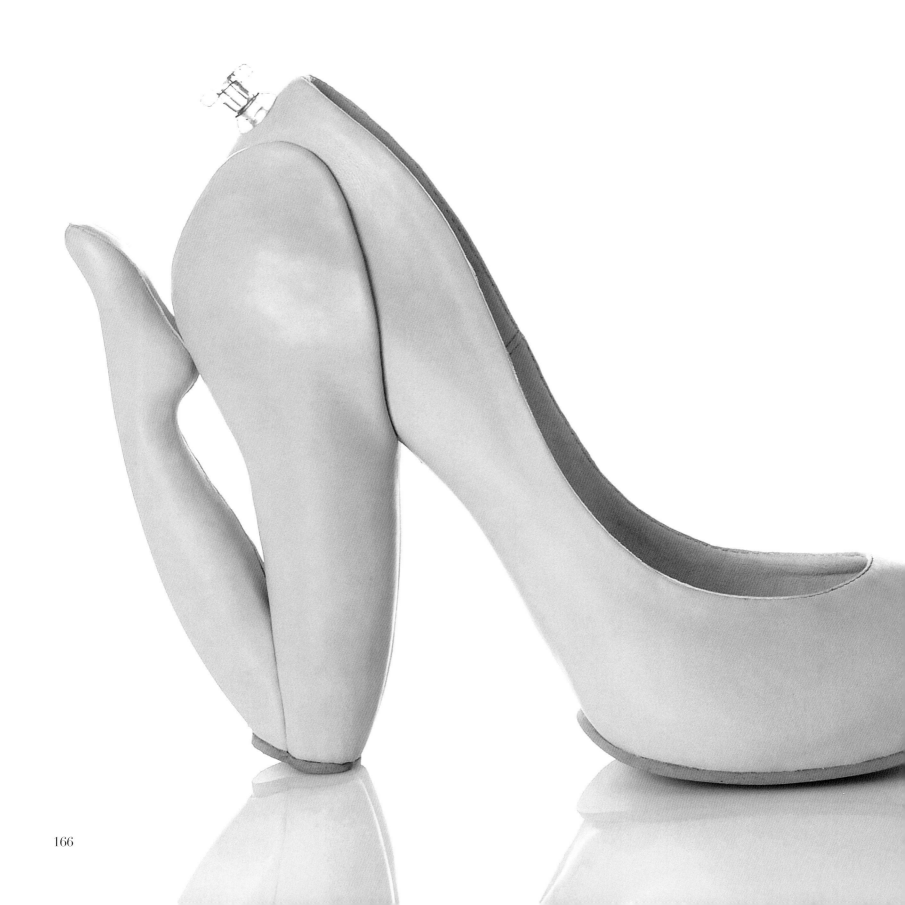

TO SAY KOBI LEVI DESIGNS ARE WHIM-SICAL IS A FASHION FAUX PAS OF THE HIGHEST ORDER. With shoes resembling furniture, fruit, and domestic animals (even in uncompromising positions), Levi's lively designs fall into a class all by themselves, in what he calls "footwear art." His creations are so unique that Lady Gaga even ordered his *Double Boot* to wear in her "Born this Way" video.

"Ever since I was a child, I always wondered about various things, like fashion items, accessories, and furniture," says the Israeli designer. "I always asked myself: 'Why are they designed in a certain way? How are they produced?'" He goes on to state that, "Real-life objects have always been the best inspiration for me; it's great to be able to suggest new looks for ordinary day-to-day objects." Even with an apparent vivid imagination and sense of wonder, Levi wasn't sure which field he would focus on for his career, only knowing that he wanted to create. "Footwear fascinated me, so I just followed my passion," he says of his professional path right out of high school. "Somehow I got involved with projects in this industry and nothing else has ever attracted me as much."

Levi does admit that he invests a huge amount of passion, love, and energy in his shoes—so much so that they are almost like children to him. His new designs are created and developed all the time. "I don't work according to seasons or collections," says the designer, adding that his shoes, which are available for sale, are exclusively offered in limited editions. Most would indeed count a plaid boot backed by a wheel for a heel, or a pair of heels that resemble a recliner—appropriately called *Rocking Chair*—collector's items.

Designs like *Miao* are exemplary. The soft brown suede heels call to mind a crouching cat, rear in air, with the heel like a bent leg. The ankle strap appearing as the cat's tail wraps around the shoe, the metatarsal is encased by a pink collar with a buckle, and the wearer's toe appears as a claw. "This represents my design language in a very clear way," asserts Levi.

Levi's designs have been the subject of various exhibitions around the world: at the SONS (Shoes Or No Shoes?) Museum in Belgium; in *Walkable*, at The Guild school for footwear design in Tel Aviv; at the *Shoe Design Exhibition*, a collaboration with apm, in Hong Kong; and in *Going Bananas*, a group exhibition in Switzerland.

The designer also admits that many of his works can probably be described as "crazy." One example is *Chewing Gum*, a heeled shoe where the heel itself is expressed as a wad of freshly chewed, just-stepped-on gum and (appropriately) painted bright pink. The shoe is not a result of a combination of a shoe and an image, as with many of his other creations, but rather a scene taken from an everyday event. Technically it's a high-heeled shoe, but visually it's a flat sneaker with gum stuck to it. "The deconstruction of the shoe parts together, presented with the everyday scene it depicts, is innovative. I hope it's fun, too."

Is it possible that Levi has not yet designed a shoe that he'd like to? "I want to design a *Wind Shoe*, a design that will make the wearer seem like she or he is levitating, rather than standing on the shoe. I'm mulling about using some transparent material that will seem like it has flown through the air and got stuck on the feet by the wind." Such a shoe will require industrial tooling to achieve the effect he's looking for, rather than the usual handcraftsmanship that goes into each work.

Humor such as Levi's has welcome bedfellows in the fashion world. He holds Alexander McQueen

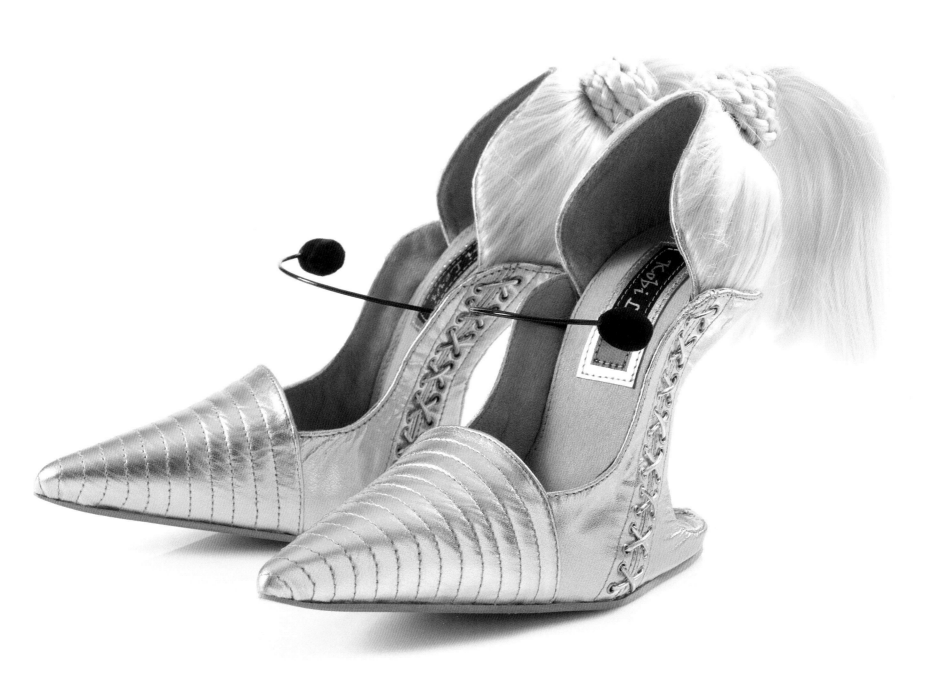

and Vivienne Westwood as icons, as well as the eccentric creations of Thierry Mugler during the 1990s. Levi can't state one specific person who has influenced him more than any other. "I like and appreciate different people from different fields; all are creative and dedicated, from artists and designers to performers and musicians." He does, however, find a great sense of style in the United Kingdom and Japan, appreciating the capacity of each culture to freely express its own character through appearance. "Generally speaking, I think individuals with great style are more interesting than the collective view," says Levi.

As to whether his homeland serves as an influence, Levi says, "Tel Aviv is a relatively young city (only a little over one hundred years old) and practicality is a main factor in its design,

architecture, and structure. Aesthetics are secondary to functionality here, and maybe in Israeli culture in general. I guess designing in such an atmosphere is challenging because people always question the use of my designs."

Another drawback is the lack of an established shoe industry with a long tradition, as in Italy or Spain. This creates limited supplies of raw materials and accessories. "I can't rely on unique or precious materials in order to create a strong effect, as they are simply not easily available," Levi says of the resources at his disposal. To overcome the shortages, the designer has had to be very inventive and solve many technical problems on his own. "Sometimes I use materials that are not normally used in shoe production in order to emphasize the design. Necessity, they say, is the mother of invention."

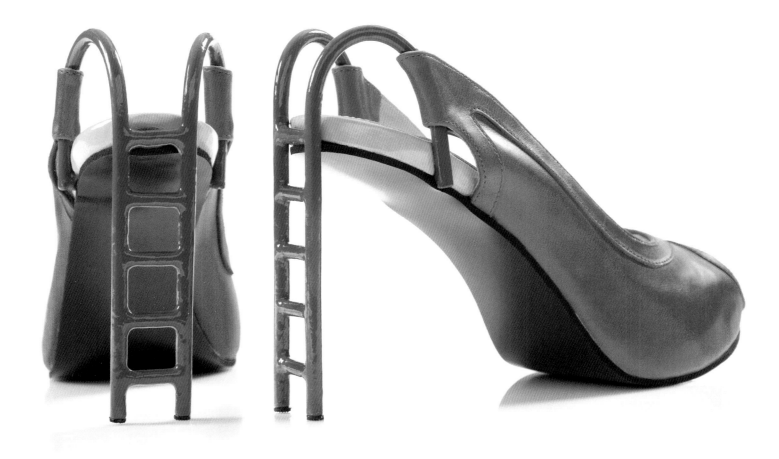

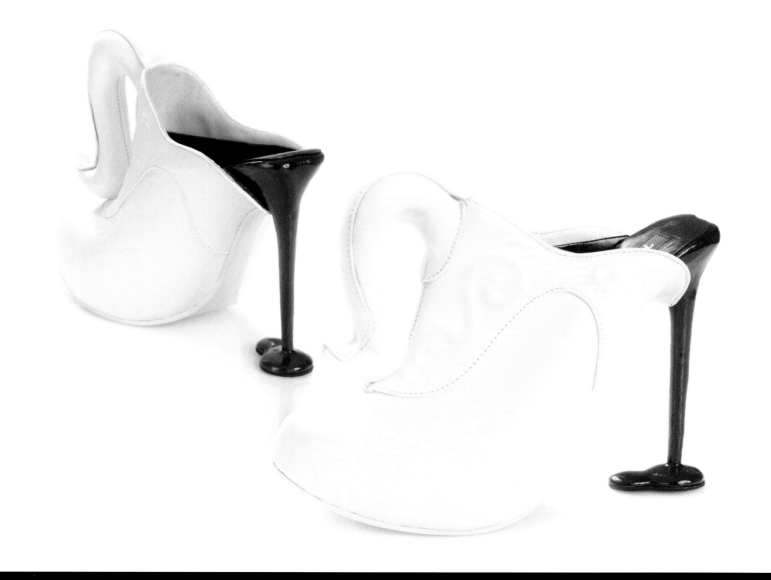

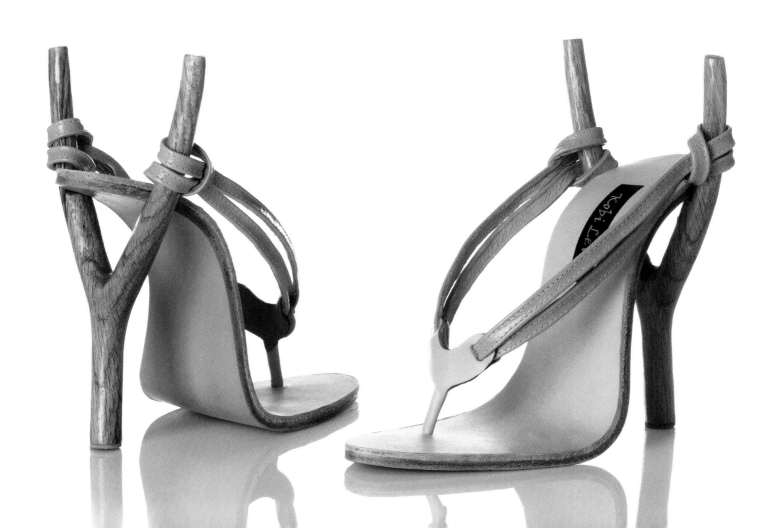

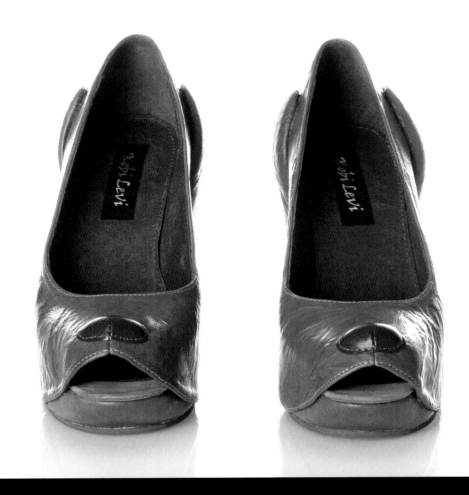

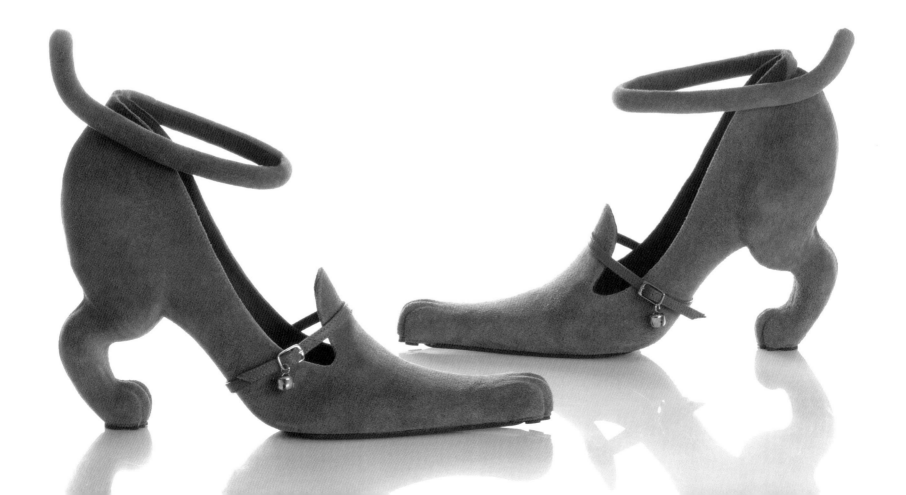

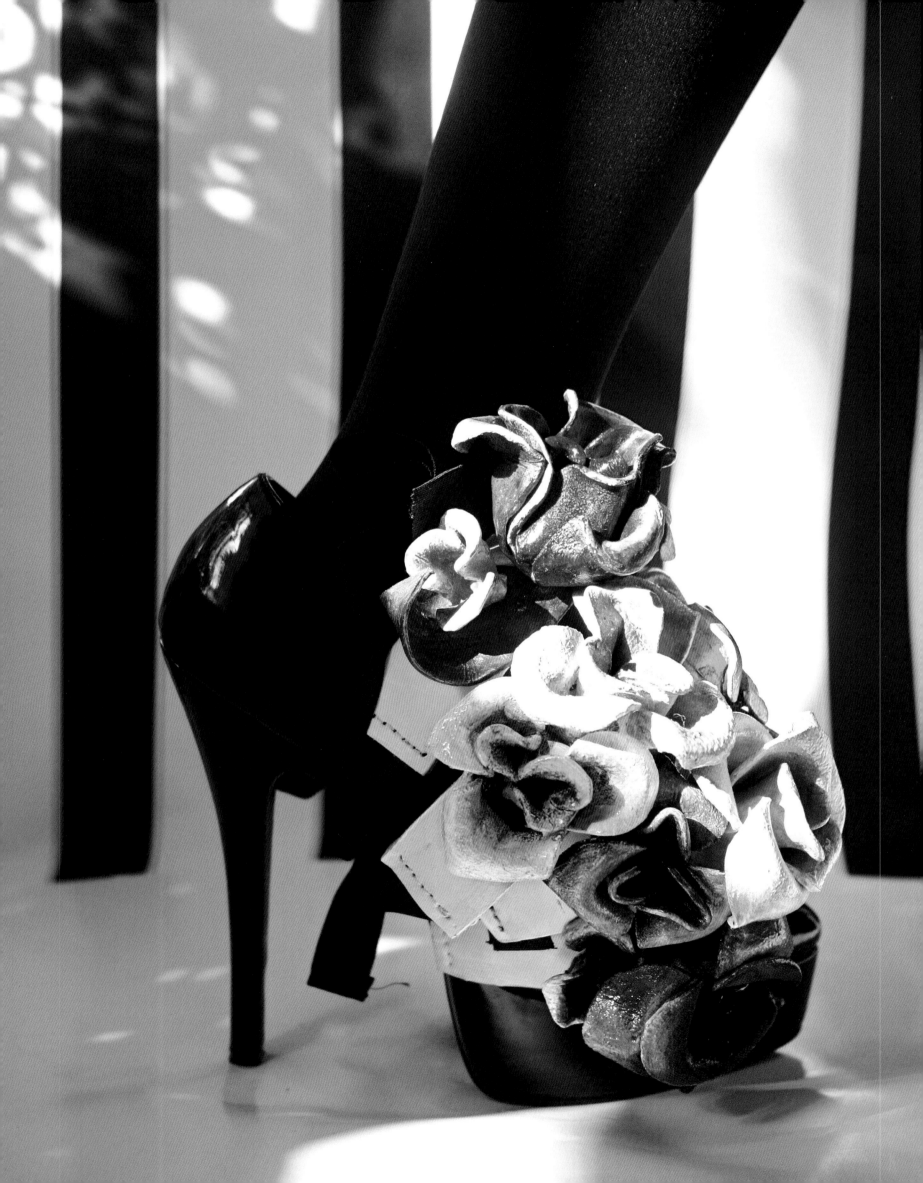

Lauren Tennenbaum is an artist who is interested in taste and what it tells us about who we are. A graduate of Vassar College, where she majored in cognitive science and art history, Tennenbaum briefly worked as an interior designer, during which she became acquainted with faux finishes. She started experimenting with different materials, pushing the limits of taste far beyond "good," but quickly discovered that most people aren't necessarily looking to live in the delightfully kooky and humorous interiors she favored. Today stylists, photographers, and performers often incorporate Tennenbaum's accessories and props in fashion editorials. She is infatuated with the sensory experience of Byzantine churches, and is fascinated by the ways in which humans augment and mimic themselves and their environment. Tennenbaum always has an eye open for the glamorous, the gaudy, the weird, and the eccentric, and hopes her projects convey her whimsy and excited sense of humor.

# LAUREN
# TENNENBAUM

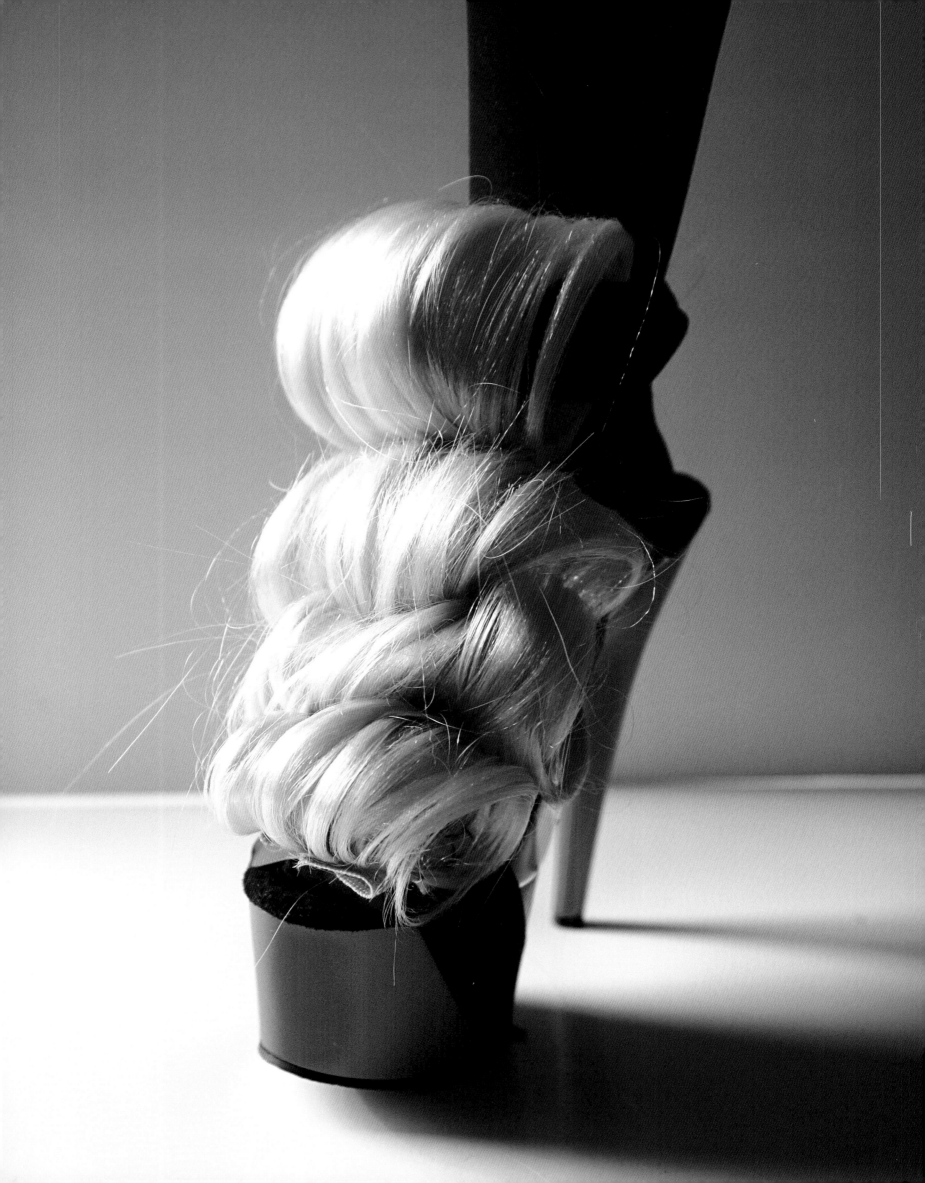

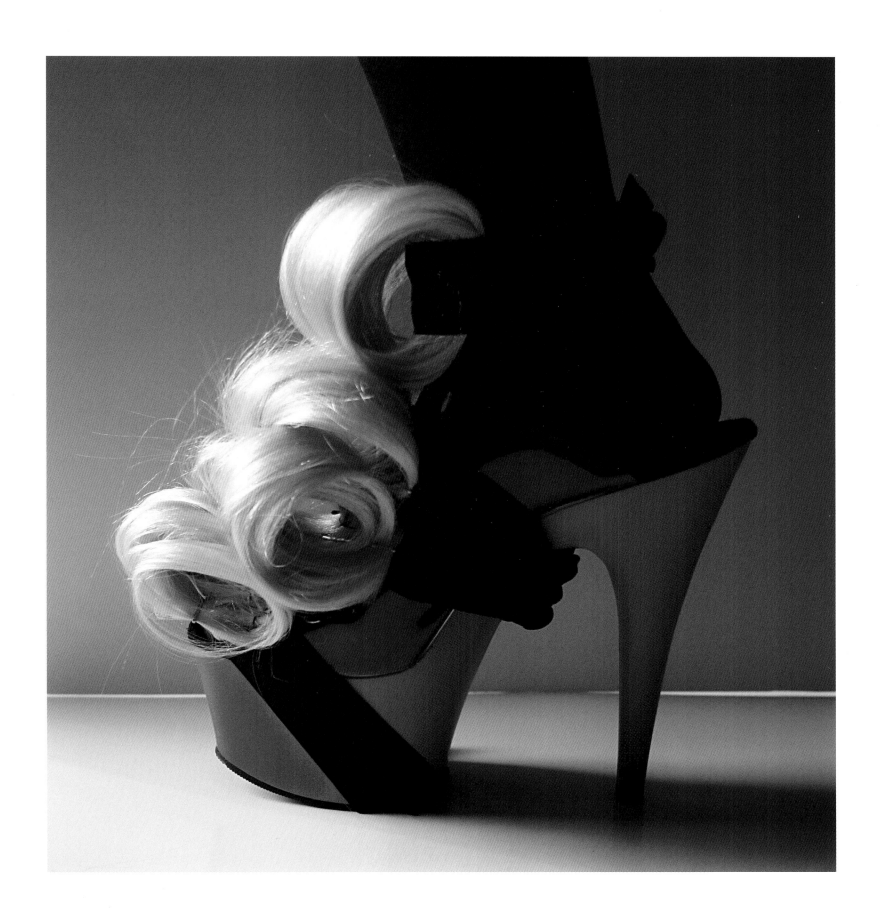

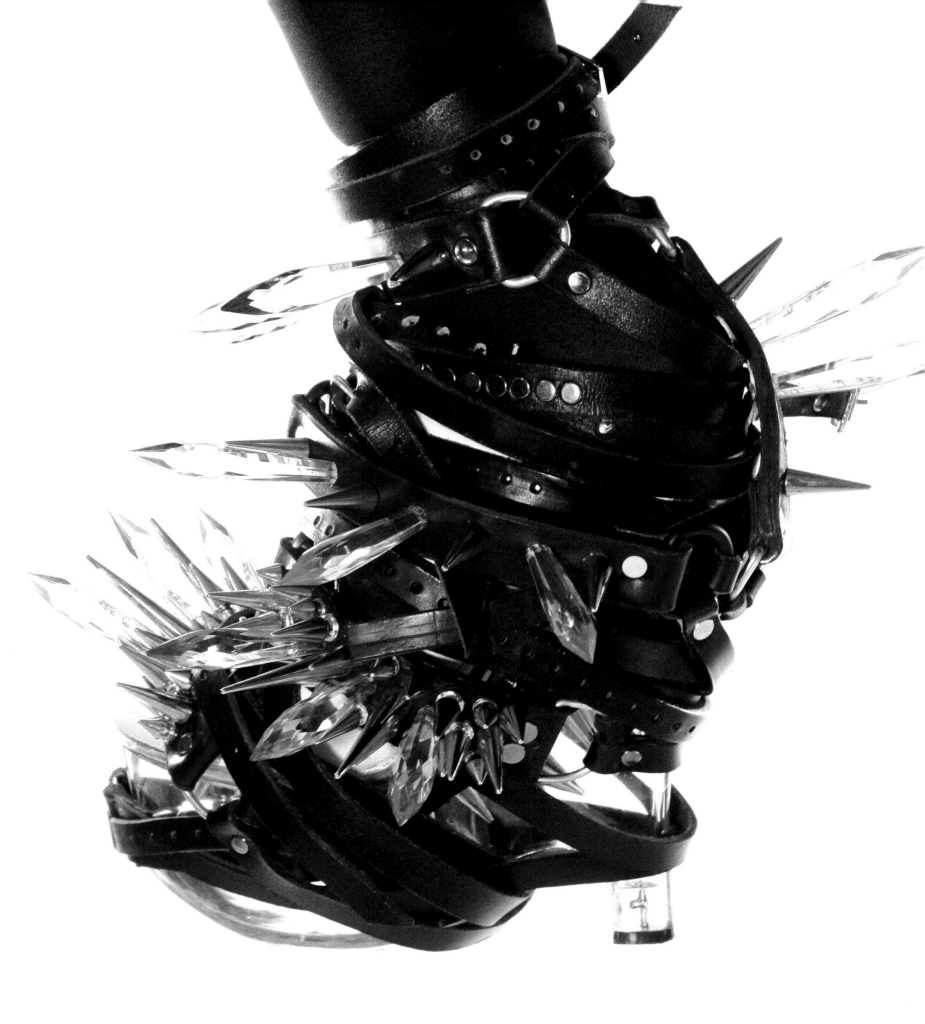

176

*PEOPLE, PERSONALITIES, AND CULTURE. DESIGNERS OFTEN GET ASKED WHAT THEIR INSPIRATIONS ARE, WHAT MAKES THEM TICK, AND HOW THEY DO WHAT OTHERS CANNOT.* Lauren Tennenbaum is one who probably gets asked that question more often than others. Tennenbaum is not shy, and her shoes are certainly not for the meek or tenderhearted. Rather, they are shoes that could be worn by a rock star of the highest order or grace the cover of Italian *Vogue* as they did in 2011. Loaded with crystal spikes, platforms, and straps galore, Tennenbaum's shoes evoke the question, "How do you stand in those things?" from all who witness their artistry.

"I love to play around with different associations and turn things you might not view as beautiful into something you'd want to wear, or at least something that will put a smile on your face," the designer explains. She cites the example of the classic plastic stripper shoe—something that many typically read as trashy, but that Tennenbaum calls into question. "What exactly is it about that shoe that makes it that way? How do you make it cool or playful?"

It should come as no surprise that cognitive science was one of Tennenbaum's majors in college, and that she wanted to be a cultural anthropologist for a while. On one hand, Tennenbaum says she can't help but be influenced by the culture she grew up in, with its icons, values, and standards of beauty. On the other hand, studying art history put it all into perspective. "What's beautiful now wasn't always so, and the same thing isn't always beautiful to all people," she says about how tastes change over time.

It's the potential and people who have lived by their own standards that make Tennenbaum take notice. She admires those who have designed their world to their own specifications and with a sense of humor and a vision—people like Rose Cumming, Elsa Schiaparelli, Marcel Duchamp, Florine Stettheimer, Isadora Duncan, and Isabella Blow. Her mother and grandfather, who was an artist in Europe during the first half of the twentieth century, had a huge influence on her. "My grandfather's approach to craftsmanship, quality, and the nuts and bolts of what makes something work influenced my mother, who in turn has this nutty 'patch it, spit it, glue it together and it will look like a million bucks' sense where she can make anything work."

Tennenbaum explains that the thing that first motivated her to start creating shoes was an idea of crystals sprouting from a foot. "It was a fantastic and otherworldly vision." To see that design through to completion, she needed to create every component of the shoe, including the crystals themselves. The actual pair is ethereal, aggressive, and full of light.

One look at Tennenbaum's repertoire (and it hardly seems there's a shoe that could outdo another each one is more outrageous than the previous. "There was a shoe I did that involved a three-foot leather spine and hundreds of buckled tentacles and straps." She is always interested in reflective surfaces, such as mirrors and glass. The designer has also played with various surrealist elements, exploring their potential for whimsy and humor. "It's whatever I'm thinking about in the moment, really," she says of what motivates her. In the end, Tennenbaum knows it's all about constant creation, and she is one designer who is having a great time doing it. "I hope my pieces are as fun to wear as they are to make."

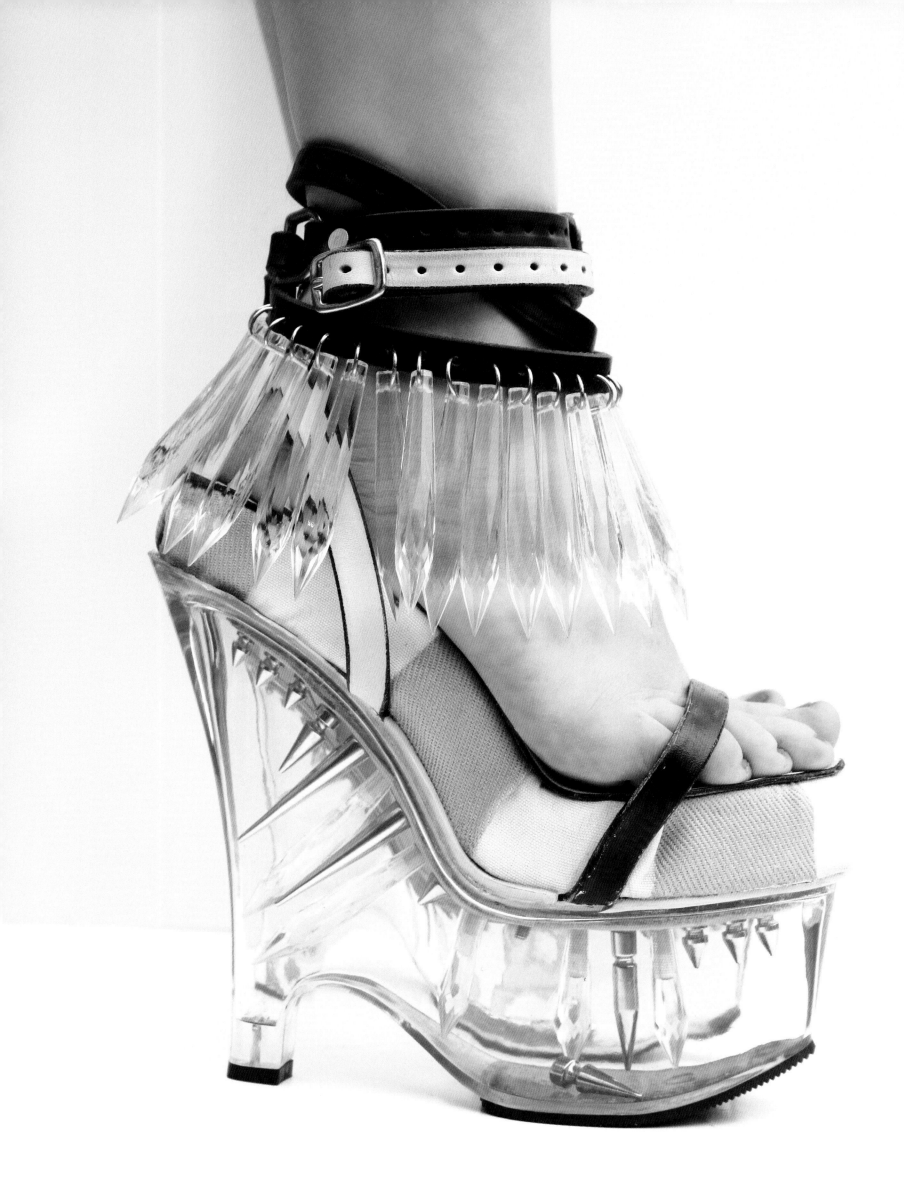

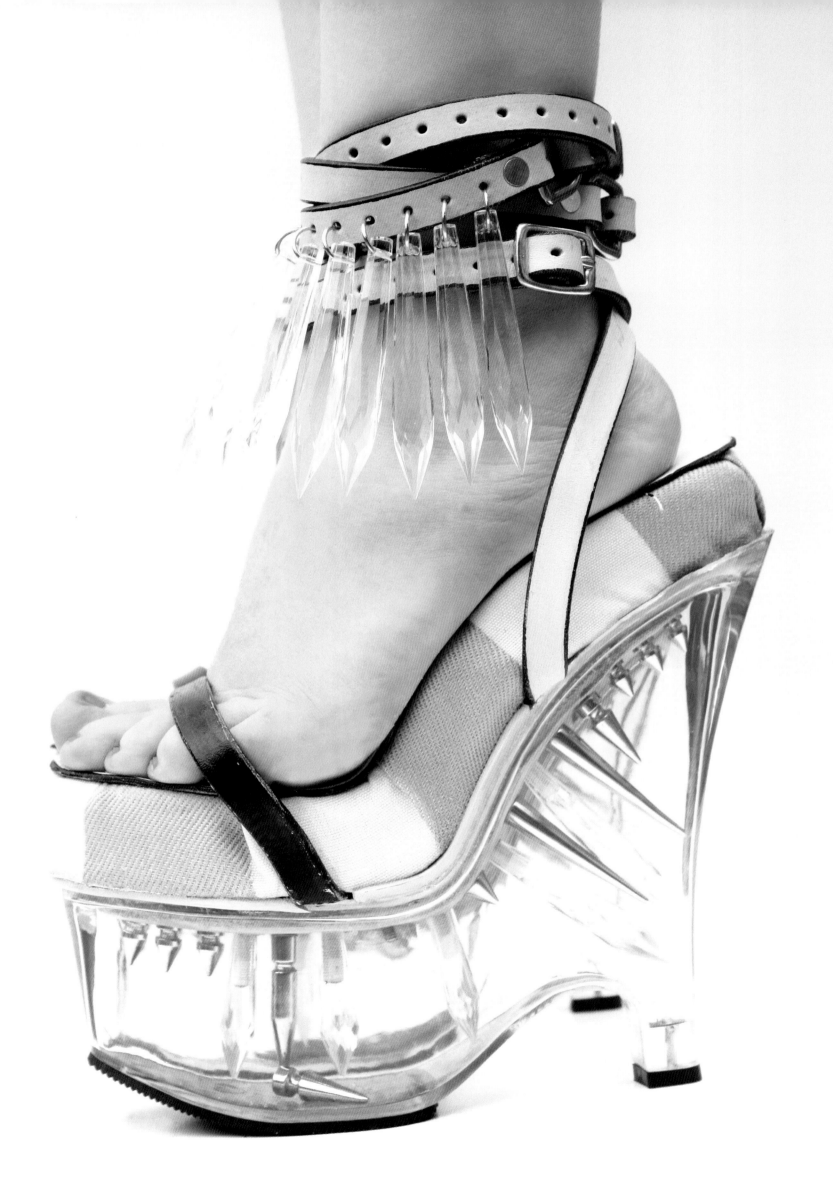

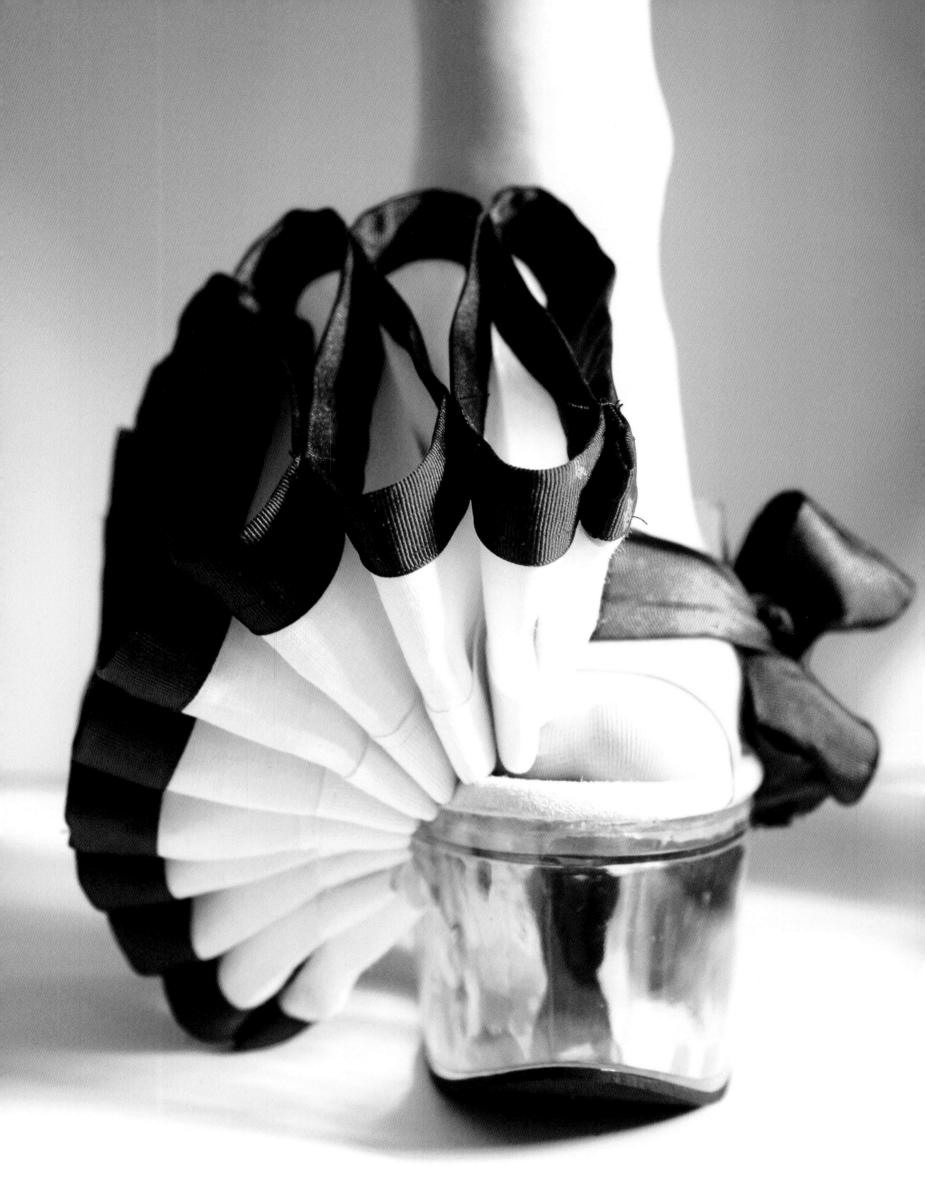

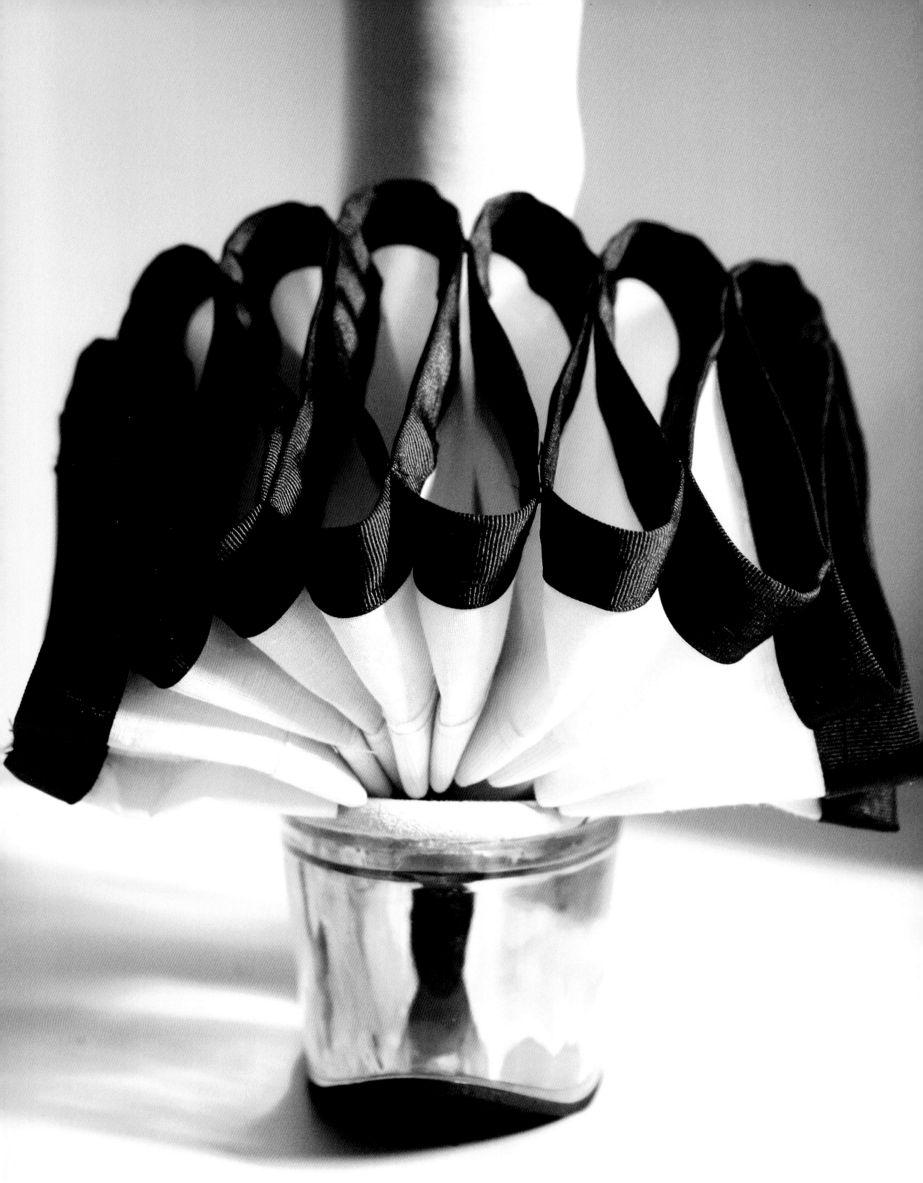

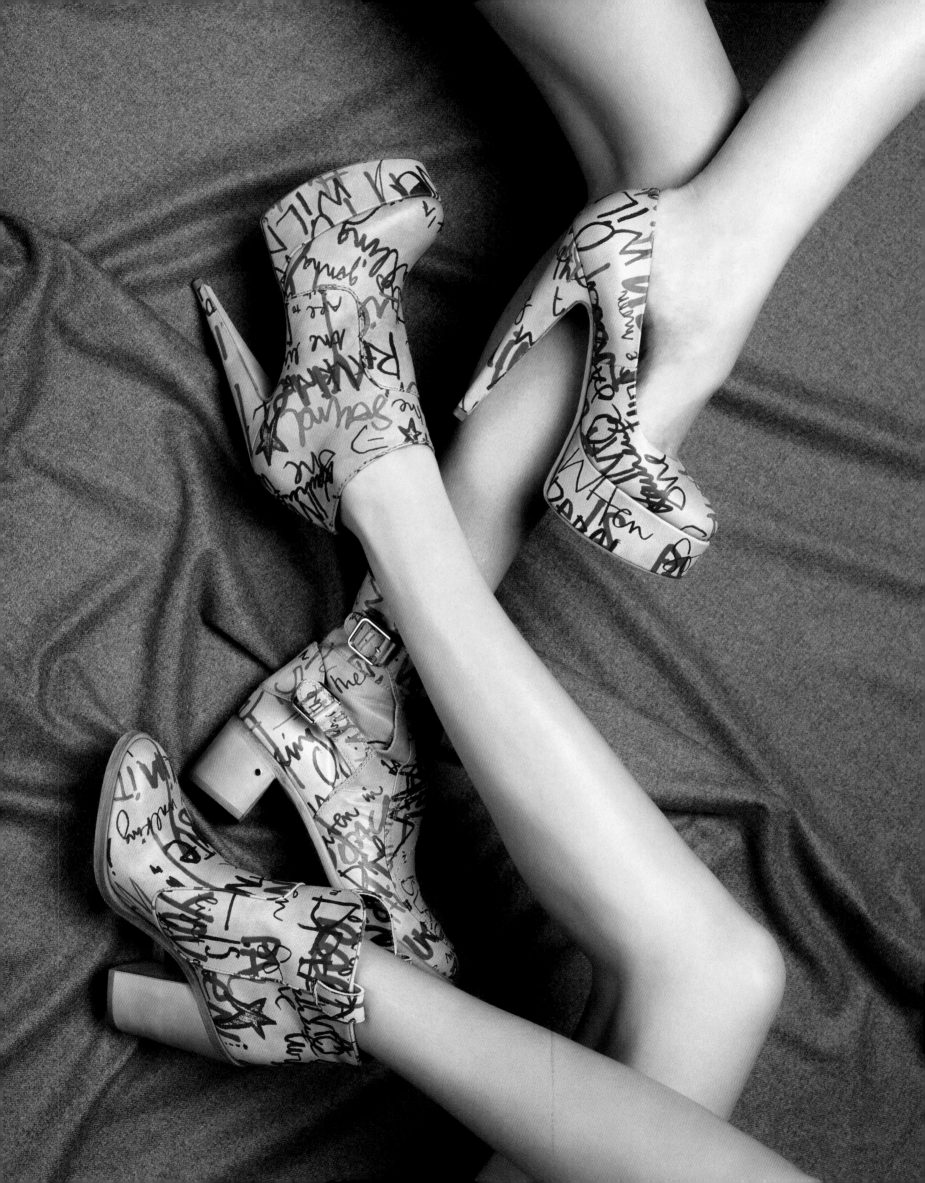

At the age of fourteen, Paris native Laurence Dacade purchased her first pair of shoes on her own—red and blue striped ballerinas with a large bow. While her friends and classmates looked at her strangely, it was then that her love affair with shoes truly began. She now owns over five hundred pairs of shoes, from alligator boots to flip-flops, and more. Wanting to master the technical aspects of shoe design, Dacade decided to attend the French shoemaking school, AFPIC (Association pour la Formation Professionnelle des Industries du Cuir). Her understanding of the construction of shoes has enabled her to produce footwear that is attractive yet comfortable. She firmly believes that there is no reason to suffer for beauty, and that shoes are sensual objects. Dacade travels extensively to study her biggest source of inspiration: women throughout the world and their cultures. Aside from designing and producing her own namesake collection, she has also designed the shoe collections for the major French fashion houses Chanel and Givenchy. She has additionally collaborated with Jacques Fath, Givenchy, Balmain, Jean-Louis Scherrer, Christian Lacroix, Karl Lagerfeld, and Oscar de la Renta on other projects. At the end of the day, Dacade's goal is to make shoes for a modern-day Cinderella with a hint of sexy and a touch of French. She wishes to make beautiful women feel even more feminine, unique, and sexy, and feels that shoes serve as the foundation upon which this can happen.

# *LAURENCE* DACADE

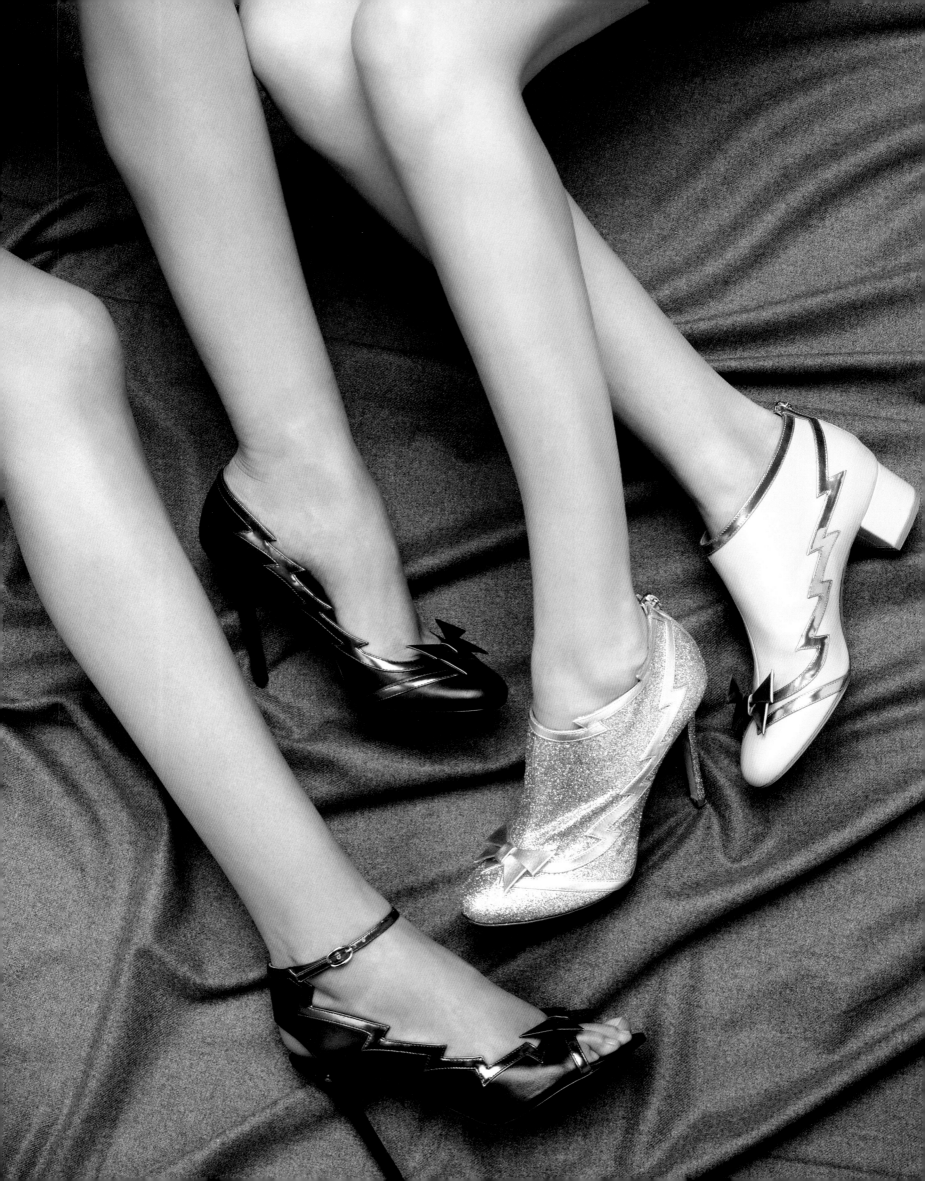

*"SHOES ARE MY PASSION; THEY LIVE WITHIN ME."* Women with a longing for fashionable footwear and whose closets are filled with many pairs think they can say the same, but Laurence Dacade can make this affirmation with total authority. As a footwear designer, she can literally stand behind what she says.

For Dacade, emotion is her mainspring—the kind she experiences when putting her naked foot into a new model, looking at a perfectly well done shoe, or touching leather. There is something visceral for her in those moments, something that goes far beyond the mere adoration of trying on a new pair of shoes and walking around a room in them. "I want to share these emotions with the women who put my shoes on. I want them to have the same desire that I have for them." Dacade believes that, "All emotions come into play no matter where they come from." Besides the style, it's the quality, comfort, and well-being that are Dacade's veritable obsessions.

When pressed as to with whom she'd like to share her designs, Dacade openly and immediately admits a fondness for her culture. "I love 'chic Français,'" she says with delight. Indeed, she has had the privilege to work beside some of the great designers in her home city, Karl Lagerfeld of Chanel being one. Dacade has also had the chance to design several completely outrageous models as well: shoes with bulbs that ignite and then go out, shoes without heels, an excessively high pair that practically defies gravity, and footwear inlaid with precious stones and coral.

She describes her 2013 collection as a big, close-knit family that answers all of her requirements: chic, glamorous, and rock and roll. Dacade has divided it into four groups that she loves in the same way. As befits its name, *Eternal Essentials* features elegant, essential, and timeless loafers, low boots, and boots. Then there is *Ultra-Féminin*, comprised of devilishly sexy, devastatingly high, audacious heels. Dacade describes this collection as "femme fatale with a definite attitude." *Extravagance Extremes* come next: shoes in colors that demand attention, get noticed, are admired, and dare to break boundaries. Finally, there are the designer's *Androgynous* shoes, which she interprets as "dedicated unconditionally to the man and woman who share everything." This includes sexy lacquered patent leather biker boots that can be worn by both men and women featuring buckles and a strong, defined shape. "The material gives the boyish boots a dandy's swagger that make you want to die to wear them."

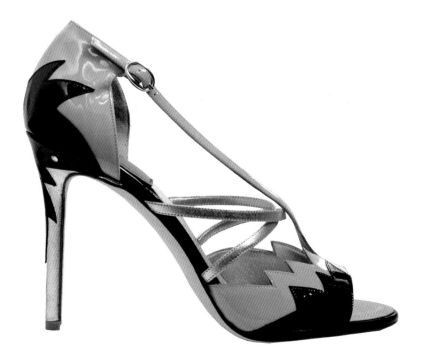

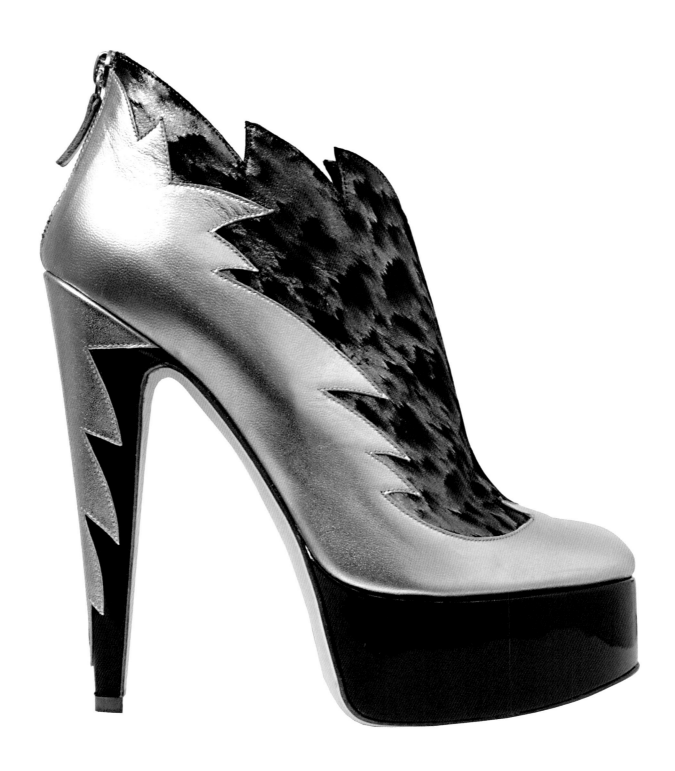

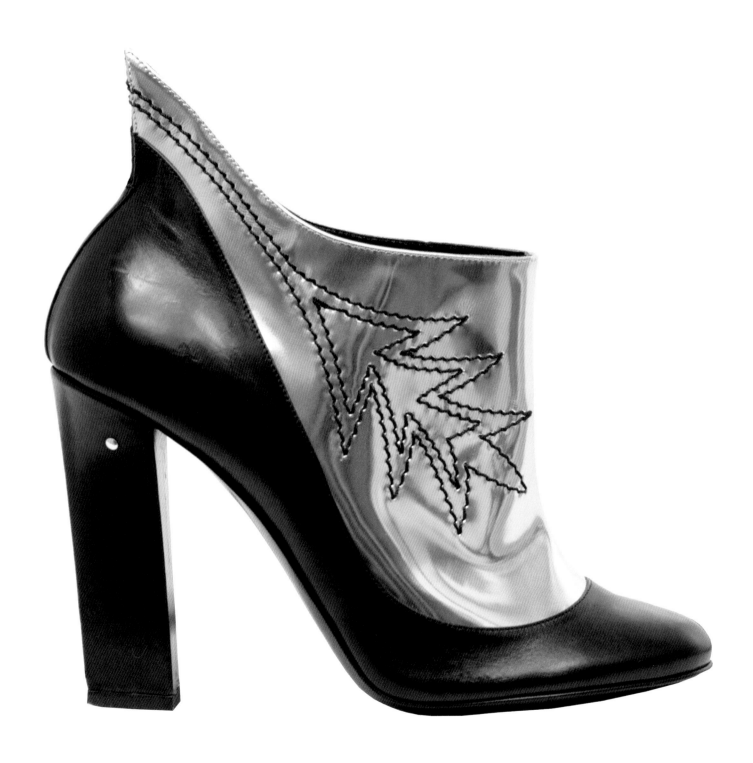

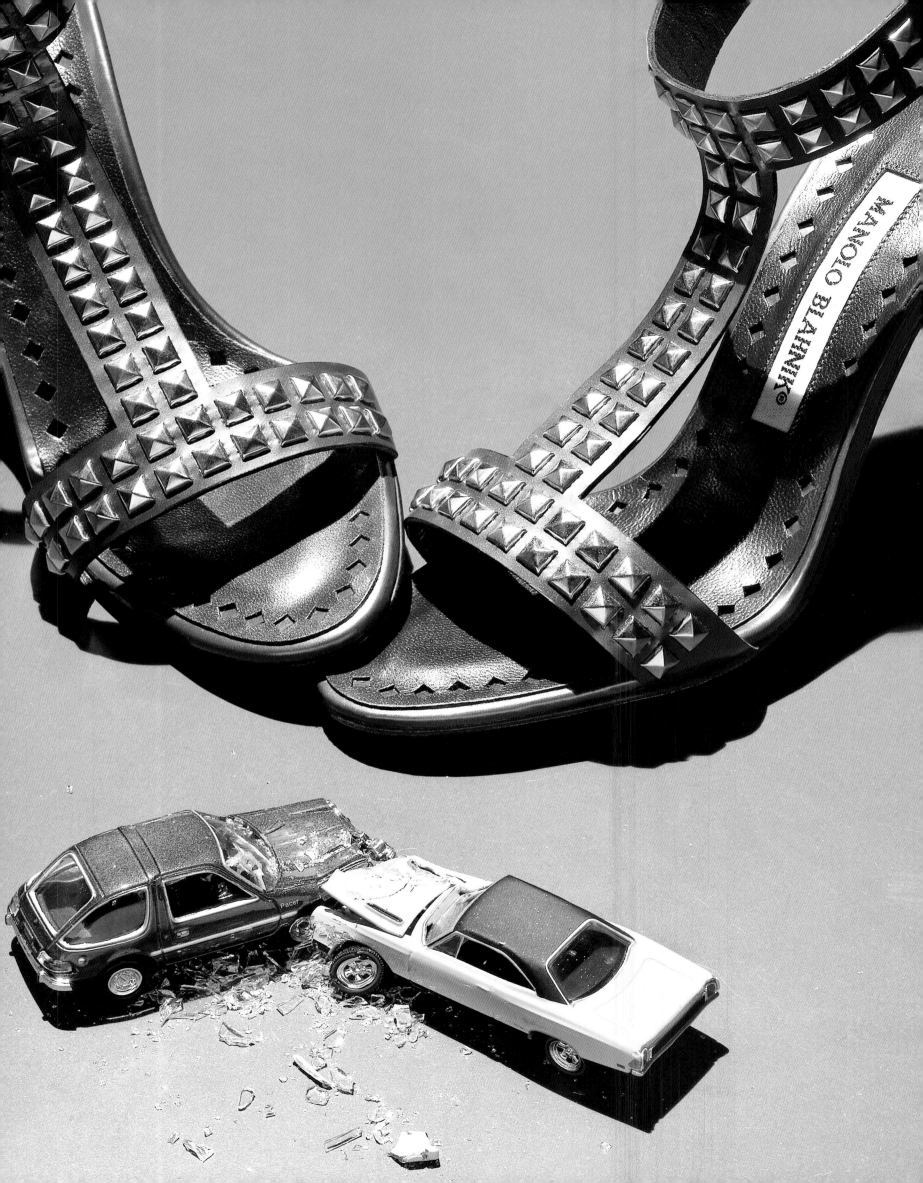

Manolo Blahnik is one of the most influential shoe designers of all time. Born in the Canary Islands in 1942, Blahnik moved to Geneva to study languages and art, and then to Paris, where he became a set designer. It was only after visiting New York in 1970 that he decided to focus on shoemaking, when Diana Vreeland, then editor in chief of *Vogue*, encouraged him to pursue this passion. Blahnik began designing men's shoes, but soon found them to be very limiting. He turned to women's shoes shortly thereafter and was able to make them stand out because they were very different from other shoes of the era: while the majority of other designers were creating clunky heels and platforms, Blahnik chose to instead focus on stilettos. Madonna has been quoted stating that Manolo Blahnik shoes are "better than sex" and that they also "last longer." Blahnik is solely responsible for his thousands of shoe designs, as he works without the aid of assistants. The legendary designer's earlier sketches, drawings, and memorabilia are so remarkable that they were featured in a 2003 exhibit at the Design Museum in London.

# MANOLO BLAHNIK

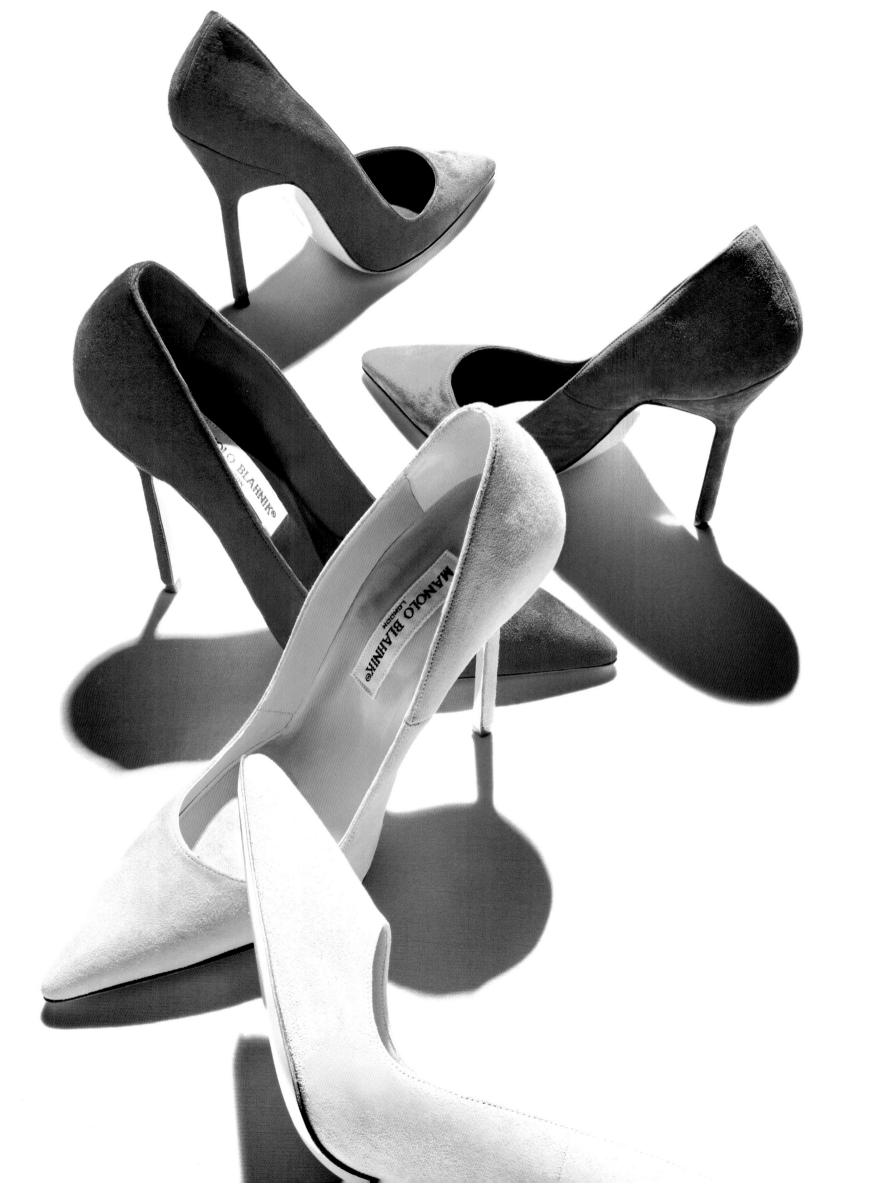

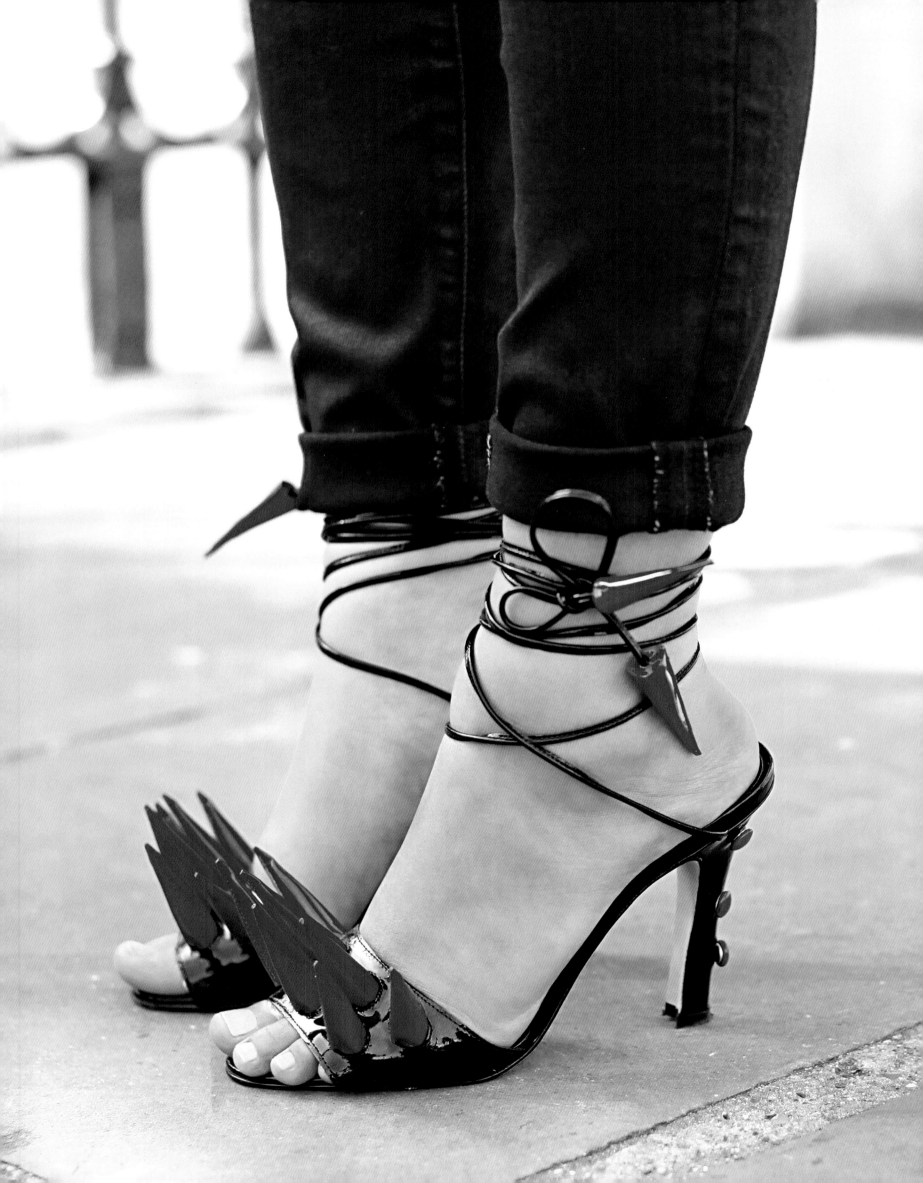

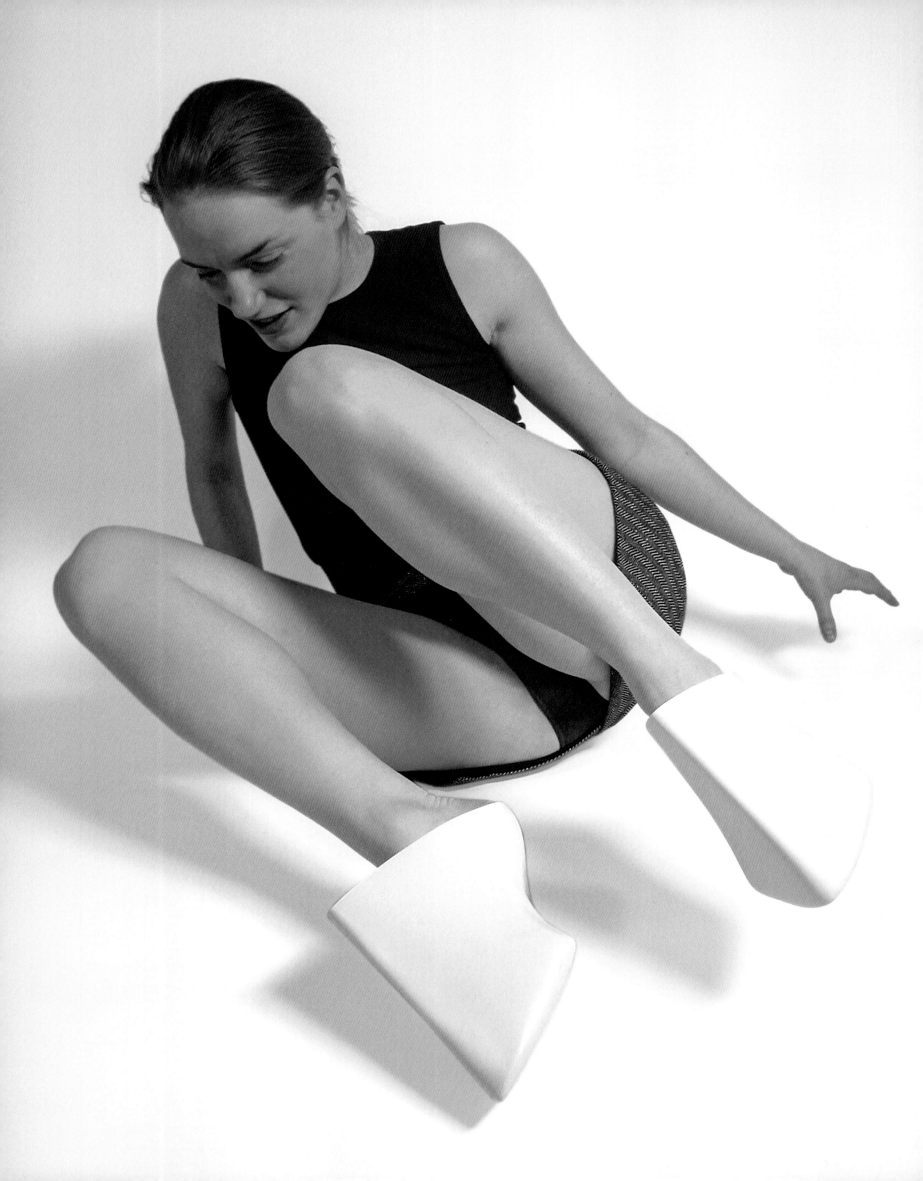

Originally from Duiven, the Netherlands, Marloes ten Bhömer studied product design at the Higher School of Arts Arnhem before graduating with a master's degree in design from the Royal College of Art in London. Ten Bhömer's inventive and unique shoes greatly differ from existing industry norms and typologies. At times closer to architecture than to fashion, her creations feature a design base founded on distinct materials, avant-garde construction techniques, and clean lines. In fact, she is recognized as a master of design and an architect of construction more so than as a designer, as her creations frame the foot like buildings. Not conforming to existing ideas about design, her shoes give their wearers the rare opportunity to be free from conventional fashion clichés and codes. Ten Bhömer's work has been widely exhibited and published on an international level, notably at the Design Museum London, the Krannert Art Museum in Illinois, Platform 21 in Amsterdam, and Tokyo Designers Block. In 2009, ten Bhömer's work was nominated for the Brit Insurance Designs of the Year award. In 2010, she was selected for the Jerwood Contemporary Makers prize and exhibition and was shown in an exhibition on fashion and technology at the Design Museum in Holon, Israel. In 2011, her work was displayed at the *Power of Making* exhibition at the Victoria & Albert Museum. That same year, ten Bhömer was awarded the Stanley Picker Fellowship for Design. Today she continues to be published and exhibited internationally.

# *MARLOES* TEN BHÖMER

*CREATING SHOES THAT FRAME THE FOOT LIKE A BUILDING ENCAPSULATES THE SPACE AROUND IT, MARLOES TEN BHÖMER IS RECOGNIZED AS A MASTER OF DESIGN AND AS AN ARCHITECT OF CONSTRUCTION.* After completing her studies in the Netherlands and in London, where she earned a master's in design products, ten Bhömer founded her business. She prefers calling it a "practice" as opposed to a design studio, the more common terminology. Within her practice, ten Bhömer applies her talents in various arenas, from museum and private commissions to consultancy work, teaching, and lecturing. "My present work focuses on construction, materials, and pattern cutting, as well as sustainable ways of producing and selling footwear."

Ten Bhömer's inspirations include abstraction, materials, and technologies that push the limit. They are evident in her work, which looks more surrealistic than realistic. Another major influence on her work is the inherent logic and mystery in machines and their highly specific language of efficiency.

More recently, ten Bhömer's starting points deal with ideas she has about aesthetics, structure, and methodology. She never creates collections, but aims to stay away from conventional style clichés and codes, such as sporty, girly, and feminine. "Rather than designing shoes based on industry standards or customer profiling, which I think mostly leads to stereotyped footwear, my approach is to use materials and technologies to discover the shoe anew. Each shoe serves as an example of new aesthetic and structural possibilities, while also serving to criticize the conventional status of women's shoes as cultural objects."

The *Rotationalmouldedshoe* (ten Bhömer's one-word names are a few words joined together) is a case in point; the use of a mechanical process plays a large role in the concept and serves as a critique on the extrinsic value of mechanically produced objects versus handmade objects. "With my work I am consistently aiming to challenge generic typologies of women's shoes through experiments." Ten Bhömer's favorite example of this is her *Carbonfibreshoe*. "What is most successful about the design is that it does not conform to conventional style."

As with any industry, accolades are dished out from time to time to those with talent that reigns supreme, and ten Bhömer has been one of them. In 2011, she was awarded the Stanley Picker Fellowship in Design, which she will use for research into the structural parameters required to support a foot in motion (in a high heel). "The aim is to completely replace common or traditional shoe manufacturing methods with materials and construction techniques (both with resulting aesthetics) developed in architecture and engineering industries," explains ten Bhömer.

The designer has never had a fashion icon because she believes that would lead to aspiring to someone else's aesthetic. Despite this, there are certain designers ten Bhömer holds in higher esteem than others, Issey Miyake being one and Dai Fujiwara being another, particularly for their *A-POC* projects. Ten Bhömer enjoys collaborations outside her field in order to understand questions and challenges from others. "Innovation very often proves difficult," ten Bhömer professes, "especially when it comes to collaborating within the fashion industry system." Tight lead-times and an inability to think beyond the next launch date makes it economically very difficult. "Ultimately, I would like to produce a piece of footwear that is positioned completely outside the industry." Ten Bhömer's current position in a more academic milieu—as a guest professor at the Universität der Künste Berlin and research fellow at Kingston University—will help her rethink style as we know it and continue to push the boundaries.

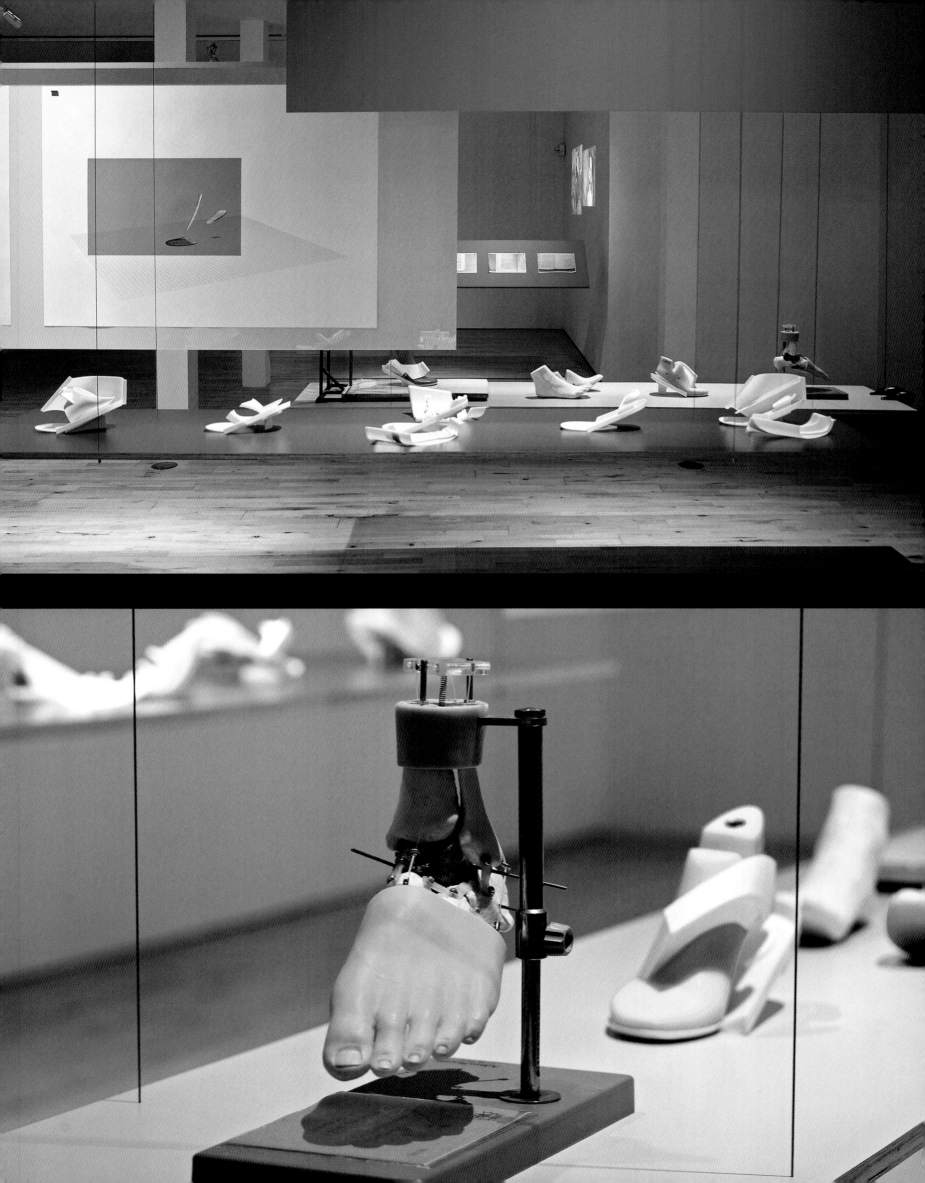

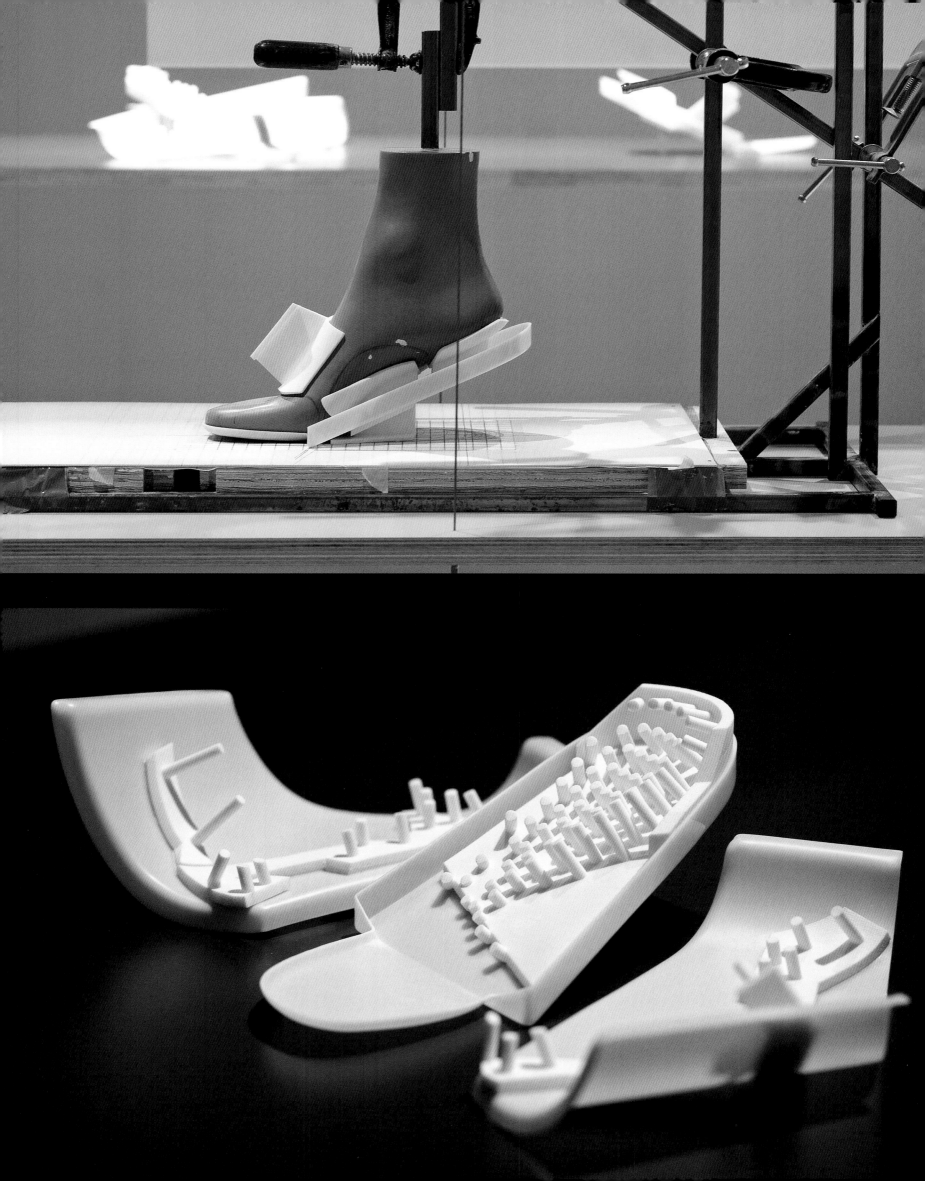

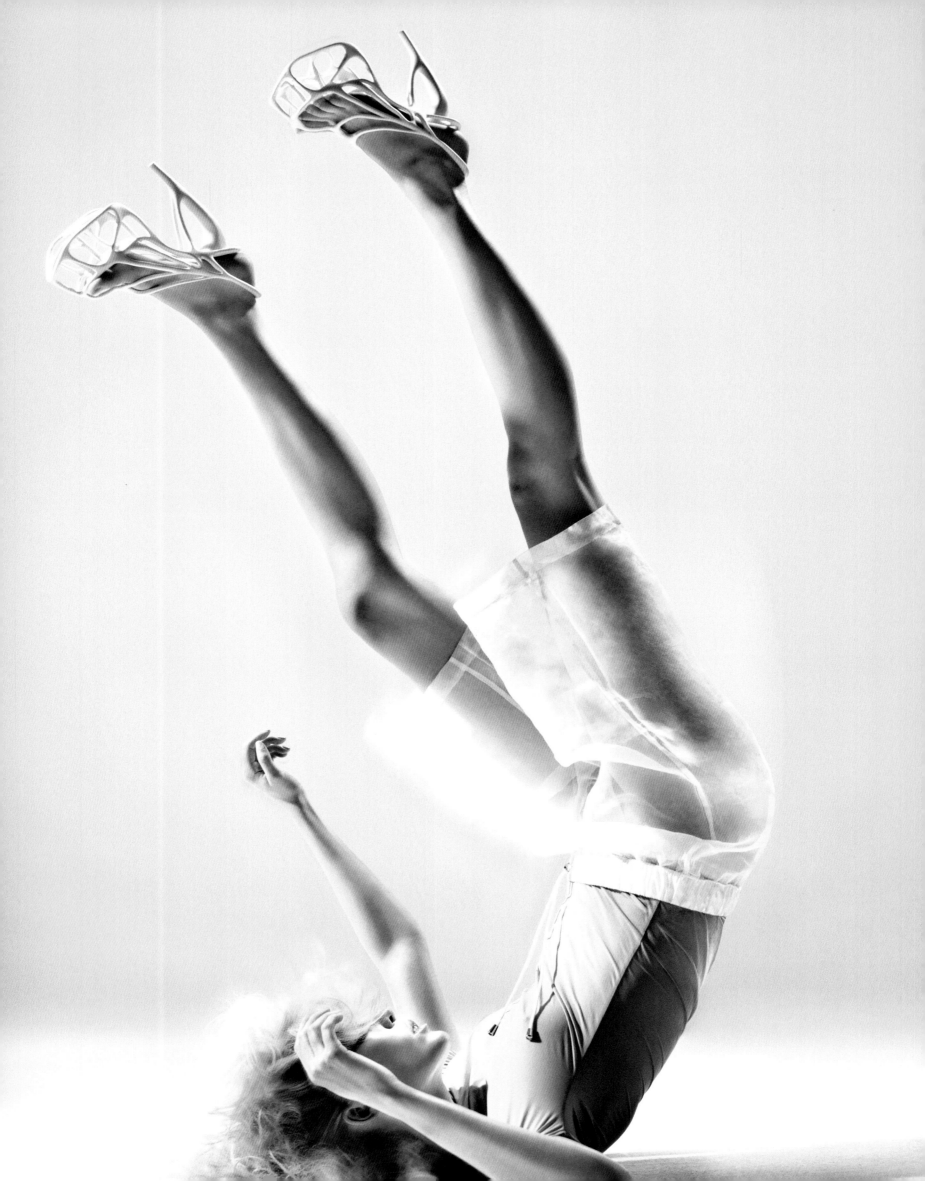

Naim Josefi is a 2011 graduate of Beckmans College of Design and is based in Stockholm. He presented his debut collection, *Melonia*, at Stockholm Fashion Week while still a student there. Before pursuing the craft of shoe design, Josefi trained as a tailor and worked in Sweden and throughout Europe before developing and launching his company. In addition to his eponymous brand, Josefi has also designed for other Swedish brands. His three-dimensional shoes were nominated for a Brit Insurance Designs of the Year award at the London Design Museum, and—despite their futuristic appearance—are fully functional. Josefi doesn't believe talent is innate, but from his ability to create fantastically successful shoes right out the gate, it seems to be for him. He also holds that artistic sense is developed through experience and passion.

*NAIM*
JOSEFI

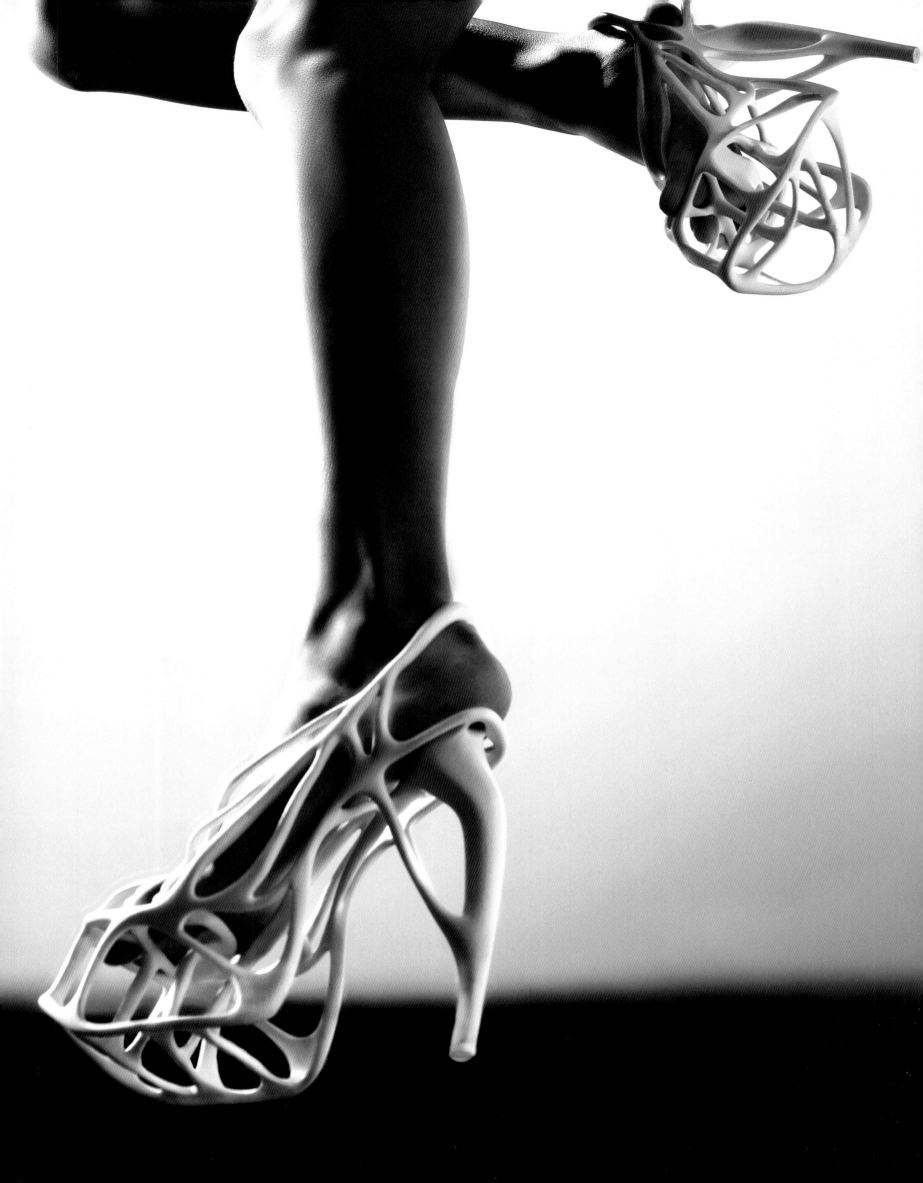

*TO SUM UP THE IMPORTANCE OF FOOT-WEAR, THE DESIGNER NAIM JOSEFI TAKES IT DOWN TO ITS ESSENCE.* "I am a fashion designer. To obtain the whole look, you need shoes, for shoes are a very important point." As a designer who goes beyond mere shoe design and into the depths of the avant-garde, his ability to encapsulate what he does comes easily. Josefi is best known for his three-dimensional printed shoes that outline the foot and almost appear like a cutout. Albeit futuristic, Josefi's 3-D shoes possess function as well as style; they are completely one-of-a-kind and tailor-made for each foot, making them extremely comfortable. "I believe all women should wear high heels at every opportunity, since with high heels you are sexier and have better posture."

While still a student in Stockholm, Josefi produced and presented his first collection. The following year, he earned a nomination for the Brit Insurance Designs of the Year award at the London Design Museum for his 3-D printed shoes. Josefi's fellow nominees included an impressive list of established designers, such as Lanvin, Comme des Garçons, Gareth Pugh, and Jil Sander. Josefi's shoes were also exhibited at London's Victoria & Albert Museum during the London Design Festival.

Given his instantaneous sudden recognition, Josefi does not believe in innate talent. "We were not born artists," he claims. "Experience and passion developed my artistic sense." He created his first shoe while still in the midst of his education. "It was a success," he acknowledges, although one of his biggest obstacles was dealing with an economy yet to get back on its feet. Thinking about his future as a businessman as well as an artist proved necessary, and Josefi has worked to put all of his efforts into his vision. "There is no difference between commerce and art. My company invites a different world, a design for a new, creative way of blending elegance with playfulness and optimism. It's more like a tailor's shop that uses exclusive material and has a curiosity about the future."

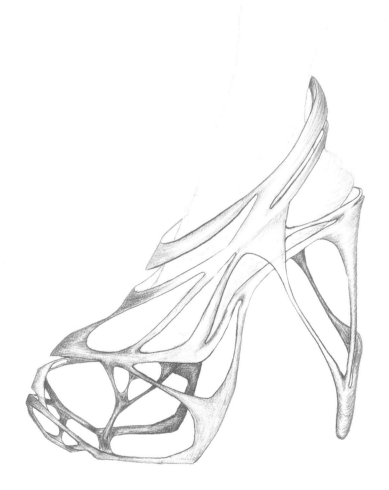

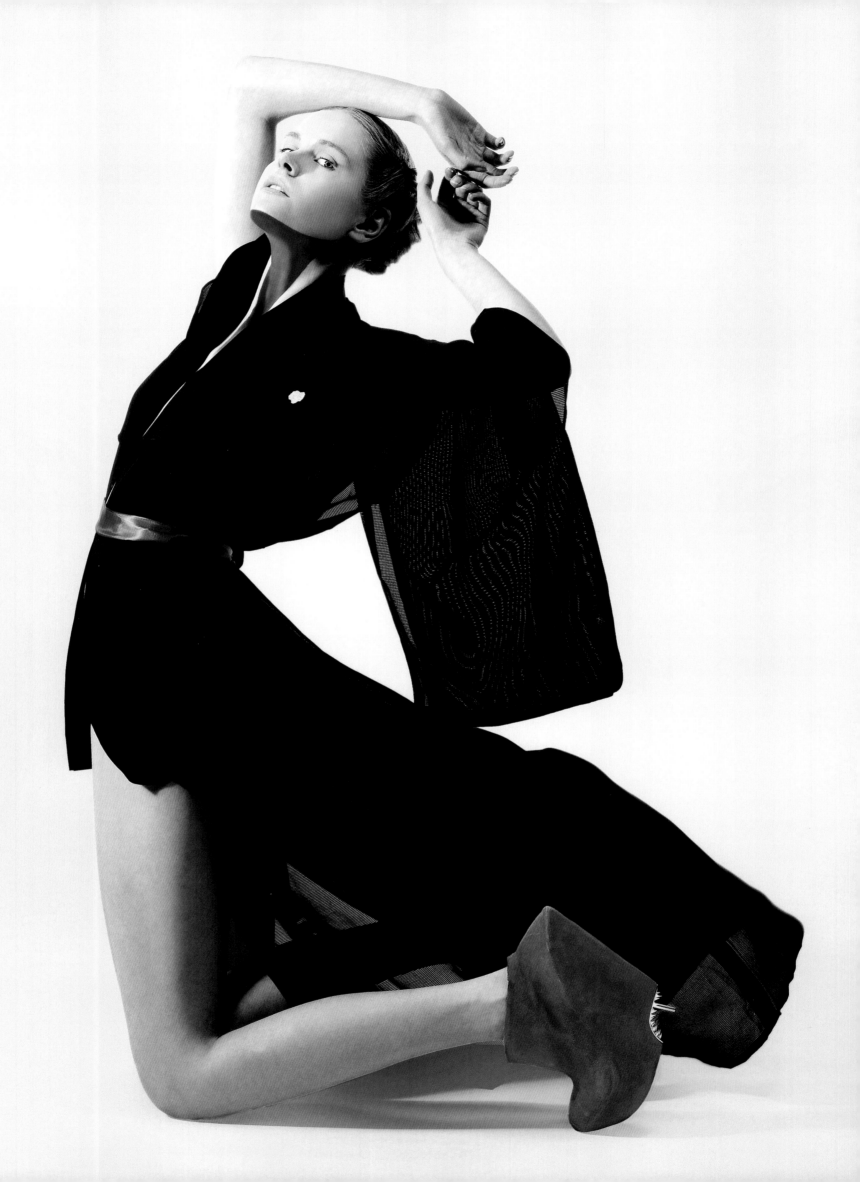

Netta Makkonen is an up-and-coming London-based designer whose debut collection directly comes from her London College of Fashion final master's degree project. Prior to moving to London, she studied footwear design in her native home of Finland. Makkonen's shoe collection was made to reevaluate and challenge the traditional silhouette of high heels in the context of contemporary fashion, and her aesthetic vocabulary concentrates on form more than decorative elements. She enjoys toying with the small surface of a high heel by introducing sculptural forms, and then observing how these shapes hide the foot's arch while still creating a heel that is flattering and proportional.

# NETTA MAKKONEN

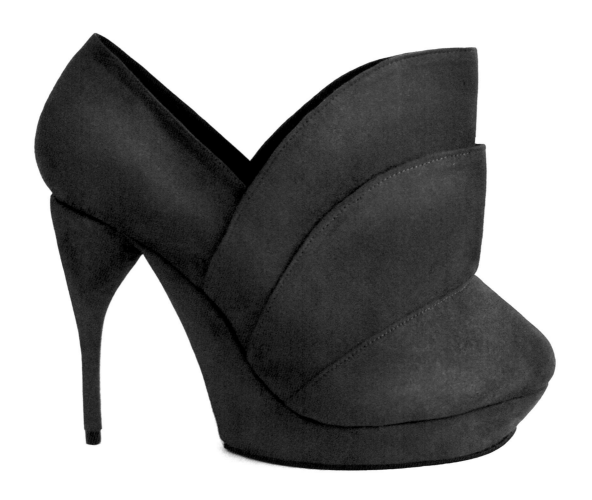

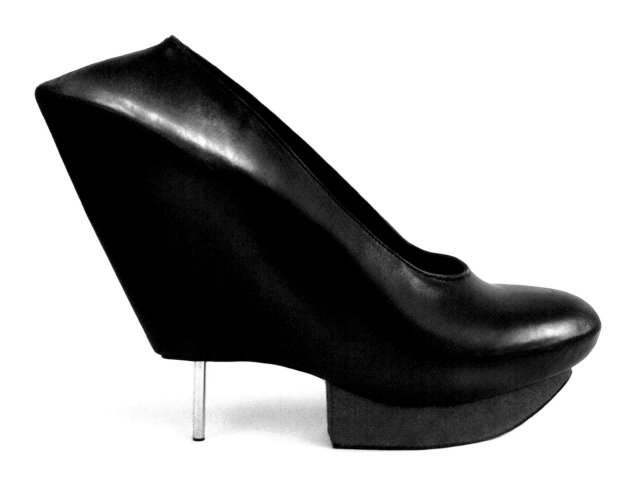

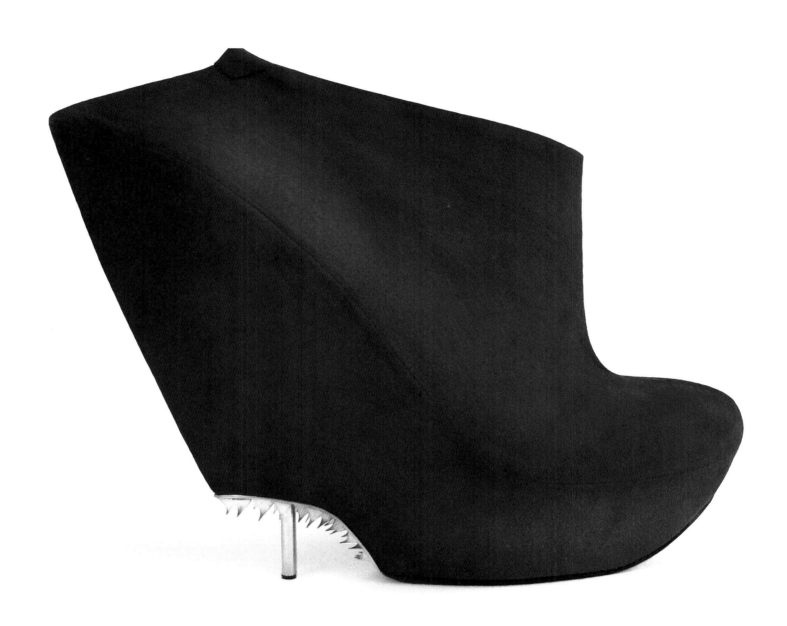

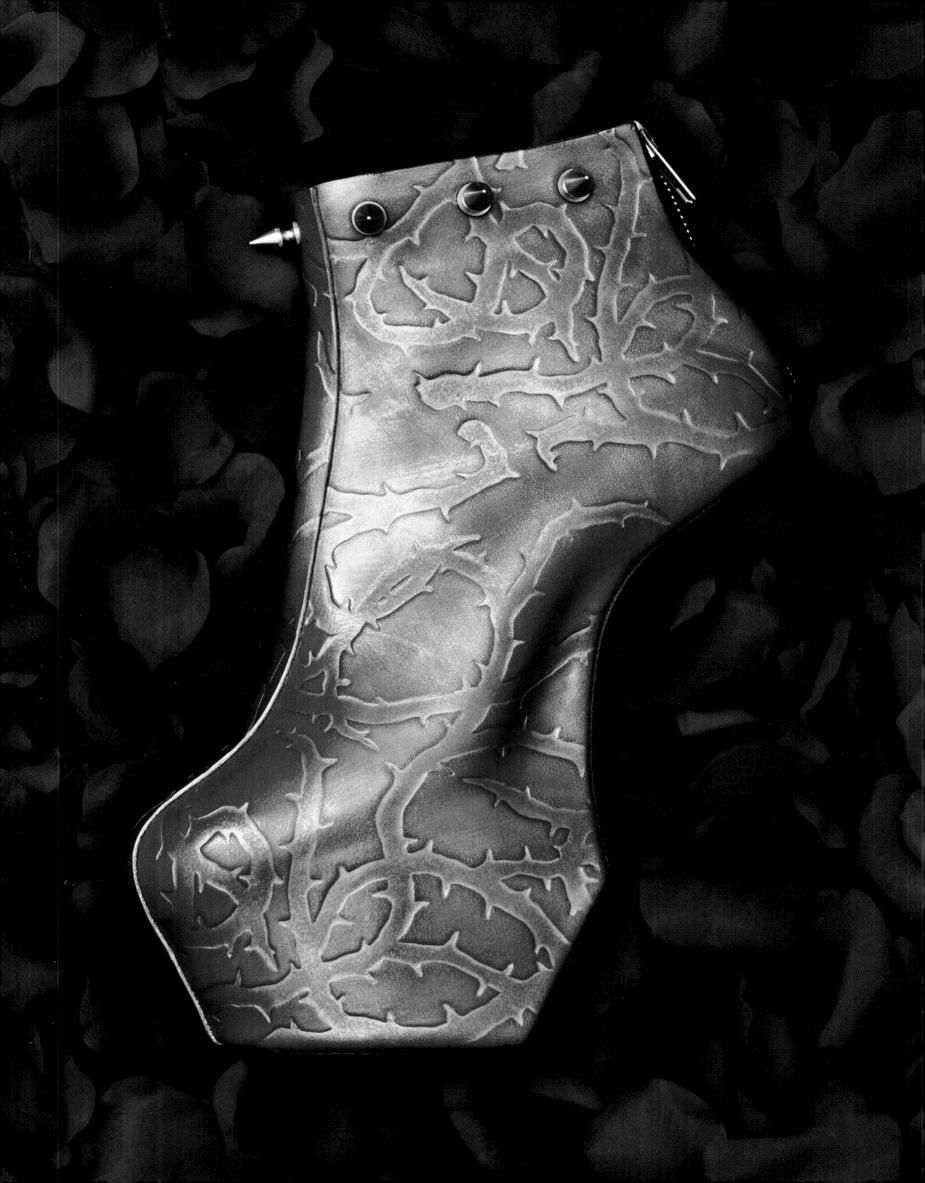

Born in 1985 to a family that owned a public bathhouse in the center of Tokyo's red-light district, Noritaka Tatehana began creating shoes and clothes when he was fifteen years old. The self-taught designer decided to expand his knowledge by getting a formal education at Tokyo National University of the Arts, where he studied fine arts and sculpture; he eventually majored in dyeing and weaving. Based in Tokyo, Tatehana strives to present Japan's rich creative and cultural evolution through his craft. Each of the shoes in his collection are handmade and manufactured exclusively by him. He is widely known for his sky-high heel-less shoes that have been worn by Lady Gaga, among others, for not only drawing attention from the fashion industry, but from the art world as well. Tatehana's 2010–2011 Fashion Week collection has been permanently stored in The Museum at the Fashion Institute of Technology in New York.

# NORITAKA TATEHANA

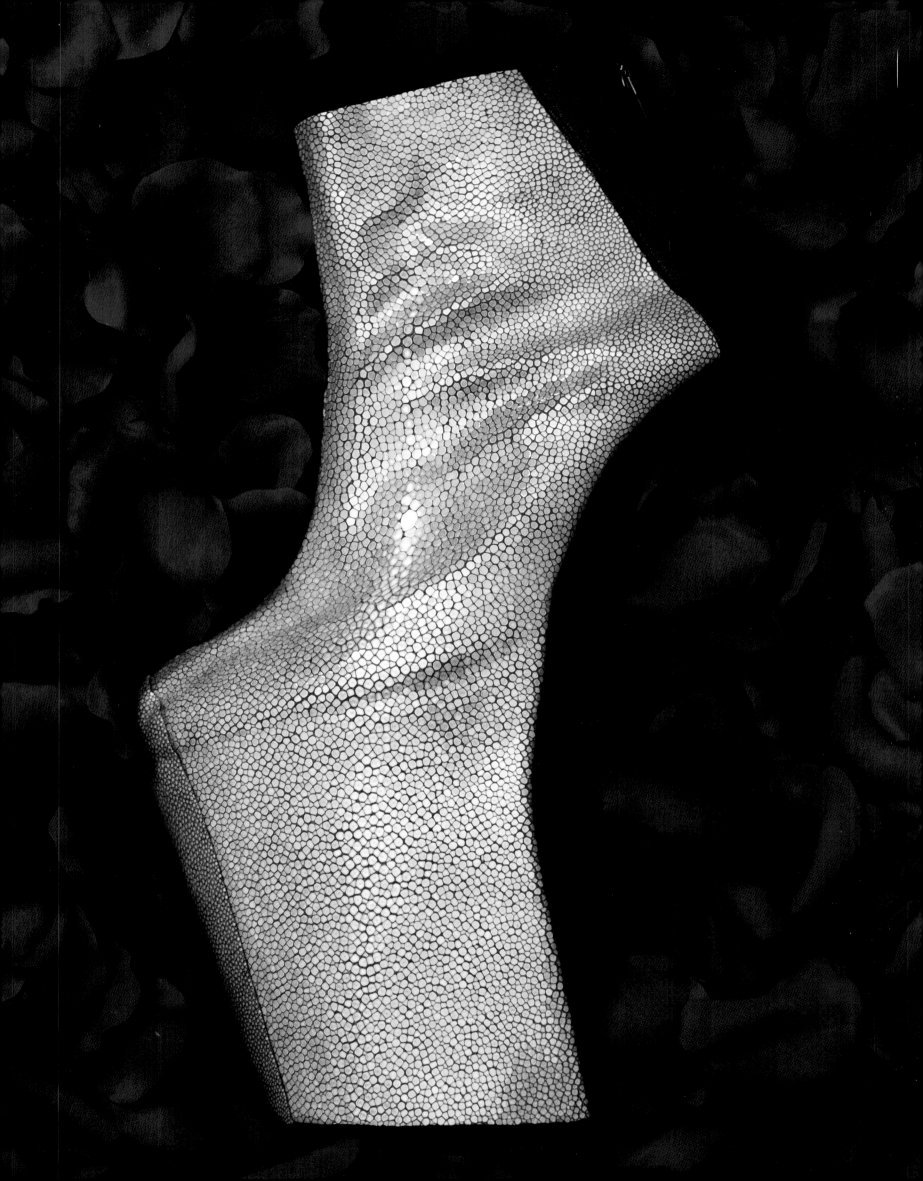

*WITH HIS SKY-HIGH SHOES WITH STUDS DRIVEN INTO ENGRAVED LEATHER, IT SHOULD BE NO SURPRISE THAT NORITAKA TATEHANA RECEIVED FREQUENT CALLS FROM NICOLA FORMICHETTI, LADY GAGA'S FORMER STYLIST.* "One of the most memorable episodes was making a ballet shoe for her called *Lady Pointe*," says the Japanese designer. "She wanted to have huge toe shoes to be a ballerina in a music video. I kept wondering how I would formulate them, but after a while, it turned out to be very simple." Tatehana finds that simplicity emerges when there is one theme driving his creativity forward and when the focus is clear.

The pop star could not be a better match for Tatehana; the former is lauded for her daring use of footwear, onstage and off, and the latter is lauded for creating such footwear, which pushes the boundaries of what we know to be a shoe. What Tatehana had in mind when he launched his career was an attempt to echo his identity. "I was born and brought up in Japan, surrounded by its unique cultural elements," he explains. "I now work globally and am in the thick of the scene." Tatehana values traditional Japanese culture for all it offers but is also grateful to present its evolution through his craft. He realizes that as a country, Japan has yet to achieve a certain measure of modernity on the world stage.

Tokyo serves as his professional home, with his atelier located in the neighborhood of Aoyama, a place that is central to Tokyo's luxury fashion market. Tatehana lives outside the bustling city, in Kamakura, one of the country's current cultural hotspots. "Kamakura is such a beautiful place. It is full of inspirations," Tatehana says.

What originally spawned the career of the twenty-eight-year-old designer was an article on Maison Martin Margiela he had read while still in high school. "As I read through the article, I learned that fashion was a communication tool that could be made real. Before that, my notion of it was that designers made beautiful things; it was a perception of what is on the surface more than anything," Tatehana recalls.

The article's message clearly took hold: Tatehana's bravura has been noticed by his peers as well as those in the greater artistic community. In 2011, his work was featured in the Comme des Garçons Trading Museum concept stores in both Tokyo and Paris. Additionally, the collection including his *Lady Bell* shoe, the design he is most proud of, is in the permanent collection at FIT.

Tatehana believes that artists are responsible for what they produce, as their designs achieve a permanence that forces them in that direction. "I'm always thinking about this figure that is a shoe and feel responsible for what I create," he says. "I get fed images by all kinds of encounters, vivid images that make for constant design inspiration."

Tatehana additionally feels obligated to have his designs firmly entrenched in the avant-garde, helping generations to come expand into new possibilities for fashion. "It's not about what is right or wrong, but about discovering that design is in perpetual flux. I'm not here to say haute couture is worth more than fast fashion," he states. "In fact, fast fashion may be more representative of the consumption that is out there."

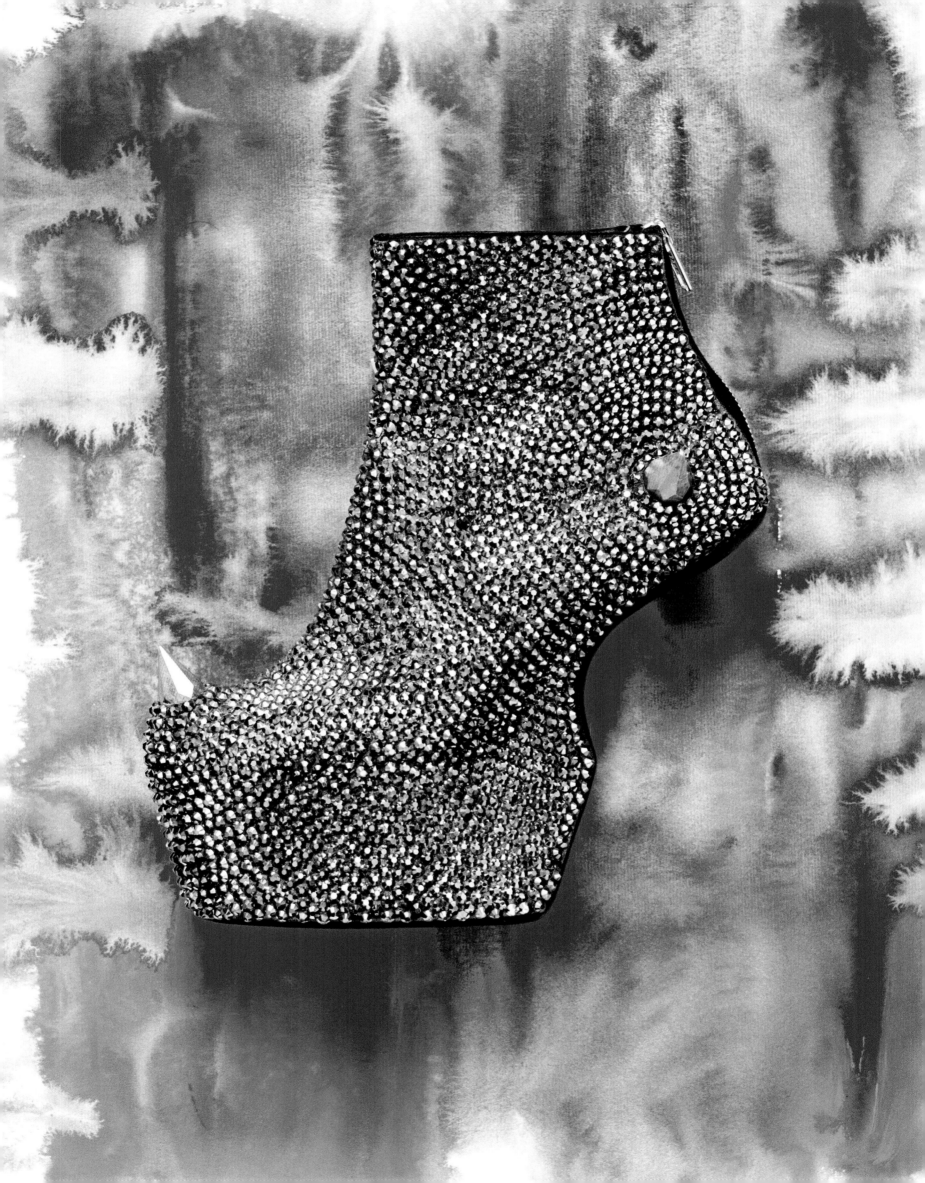

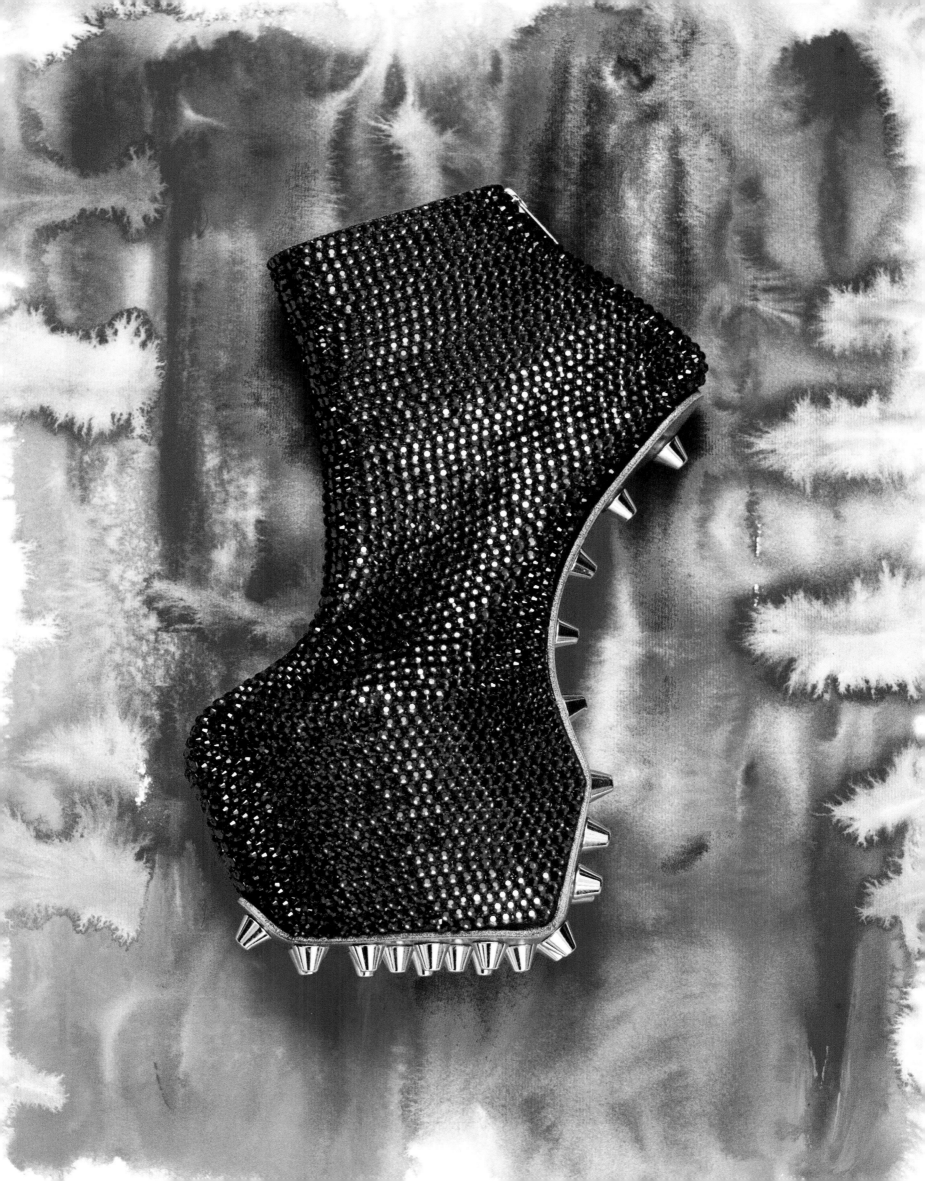

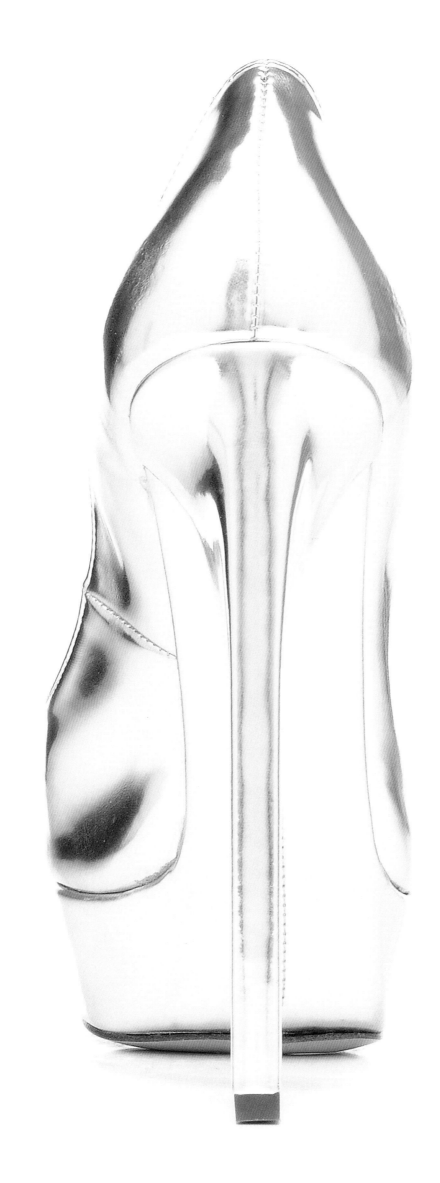

For some women, owning 1,200 pairs of shoes would be a dream that they would hope to attain in their lifetime. "The more the better," they might say. There is no level, no limit, and certainly no end to the amount of shoes one could obtain. No closet too small, no crevice untouched, no shortage of space under the bed for just one more pair. Director Julie Benasra knows this all too well as the creator of a 2012 documentary entitled *God Save My Shoes*. In her directorial debut, Benasra takes viewers into the closet—actually, the *four* closets—of shoe lover Beth Shak. Each closet in her suburban Philadelphia residence is filled stem to stern with footwear, supposedly the largest private collection of high heels in the United States. A professional poker player, Shak takes shoe-aholism to new heights—sky-high stiletto heights, that is. Shak is obsessed with high heels—all of the shoes in her closets bear that status, and not one is of the lowbrow variety. Of the 1,200 shoes in her collection, seven hundred are from the luxury French shoe designer Christian Louboutin. This is indeed a woman who would spend her last penny on shoes, big jackpot win or not. The never-ending obsession with shoes begs the never-ending question: *why?* What is it about the object, the accessory, the art form, that makes it not just wearable, but collectible? Here, Julie Benasra discusses the unique fascination, the connection, and (sometimes) the addiction women have with shoes.

# *GOD SAVE MY SHOES:* JULIE BENASRA

**Q:** *WHAT WAS YOUR PERSONAL FEELING ABOUT SHOES WHEN YOU FIRST BEGAN THIS DOCUMENTARY?*

**JB:** When I started the project, I didn't think I could draw inspiration with my own lack of desire for shoes. I thought that to truly understand women's fascination with shoes I had to reach out to serious shoe fanatics. Out of curiosity I counted the number of shoes in my closet and was surprised to find that I own forty pairs, and I don't even have a major love for shoes. Then came the sense of mutual understanding when I began speaking with shoe aficionados.

*IN YOUR OPINION, WHERE DOES THE ROOT OF THIS DESIRE COME FROM?*

Well, shoe lover or not, every single woman I contacted spoke so fondly of shoes. I found that women tend to expose a different side of their personalities with every pair. For instance, when you put on black thigh-high boots or red patent leather high heels, you are not giving off the same message as when you are sporting ballerina flats or plain flat boots. In general, high-heeled boots give off a more domineering personality. Flats, on the other hand, reflect a more casual kind of girl. The right high heel can express a feminine personality. Shoes allow you to change, to be someone else, and it is part of the Cinderella fairy tale.

*ARE SHOES A CRUCIAL PART OF THE FEMININE COSTUME?*

Shoes allow women to go into a fantasy world but with a touch of reality intertwined. You might not wear a super sexy top with cleavage because you think it is inappropriate, but you will allow yourself to wear super sexy shoes for the same—yet more modest—effect. High-heeled shoes are a more socially acceptable sexy costume—they permit you to pull your personality to the extreme.

*IS THIS HOW PEOPLE SEE THE WOMAN WEARING THE SHOE, OR WHAT THE WOMAN EXUDES IN CONFIDENCE?*

It has a lot to do with the shoe itself. It's the only accessory that actually changes your body shape. Men's shoes don't change their bodies. When a woman wears high heels, she walks with better posture and much more confidence. And from that physical change in posture and shape, she feels more powerful.

*HOW DO SHOES HELP EMANATE CONFIDENCE?*

It is a known fact that you walk slower and are more careful of your movements in high heels. Slowness is a feminine quality. When I say slowness, I mean a graceful aspect. High heels instantly force you to be a little more feminine.

*LIKE THE KIND OF FEMININITY IN TRYING TO WALK ACROSS A PARISIAN COBBLESTONE STREET IN A PAIR OF NINE-INCH HEELS.*

Every shoe designer will say if you can't walk in heels, then don't. There's always a little excitement in the danger associated with wearing heels. If they were 100 percent comfortable, then I'm not sure if we would have so much fascination—as well as desire—for them. Personally, I didn't find myself crazy about heels, but now when I want to feel feminine, I immediately grab a pair. And it goes without saying that when women perceive themselves as more attractive and feminine, they immediately communicate confidence.

*IT'S TRUE. NOT ONLY DO HIGH HEELS BOOST CONFIDENCE, BUT THEY ALSO ENHANCE EVEN THE SIMPLEST OF OUTFITS.*

That is the next important aspect to shoes, the fashion aspect. They are the most important accessory to any outfit. Unlike all other accessories—a hat, glove, or purse—that are items you can take off, with shoes you cannot remove them. Shoes are always an extension of an outfit. And because of this, accessories are one of the only

market segments that keep going up in price regardless of the economic crisis.

## WHY DO YOU THINK SHOES HOLD AN IMPORTANT ROLE IN SOCIETY?

The foot has always held an important role in different civilization periods. In many cultures, feet are adorned in a certain way. I found out that not just today, but also historically, high heels were proportional to social status. In *God Save My Shoes*, we show a pair of fifty-three centimeter–high chopines that were worn during the Renaissance era in Venice. The women had to walk with servants, which displayed their wealth and social status. Another way they showed their wealth was in lengthening their skirts with more fabric, which was very expensive at the time.

## WITH TODAY'S PRICES FOR SOME OF THE MOST DESIRABLE SHOES, THE ACT OF DISPLAYING ONE'S STATUS HAS NOT CHANGED MUCH.

Shoes are definitely a sign of social status. I don't think Louboutin created his signature red soles for nothing. There are women who would starve themselves for months for a pair of Louboutins.

## BUT IS THERE A POINT WHERE THIS LITERAL STARVATION FOR SHOES BECOMES AN OBSESSION WHERE THERAPY IS IN ORDER?

Why therapy for a very legal and harmless addiction? Besides hurting your finances, who are you hurting? In the first two minutes of the film, one of the women featured says that she was very unhappy in one point of her life, and so she bought many pairs of shoes for immediate comfort. There is a comfort factor in addiction. Addiction always depends on how obsessed you are. I don't want to be judgmental and sound like a therapist, but those who excessively hoard anything are filling up a void. In my opinion, it's healthier to fill that void with shoes, rather than food or drugs.

## WHAT WAS THE MOST SURPRISING PIECE OF INFORMATION YOU LEARNED DURING YOUR RESEARCH?

Even though my focus was on women and their relationships with shoes, the most surprising fact was the proposed root of men's fascination and attraction toward women in high-heeled shoes. It is said that when a women slips into a pair of high heels, her feet mimic the position she is in during an orgasm.

## HAS THIS BEEN PROVEN?

It's a Freudian way of approaching the love of shoes. There's also this other psychological analysis to it that says the foot represents the penis and the shoe represents the vagina. One of the women in *God Save My Shoes* talks about this phenomenon and says whether you know it or not, it's unconscious.

## IS THAT WHY YOU THINK WOMEN LUST AFTER SHOES, AS IF THEY WERE SEXUAL OBJECTS OF DESIRE?

It's like a bad boyfriend. You know it's bad and dangerous for you, but you still want it because it's thrilling.

## YOU SPOKE WITH SOME OF THE TOP SHOE DESIGNERS IN THE WORLD FOR THE FILM. HAVE YOU FOUND A COMMON TRAIT THEY ALL SHARE?

Every shoe designer venerates women, whether they are gay or not. They truly worship women— you can see it in their eyes when they speak about shoes.

## BUT ON THE OTHER HAND, SHOE DESIGNERS ALSO PUT WOMEN THROUGH A LOT OF PAIN AS WELL. SHOES CAN BE EXTREMELY RESTRICTIVE AND LIMITING—SOMETIMES EVEN PAINFUL AND DEFORMING—AS WARNED BY MOST ORTHOPEDIC SURGEONS.

I don't get too much into that in the film for one reason: women don't care. Even the doctors I've

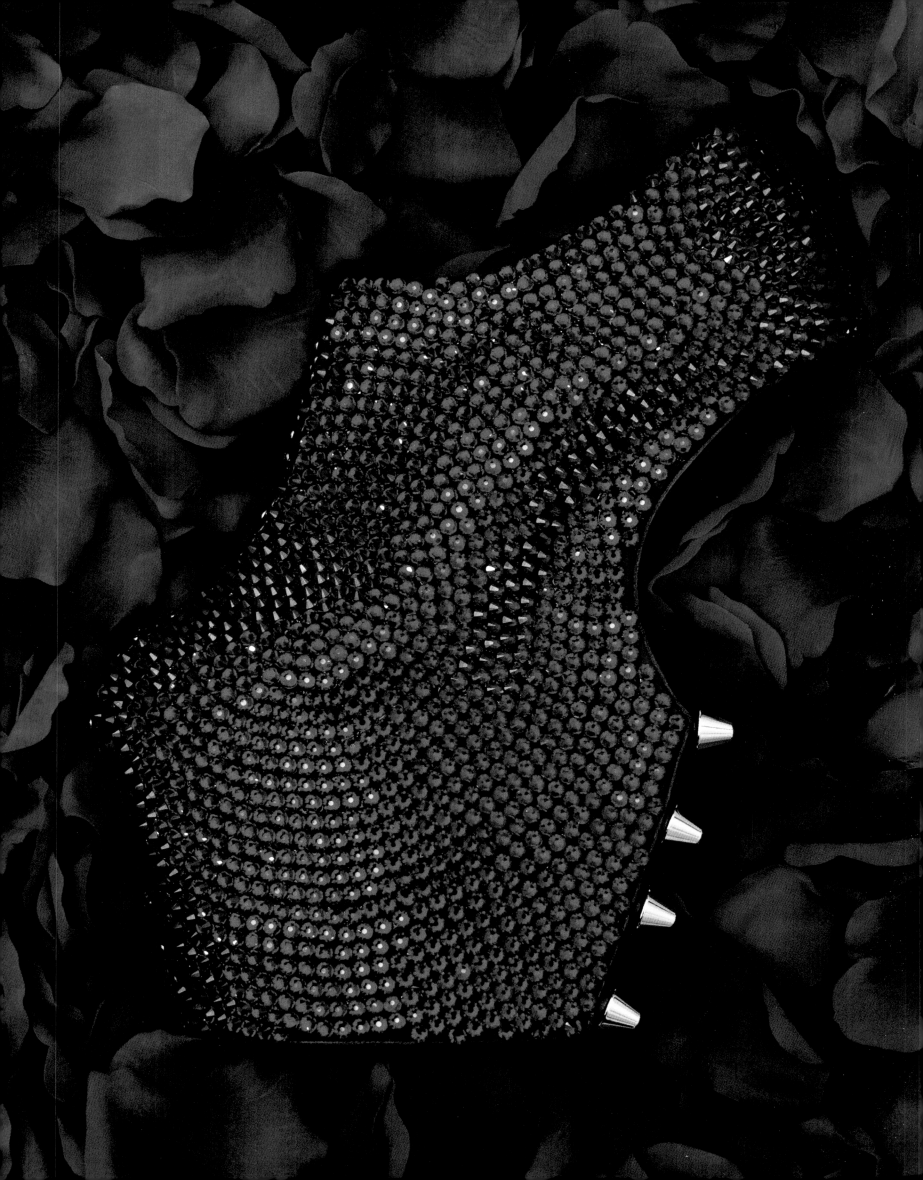

interviewed say that no matter how many times they tell their patients to take care of their feet, the plain and simple fact is that women are not concerned with it. Doctors try to advise patients to wear sensible heels, but they know it's useless.

*AFTER COMMUNICATING WITH VARIOUS DESIGNERS, WHAT IS THE BIGGEST OBSTACLE IN SHOE DESIGN IN YOUR OPINION?*

The height problem. They all want women to wear heels that are higher and higher. But we are not like Barbie, whose feet are shaped to only walk in heels. Our feet are flat.

*SEEING AS YOUR DOCUMENTARY HAS HELPED YOU BECOME SOMEWHAT OF A SHOE EXPERT, DO YOU HAVE ANY ADVICE FOR SOMEONE WHO WANTS TO BREAK INTO SHOE DESIGN?*

Surprisingly, most successful shoe designers are male. It's a cobbler's craft handed down from generations—a men's trade transmitted from father to son. So my biggest piece of advice is that every designer should wear their own shoes. Funny enough, though, Manolo Blahnik tries on all of his shoes, but revealed, "You know, I'm not in heaven." Walter Steiger told me, "I tried them on and I was like, I don't know how they do it." My reaction is that they should design shoes that women can be comfortable in.

*THE RESTRICTIVE NATURE OF SHOES HAS HISTORICALLY BEEN THOUGHT OF AS A WAY TO RESTRICT WOMEN'S POWER. FEMINISTS TODAY FIND THAT THIS STILL HOLDS TRUE.*

I believe the exact opposite is true. Modern-day women have decided to wear high heels the same way in which they have decided to wear corsets and red lipstick. Women have liberated themselves by taking those objects that used to be demeaning and oppressive and using them to their own advantage. Today women are in the work force, they know what they want, and they know what they need. If they want to wear high heels to feel more powerful, then it's not demeaning to them. It is a way to feel stronger. In any case, with high heels it is easier to look a man straight in his eye as his equal, rather than looking up at him.

*HOW DO SHOES PLAY A ROLE IN THE REALMS OF FETISHISM AND SEX?*

They play a huge role. Just think back to the beginning of photography, when there were many images of feet and shoes. And even though some shoe designers will not admit it, I believe they draw much of their inspiration from the world of fetishism in footwear. In the film, Dr. Valerie Steele [fashion historian, curator, and director of The Museum at the Fashion Institute of Technology] compares a fetish shoe from the 1950s to a modern Manolo Blahnik shoe from the 1990s. You only have to see the trends in shoe design to see the same fetish style recreated for the market, from bondage straps on high heels to the simple black patent leather pump. Sexuality plays a huge role just from the change in posture. Your chest sticks out, and immediately you become a lot more feminine. A therapist in the film goes further to postulate that wearing high heels renders you into sexual prey because you can't run away, whether you want to take advantage of it or not.

*YOU SAID THAT BEFORE FILMING THE DOCUMENTARY, YOU DIDN'T CONSIDER YOURSELF A SHOE PERSON. HAS THAT CHANGED NOW?*

Well, I just recently bought three pairs of shoes.

*SHOES CAN BE A CONTAGIOUS ADDICTION.*

I try not to feel bad because I made a film about shoes, so it's part of continued research.

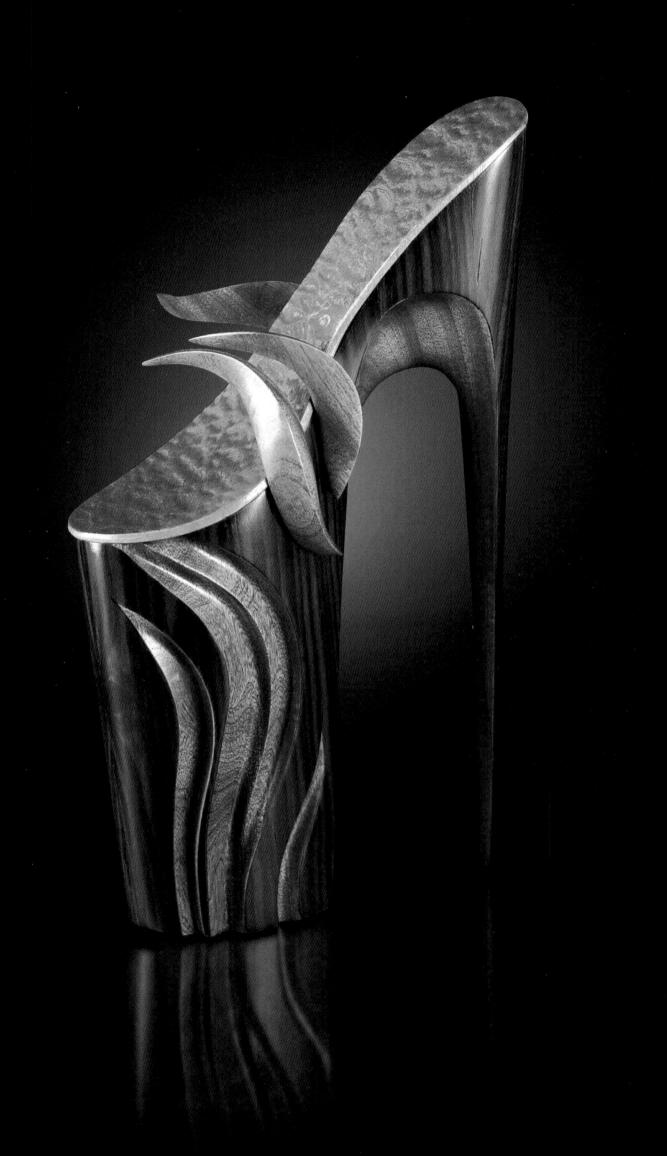

Omar Angel Perez discovered at an early age his passion for building and creating. The Texan native studied fine arts and graphic design at the University of Houston, and is also a mostly self-taught woodworker. Shoes are a new transition for the Emmy Award–winning television animator and designer. Each pair is custom built for the commissioning client, meaning that his collections are not created on a season-to-season basis. What's really put Perez on the map are his colossal wooden *Stilett "O"* shoes, which combine his passion for design and woodwork with fashion. The heels run from fifteen to twenty-four inches high—making them only for those who can handle such height and drama. A pair of his higher-than-high shoe sculptures were on display at the Fuller Craft Museum in Brockton, Massachusetts, in 2012. His craziest creation to date is dubbed the *Cradle,* a shoe covered with a fifteen-inch band sawblade. Its aptly attributed name comes from the fact that the foot is cradled within the shoe, stopping any blade from ever touching the skin.

OMAR ANGEL
PEREZ

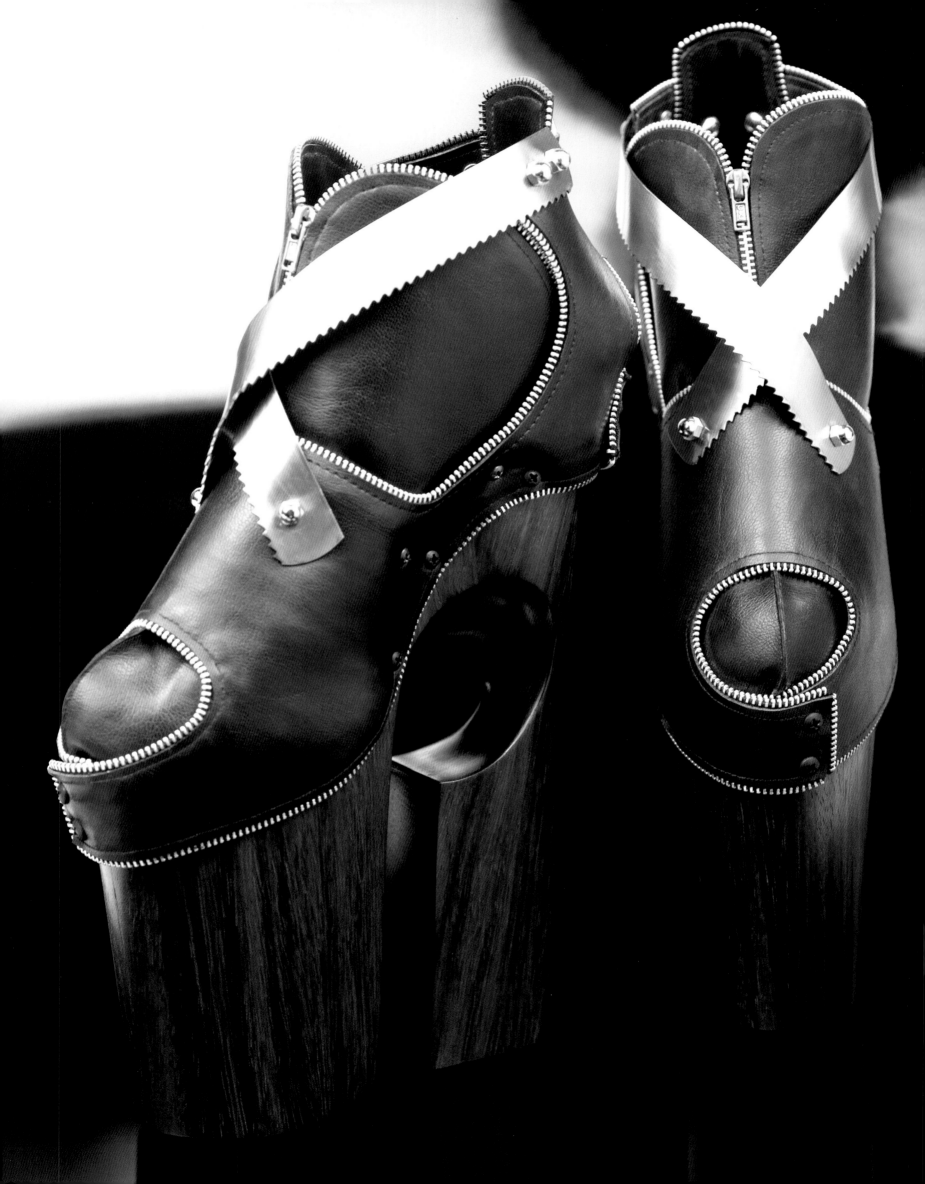

OMAR ANGEL PEREZ HAS TRANSITIONED THROUGH A FEW CAREER PATHS DURING HIS LIFETIME, WITH FURNITURE AND SHOE DESIGN AS HIS CURRENT OCCUPATIONS. In discussing his previous work, the designer almost adds as a side note that he was a broadcast television animator and designer for twenty years, even winning an Emmy for Excellence in Broadcast Graphics.

As is the case for many shoe designers, Perez has felt the sway of Alexander McQueen and Tom Ford, but because he is a woodworker, he has also been deeply influenced by master furniture makers such as Mies van der Rohe, Le Corbusier, Eames, and Wendell Castle. He describes his designs as sculptural pieces of artwork that happen to be wearable, and views them as a sculptor might study a block of wood or marble. Because he custom builds each pair of shoes, which are commissioned by private clients, his collections aren't executed on a seasonal basis.

His famous *Stilett"O"* sculptures—as he calls them—put him on the map, particularly the ones entitled *Azzurra*. "They are made from mahogany and ebony. The shoe is not overly embellished, but the woodworker in me loves the simplicity and warmth of the materials that I chose."

Despite the fact that he spends much of the year in the heat in his hometown in Texas, Perez says he does not like exposing the foot. "It's my challenge to take just enough away to reveal a striking silhouette."

Because Perez's shoes are colossal (in every sense of the word), they are only worn by those who can handle their height and drama. Perez names the outrageous creation entitled the *Cradle* as his most dramatic shoe. "It's fifteen inches high and covered in band saw blade. The foot is 'cradled' within the shoe, but no blades actually touch the skin."

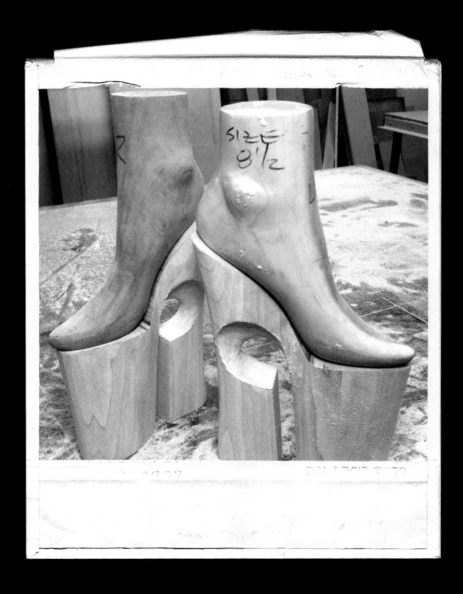

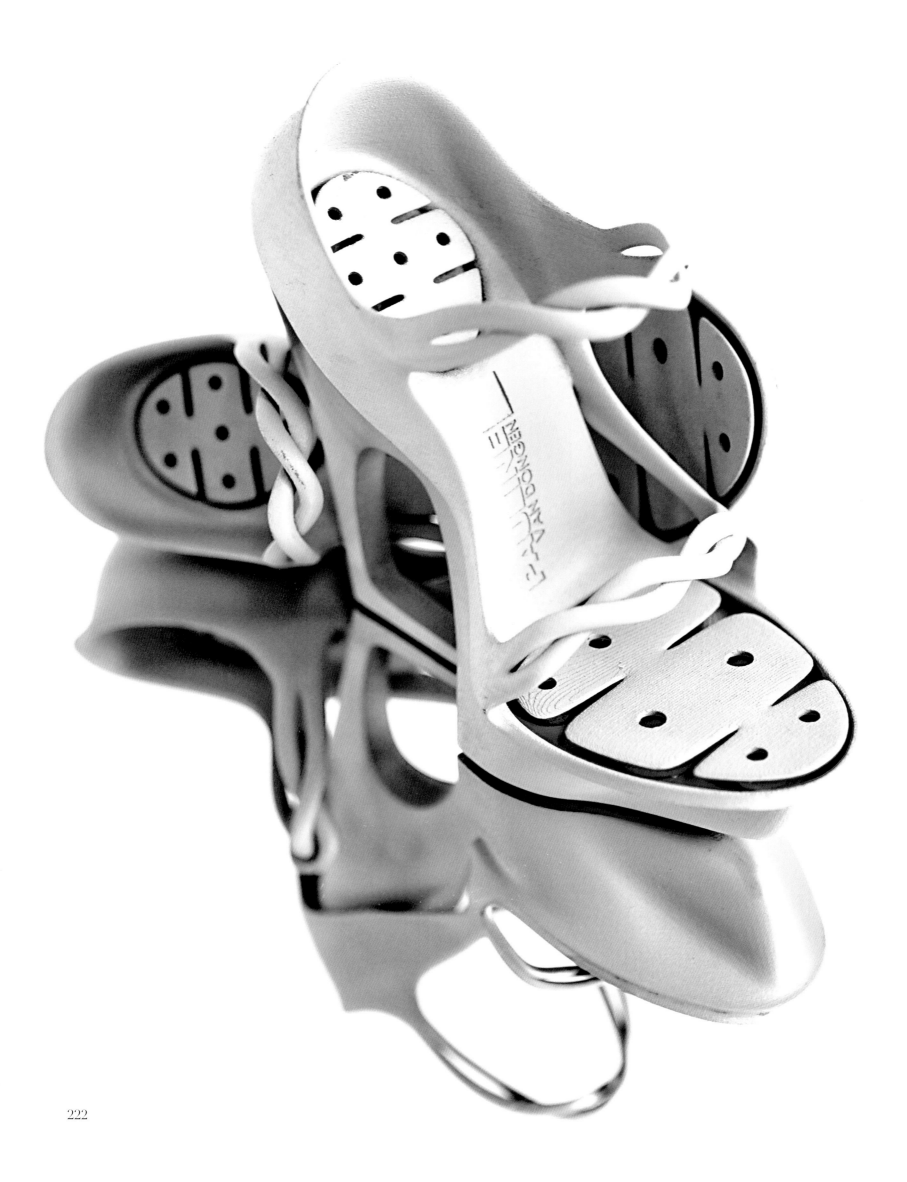

It wasn't until Pauline van Dongen took a shoe design course while completing her master's at ArtEZ Institute of the Arts in Arnhem, the Netherlands, that she discovered her love for shoe design. This also allowed her to further develop her own personal signature, best described as "sculptural science." Van Dongen enjoys exploring the use of unconventional materials and finding new ways of construction, and has studied anatomy, physics, and math to help her understand the relationship between the body and its surroundings. She believes shoes reveal a lot about the person wearing them, and is interested in how shoes influence a person's posture or the way they move. Her curiosity constantly drives her to surprise herself, and she experiments with unconventional materials and techniques, making her style very easy to recognize.

# PAULINE VAN DONGEN

*PAULINE VAN DONGEN IS FASCINATED BY THE RELATIONSHIP BETWEEN HUMANS AND THEIR SURROUNDINGS; HOW THE BODY BEHAVES IN SPACE, WITH ITS MOVEMENT AND INTERACTIONS; AND HOW THE ENVIRONMENT IS CONSTANTLY CHANGING SHAPE.* "The relationship between the body and the environment raises questions about boundaries and perception," she says. "Is clothing a container, a casing, and the body the content, or vice versa? And what exactly is space?" she wonders. "With my designs I create a dialogue between the space and the body that moves in it."

The designer had been interested in various art forms from an early age, typically drawing or dancing with friends after school. "We would spend the whole afternoon engaged in our creativity and send a selection of our best drawings to big fashion houses. We looked up the addresses on perfume bottles," van Dongen remembers. "Of course these letters got returned, unopened."

As a footwear designer, van Dongen is well aware that developing beyond traditional ideas into the sculptural, the avant-garde, or even the extraordinary is perfectly acceptable. "Shoes are very desirable objects. They tell so much about the person wearing them," she states. "Shoes influence someone's posture and the way that person moves and behaves, which is interesting to me." Experimentation with offbeat materials and techniques is easily recognizable in her style that is at once conceptual and very wearable. Creating highly artistic pieces comes naturally, but producing what she creates can be an obstacle at times, especially since the construction of her shoes is often quite unconventional and expensive.

Drawn as she is to the body, van Dongen has studied subjects that informed her thinking and garner ideas that will help hone her approach. She studied fashion design at a leading arts school in the Netherlands, earning a master's degree and formulating a unique personal style. It was there that she took a course in shoe design and discovered that she loved a shoe's rigid aspect. "I like the fact that it allows me to work with another range of materials, like metal, wood, and plastic," she says. "Designing shoes has influenced my work because it emphasizes a more architectural look." Van Dongen prefers to begin with an abstract concept and transform it into a more visual one during the process. Her curiosity constantly drives her to renew, experiment, and search out new materials. "I always want to surprise myself," van Dongen states. "My work is characterized by a minimalistic, clean look, but also by an experimental approach. This has not always been a point of focus within fashion. In that sense my designs don't refer to the classic Western tradition, where clothing casts the body in a certain form. I prefer the idea that the body is what gives pieces a certain volume. It's a way of seeing and experiencing shapes and volumes around a moving body."

Her brand of experimentation is, however, a clear and recognizable signature—complete with high-tech materials and new technologies. An example of her innovative approach is the three-dimensional *Morphogenesis* printed shoes she created in 2010, developed in collaboration with the company Freedom Of Creation. For van Dongen, this kind of work is consistently challenging, motivating her to find solutions and invent new ways of construction.

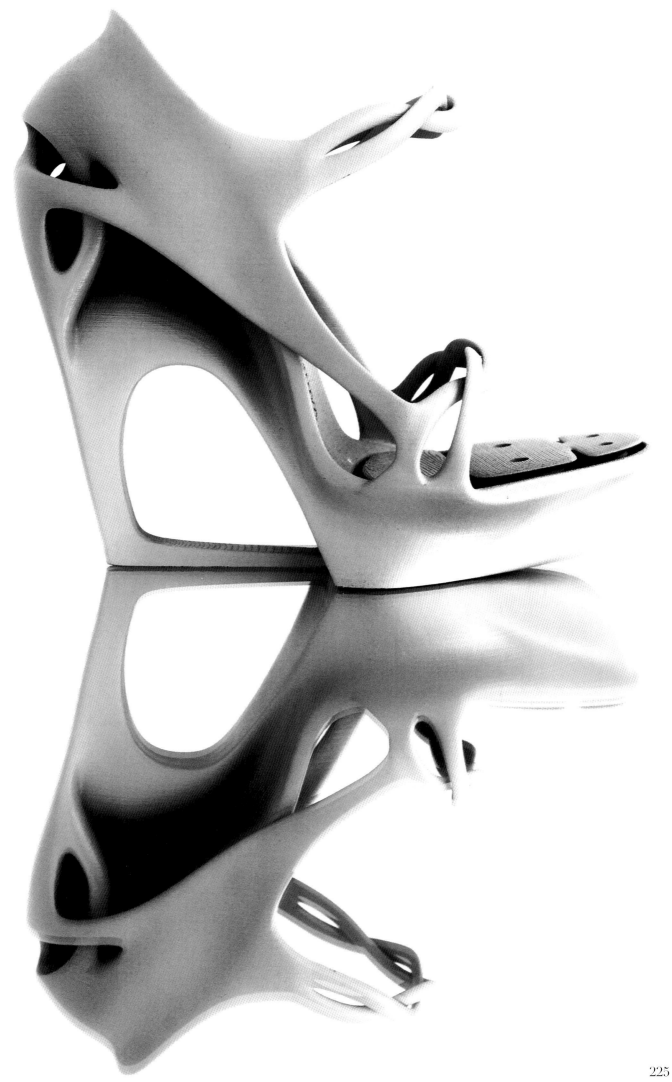

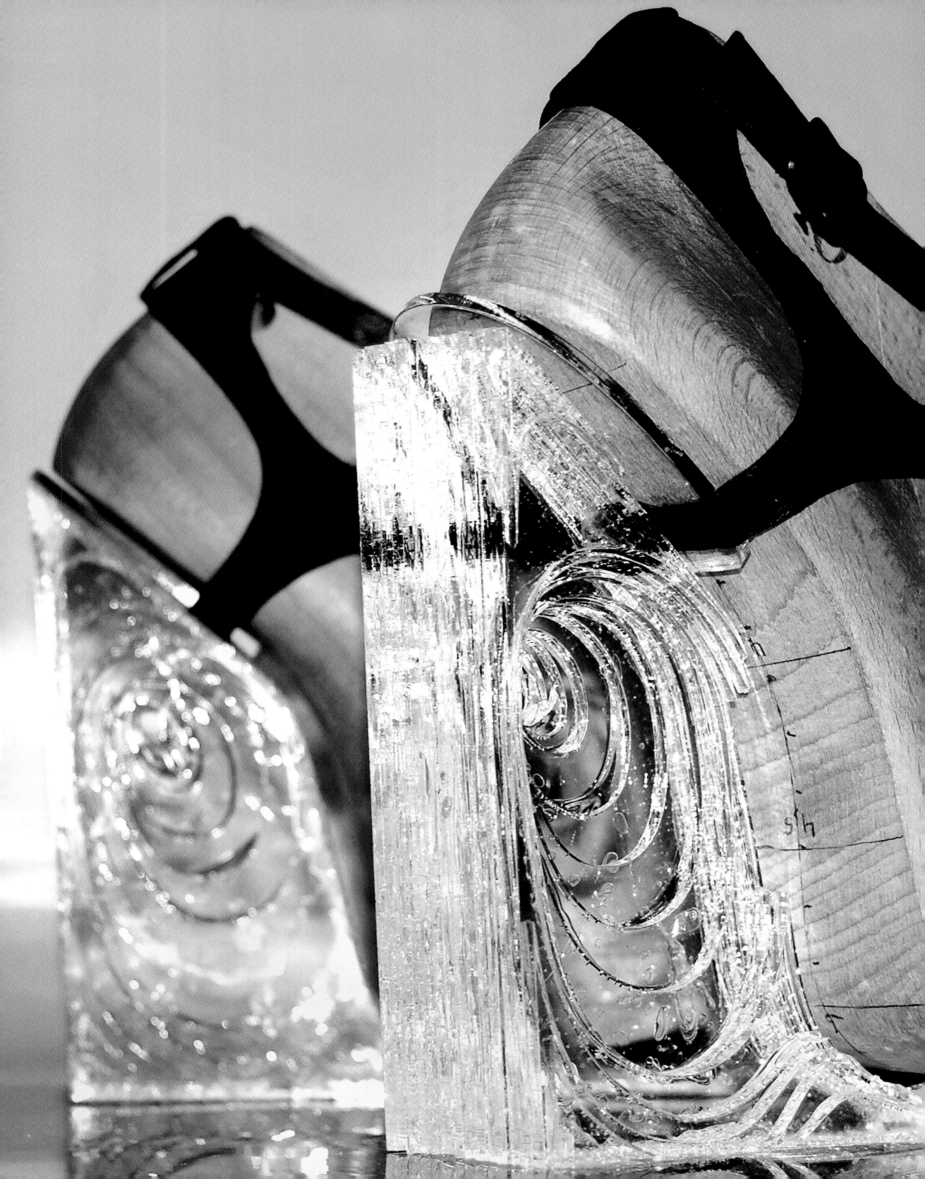

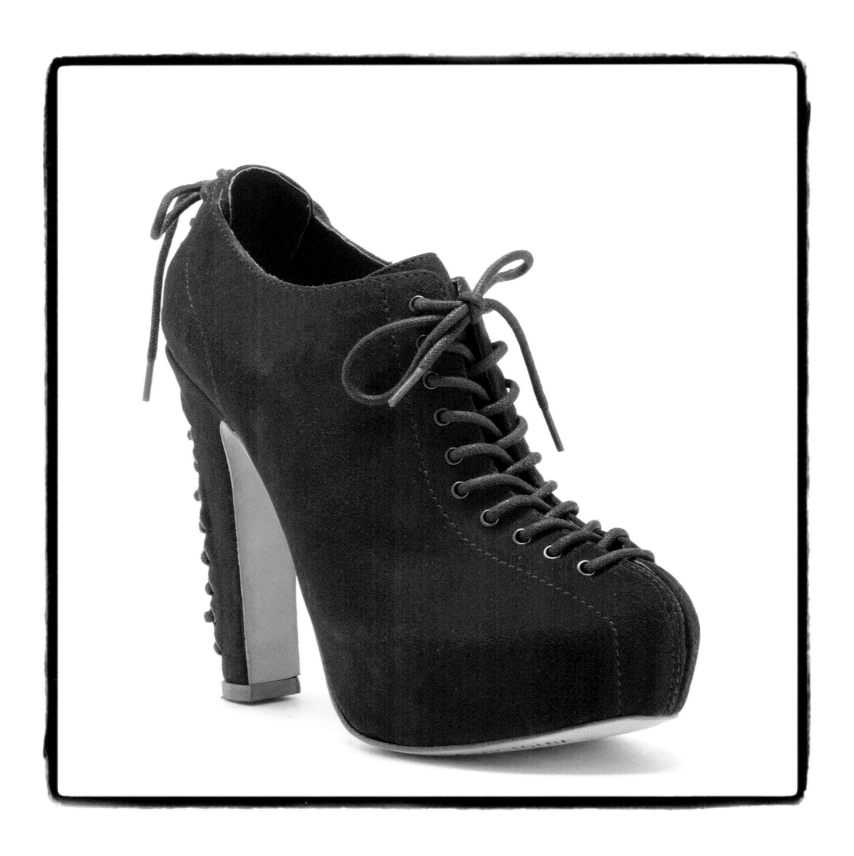

Pour La Victoire's collection of shoes exemplifies a luxury accessories brand with a modern twist on Parisian heritage, drawing inspiration from a blend of refined French indulgences that inspire a woman's natural convictions of confidence. Designed by the brand's cofounder and creative director, David Giordano, the footwear collection embodies a spirited offering with a commitment to style, design, and the continuous pursuit of quality. Exuding sensuality and elegance, Pour La Victoire reflects the personality and refinement of the modern Parisian woman: chic, empowered, and driven by passion. Pour La Victoire shoes are a representation of beautiful insights, accomplished women, and a genuine luxury that is universally accessible and embraced.

# POUR LA VICTOIRE

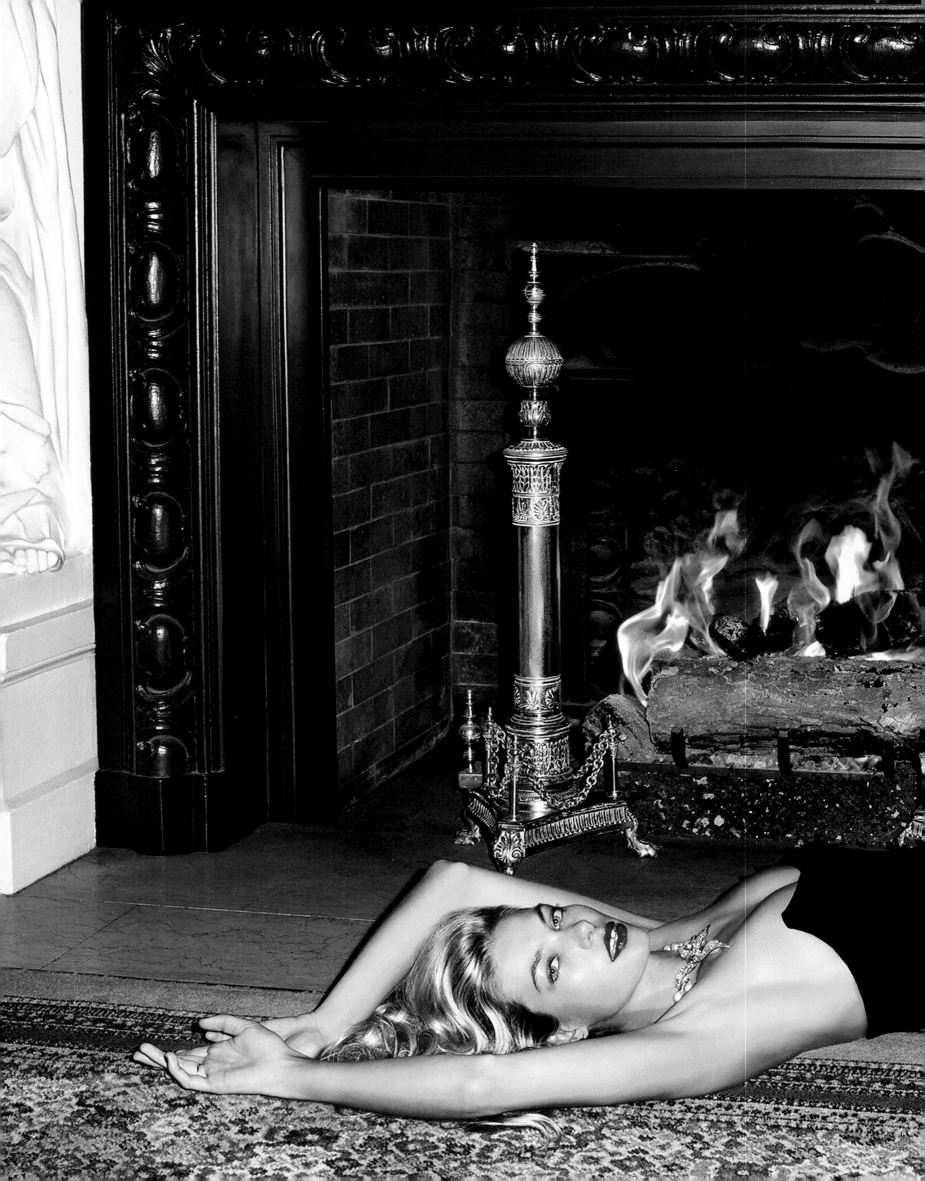

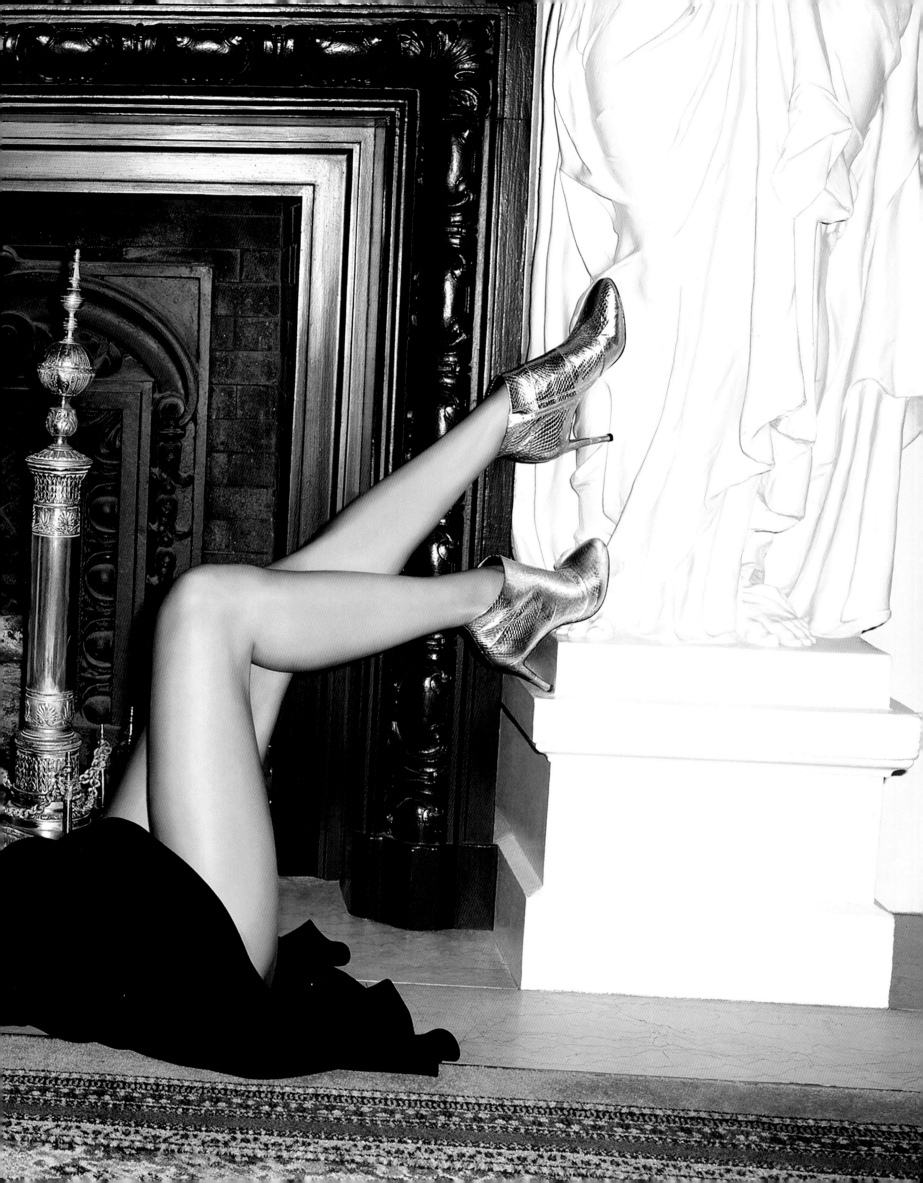

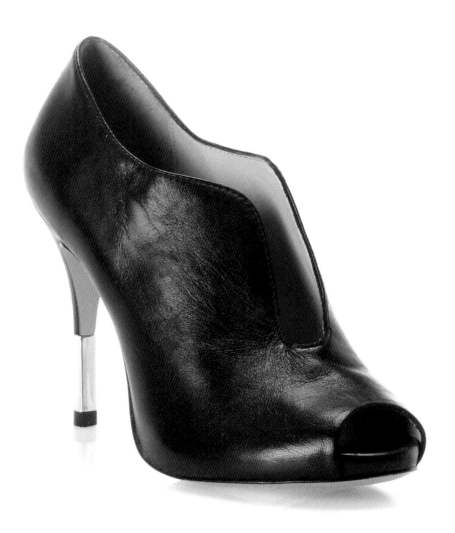

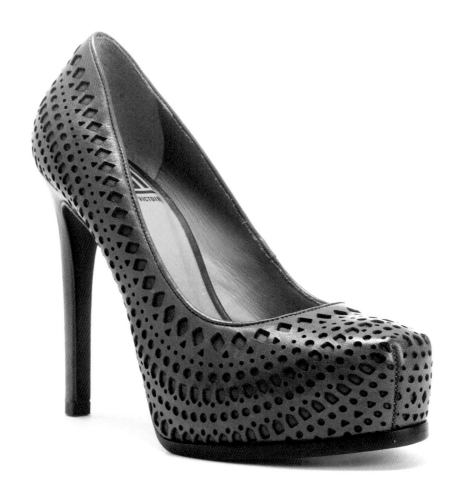

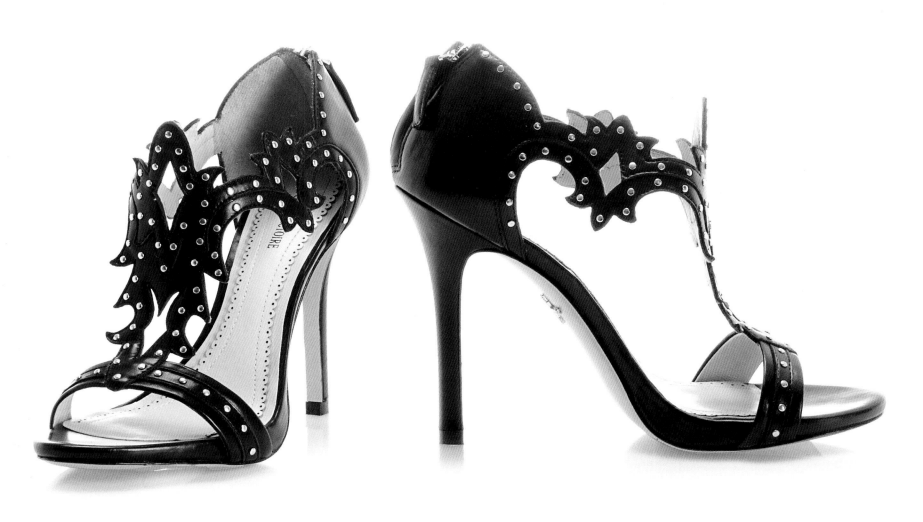

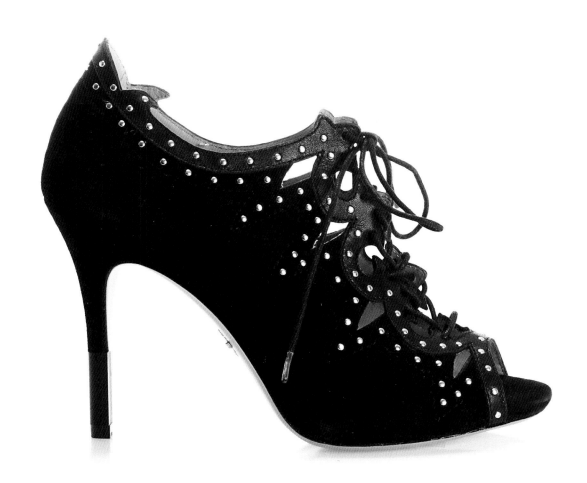

René Caovilla spent most of his childhood in his father's small shoe workshop in Venice, Italy. Shoes became a love and passion for him, and he was eventually able to take over his father's business. He had the idea to create shoes as objects of art, since they are, according to him, "the most important accessory in a woman's closet." Taking influence from his father's "handcraft meets couture" style, Caovilla became a sculptor of sophisticated evening shoes. When he entered the fashion world in the 1970s, he was introduced to the illustrious designer Valentino, where the two created cult objects and fetish creations under the name "Valentino by René Caovilla." The collaborations with top designers continued: he made dreamlike, imaginative designs with Christian Dior, and eventually joined forces with Karl Lagerfeld of Chanel. The official brand logo—a snake sandal that wraps itself around the ankle—is modeled after a gold Roman bracelet in the form of a snake that Caovilla had seen at the National Archaeological Museum of Naples. Today the logo is on display at the Museum of Modern Art in New York.

# RENÉ CAOVILLA

236

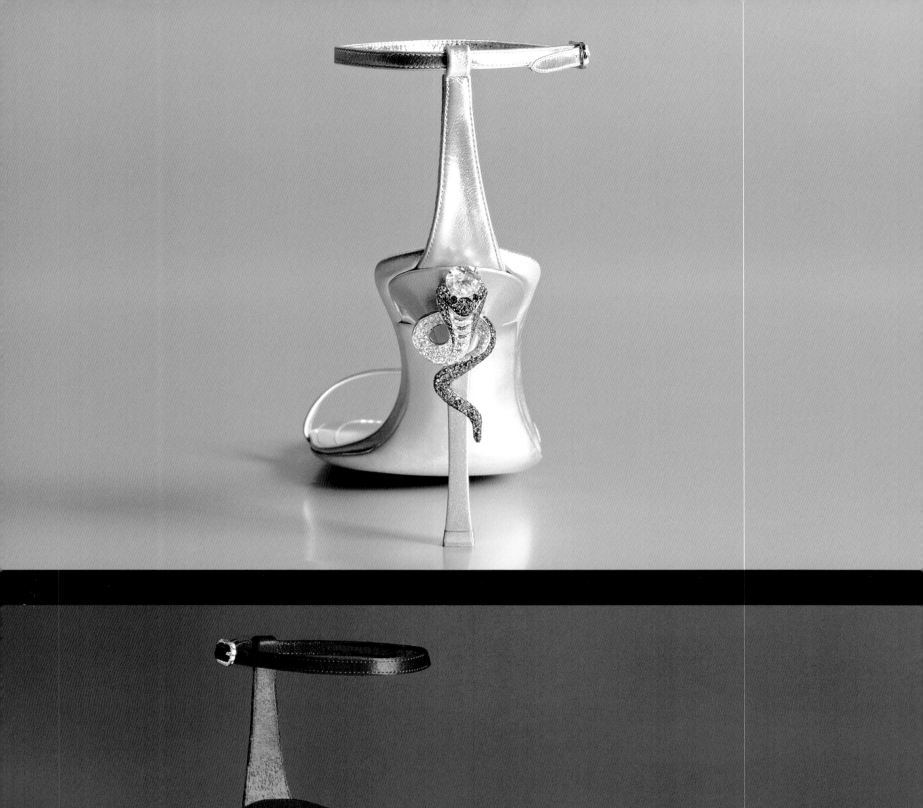

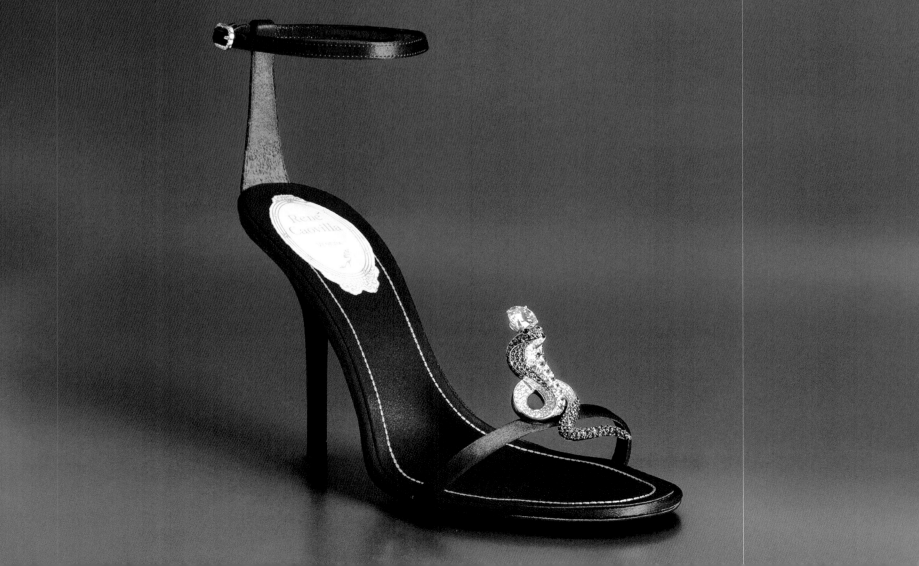

*IT WAS AT THE YOUNG AGE OF SEVENTEEN THAT RENÉ CAOVILLA ATTENDED A TRADE FAIR IN GERMANY TO MARKET HIS FIRST DESIGNS.* "My styles at the time came from the idea to link art and fashion. While they were ideas I always had, they were different from anything we had done before in the workshop," tells René Caovilla, who comes from a family of shoemakers. "My father was dubious, but he wanted to give me a chance, so he paid for the trip to Germany. When I came back to Venice, I didn't have one single piece left; everything had been sold. That day, my father left me with the creative reins of the business."

Caovilla's father, Edoardo, greatly informed his interest in shoes, so it was a natural step for him to take over and extend the family business in the early 1960s. Forming his own company also gave Caovilla the chance to make something completely different from what the market offered. "I fell in love with the idea of creating shoes that were objects of art," the designer says.

Caovilla's creations are luxury, pure and simple, and his perfectionism is evident in all that he designs. Indeed, Caovilla's shoes are works of art, the ideas for them stemming from all that he observes, from the beauty of a small piece of lace to an ancient brooch or painting. When he is particularly struck by something's beauty, Caovilla's first thoughts turn to how he will recreate that vision anew and sign it "RC."

These ideas are apparent in pieces like Caovilla's diamond cobra sandal entitled *Nyssia* — a piece of rare beauty and handcrafted skill that is also an haute couture jewel. Featuring a cobra-shaped jewel set on the front strap or at the back of the heel, *Nyssia* is fashioned with white gold, ruby eyes, and a brilliant 3.5-carat diamond on its head. Its body is studded with round-cut, pavé-set sapphires with a total of 20.60 carats. The price tag for *Nyssia*? More than $100,000. While Caovilla makes the shoe in two models, it is only released in a limited edition. Since *Nyssia*'s initial creation, Caovilla has been asked to craft special versions of the shoe, such as a pair of boots completely embroidered with emeralds he made for one of the wives of a prominent official of the United Arab Emirates.

Caovilla feels that every woman should own a jeweled sandal for a very important occasion or special event. In general, he believes that shoes are the most important accessory in a woman's closet. To quote the designer, "Shoes are, after all, something that makes you dream."

For Caovilla, it is the love for his job and the beauty in all its expression that keeps him inspired, and he feels that people are tired of buying mass-produced, unoriginal designs. "They want special, unique pieces that will last for years. Our clients are always more informed and more exigent," says the designer. "In a very crowded market, it is imperative for shoe designers to distinguish themselves from others," he explains. Caovilla also realizes that his brand possesses a historical and glamorous past. "Our products are handmade and reflect high standards of craftsmanship," the designer conveys. "Our clients want something that is not made industrially. They expect from us quality, fit, and elaborate embellishments."

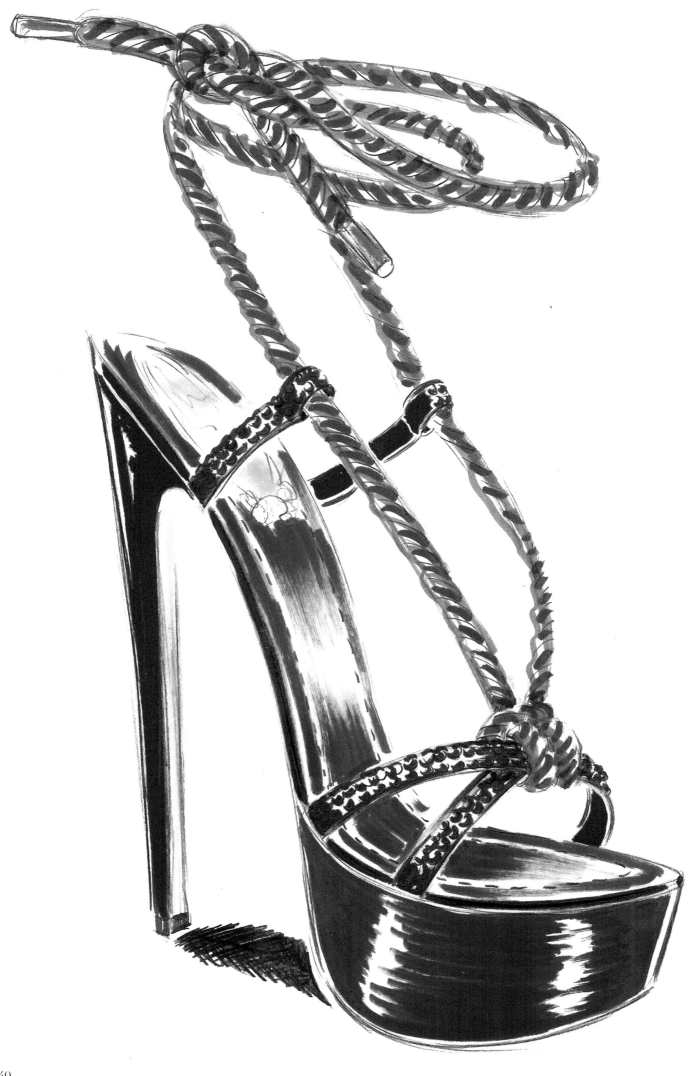

240

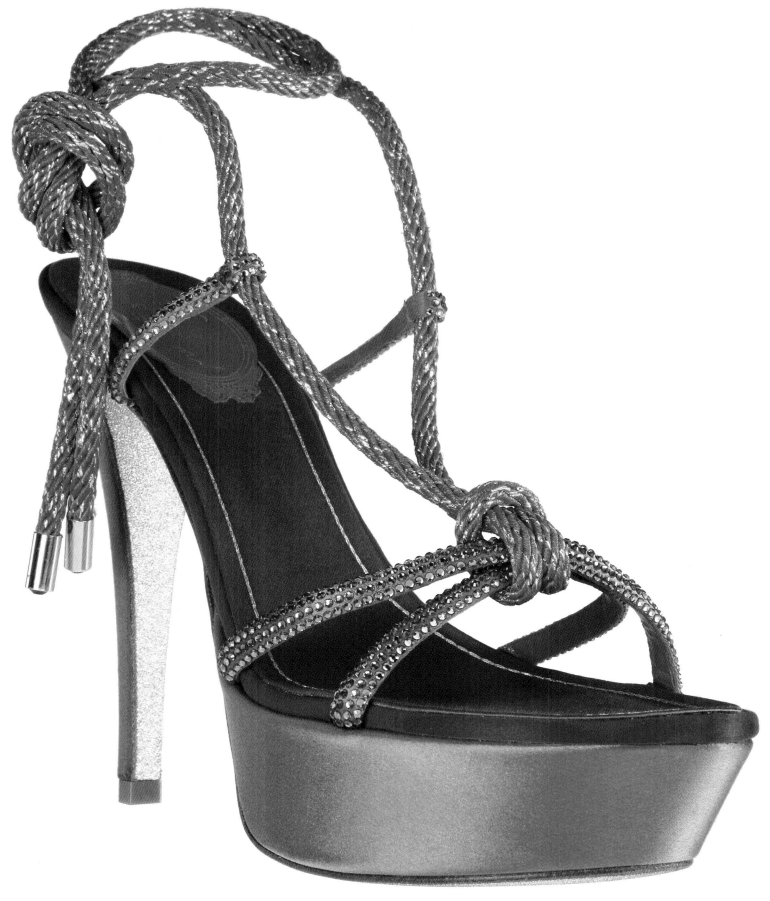

241

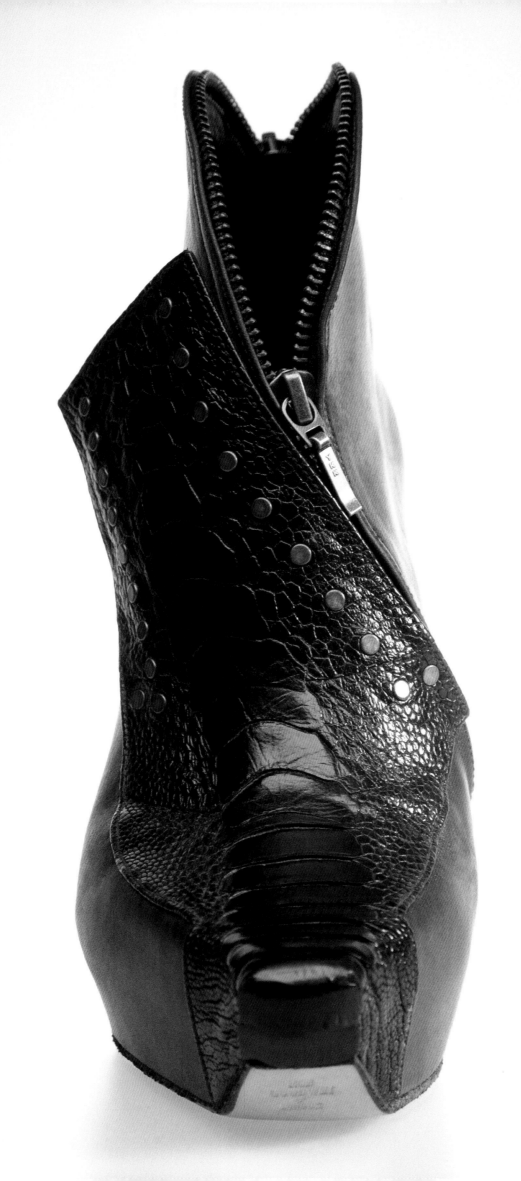

Based in London, Rob Goodwin began his professional career in a freelance technical role in the television industry. When he decided that he wanted to work more with his hands, he went to the London College of Fashion to study fashion footwear after becoming drawn to shoes and their transformative effect on women. While still at university, the young designer was commissioned by British and Italian *Vogue* to create custom pieces for their publications. He mastered leatherworking techniques and today makes all of his shoes by hand, from the leather dying and hand stitching to decorating techniques. Some of his greatest inspirations for shoe design are the costume and mask-making traditions of the Venetian carnival and indigenous tribes of the Congo. Aside from shoes, Goodwin also makes various leatherwork pieces—including masks and costumes—as well as leather sculptures. Many of Goodwin's creations have been featured in exhibitions around the world.

# ROB GOODWIN

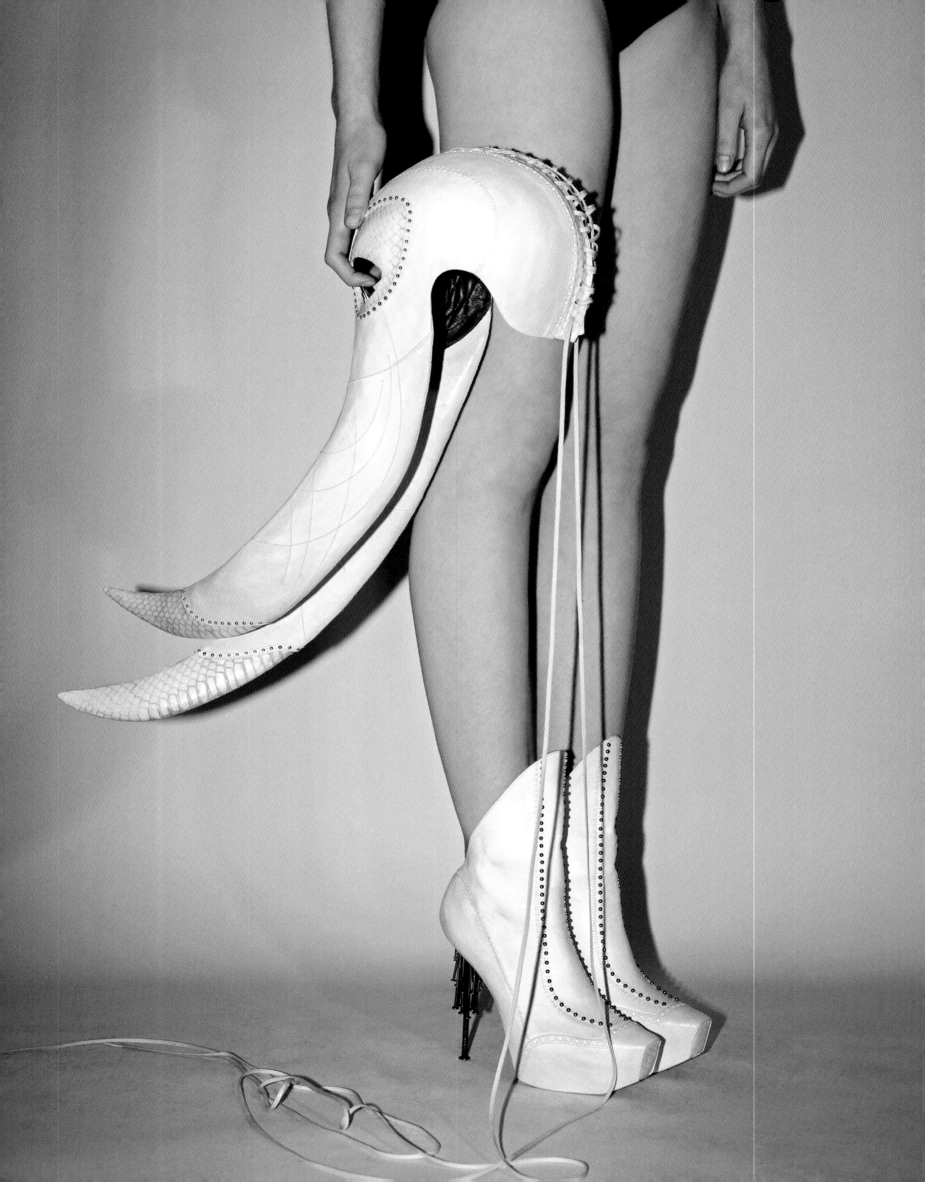

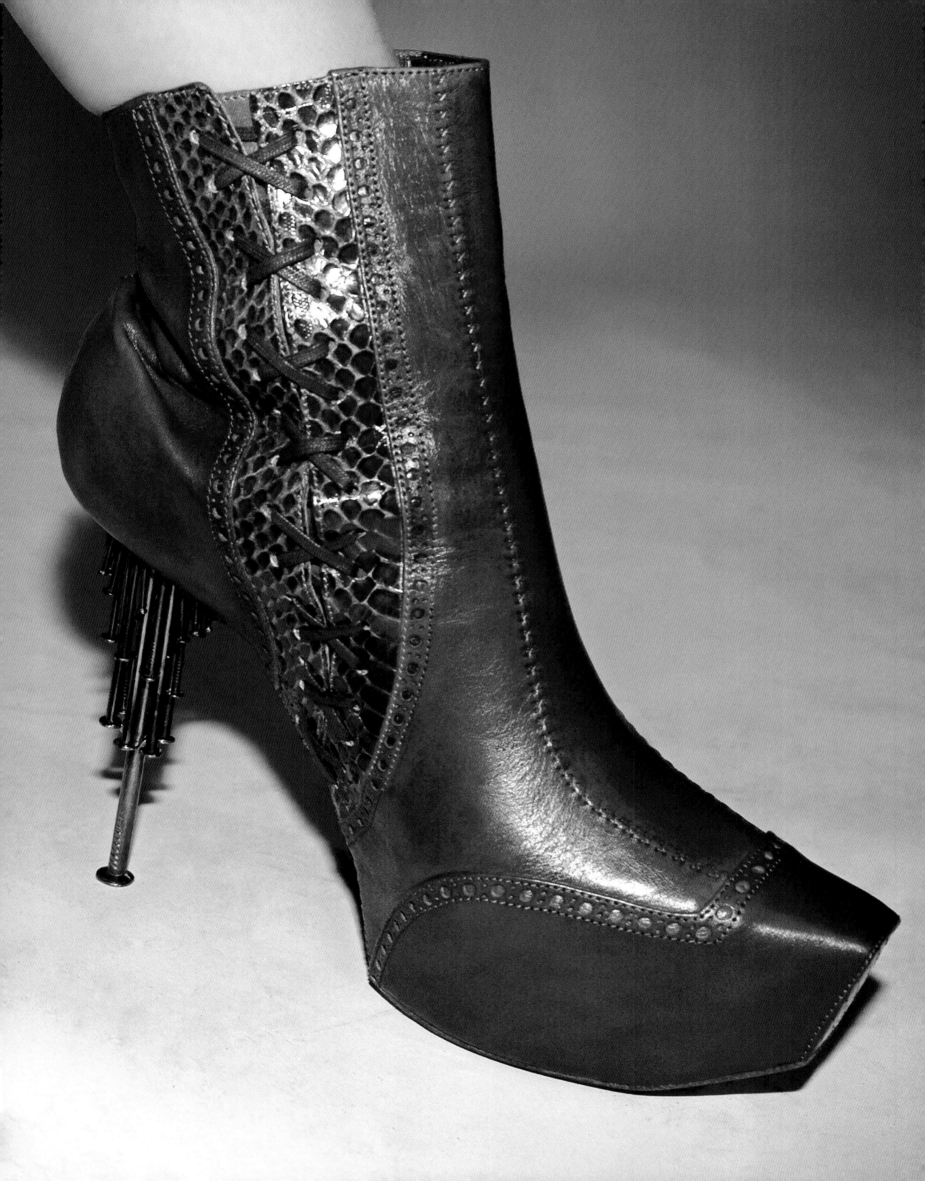

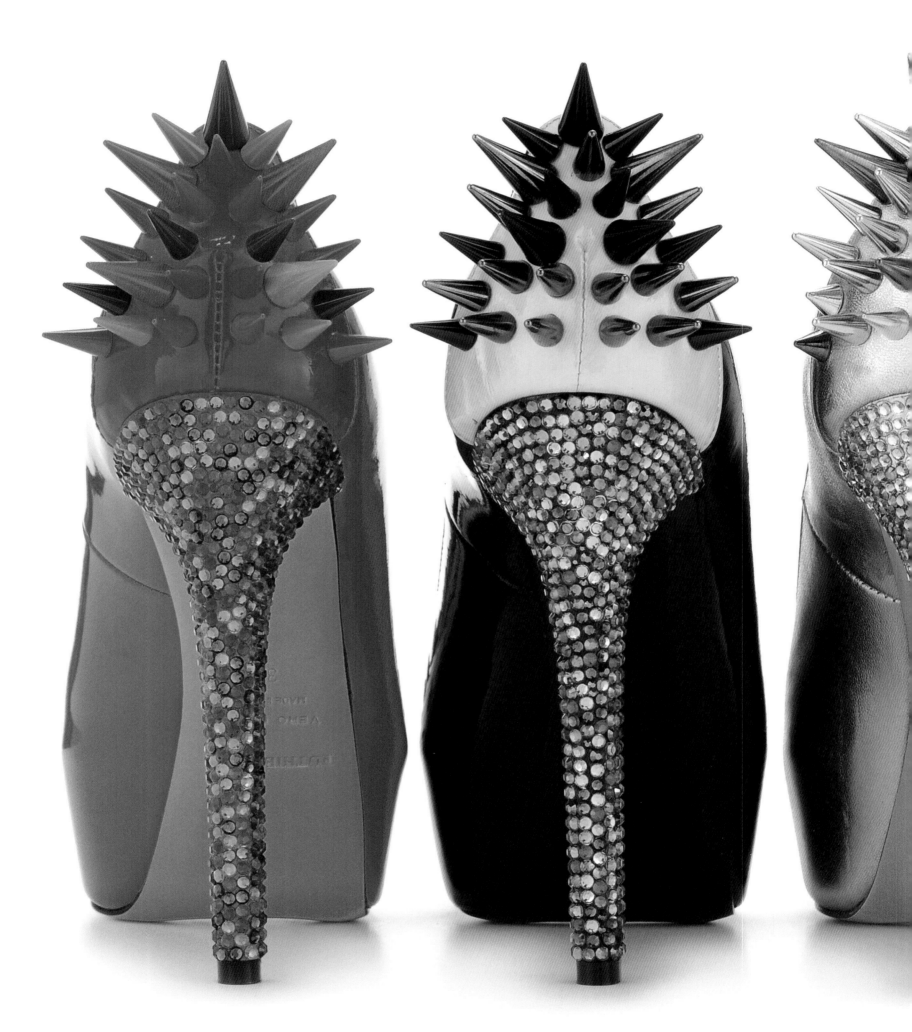

Inspired by what women want, Ruthie Davis designs shoes for the modern, fashion-forward consumer, similar to herself. With an MBA in entrepreneurship, it was clear from the start that Davis had the mindset of a businesswoman. Before launching her eponymous label in 2006, she worked for famous brands, such as Reebok, UGG Australia, and Tommy Hilfiger. Her shoes are extroverted and feature vivid shapes and colors, towering heels, studs, and spikes. She thinks of shoes as mini skyscrapers, and each one has its own story, from the colors and details to the shape of the heels. Davis herself imagines and sketches each shoe in New York, while the actual construction takes place in Italy. With a client list including Beyoncé, Lady Gaga, and Fergie, it's obvious that Ruthie Davis shoes are meant for strong, sexy, and confident women.

# *RUTHIE* DAVIS

*IT'S ARCHITECTURE, POP CULTURE, GIRLS ON THE STREET, FASHION EDITORIALS, AND ALL THINGS THAT PUSH THE ENVELOPE THAT DRIVE RUTHIE DAVIS TO MAKE SHOES.* "I'm inspired by what I want—and by what women want," states the designer. "I am a woman designing for modern, fashion-forward women. I test drive the shoes and know what makes a woman feel gorgeous and sexy."

Davis had an inkling that shoes might be her true calling after her father remarked that her passion for footwear had reached overload. "I guess I should have known when my father took me aside one day as he looked at my closet—which was a sea of shoes—and told me, 'Ruthie, you are going to either need to marry rich or get into the shoe business.'" As with most children, Davis had dreams of being all sorts of things, including an Olympic downhill ski racer, a tennis pro, and an architect. When she began sketching and illustrating shoes in junior high school, the turn toward footwear slowly took shape. "But I had no idea I would become a shoe designer."

Davis launched her brand with a wedge shoe made of titanium, a material she is prone to working with, along with stainless steel and wood. Davis enjoys authentic industrial elements and mixing them with rich leathers and fine detailing. "People say my shoes are like works of art and I think this is because I approach each shoe as having its own story, or reason for being," she reveals. "From the name of the shoe to the colors, details, and heel shapes, there is a story that makes each one special."

Being an urbanite helps her shape those stories in rich detail. Davis lives in West Chelsea, a neighborhood wedged between the far West Side, Flatiron, and Meatpacking districts in New York, each possessing their own measure of city grit. Davis asserts that inspiration is literally bouncing off the pavement—even her walk to work takes her past countless art galleries and cool New York denizens. "It's amazing," she says. "I'm influenced not so much by the individuals, but by the incredible feeling of being a woman in sky-high heels that make you feel strong, sexy, and confident. The modern architecture in this area is also a huge inspiration and greatly influences my designs."

Davis tends to be futuristic in the way she designs, and would one day like to create a pair of heels that a woman can literally run in as she bustles around town (Davis is an avid runner). This concept falls in line with her admiration for authentic, smart, sporty, and unstoppable women. Think Bond Girl, Wonder Woman, businesswomen, entrepreneurs, or someone you pass on the street that you can't forget. Davis's idea of sexy is Lauren Hutton or the former French *Vogue* editor Carine Roitfeld—women who embody an edgy mix of luxury, casual chic, and uncompromising glamour. "I like a woman who looks strong and has style," Davis states. "It's not about the makeup and bling and designer clothes; it's about the fresh faced woman and her confidence and look, like she actually walks around and lives."

That kind of woman is a lot like Davis herself. After receiving an MBA in entrepreneurship, her first job in the footwear industry was at Reebok, where she was hired as an associate product manager, soon becoming, as she calls it, the resident "cool hunter." "I realized that my passion was finding trends and what's hot, and adding what I call the 'sizzle' to the steak," she recalls of her work at the time. Moving into the role of director of Reebok Classic enabled Davis to put colors, materials, trends, and the right detailing into the classic white Reebok shoe. She soon realized her true talents and was able to bring them to other brands as well. "When

UGG Australia asked me to move to California to work on UGG boots, I saw that as a great opportunity to recreate UGG as a fashion brand rather than a surfer label," Davis explains. After serving as UGG's vice president of marketing and design, Davis became vice president of women's footwear design and marketing at Tommy Hilfiger, until one day when her husband asked her, "Do you want to work for Tommy Hilfiger or be Tommy Hilfiger?" Davis chose the latter, and soon launched her namesake label.

With shoes like her *Spike* bootie, Ruthie Davis is always the one setting trends. The heel counter is completely adorned with metal spikes, in addition to being encrusted with various sizes of Swarovski crystals. "It was certainly crazy at one time, and represented new territory for the shoe industry, but the concept has since become a mainstream look for shoes," Davis reports. Her all-time favorite and wardrobe staple are her *Microcompact* black booties. The boots have a six-inch heel and a two-inch platform that make its wearers supermodel tall. "When you put them on, not only do they make you feel amazing, but they work with virtually any outfit. Your legs go on for miles!" she enthuses. "I cannot live without them—they are necessary leg extensions for me."

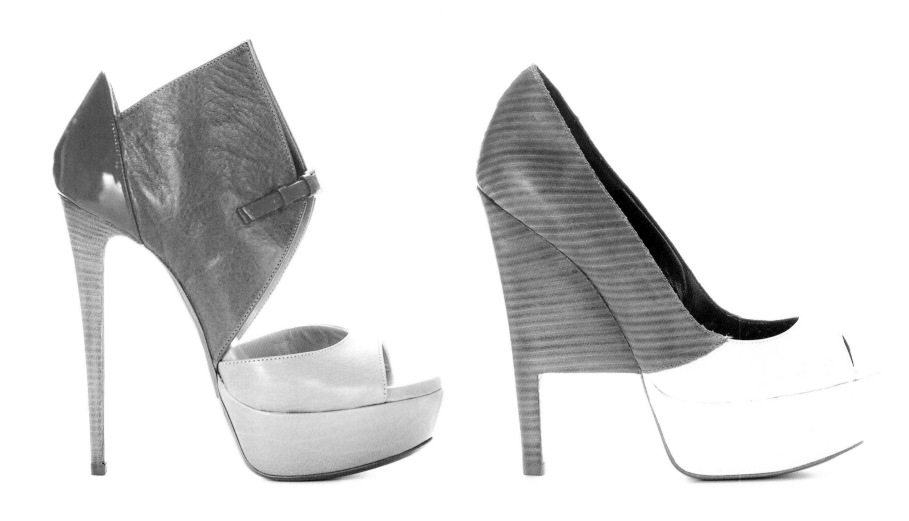

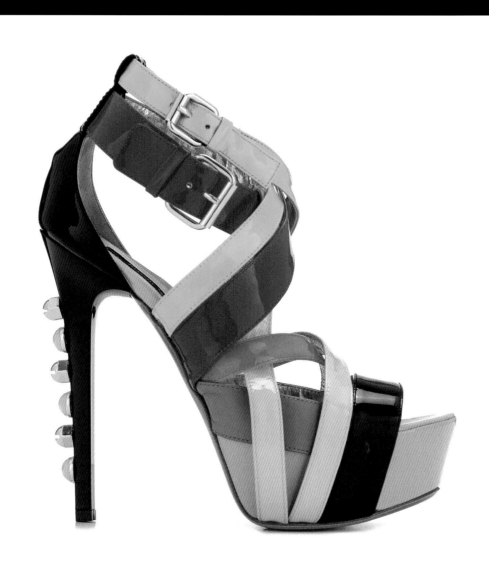

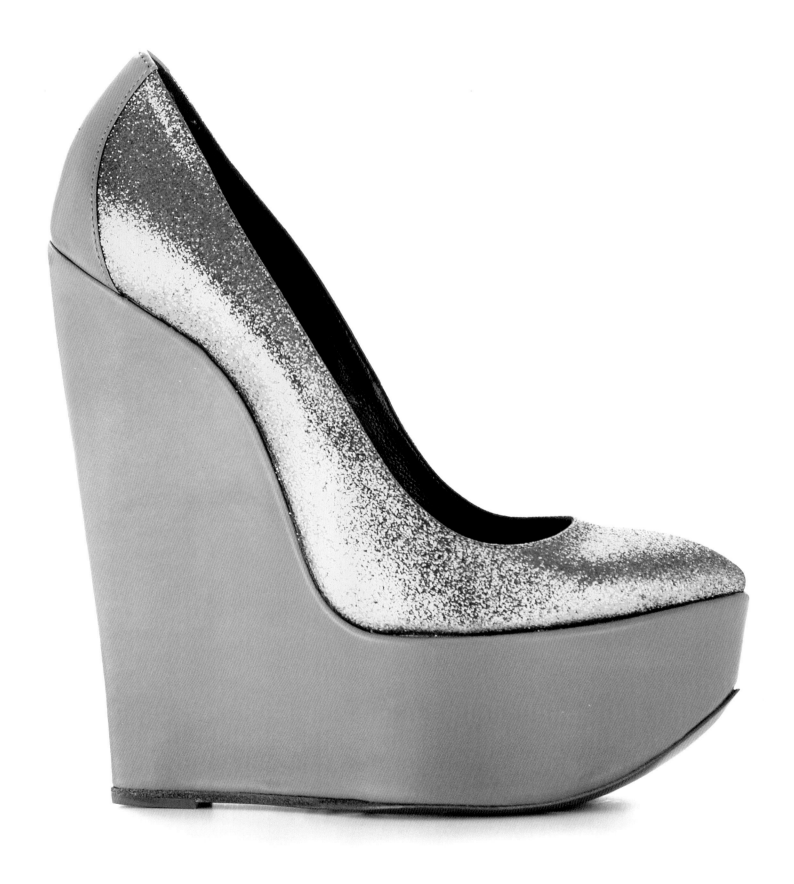

253

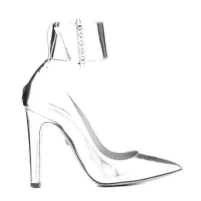
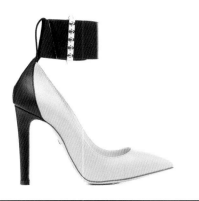
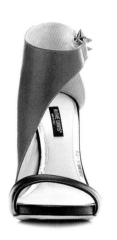
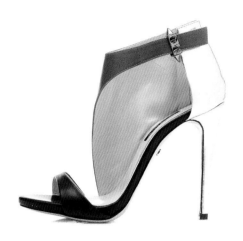

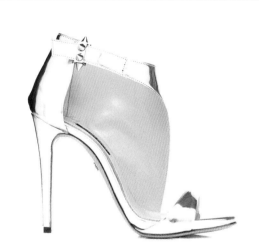

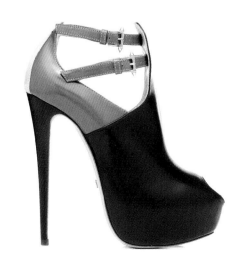

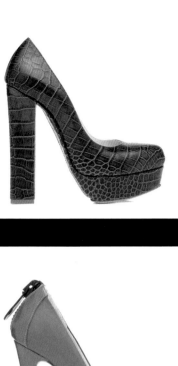
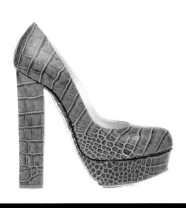

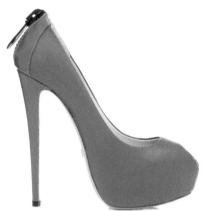
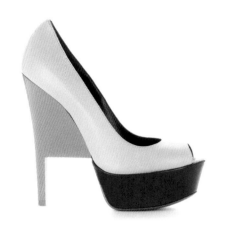
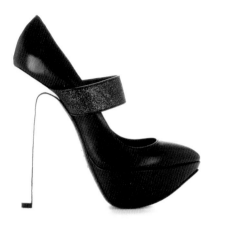

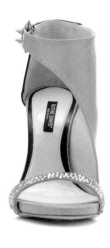
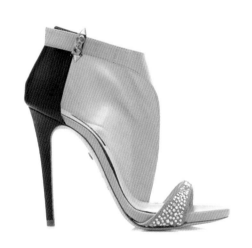

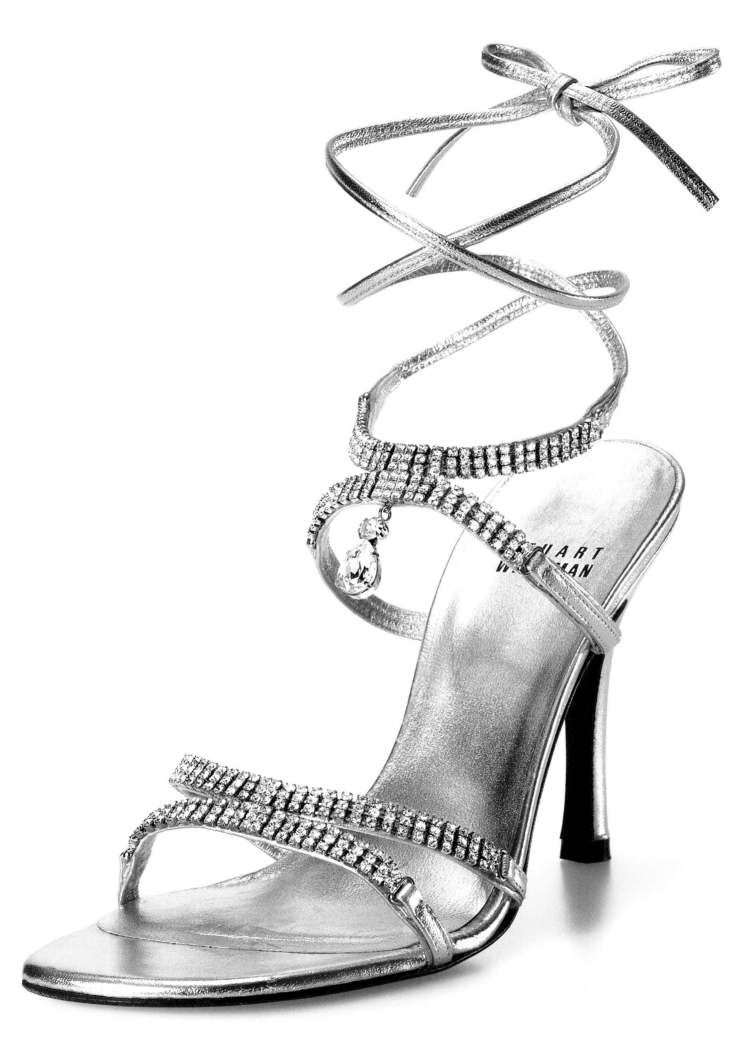

256

Stuart Weitzman understands that a great shoe is about making a woman feel beautiful. He is also a firm believer that a beautiful shoe has no use unless it feels as good as it looks. With a father who owned a shoe factory, Weitzman took over the family business when he finally gave in to the sketching that he thought was just a hobby. He was inspired to have his shoes manufactured in Spain after viewing a group of shoes made in the town of Elda featuring exceptional quality and workmanship. Weitzman's trademark is his use of unique materials, such as Lucite, cork, vinyl, wallpaper, or twenty-four-karat gold. One pair—inspired by the ruby slippers from *The Wizard of Oz*—was woven from platinum thread set with 642 rubies, and cost a cool $1.6 million. The use of unconventional components paired with an immaculate attention to detail and craftsmanship has earned Weitzman a huge celebrity fan base, with his shoes gracing almost every red carpet and sold in forty-five countries around the world.

# *STUART* WEITZMAN

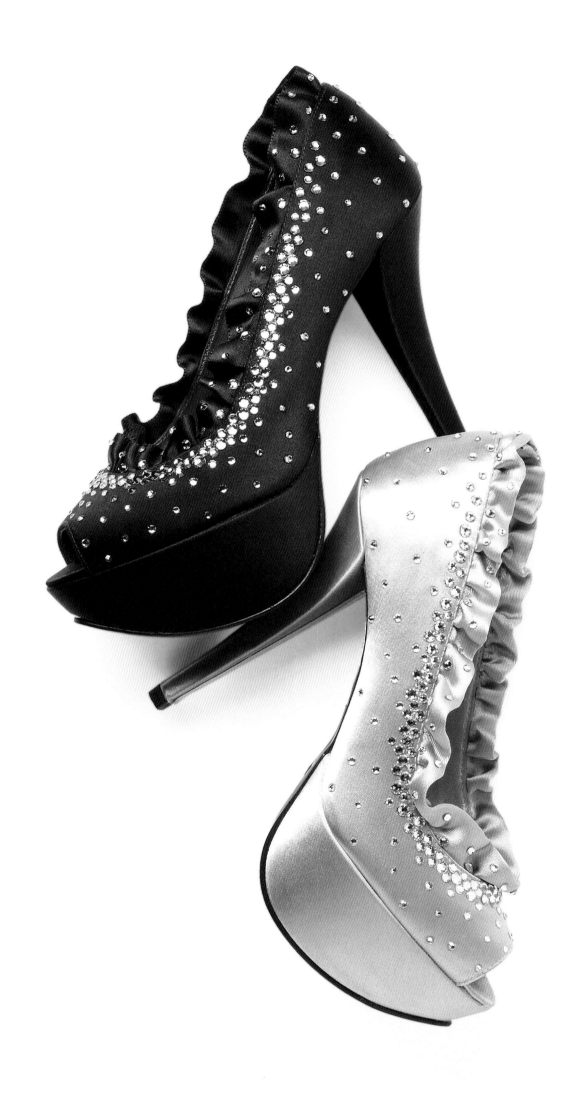

"THE WIZARD OF OZ *IS MY FAVORITE FILM. I ALWAYS LOVED THOSE RUBY RED SLIPPERS.*" One would expect nothing less from a shoe designer, especially one like Stuart Weitzman. Say his name and even the most unfamiliar will recall his luxurious shoes. The Stuart Weitzman logo is hard to ignore, gracing the awnings and exteriors of storefronts on many fashionable avenues worldwide, from Monte Carlo, Madison Avenue, and Rome to Paris and Rodeo Drive in Beverly Hills. In business for over three decades, the boy from Long Island dreamed big and conquered. "Our entire team, from sewers to partners, gives their all to the product, treating it as if it were their own," he says of the group of craftsmen who produce his elegant shoes at his factory in Spain, a place he landed upon after visiting the city of Elda and seeing a pair of high-quality shoes. "It's quite unlikely that I could have established such camaraderie elsewhere."

Weitzman went into the shoe industry at the prompting of his father. While still in school at the University of Pennsylvania, the elder Weitzman made a shoe from one of the sketches the younger Weitzman had fashioned. It sold so well that his father had it cast in bronze. "I knew then that I wanted to try to make my mark in the shoe business, and I haven't looked back."

Oddly enough, the designer's personal style where shoes are concerned is pure comfort. Weitzman says he tends to wear Chuck Taylors or moccasin loafers—all-American shoes that would surprise most who know his work to be the polar opposite. He has designed shoes for various film stars to wear at events, particularly some of the most famous Oscar winners. What motivated him toward the celebrity set? "I got tired of the media always asking only about the dress and jewelry during the pre-Oscar paparazzi fest, so I started to create footwear that could demand a spotlight of its own."

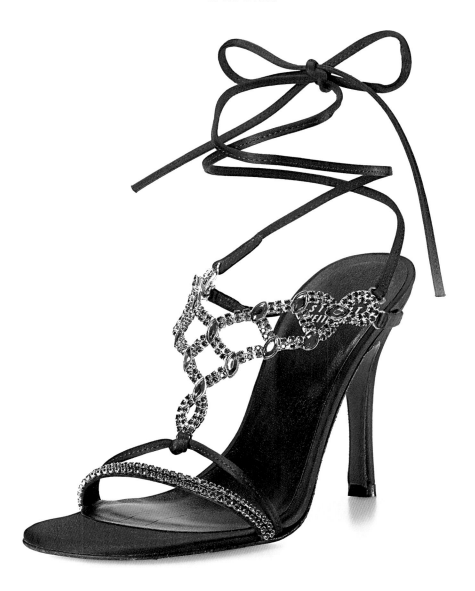

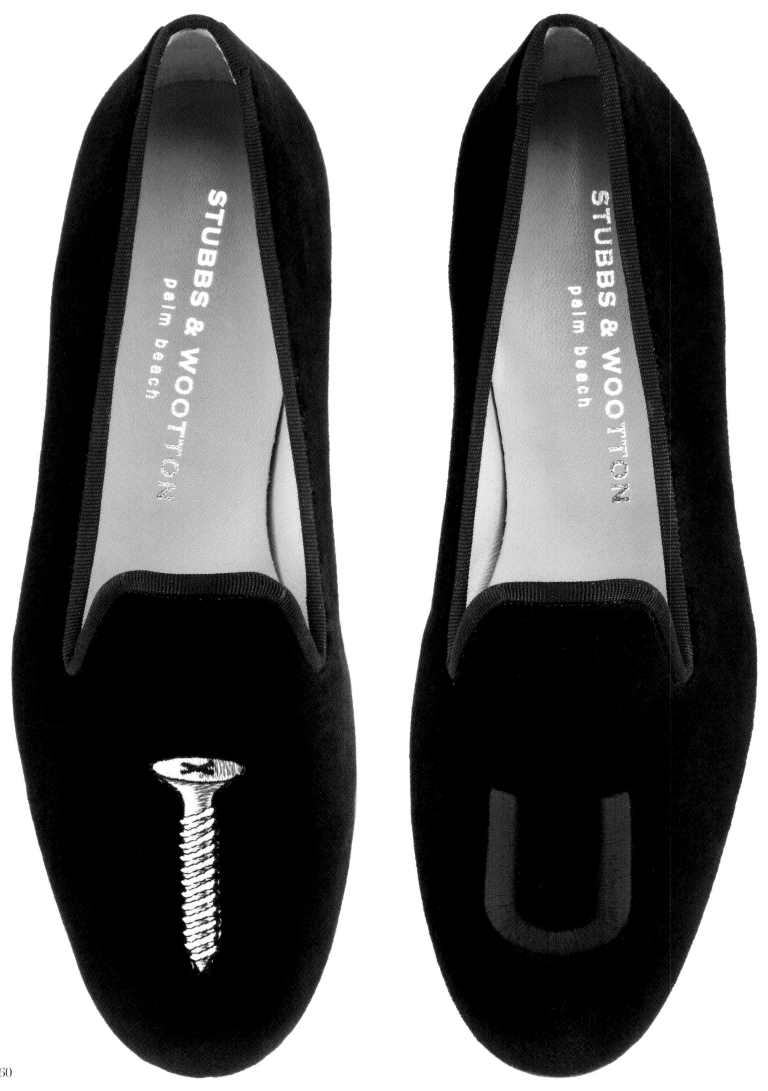

260

The name Stubbs & Wootton derived from founder Percy Steinhart's two favorite eighteenth-century artists—George Stubbs and John Wootton—who painted scenes of gentlemanly sporting events. After graduating from Georgetown University, Steinhart became a private banker. He eventually left the banking world to design shoes modeled from embroidered twentieth-century house slippers. Steinhart's modern interpretation of such slippers (made iconic by Hugh Hefner, among others) soon morphed into a symbol of luxury. The designer has seen people wear his shoes with everything from black tie to denim, and he enjoys experimenting with colors and imagery that can be paired with jeans, tailored trousers, or even casual shorts. Stubbs & Wootton shoes are crafted by a community of artisans in La Mancha, Spain, who are known for their quality and expertise in stitching, sewing, and assembling footwear. Fans of Stubbs & Wootton include diverse fashion icons and celebrities, such as Valentino, Kanye West, Mary-Kate Olsen, Sarah Jessica Parker, and Olivia Palermo.

# STUBBS & WOOTTON

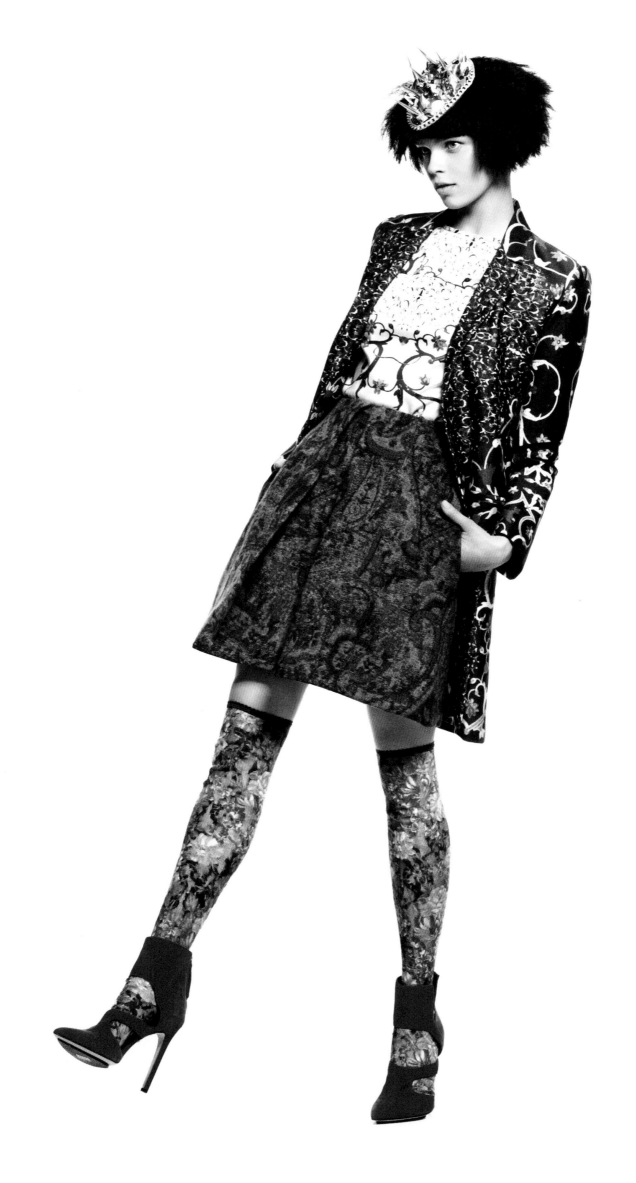

The daughter of a Sicilian tailor and seamstress, Tania Spinelli was introduced to beautiful materials and exquisite craftsmanship at an early age. As a child, she designed her own clothes and her mother executed them, and later she went on to obtain a bachelor's degree in fashion design from Philadelphia University. Spinelli was first introduced to shoe design after moving to São Paulo with her husband, Marcello Spinelli, the son of a footwear industry veteran. She began to work for her father-in-law, which sparked her imagination and left an indelible mark. After moving back to the United States, Spinelli joined Tommy Hilfiger's ready-to-wear design team, where she spent six years until being appointed design director of the Hilfiger Collection. To motivate herself to launch her own collection, she vowed to not buy another pair of shoes until she made a pair of her own that she could wear. Spinelli's collection debuted approximately a year later, in February 2005, and immediately received widespread appraise. Today Tania Spinelli shoes exemplify her modern sensibility, impeccable taste, and traditional Italian craftsmanship.

# TANIA SPINELLI

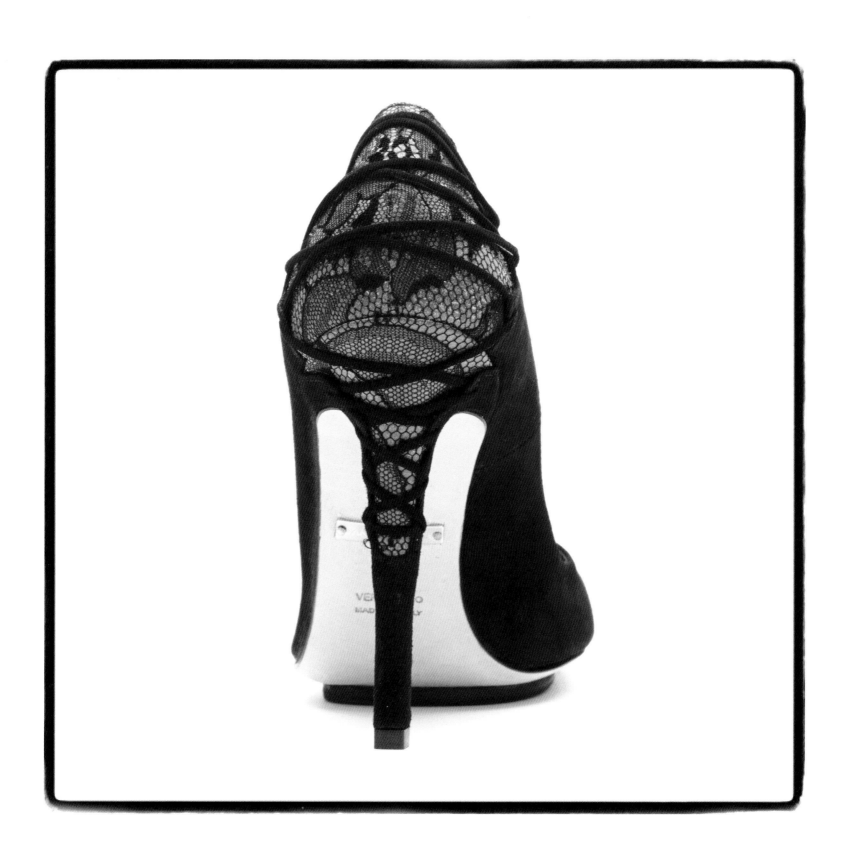

*TANIA SPINELLI SAYS SHE STARTED DESIGNING SHOES OUT OF A DESIRE TO MAKE HIGH HEELS SHE COULD WEAR ALL DAY AND NIGHT WITHOUT SUFFERING.* And her husband had a little to do with it. "I was in Florence, Italy, on a design trip while working for Tommy Hilfiger when my husband called to tell me he had found five shoe factories we needed to visit in Venice," the designer recalls. Spinelli had been thinking about starting her own line of footwear for some time, having made a name for herself as the design director for the Hilfiger Collection, but with that one phone call and a few factory visits with sketches in tow, she was on her way a mere six months later. "My husband was the driving force in my start," Spinelli says about the development of her first collection. "He has been, and always will be, my biggest supporter."

A true love of beautiful materials and exquisite craftsmanship has been Spinelli's passion from an early age. She had always wanted to be a designer, having watched both her parents create in their respective fields. "Witnessing their talent and love of craftsmanship left an indelible impression on me," Spinelli fondly reminisces. "My parents influenced me the most out of anyone in my life."

However, it was her father-in-law, Altemio Spinelli, who introduced her to footwear design in São Paulo. Working for him inspired Spinelli's imagination for shoemaking. She soon spread her wings to become a design director after she returned to the United States in 1998. After discovering the factory that would manufacture her line of shoes, Spinelli knew she had found her true calling in 2005, when she started her own collection, immediately gaining excellent reviews.

Spinelli's shoes reflect her awareness of modernity and taste for refinement. Her use of exotic skins, interesting silhouettes, and the traditional excellence of Italian craftsmanship exude the utmost in elegance and luxury. She spends a large amount of time in her factories, involving herself in every part of the process to get it right. "Seeing my creations come to life is always surreal," Spinelli professes.

Detailing with metal shapes—such as toe caps and heels—give her collections a cool, modern edge with clean, strong silhouettes. "There is a play of contrasts between refined and sleek lines. There are also textured uppers, such as perforated leathers, exotic skins, haired calf, and fur," says Spinelli of some of her current work. "I consider my shoes to be sexy and strong, yet very wearable," Spinelli explains, which was her goal from the beginning.

While her home is in New York, Spinelli often travels to Venice and the surrounding Italian countryside where her collection is produced. She finds the energy and constant movement of New York energizing. "Living here motivates me to move forward, work harder, and strive to succeed," she proclaims. "The excitement of the new," as Spinelli calls it, "is always exhilarating. I feel each season I grow as a designer and become more confident in expressing my vision and who I am in that role."

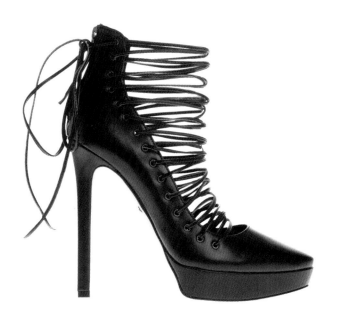

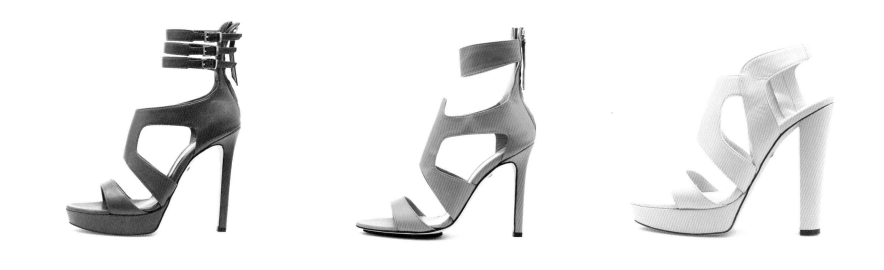

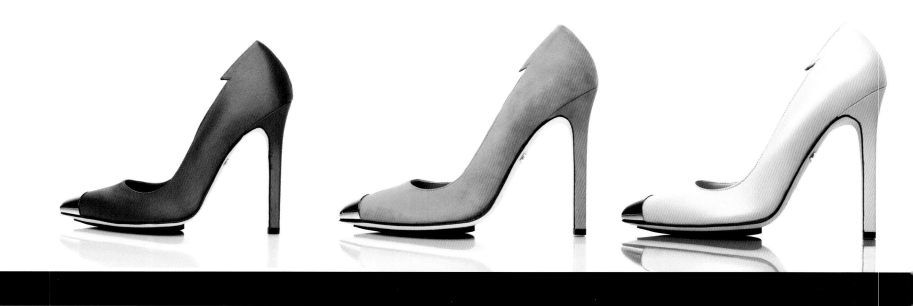

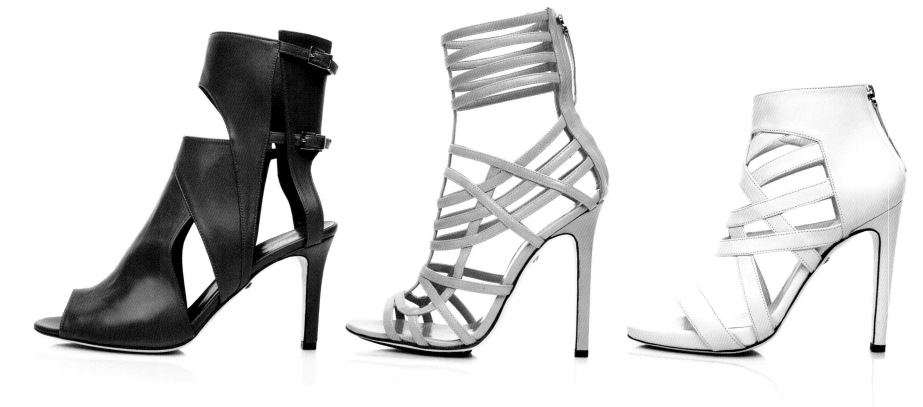

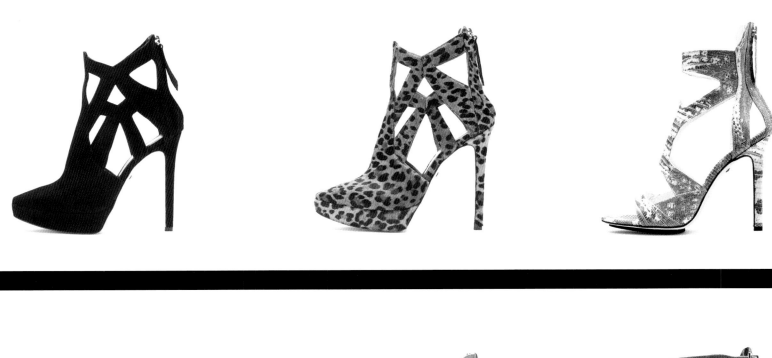

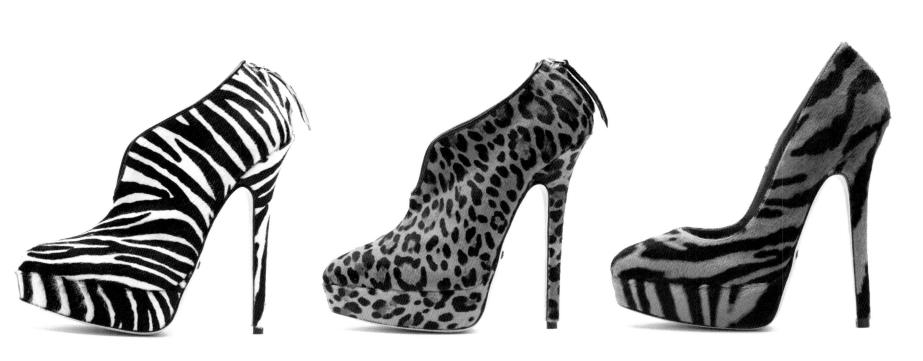

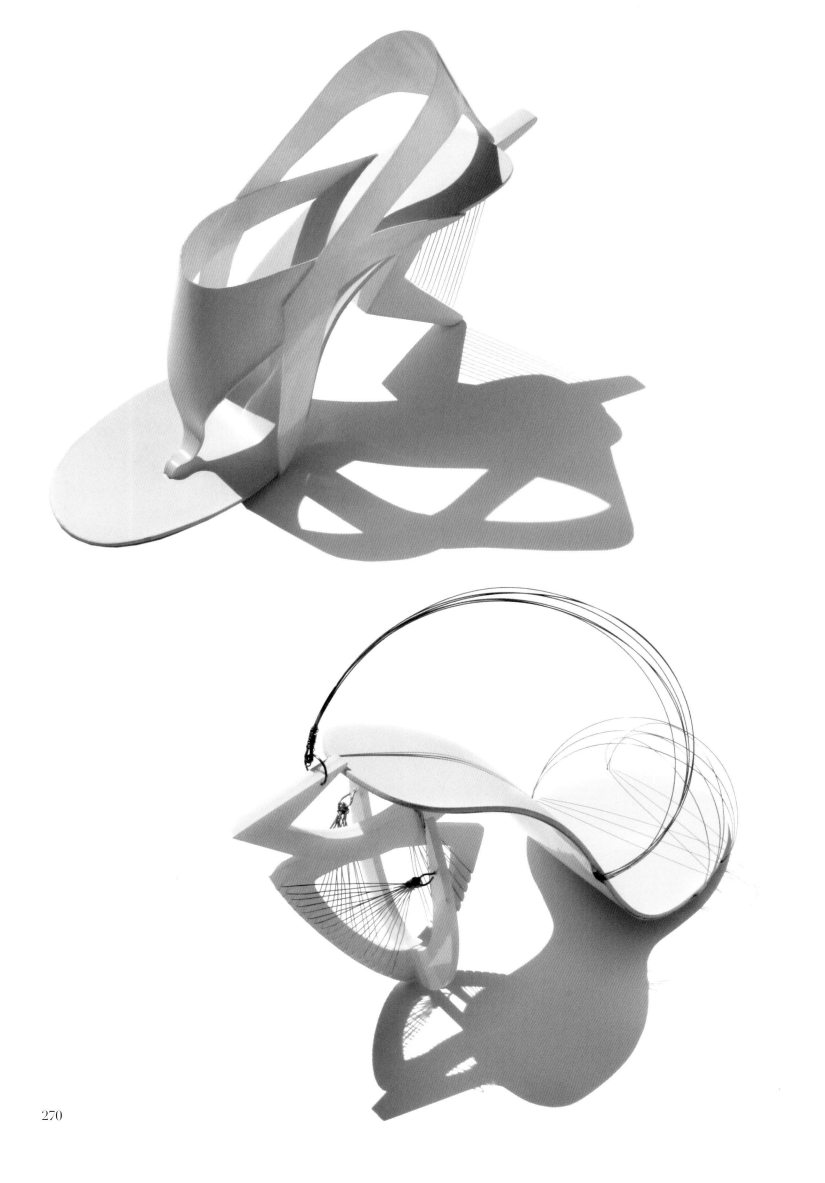

Designer and artist Tea Petrovic was born in Sarajevo, Bosnia and Herzegovina, a city devastated during the Bosnian War in the early 1990s. In 2009, Petrovic graduated from the Fine Arts Academy in Sarajevo and shortly thereafter organized an exhibition of handmade shoes called *Extension of the Ego*. The collection was aimed to showcase shoes as works of art rather than functional objects, and the exhibition attracted much international interest due to the experimental, sculptural, and architectural elements involved. One of Petrovic's inspirations is flying objects, and she is greatly influenced by the sculptor Alexander Calder's mobile sculptures. Because of this, she designs shoes that are meant to move with the person wearing them. Petrovic plans on experimenting with high heels in the future because she enjoys the way they exploit the space between the floor, heel, and sole of the foot.

# TEA PETROVIC

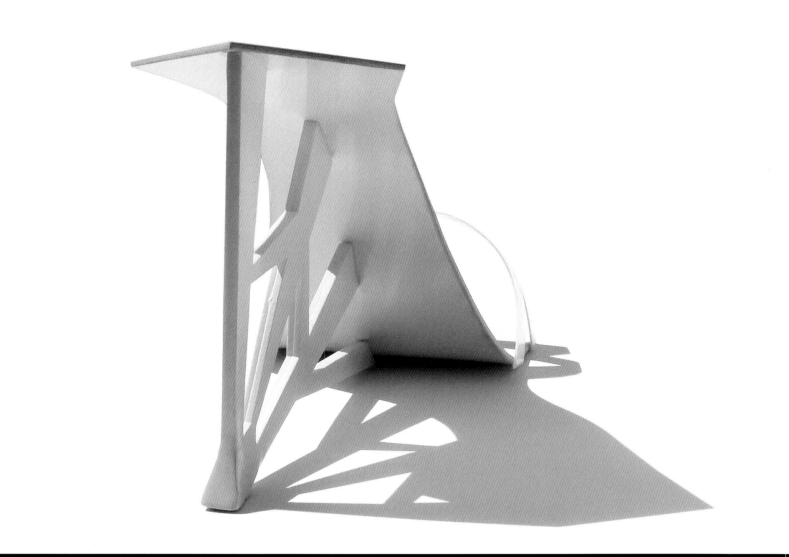

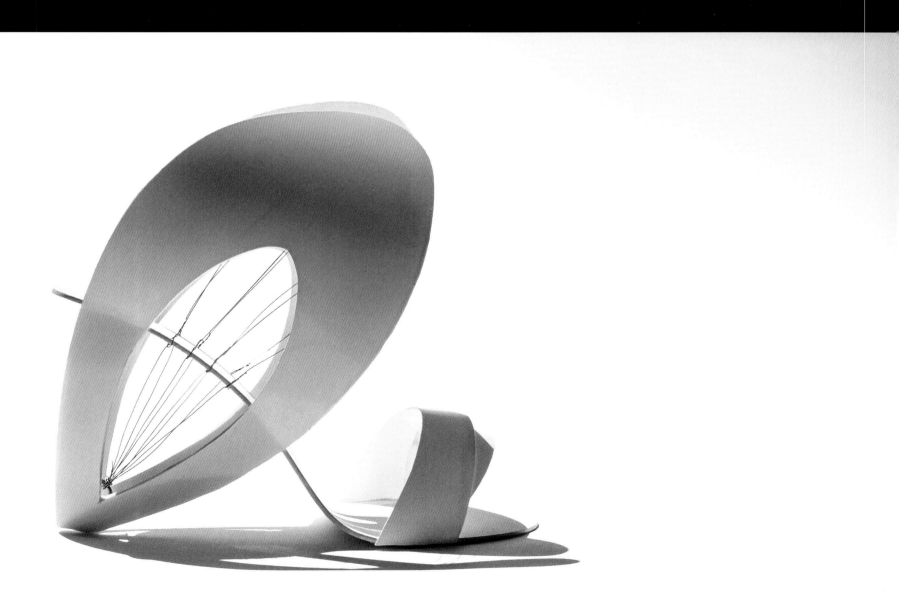

*IT'S NOT OFTEN THAT A SHOE DESIGNER INVOKES THE WORK OF ALEXANDER CALDER, BUT TEA PETROVIC HAPPENS TO BE FASCINATED BY FLYING OBJECTS.* Petrovic's footwear resembles a twentieth-century suspension bridge more than something that would suspend a foot. "Someday I hope to design a personal one-man flying machine, like they are planning to make in Japan," she says playfully.

Inspired by Calder's mobile sculptures, Petrovic designs shoes that move with the person wearing them. The designer admits that they are still a work in progress, seeing as she's only been in the profession a few years. But the idea is too revolutionary not to experiment with. "Art plays a huge role in my life and definitely influences my work. And technology is unavoidable," the designer says of the current state of modernity and how it even trickles down to feet.

Art has been Petrovic's preoccupation her entire life and she actively searches for sources of ideas. "Sometimes it's enough to see a shape that triggers you to create something similar in a different function. It can even be a piece of trash." Residing in Sarajevo, Petrovic bills herself as an industrial designer and fashions jewelry and two-dimensional art in addition to shoes. Many designers soak up their environment and often live in a place because they find its energy and creativity stimulating. Unfortunately, Petrovic's home was at the receiving end of one of the biggest conflicts in modern times. "My hometown was destroyed in the war, so it's quite a depressing and uninspiring environment," she tells of the Bosnian War of the early 1990s.

Still, Petrovic is not one to look back, and pushes into new territory with her craft. "I am focused on experimenting with high heels because they determine the whole form of a shoe and always aim to exploit the space between the sole, heel, and floor. That is my obsession," states Petrovic. "In my opinion, a shoe is an artistic expression, one which I treat as a sculptural/architectural form, because a shoe is, in a way, a supporting column for a female human body."

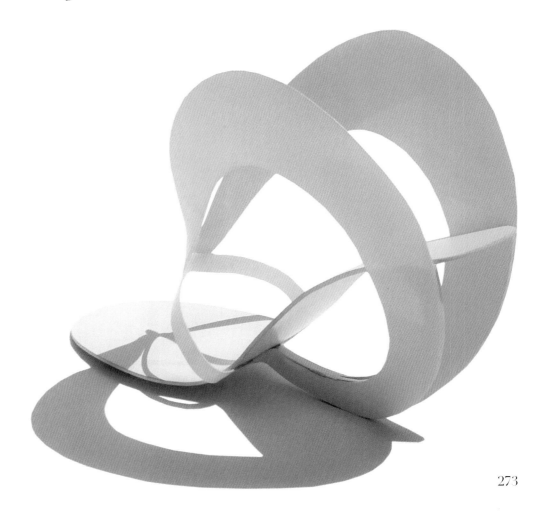

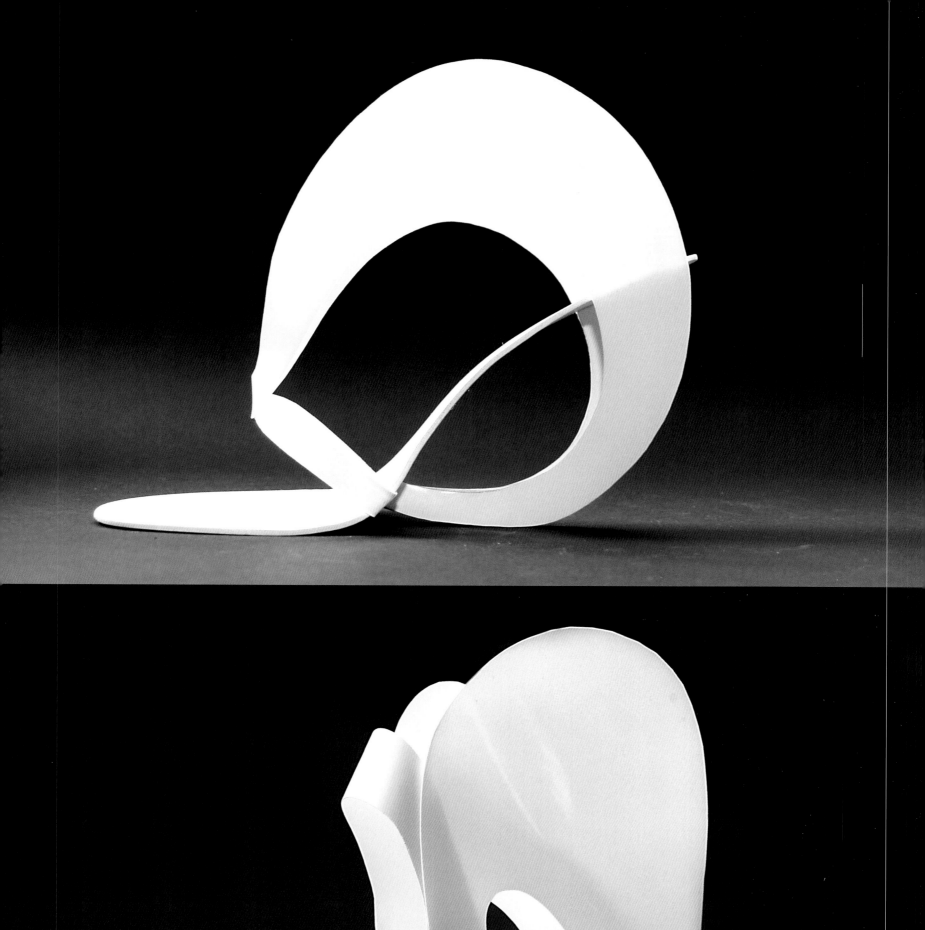
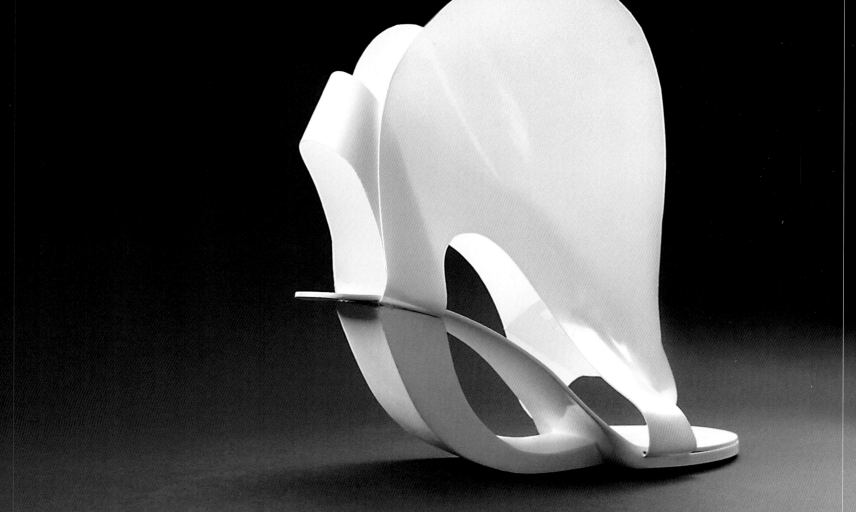

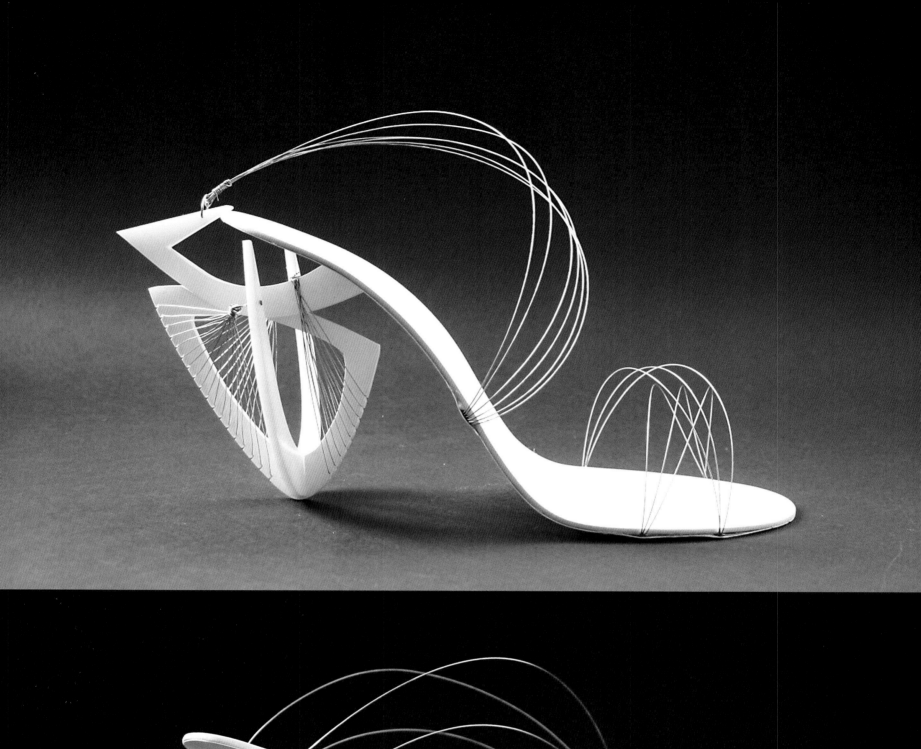

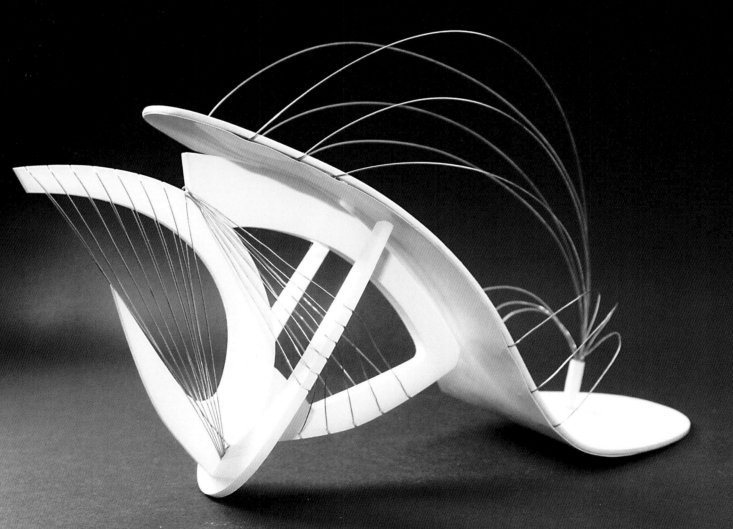

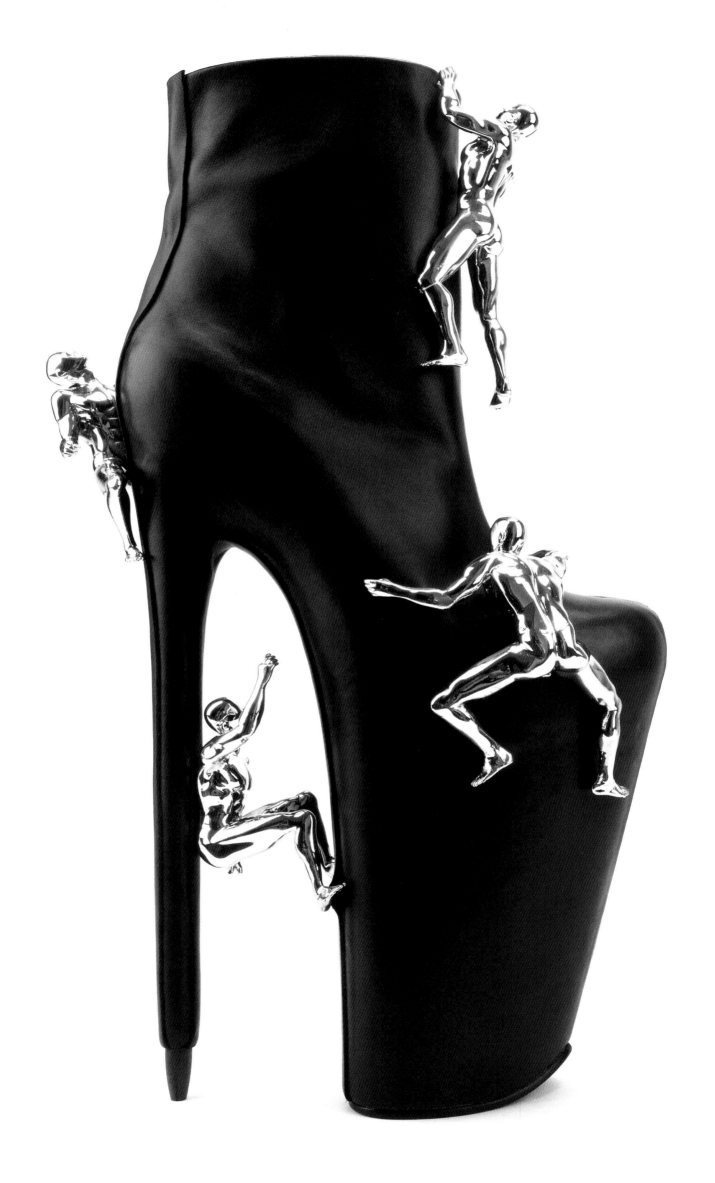

Rem D. Koolhaas founded United Nude to produce a shoe that he designed as an homage to his broken heart. Koolhaas originally studied architecture at the Delft University of Technology in the Netherlands, where he laid down the foundations for his company. He later joined together with Galahad Clark, a seventh-generation shoemaker from the family that founded Clarks shoes. While Koolhaas had never intended on going into shoe or fashion design, United Nude has seen tremendous success due to its accidental evolution. Koolhaas goes beyond the boundaries of traditional construction with his widely experimental designs, using new materials, technologies, and shapes. The name United Nude stands for work that is done in an open and transparent way because Koolhaas believes that "good things happen when people have nothing to hide." He describes his company as "item-driven," as its items have become more connected with the use of color and materials. In the future, Koolhaas aspires to expand his immense design talent by conceptualizing cars and villas.

# *UNITED* NUDE

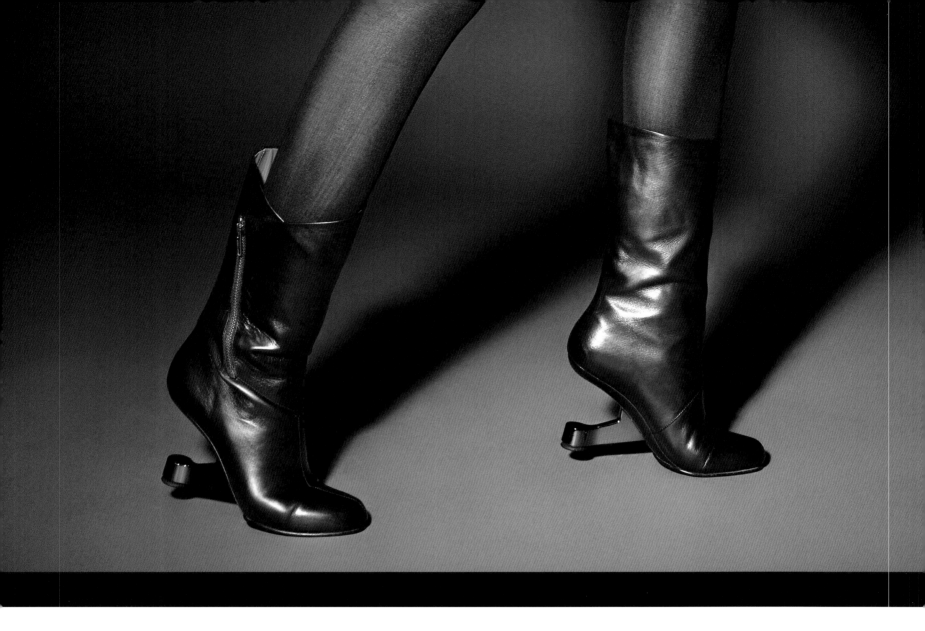

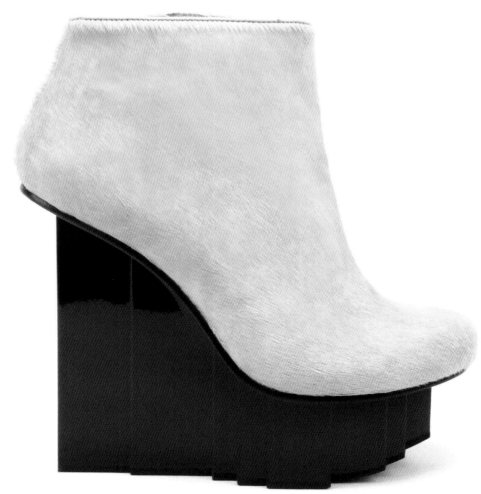

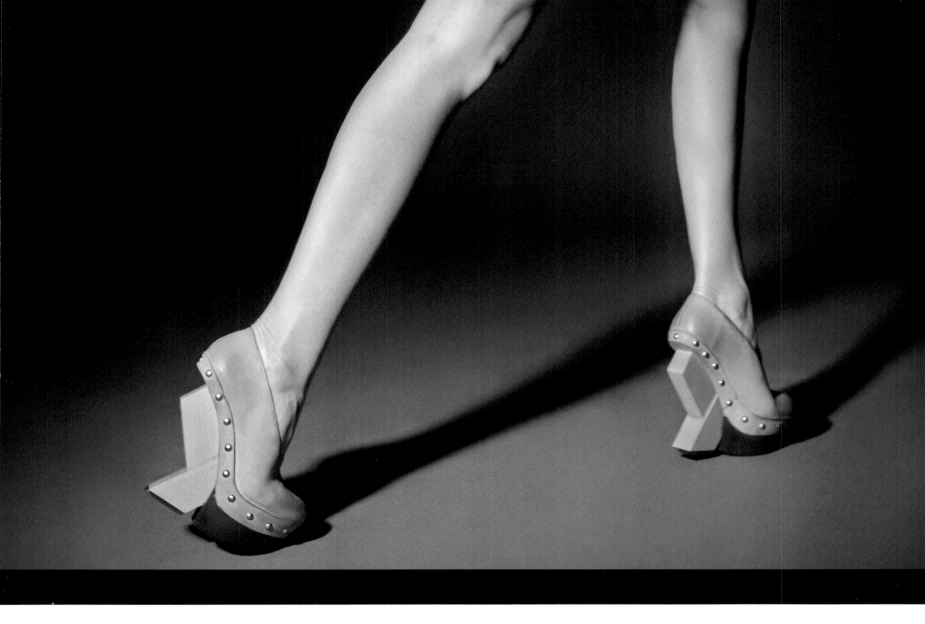

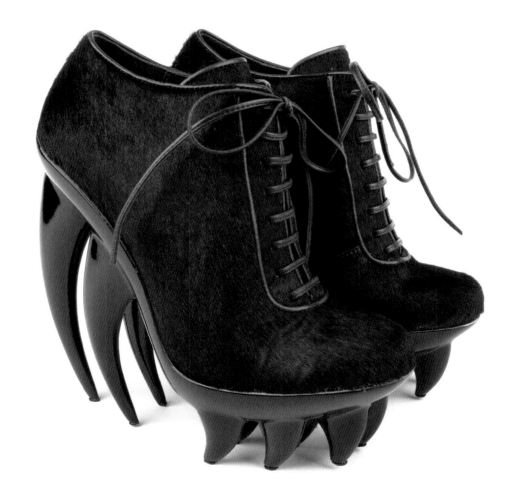

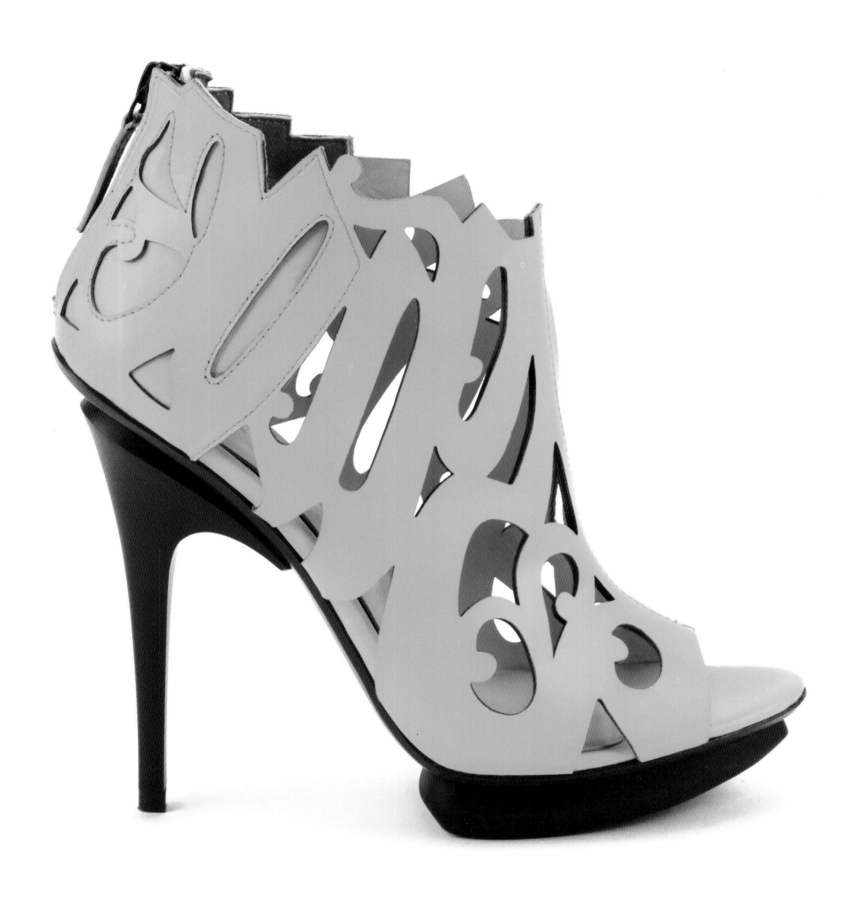

*IN ORDER TO DESIGN THE* MÖBIUS *SHOE, REM D. KOOLHAAS SAYS HE HAD TO PRACTICALLY REINVENT SHOEMAKING.* Fashioned from a broken heart, the designer created his design as an homage to a lost love. It was a shoe that, according to him, literally changed his life. "When I invented the *Möbius* shoe, I felt a strong need to turn it into a real product and the only way to do that was to start a brand for it."

Koolhaas is the creative director and cofounder of United Nude, a footwear company that goes beyond the boundaries of traditional construction when it comes to encasing the foot. His name garners instant recognition as a result of his well-known architect uncle with the same name (the younger Koolhaas distinguishes himself by utilizing his middle initial, "D"). He, too, is an architect by training, completing his studies at the Delft University of Technology. It was there that he set the stage for his company with Galahad Clark.

Despite the fact that Koolhaas never truly wanted to go into shoe or fashion design, United Nude has seen huge success. He always designed things as a child and worked at several architectural firms while he was a student. An almost accidental evolution pressed him straight into his present occupation directly following his studies.

Today United Nude is what Koolhaas describes as an item-driven brand, and is much more than just shoes. "With the use of color and materials, we connect things and the items become a collection," the designer explains. "There are shoes such as the *90 Degrees*, the *Web Hi*, the *Geisha*, and the *Crazy Lacy* that really stand out, but for me the *Möbius* is always my favorite as this is the pair where it all began."

According to the designer, it is mostly his great curiosity that has made for the wide experimentation he does with new materials, technologies, and shapes, giving him the urge to constantly create. He has also dipped into film, creating *Moving Manhattan* with an accompanying book entitled *Shadow Book* in 2000. Incessant and expansive, his interests have reached into collaborating with others, such as Iris van Herpen, K-Swiss, 223, and Dr. Sky. Koolhaas actually desires partnerships with people from other fields more than his own, an example being film directors such as Joe Kosinski, the director of the sci-fi movie *Tron: Legacy* (oddly enough, Kosinski is also an architect).

His present collaboration with Iris van Herpen (now on their sixth collection) has led the two to further push the boundaries of what they do. "People like Beyoncé and Lady Gaga have all picked them up." What else would he like to design that he has not? "Private villas," he says. "This will happen someday, when one of my clients can afford one," he jokes. Fashion is not out of the question, though. "I'm also fantasizing about clothing as I really envy the moment of a United Nude fashion show."

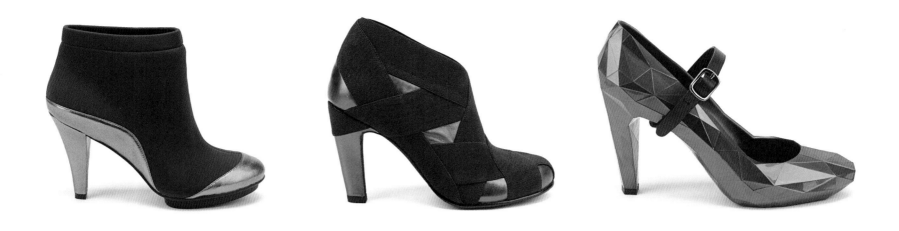

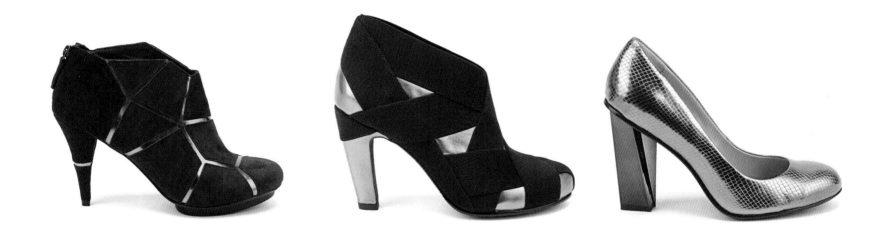

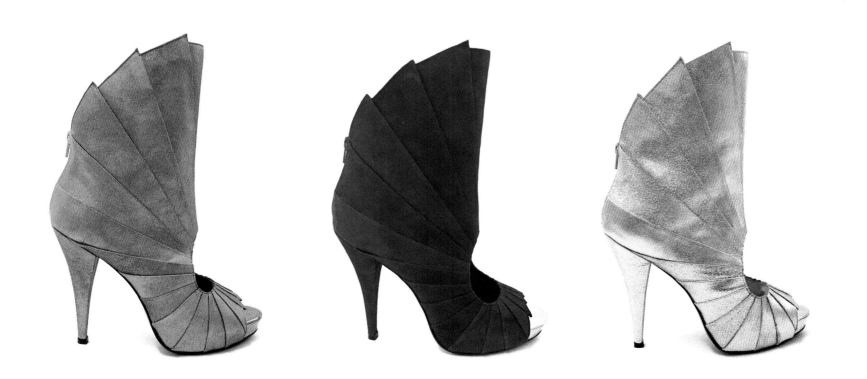

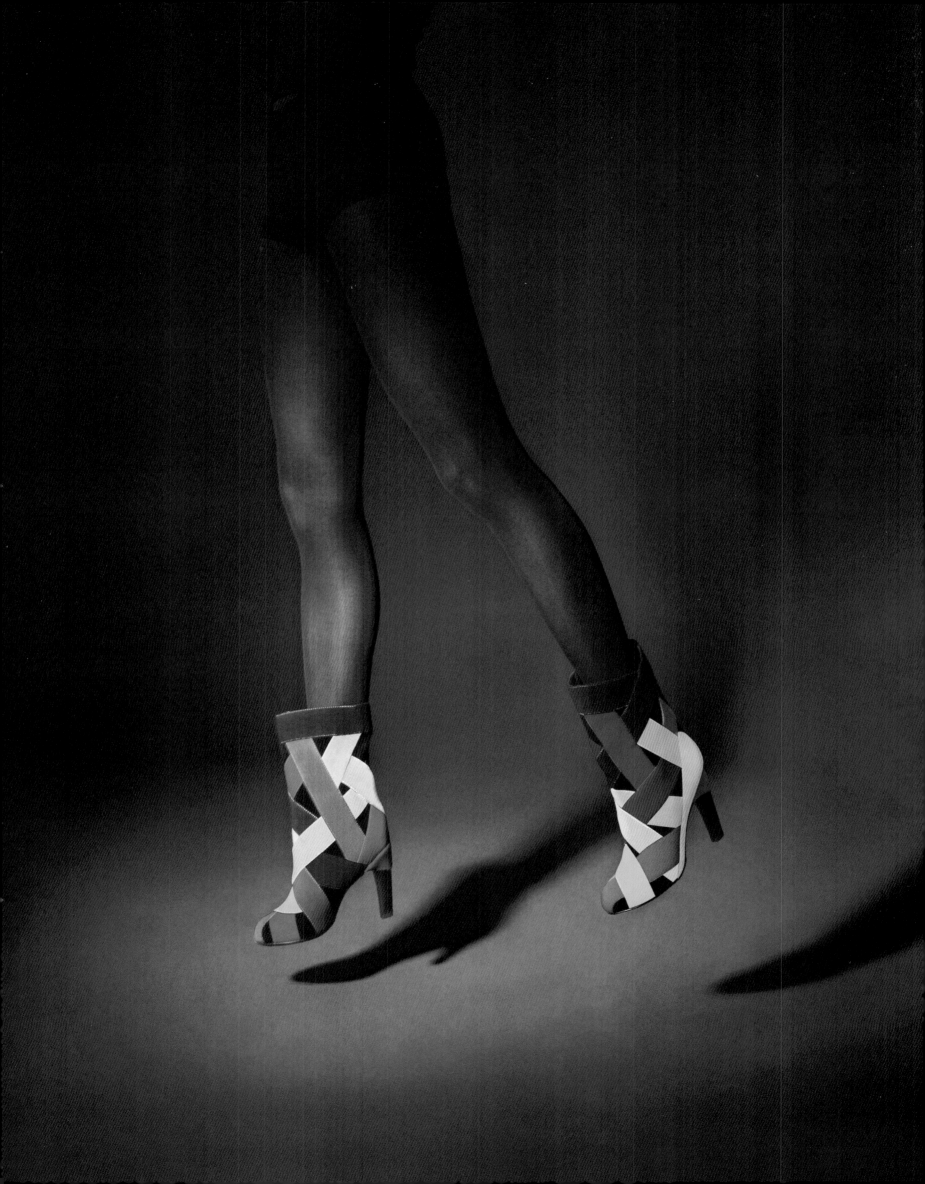

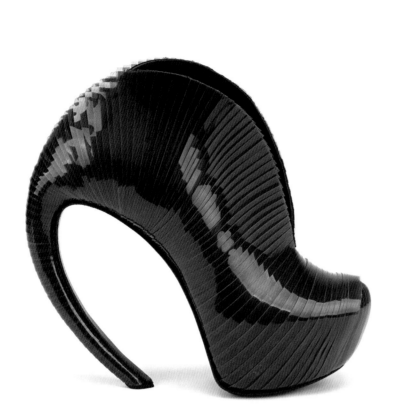
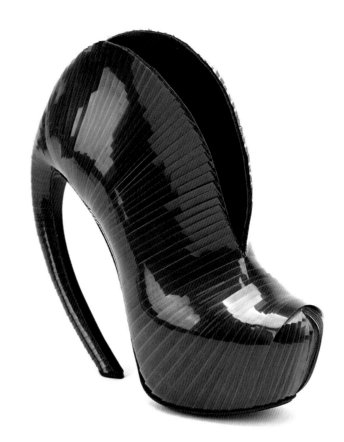
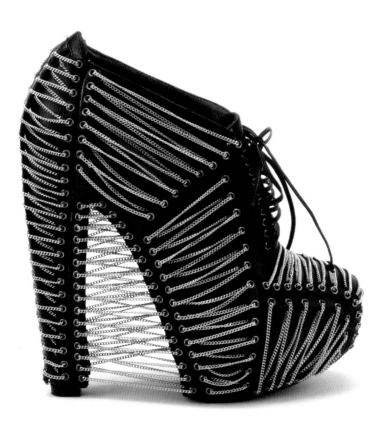
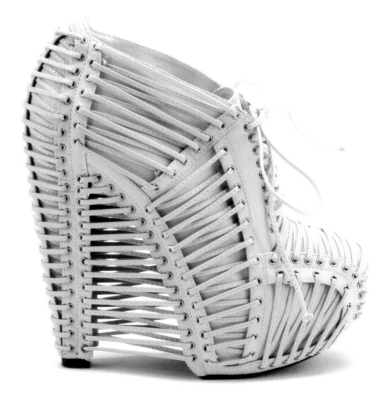

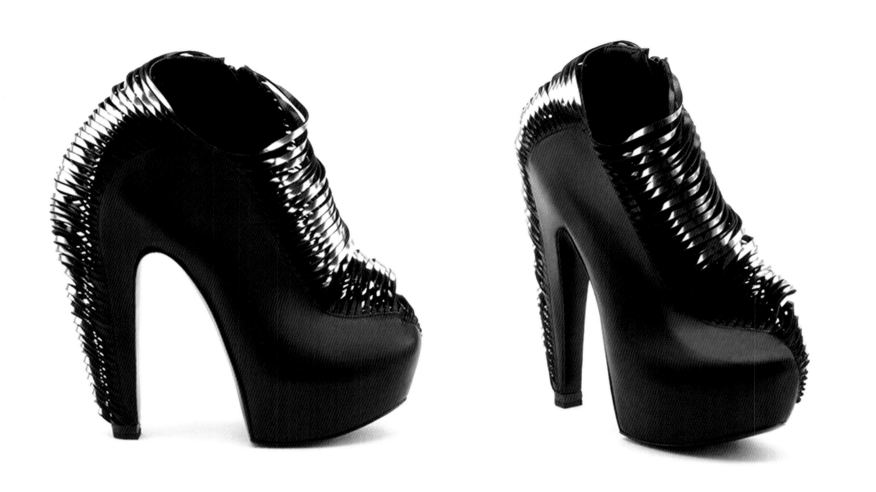

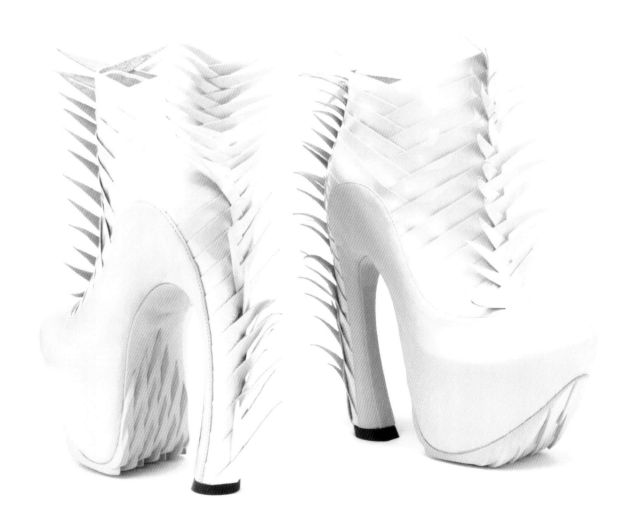

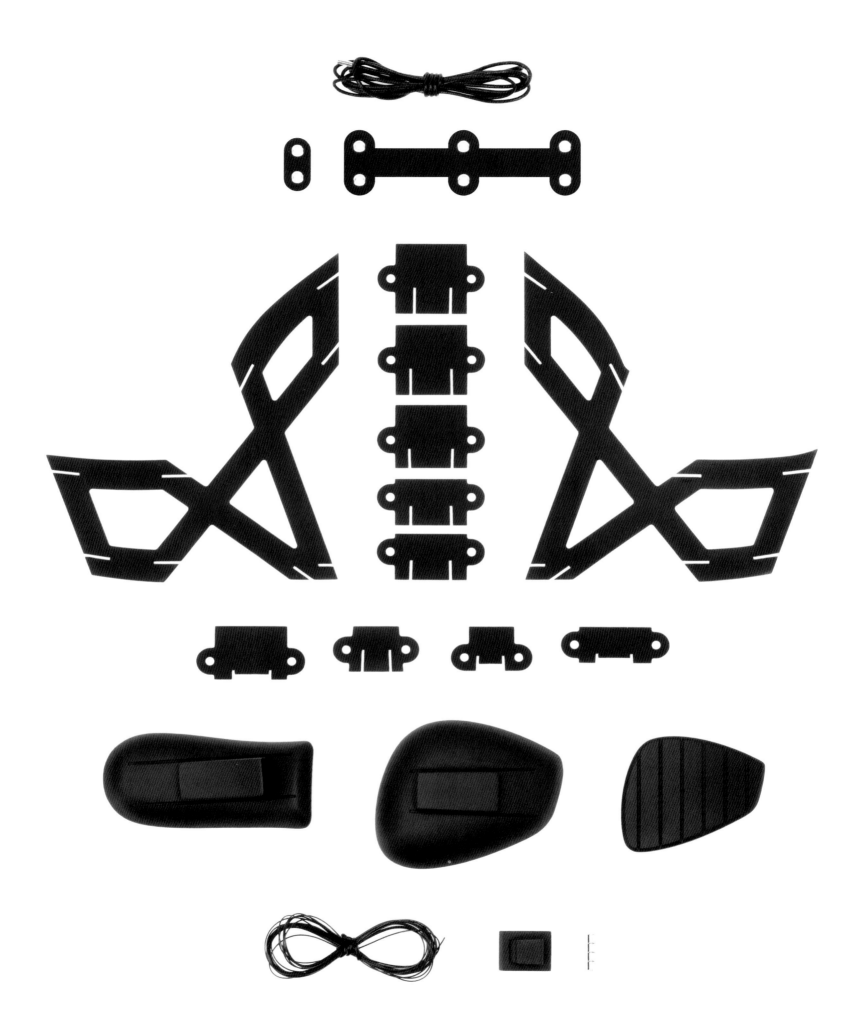

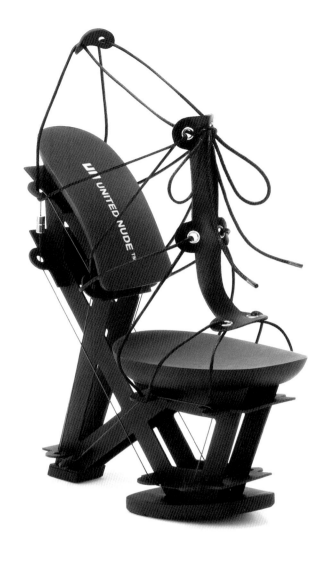

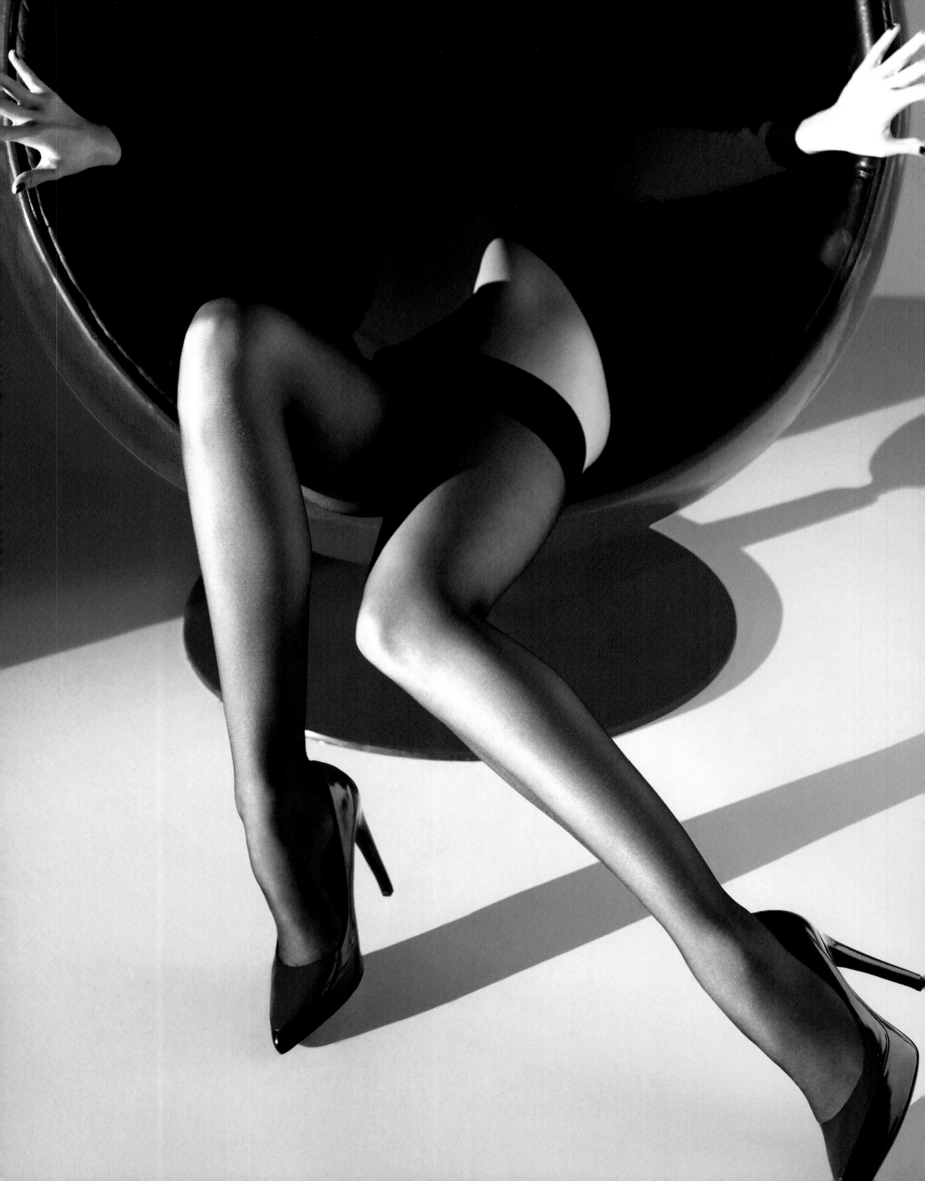

From its namesake—a famous shopping district in Milan—to the fine leathers and fabrics used to construct each shoe and the creator of the brand, Via Spiga thoroughly reflects pure Italian sophistication. Paolo Batacchi established Via Spiga in 1985 and by 1991 he was named "Designer of the Year" by the leading shoe industry publication, *Footwear News*. Via Spiga's luxurious, polished style along with its architectural influences received recognition worldwide, allowing the brand to expand globally by opening stores in New York, Miami, and Hong Kong, as well as introducing a men's collection. In 2011, Edmundo Castillo was named the creative director of Via Spiga, bringing with him a modern, timeless, and ultra-feminine aesthetic to this luxury brand.

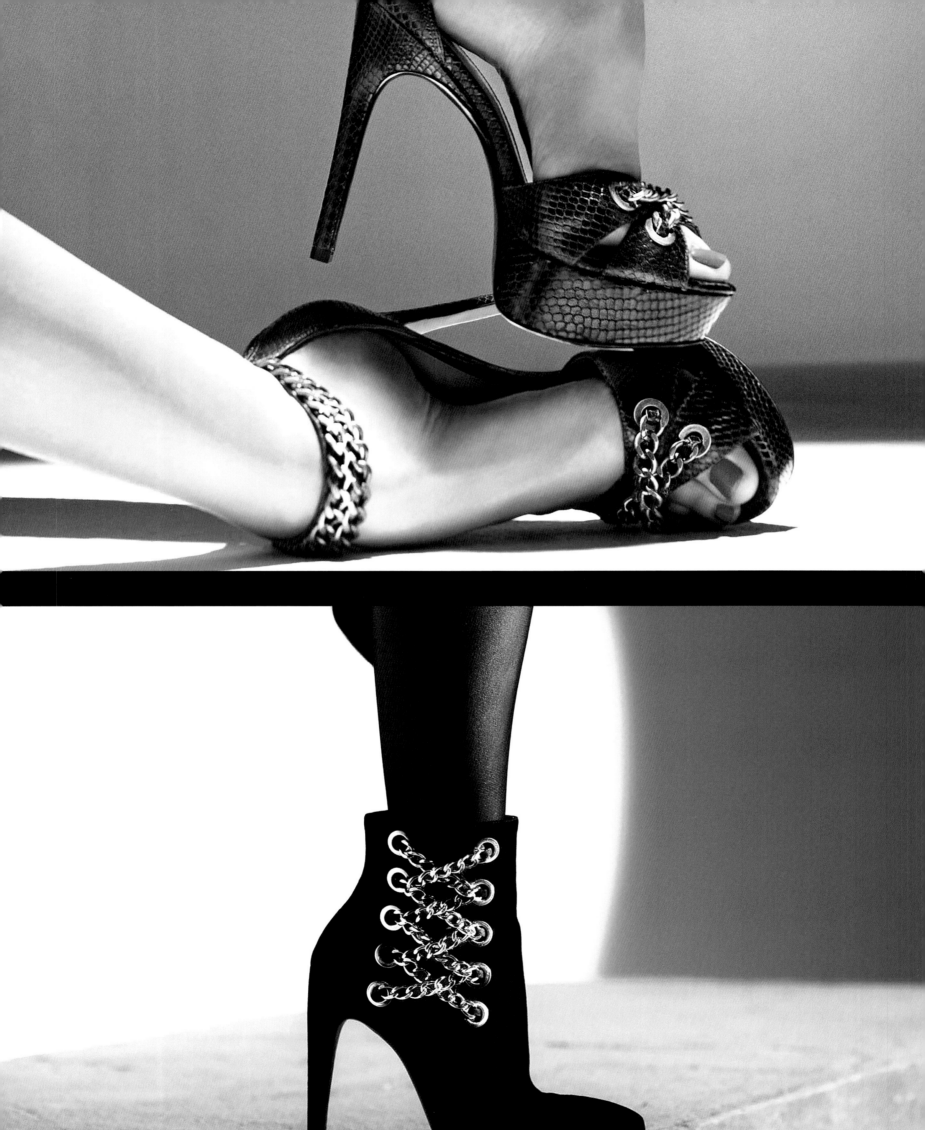

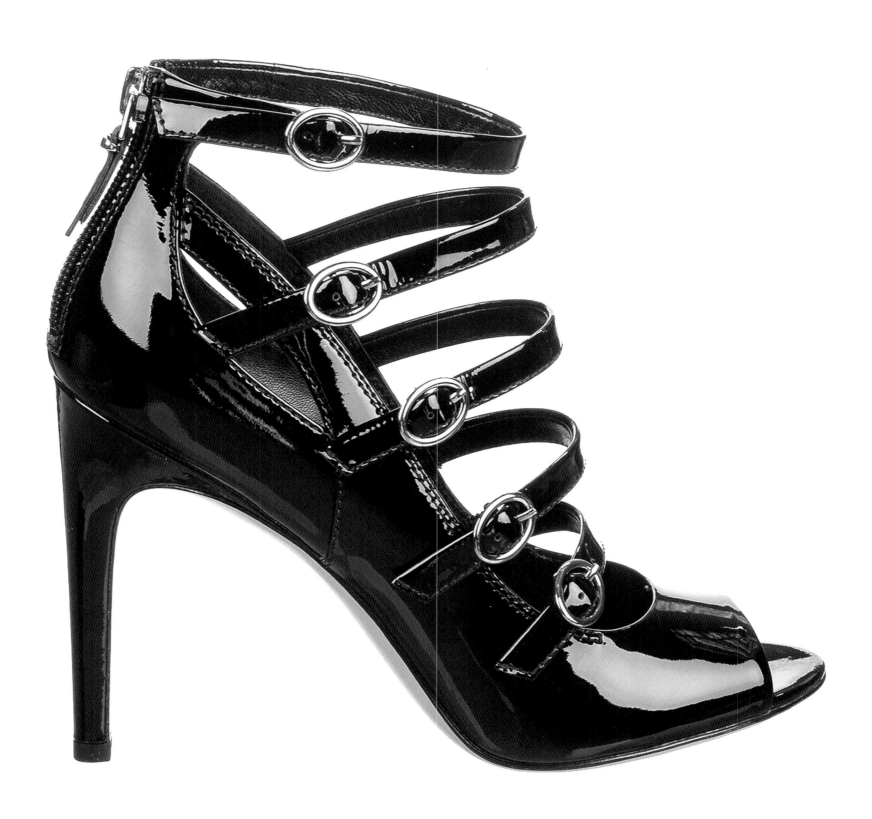

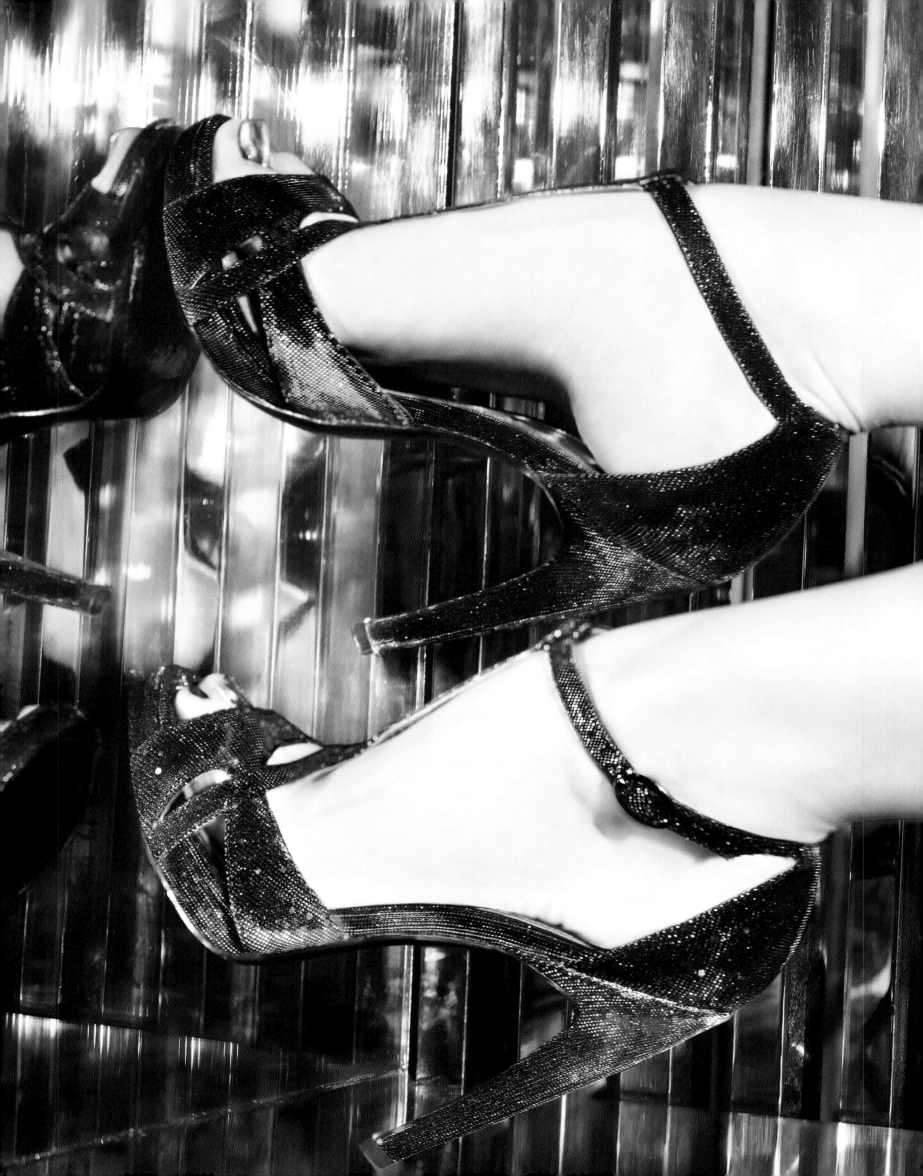

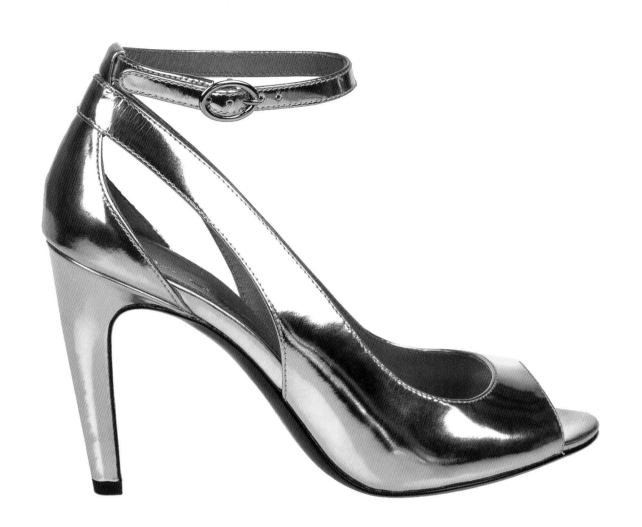

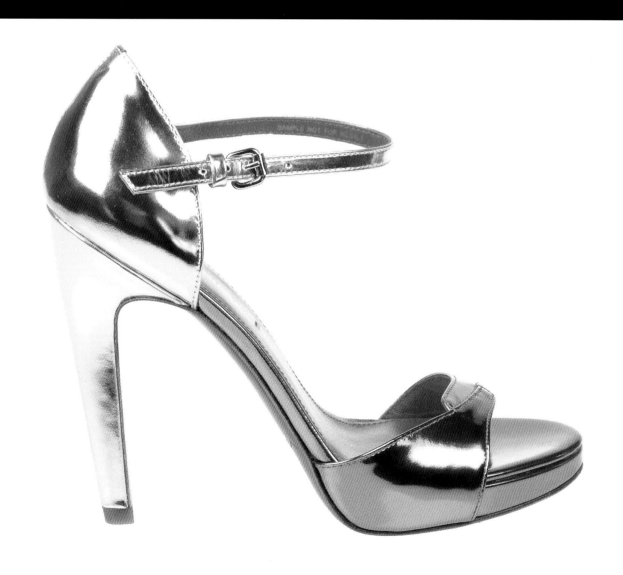

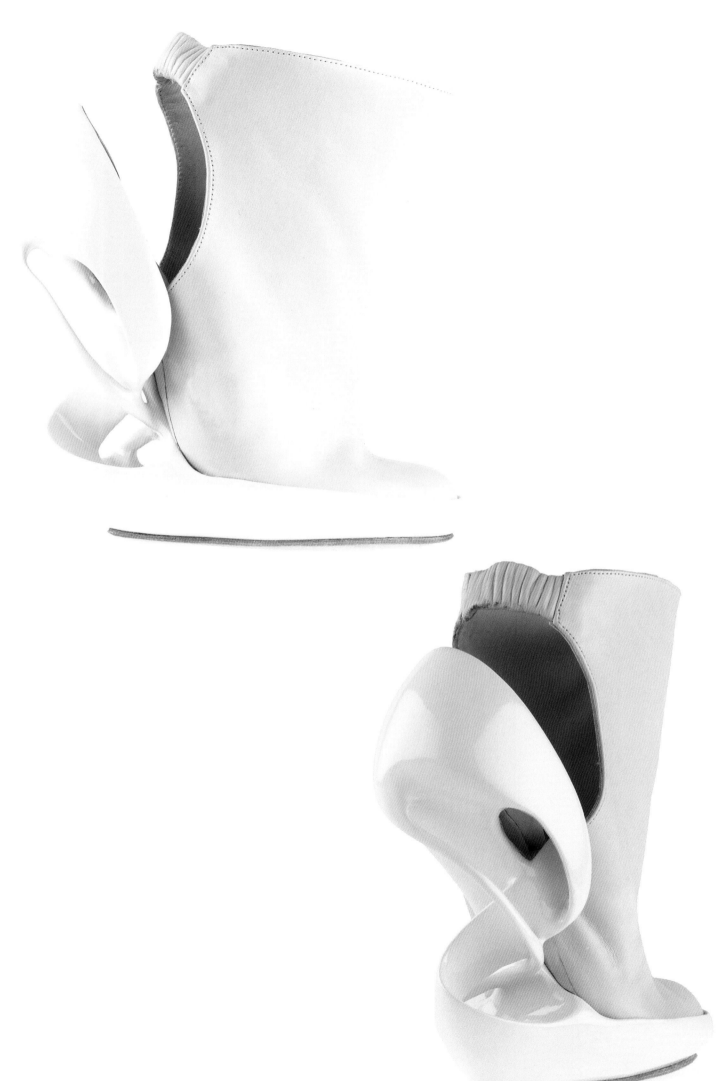

When Victoria Spruce was born, her feet were deformed and she had to wear corrective shoes for the first few years of her life—something she thinks may have to do with her affinity for footwear. Today the London-based shoe designer cites architecture and sculptures among her countless inspirations, and her shoes are a perfect reflection of these influences, from the use of interesting materials and new technologies to traditional leathers and shoemaking techniques. Spruce believes that the beauty of shoes lie in their simplicity as well as in the lines and silhouettes they create. As one of the few designers experimenting with new ways to make shoes, her mixing and contrasting of materials and techniques makes her footwear extremely unique. For Spruce, it will be a very exciting time for footwear when it reaches the forefront of fashion.

# *VICTORIA* SPRUCE

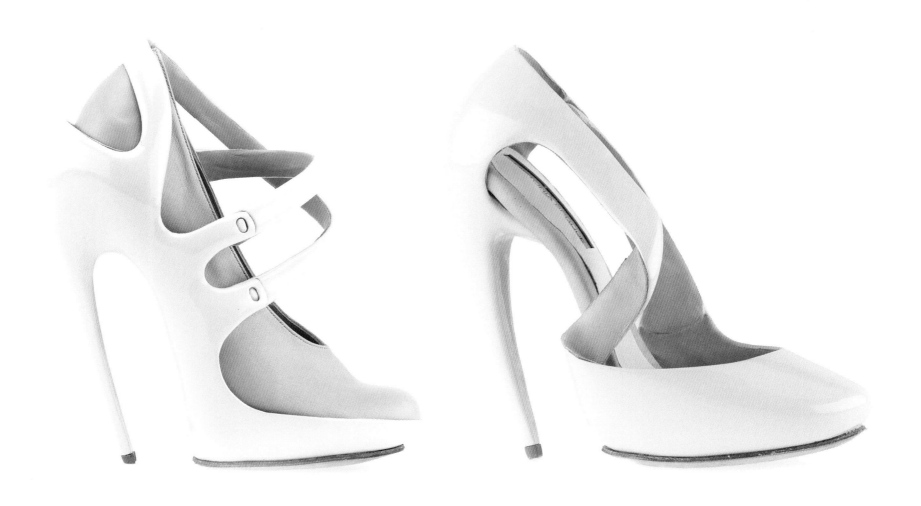

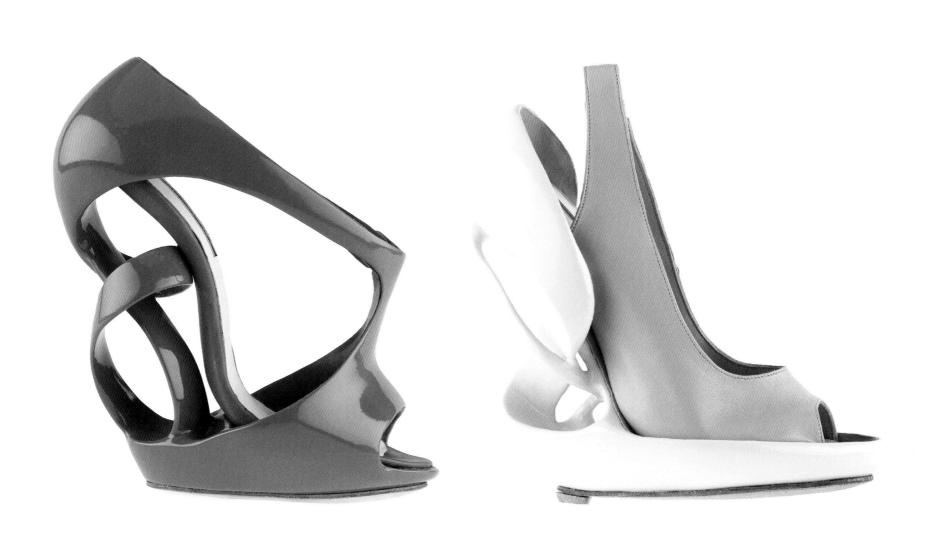

VICTORIA SPRUCE IS NOT ONE GIVEN TO CRAFTING ANYTHING COVERED IN STUDS, SPIKES, OR SIMILARLY HIGHLY DECORATIVE TRIMS. She is, however, given to luxury with a dash of urban verve. Spruce's style is modern and decidedly lovely. The designer feels the beauty of a shoe is often found in its simplicity and the perfection of its lines and silhouette. Trims, buckles, and added details are unnecessary to the otherwise clean creation—pun-making aside—that is underfoot. "I am constantly inspired by the lines, shapes, and silhouettes found in architecture and sculptures. I think it's fascinating to take elements of a large structure and scale them down to the proportions of a shoe," says the designer.

Her ability to plan and think innovatively has been a factor that nurtured Spruce's success as well. She believes in utilizing untried manufacturing techniques and materials to push the boundaries of footwear design while staying true to traditional materials and techniques. "Through the juxtaposition of the old and the new, I focus on creating future-forward designs that still retain a traditional aesthetic we can all recognize."

The British designer says her passion has always been shoes "for as long as I can remember." Upon finishing high school, she attended Cordwainers College, London College of Fashion, and received a bachelors's degree in footwear design followed by a master's degree in womenswear footwear from the Royal College of Art. After six years of education, the designer is finally happy to be putting it all into practice.

The prospect of creating something new and more exciting than the last collection is what motivates Spruce each day. "I cannot wait to get my ideas down on paper and into development. Having a complete passion for your career keeps you inspired to constantly build and improve what you have already started and [so far] the designs haven't stopped," she proclaims.

Spruce would encourage anyone who is interested in the profession to go for it and to keep going. "Persevere with the ups and downs and keep trying," she advises. Where does she think the industry is going? "I believe that there will be an increase in designers changing the way shoes are designed and manufactured with new materials and technologies paving the way," she forecasts. "I am only one of a few experimenting with new ways to make shoes, and when it finally comes to the forefront, I think it will be a very exciting time for footwear."

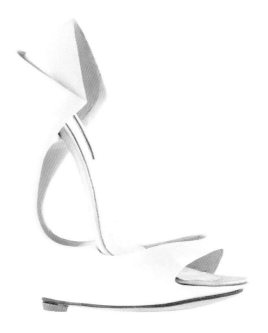

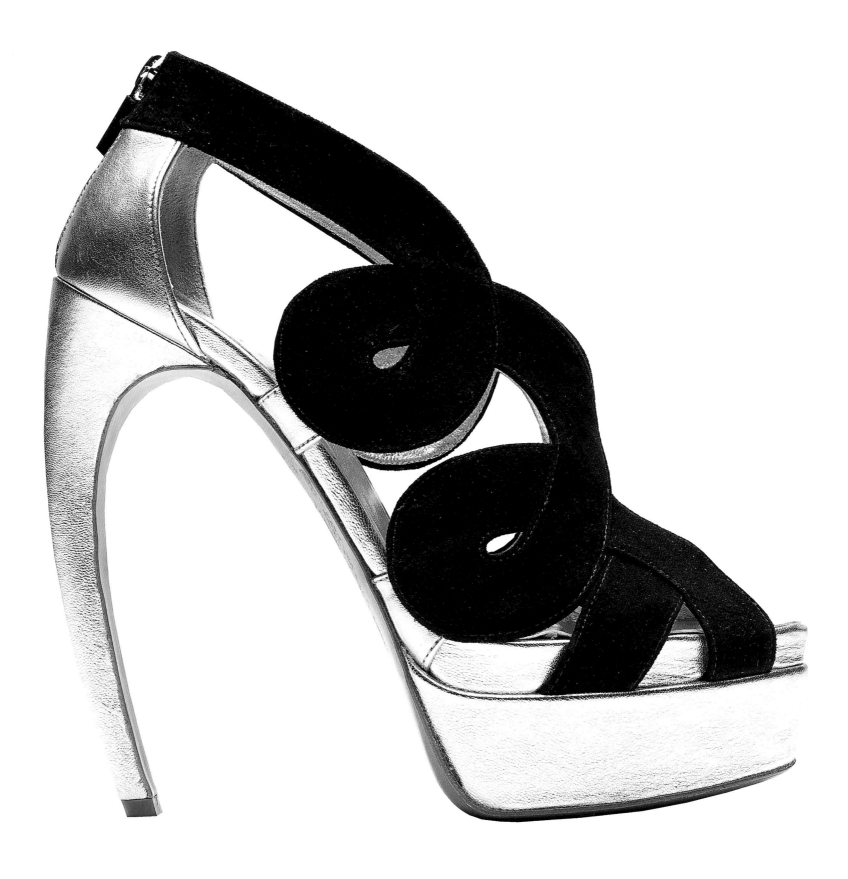

Born in Geneva in 1942, Walter Steiger was interested in art and design as a child and wanted to work alongside his shoemaker father. He began an apprenticeship when he was fifteen years old and worked until the age of twenty in a prestigious shoemaking workshop. In 1962, he went to Paris to work for the studio Capucine and also designed the collection for Bally Madeleine. Shortly thereafter he moved to London and participated in the escapades of the "Swinging London" period. During that time he also designed shoes for Mary Quant and Michelangelo Antonioni's 1966 film *Blow-Up*, and his creations were published in *Queen*, *Vogue*, and *Harper's Bazaar*. When Steiger presented his first collection under the family name in 1967 it was a huge success, particularly in the United States. Since then, Steiger has collaborated with many of the most renowned fashion houses in the world, including Karl Lagerfeld, Nina Ricci, Chloé, Calvin Klein, and Oscar de la Renta. Today Giulio and Paul Steiger, the third generation to run the family company, exercise a significant influence on Walter Steiger's collections, but Walter Steiger himself still retains an essential role in the creative process.

# *WALTER* STEIGER

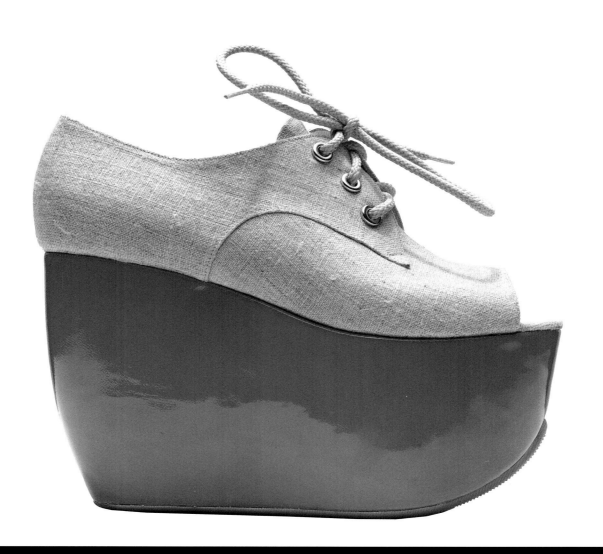

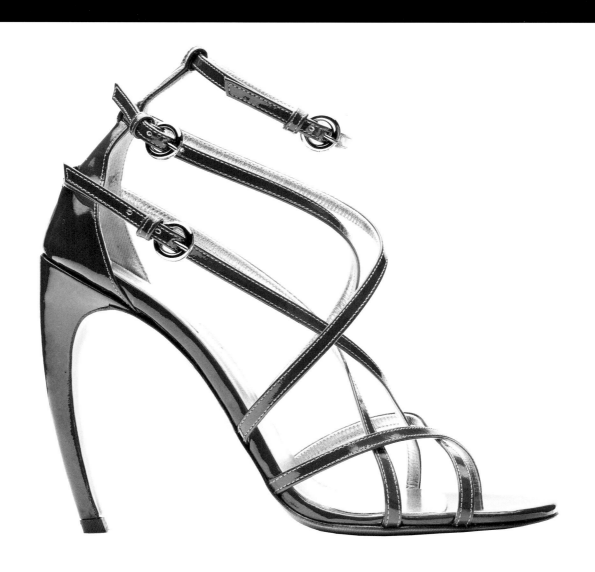

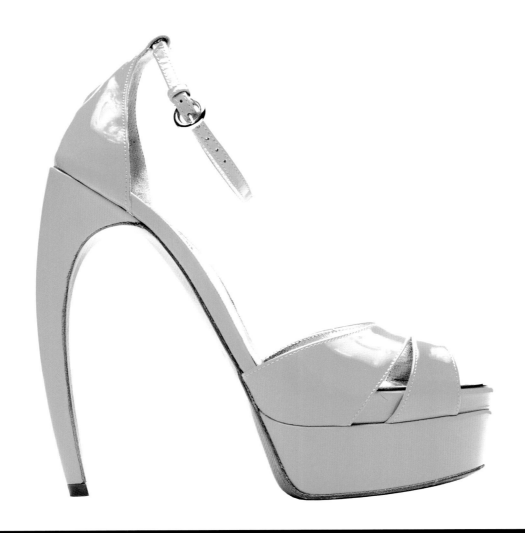

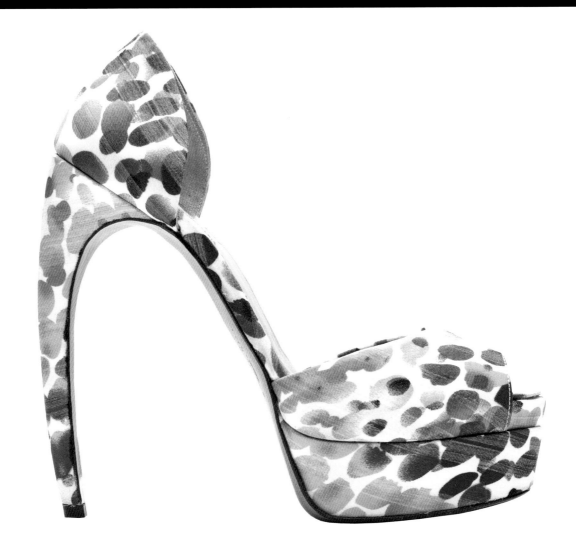

# CREDITS

We extend our gratitude to all the creative spirits featured in this book who make it possible for women to continue their love affair with shoes. All images have been supplied by courtesy of the respective designers including the special instances below:

*Front Cover (from top, left to right):* Courtesy of Walter Steiger; © Gianfilippo De Rossi; Courtesy of Diego Dolcini Studio; Courtesy of Charlotte Olympia; © Ruthie Davis; Courtesy of Charlotte Olympia; Courtesy of United Nude; Courtesy of Charlotte Olympia; Courtesy of Walter Steiger; Courtesy of Diego Dolcini Studio; Courtesy of GINA; © Gianfilippo De Rossi; Courtesy of Walter Steiger; © Ally Blackwood; Courtesy of Cesare Paciotti; © Gianfilippo De Rossi; Courtesy of United Nude; Courtesy of Diego Dolcini Studio; © Thomas Kletecka; Courtesy of United Nude; Courtesy of Walter Steiger; © Ruthie Davis; © Mark Buenaobra; Courtesy of Charlotte Olympia; © Ruthie Davis; © Ruthie Davis; © Alexander McQueen; © Kay Wahlig; © Gianfilippo De Rossi; © Mark Buenaobra; © Ruthie Davis; Courtesy of Diego Dolcini Studio; Courtesy of Netta Makkonen; Courtesy of Diego Dolcini Studio

*Back Cover (from top, left to right):* Courtesy of Walter Steiger; © Ally Blackwood; Courtesy of Via Spiga; Courtesy of Via Spiga; © Mark Buenaobra; Courtesy of Greg Mills; Courtesy of Netta Makkonen; Courtesy of Diego Dolcini Studio; © Ruthie Davis; Courtesy of Diego Dolcini Studio; Courtesy of Greg Mills; Courtesy of Charlotte Olympia; Courtesy of Diego Dolcini Studio; Courtesy of Cesare Paciotti; © Gianluca Pasquini and Diego Dolcini; © Mark Buenaobra; © Kay Wahlig; Courtesy of Casadei; © Ruthie Davis; © Mark Buenaobra; © Gianfilippo De Rossi; © Ruthie Davis; Courtesy of Diego Dolcini Studio; Courtesy of Diego Dolcini Studio; © Andrea Barbiroli; Courtesy of United Nude; © Roberto Mazzola/Daylight Studio; Courtesy of GINA; Courtesy of Casadei; © Roberto Mazzola/Daylight Studio; Courtesy of Diego Dolcini Studio; © Gianfilippo De Rossi; Courtesy of Diego Dolcini Studio; © Alexander McQueen; © Alexander McQueen; Courtesy of Diego Dolcini Studio; Courtesy of Jimmy Choo; © Gianfilippo De Rossi; Courtesy of Diego Dolcini Studio; © Ally Blackwood

*Dust Jacket:* © Diego Dolcini and Gianluca Pasquini
*Title Page:* Courtesy of René Caovilla (p 2)

*Patrice Farameh Introduction (pp 4–9)*
© Alexander McQueen (p 4)
© Nathaniel Goldberg/Trunk Archive (pp 8–9)

*Mary Alice Stephenson Feature (pp 10–13)*
© The Coveteur/Trunk Archive (p 10)
© Alexander McQueen (p 12)

*Alejandro Ingelmo (pp 14–19)*
www.alejandroingelmo.com
© Jose Marquez (pp 16, 18–19)
Courtesy of Alejandro Ingelmo (p 17)

*Alexa Wagner (pp 20–25)*
www.alexawagner.com
© Maurizio Tosto (p 20)
© David Lantermoz (pp 22–25)

*Alexander McQueen (pp 26–31)*
www.alexandermcqueen.com
© Norbert Schoerner/Trunk Archive (p 26)
© Alexander McQueen (pp 28–31)

*Aoi Kotsuhiroi (pp 32–37)*
www.aoikotsuhiroi.com
© Aoi Kotsuhiroi (pp 32, 34–37)

*Atalanta Weller (pp 38–43)*
www.atalantaweller.com
© Saty + Pratha (pp 38, 41–43)
© Kay Wahlig (p 40)

*Barbara Briones (pp 44–49)*
www.barbarabriones.com
© Nacho Rojas (p 44)
© Denise Behrens (pp 46–49)

*Bionda Castana (pp 50–53)*
www.biondacastana.com
© Aaron Tilley (pp 50, 52–53)

*Camilla Skovgaard (pp 54–57)*
www.camillaskovgaard.com
Courtesy of Camilla Skovgaard (pp 54, 56)

*Casadei (pp 58–65)*
www.casadei.com
© Raymond Meier (pp 58, 65)
Courtesy of Casadei (pp 60–61, 64)
© Ilaria Orsini (pp 62–63)

*Cesare Paciotti (pp 66–75)*
www.cesare-paciotti.com
Courtesy of Cesare Paciotti (pp 66, 69, 70–72, 75)
© Stefano Galuzzi (pp 69, 73–74)

*Charlotte Olympia (pp 76–81)*
www.charlotteolympia.com
Courtesy of Charlotte Olympia (pp 78–79, 81)
© Julia Kennedy (pp 76–77, 80)

*Chau Har Lee (pp 82–89)*
www.chauharlee.com
© Sylvain Deleu (pp 82, 84, 85 bottom, 87)
© Viktor Vauthier (p 85 top)
© George Ong (pp 88–89)

*Christian Louboutin (pp 90–95)*
www.christianlouboutin.com
© François Dischinger/Trunk Archive (p 90)
© The Coveteur/Trunk Archive (p 92)
© Arthur Belebeau/Trunk Archive (p 93)
© David Roemer/Trunk Archive (pp 94–95)

*Daniele Michetti (pp 96–101)*
www.michettidaniele.com
© Roberto Mazzola/Daylight Studio
(pp 96, 98–101)

*Diego Dolcini (pp 102–111)*
www.diegodolcini.it
© Gianluca Pasquini and Diego Dolcini
(pp 102, 107–111)
Courtesy of Diego Dolcini Studio (pp 104, 106)

*For the Love of Shoes* © 2013 teNeues Verlag GmbH & Co. KG, Kempen/
© 2013 Farameh Media. All rights reserved.

*Edited with love by* Patrice Farameh
*Design concept by* Susanne Schaal
*Designed by* Allison Stern
*Editorial coordination by* Victorine Lamothe, teNeues Publishing
*Editorial and research coordinators:* Maureen Chung, Cindi Cook, Alexis Kanter,
Monica Oluwek, Illyssa Satter
*Copywriters:* Maureen Chung, Cindi Cook, Monica Oluwek, Nicky Stringfellow
*Copyeditors:* Victorine Lamothe, Monica Oluwek
*Production by* Nele Jansen, Alwine Krebber, teNeues Verlag
*Color separation by* MT Vreden

*Special acknowledgment* to Julie Benasra, Dr. Valerie Steele, and
Mary Alice Stephenson for their special insight into the love of shoes.

*Produced by* Farameh Media, New York
www.farameh.com

*Published by* teNeues Publishing Group
www.teneues.com

teNeues Verlag GmbH + Co. KG
Am Selder 37, 47906 Kempen, Germany
Phone: +49-(0)2152-916-0
Fax: +49-(0)2152-916-111
e-mail: books@teneues.de

Press department: Andrea Rehn
Phone: +49-(0)2152-916-202
e-mail: arehn@teneues.de

teNeues Digital Media GmbH
Kohlfurter Straße 41–43, 10999 Berlin, Germany
Phone: +49-(0)30-7007765-0

teNeues Publishing Company
7 West 18th Street, New York, NY 10011, USA
Phone: +1-212-627-9090
Fax: +1-212-627-9511

teNeues Publishing UK Ltd.
12 Ferndene Road, London SE24 0AQ, UK
Phone: +44-(0)20-3542-8997

teNeues France S.A.R.L.
39, rue des Billets, 18250 Henrichemont, France
Phone: +33-(0)2-4826-9348
Fax: +33-(0)1-7072-3482

ISBN 978-3-8327-9697-6

Library of Congress Control Number: 2013940490

Printed in Belgium

Bibliographic information published by the Deutsche Nationalbibliothek.
The Deutsche Nationalbibliothek lists this publication in the Deutsche
Nationalbibliografie; detailed bibliographic data are available on the Internet
at http://dnb.d-nb.de.

**teNeues Publishing Group**
Kempen
Berlin
Cologne
Düsseldorf
Hamburg
London
Munich
New York
Paris

**teNeues**